Eardrums

Eardrums

Literary Modernism as Sonic Warfare

✦

Tyler Whitney

NORTHWESTERN UNIVERSITY PRESS
EVANSTON, ILLINOIS

Northwestern University Press
www.nupress.northwestern.edu

Copyright © 2019 by Northwestern University Press.
Published 2019. All rights reserved.

Printed in the United States of America

10 9 8 7 6 5 4 3 2 1

Library of Congress Cataloging-in-Publication Data

Names: Whitney, Tyler, author.
Title: Eardrums : literary modernism as sonic warfare / Tyler Whitney.
Description: Evanston, Illinois : Northwestern University Press, 2019. | Includes
 bibliographical references and index.
Identifiers: LCCN 2019005602 | ISBN 9780810140219 (paper text : alk. paper) |
 ISBN 9780810140226 (cloth text : alk. paper) | ISBN 9780810140233 (e-book)
Subjects: LCSH: German literature—19th century—History and criticism.
 | German literature—20th century—History and criticism. | Modernism
 (Literature)—Germany—History and criticism. | Sound in literature.
Classification: LCC PT395 .W48 2019 | DDC 830.936—dc23
LC record available at https://lccn.loc.gov/2019005602

CONTENTS

List of Illustrations	*vii*
Acknowledgments	*ix*

Introduction
Writing Sound across the Modernist Divide: Phonography,
 Acoustical Embodiment, and the Tympanic Regime — *3*

Chapter 1
Liliencron, Captain of the Nineteenth Century: Naturalism
 as Martial Phonography — *19*

Chapter 2
Bringing the War Home: Tympanic Transductions from the
 Battlefield to Fin-de-siècle Vienna — *47*

Chapter 3
Drumming Literature into the Ground: Dada's Tympanic Regime — *71*

Chapter 4
Toward a Modernist Ear: Robert Musil and the Poetics of
 Acoustic Space — *97*

Chapter 5
Into the Inaudible: Sound and Imperception in Kafka's Late Writings — *119*

Conclusion
Nazi Soundscapes and Their Reverberation in Postwar Culture — *137*

Notes — *149*

Works Cited — *191*

Index — *215*

ILLUSTRATIONS

Figure 1. Plessner's antiphone — 4

Figure 2. Anatomical diagram of the ear with antiphone — 4

Figure 3. Frontal view of an ear plugged with Plessner's antiphone — 5

Figure 4. Liliencron's "The Music Is Coming" (1882) — 21

Figure 5. Musical notation from Liliencron's *Adjutantenritte und andere Gedichte* (1883) — 28

Figure 6. Liliencron's onomatopoeic rendering of a grenade explosion — 31

Figure 7. Liliencron's first onomatopoeic rendering of the drum — 33

Figure 8. Liliencron's second onomatopoeic rendering of the drum — 33

Figure 9. Politzer's lithographic reproductions of perforated eardrums — 52

Figure 10. Facade of the "Etablissement Ronacher," ca. 1899 — 53

Figure 11. A page from Marinetti's sound poem "Zang tumb tumb" (1914) — 72

Figure 12. The inside of one of Luigi Russolo's percussive noise instruments, ca. 1913 — 73

Figure 13. Architectural tympanum (*Giebel*), from the Museum Alexander Koenig in Bonn — 95

Figure 14. Hornbostel and Wertheimer's *Richtungshörer* — 100

Figure 15. Bell's telephonic setup for his experiments on binaural hearing — 101

Figure 16. Anatomy of the ear as a kind of "tunnel space" — 126

vii

viii Illustrations

Figure 17. Hitler's voice and supporting media apparatus *142*

Figure 18. Nazi wind gun *144*

Figure 19. Nazi sound weapon incorporating large parabolic projectors *144*

Figure 20. Firing chamber for a Nazi sound weapon *145*

ACKNOWLEDGMENTS

I feel fortunate to have written this book with the support of so many friends, mentors, and colleagues. During the project's earliest phases, Stefan Andriopoulos offered invaluable guidance and encouragement. His scholarship inspired me to rethink what the field of German Studies could be, and his work continues to be an inspiration for my own. Andreas Huyssen was a generous and attentive reader of early iterations of the project. He also taught me to see what was at stake in doing literary and cultural analysis in the present. Jonathan Crary, Mara Mills, and Tobias Wilke provided helpful comments on how to turn the earlier version into a proper book. I am also grateful to Andreja Novakovic for her care and and support early on. Her thinking has left indelible traces on my own.

The entirety of the book in its current form was written during my first five years at the University of Michigan in Ann Arbor, and I could not have imagined a more supportive environment and group of interlocutors. In particular, I would like to thank Johannes von Moltke, Kerstin Barndt, Julia Hell, Kristin Dickinson, Kira Thurman, Helmut Puff, Andreas Gailus, Peter McIsaac, and Scott Spector. I received precious feedback from both Michael Cowan and Patrizia McBride during my book manuscript workshop, an event generously supported by the University of Michigan and indicative of its commitment to intellectual exchange on campus. Brian Hanrahan has kindly shared his friendship and vast knowledge about sound since we were graduate students together at Columbia University. I am thankful for conversations with my friend Daniel Braun about all things media and literary from our time together in a former Stasi headquarters in Weimar to the taquerias of New York City. I would also like to thank Mary Helen Dupree, Joy Calico, David Imhoof, and Sean Franzel for their input on the project over the past few years. I benefited enormously from presenting an early version of chapter 3 to a humbling group of my colleagues at the Midwest Symposium in German Studies. I would like to thank Marion Gillum and the staff at the Deutsches Rundfunkarchiv for digitizing dozens of historical audio recordings and sending them across the Atlantic. I am grateful to my research assistant, Domenic DeSocio, for editing parts of the manuscript and tracking down many of the images. I also feel compelled to thank the staff at the Interlibrary Loan office at the University of Michigan, who work tirelessly, and often invisibly, to facilitate the type of research required for a book like this.

ix

The motivation behind the book, as is often the case, was not only academic but also deeply personal. To this end, I would like to express my gratitude to Erik Sahd and Chris Fischer, who, as much as any book, have shaped my understanding of sound and supported me creatively. Finally, this book would not exist without the loving support of Megan Ewing, who has been an intellectual and creative inspiration to me through thick and thin. I dedicate this book to her and to Elka, the tiny bubba who lights up our lives.

Eardrums

Introduction

✦

Writing Sound across the Modernist Divide

Phonography, Acoustical Embodiment, and the Tympanic Regime

In 1885 a retired captain of the Royal Prussian Army, Maximilian Plessner, published a fifty-page treatise on modern noise and a commercial tool for its abatement under the title *Die neueste Erfindung: Das Antiphon; Ein Apparat zum Unhörbarmachen von Tönen und Geräuschen* (The Latest Discovery: The Antiphone; An Apparatus for Rendering Tones and Noises Inaudible). Plessner's text functioned first and foremost as an advertisement for his so-called antiphone, the earliest documented commercial earplug, which consisted of metal cones and anchor-shaped discs that fit firmly into the folds of the outer ears (see figures 1–3). The antiphone's stated goal was to subdue the cacophony of late nineteenth-century industrialized society and mitigate its physical effects on listeners.[1] Appealing to late nineteenth-century developments in electroacoustics, Plessner presented the crude device as a way to exclude rather than transmit, record, or process unwanted signals: "Teach me how not to have to hear long-range acoustic effects."[2]

Plessner's military background pervades the text, serving as both a model for potential applications of the device and a framework for analyzing the broader acoustical-social conditions that inspired it. While he recommends incorporating the antiphone into modern military training and service, he also characterizes civilian, urban spaces as environments filled with "acoustic projectiles" (akustische Projektile) launched by the noisy rabble against bourgeois "mind workers" (Kopfarbeiter; Plessner, *Die neueste Erfindung*, 12).[3] In this way, the antiphone was a piece of military hardware indispensable for a still ambiguous war brewing on the streets of German-speaking cities during a period of ostensible peace. Specifically, Plessner's text articulates what Steve Goodman has described as the expansion of "sonic warfare" into the everyday, an attempt to harness sound as a weapon in a battle of "mood, sensation, and information" among opposing classes, professional identities, and political orientations.[4]

3

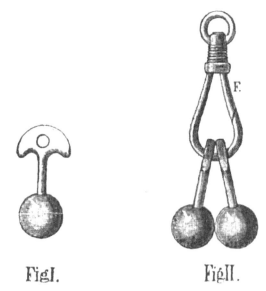

Figure 1. Plessner's antiphone. From Plessner, *Die neueste Erfindung: Das Antiphon; Ein Apparat zum Unhörbarmachen von Tönen und Geräuschen* (Rathenow: Schulze und Bartels, 1885), 26.

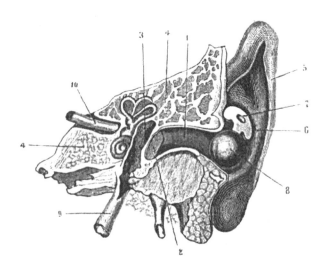

Figure 2. Anatomical diagram of the ear with antiphone. From Plessner, *Die neueste Erfindung*, 27.

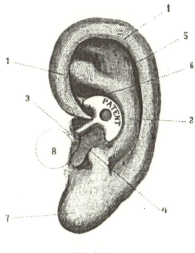

Figure 3. Frontal view of an ear plugged with Plessner's antiphone. From Plessner, *Die neueste Erfindung*, 28.

This account of an encroaching urban war hinges on the figure of the *eardrum*, or tympanum (Trommelfell), a part of the ear that was, on its own, incapable of perception. Its function consisted in transducing vibrations of air into vibrations of water on their way to the cochlea, and ultimately the brain. In Plessner's text, the eardrum functions as a synecdoche for the maligned bodies of bourgeois citizens amid an explosion of sense stimuli and threatening social changes in rapidly changing urban spaces. He identifies the eardrum as one of the least protected parts of the body and, as a result, a frequent site of violent confrontation between opposing groups and the target of competing sonic assaults.

Plessner's prioritization of this particular part of the ear is reinforced by his assurance to readers that, although not capable of abating all external sounds, his invention would prevent the eardrum from being struck violently: "Incidentally, each direct vibration of the eardrum is impeded through a hollow sphere located at the bottom end of the antiphone, which hermetically seals the outer ear canal, while the upper end of the instrument is embedded in the ear pinna and, enveloped by the antihelix of the auricle, is kept in such a position that all contact with the eardrum is made impossible."[5]

6 Introduction

According to Plessner, the protection of the eardrum was a defense against an encroaching working class and urban poor, who could no longer be spatially contained or separated sonically from a more sensitive and intellectually oriented bourgeoisie. "The true despot of our times is the rabble [Pöbel]," Plessner stated unambiguously, "who possess unlimited power over the well-being and woes of educated people."[6] At the end of the nineteenth century, he continued, "educated people are not even in position to protect their property against arbitrary damage from a distance."[7] This distinctly modern breakdown of auditory boundaries between the various classes resulted in nothing less than "the most degrading slavery [Sklaverei]," with the educated terrorized by the uneducated, the civilized by the barbarous, and "the most useful in general by the most expendable to humanity" (der der Gesamtheit Nützlichsten durch die der Menschheit Entbehrlichsten; Plessner, *Die neueste Erfindung*, 8).

In increasingly violent and militaristic language, Plessner went on to lament the fact that, although the poor were permitted to wage their acoustic assault with no repercussions, the law prevented the higher classes from seeking "retaliation" (Wiedervergeltung) by "drumming on other parts of their hides" (anderen Stellen ihres Felles herumzutrommeln; 12). While the lower classes fired acoustic projectiles at bourgeois eardrums from the street, the educated classes fantasized of "drumming" their attackers' bodies in bloody retaliation. In his observations on modern noise, Plessner imported a military vocabulary as a way to diagnose the shifting power relations of urban spaces, according to which class tensions were made perceptible as sonic warfare. "It is only because certain types of people are outside any representation of social harmony," Douglas Kahn observes, "that their speech and other sounds associated with them are considered to be noise."[8] Plessner's outline for restoring bourgeois social order by means of percussive assaults on the bodies of the poor sought to defuse the rabble's sonic assault on the bourgeois eardrum by treating the enemy's body as an eardrum, matching the firing of acoustic projectiles with full-body drumming.

The eardrum therefore functioned as both the target of antagonisms between classes and a model of retaliation. But the connection between the eardrum and sonic warfare went even farther, taking on the hallucinatory potential to simulate war from within. Indeed, in a bizarre reversal of the logic of noise abatement, Plessner presented the antiphone as a device that would be beneficial to otologists and other scientists seeking to *produce* subjective noises for their research.[9] By eliminating the noise of the surrounding environment and applying pressure to the eardrum, he asserted, the internal noises of the body—for example, the "rushing" (Rauschen) of the blood as it circulated—could be amplified, with the antiphone coming to function as what he paradoxically referred to in the text as a "microphone" (Mikrophon).[10] With the antiphone, he continued, previously inaudible sounds of the external world and those inside the body could be intensified to such

Writing Sound across the Modernist Divide

an extent that they resounded inside the user as "the continuous blast of rapid-fire guns" (ein kontinuierliches, von Schnellfeuer begleitetes Krachen von Geschützen).[11]

Thus, alongside its stated goal of eliminating noise and artificially producing silence, the antiphone could simulate the sounds of war via subjective noises with no source beyond the user's own body. If the eardrum was a prized target and model of violent retaliation in a growing class war on the streets of the metropolis, it also enabled a turn inward to a subjective theater of simulated gunshots and explosions. Mediated through the eardrum, sonic warfare materialized both inside the listener's body as hallucination and outside in the reality of urban spaces shot through with social antagonisms. To strike the eardrum, to imagine it as under attack, to take it as a privileged metaphor for the experience of modern sound, was to beat the drum of war, whether real or imagined, literal or figurative, in an escalation of sonic warfare unmoored from the conventional battlefield and displaced to the city.

Romantic Materialities of Sound and the Tympanic Regime

Plessner's intervention marks a significant shift in scientific and aesthetic understandings of hearing and the ear dominant at the turn of the eighteenth century. Within the context of German Romanticism, Johann Gottfried Herder argued that the ear was "the proper door to the soul" (die eigentliche Tür zur Seele),[12] while Friedrich Schiller similarly remarked that "the path of the ear is the most practical and proximate to our hearts."[13] Such characterizations of the ear were predicated on hearing's assumed immediacy to the world of external sense stimuli. According to these accounts, the ear was a perpetually open portal leading directly to an internal theater of human emotions, a mere passageway to the heart and soul, which allowed music and voices to enter and proceed unobstructed through the internal spaces of the auditory organ.

The Romantics also recognized the potentially violent effects of sound and music on the bodies and minds of listeners. Shorn of all reference to the material world, music enabled the free play of the imagination, but, more negatively, it could also lead to madness and social pathologies, as depicted in literary narratives by E. T. A. Hoffmann. Further, critics at the time did occasionally revert to materialist arguments involving the ear's anatomy.[14] The Swiss mathematician and philosopher Johann Georg Sulzer, for example, spoke of the ear's direct connection to the heart and soul, but he did so with reference to the physical effects of sonic vibrations on the aural nerves. "Due to the violence of the shocks they receive," he observed, "the aural nerves consequently transmit their effects to the entire nervous system, which is not the case with vision. Hence it is understandable how sounds exert a violent force on the entire body and, in turn, the soul."[15]

8 Introduction

In a brief discussion of hearing in his *Philosophical Enquiry into the Origin of Our Ideas of the Sublime and Beautiful* (1757), Edmund Burke singled out the eardrum as a key to the sonic sublime. "When the ear receives any simple sound," he wrote, "it is struck by a single pulse of the air, which makes the ear-drum and the other membranous parts vibrate according to the nature and species of the stroke." If the eardrum suffers a "considerable degree of tension," he continued, "it is worked up to such a pitch as to be capable of the sublime."[16] In contrast to his German contemporaries, Burke appears to have had little interest in music. Instead, Burke's examples come from the battlefield: the stroke of a drum, the firing of a canon, and low intermittent drones. Drawing on the battlefield for his source material, Burke's theory of hearing prefigured the eardrum's ascendancy as a central anatomical figure over the course of the nineteenth century and its privileged epistemological role in an environment remade as a sonic war zone.

In his *Fourth Critical Forest* (*Viertes Kritisches Wäldchen*) from 1769, Herder discussed the nature of sound and aesthetic pleasure with repeated reference to the anatomical structure of the ear, drawing readers' attention to the ear's "whorls" (Schraubengänge)," "tympanum" (Tympanum), "eardrum" (Trommelfell), "nerve branches" (Nervenäste), and "fibers" (Fasern).[17] Yet, for all of his presumed familiarity with the physiology of hearing, Herder's text epitomizes the Romantic insistence on aural immediacy. Not only would allusions to the ear's anatomical structure vanish in his subsequent writings—most notably in his essay on the origin of language, which celebrated hearing—but even in his brief foray into physiological aesthetics, Herder would explicitly pass over the eardrum in favor of the inner ear and a sympathetic model of auditory attunement. The eardrum, he contends, functions only "to prepare" (erst zubereiten) and "refine" (zu verfeinern) vibrations as they enter the ear, while the soul and interplay of the aural nerves facilitate aesthetic pleasure.

For Herder, the eardrum was a part of the ear only tangentially implicated in aesthetic experience. It was, according to his essay, an entity to be bypassed in any theory of acoustical aesthetics, incapable as it was of rendering anything "sensually" (sinnlich). Such sensuous qualities depended instead on the aural nerves, which ultimately set in motion vibrations of the soul. The eardrum could not, Herder proclaimed, serve as a tool for "sensation" (Empfindung). Its function was not transductive, as the early modernists and Dadaists would have it, but merely preparatory. It molded and modified, but did not transduce or convert, incoming auditory signals to prepare them to interact with the aural nerves, the true site of aesthetic experience.

A crucial explanation for the eardrum's devaluation during this earlier period relates to contemporaneous medical understandings of its particular function in the auditory apparatus, which lacked any notion of transduction. Less than a decade before Herder began work on the text, the Italian anatomists Domenico Cotugno and Antonio Scarpa discovered that the cochlea of

the inner ear contained a liquid and not air, as had been previously theorized by Aristotle and Galen.[18] It is only in light of this medical breakthrough, which leaves no trace in Herder's writings about sound, that we can begin to think about the eardrum as an organ of *transduction*, that is, as an organ of conversion between two distinct media such as water and air. Around 1800 the eardrum was still a marginal discursive element in theories of hearing oblivious to transductive processes and a world devoid of the abrasive noise that facilitated the convergence of martial and civilian soundscapes.

In his influential study *The Audible Past*, Jonathan Sterne shows how the revolution of mechanical sound reproduction in the middle of the nineteenth century relied on the gradual isolation of the tympanum, or eardrum, in contrast to other parts of the ear.[19] This shift in focus across multiple domains of knowledge can be said to have introduced a *tympanic regime* of sound reproduction. Whereas the talking automata of Charles Wheatstone and Wolfgang von Kempelen took the mouth as a privileged model for mechanical sound reproduction around 1800, later acoustic devices such as the phonograph, phonautograph, and telephone were not only based on imitations of the eardrum but also quite literally integrated dissected eardrums into mechanical apparatuses. Édouard-Léon Scott de Martinville incorporated "a tympanum of English goldbeater's skin" into his phonoautograph.[20] Later, Clarence Blake and Alexander Graham Bell constructed an "ear phonautograph," attaching a severed human eardrum to a wooden chassis to produce visual tracings of sound on a sheet of smoked glass.[21] The same strategy of inserting a human eardrum into a technological apparatus was repeated in the context of the telephone,[22] while an early commentary on the phonograph noted how "recent experiments seem to show that the more the vibrating membrane of the phonograph resembles the human ear in its construction, the better it repeats and registers the sound vibrations: it should be stretched, as far as possible, in the same way as the tympanum is stretched by the hammer of the ear, and moreover it should have the same form."[23]

Even after the human eardrum had been supplanted by other materials, such as the stretched outer membrane of a calf's intestine, the phonograph retained a figurative connection to the eardrum. As one observer put it in an article in Vienna's *Neue Freie Presse* in 1889, "The tiny phonograph's vibrating membrane is the eardrum of the world."[24] With a more nuanced understanding of the eardrum's transductive features, another commentator noted one year later, "Just as the relaxed circular membrane, the eardrum, is set in motion by incoming air waves and that motion is transmitted through a chain of small bones into the inner parts of the ear and the extended fibers within it, so too is the membrane of the gramophone made to vibrate."[25] Thus, the eardrum was both a literal component in early sound reproduction devices and a model for understanding their mechanical functionality.

Eardrums does not posit the phonograph as the obvious telos of sound reproduction, but rather suggests it is one of many related and equally

important iterations of the tympanic regime across multiple scientific disciplines and domains of cultural production in the late nineteenth and early twentieth centuries. As the eardrum became a principle upon which sound technologies were to be devised, the figure also became a privileged site for registering the unprecedented noise of modern life, often along race, class, and gender lines. While cultural critics decried the pernicious effects of urban noise on the eardrum, commercial products like Plessner's antiphone entered the marketplace to protect the ear from the sounds of the underclass and racial others. And at the same time as medical scientists documented the callused eardrums of factory workers exposed to industrial noise, intellectuals and antinoise activists reveled in the exceptional sensitivity of their own eardrums as signs of intellectual and social superiority. This is how one arrives at universalist formulations about the listening body that describe the subject as a "full-body-ear-drum"[26] and a "body-box, strung tight, . . . covered head to toe with a tympanum."[27]

Acoustical Modernity as Sonic Warfare

In sound studies, acoustical modernity has been analyzed as a period marked by significant changes in how sound was produced, consumed, and theorized in western Europe and the United States in the wake of industrialization, urbanization, and the media revolution of recorded sound at the end of the nineteenth century.[28] According to these accounts, new media infrastructures encompassing the telegraph, telephone, phonograph, microphone, and loudspeaker coevolved with new listening techniques and ways of thinking about sound. For Emily Thompson, the modern period was defined by an unprecedented compulsion to control sound, to commodify it and render it more efficient, to enclose it and distinguish it from noise.[29] Other critics have similarly highlighted the compulsion to eradicate echo, on the one hand, and the "rise in close listening" and attention to "certain kinds of [sonic] detail," on the other.[30]

For Friedrich Kittler, the Romantic discourse network of 1800, which had served to obfuscate writing and the signifier behind fantasies of aural immediacy, was supplanted in the nineteenth century by the electrical impulses and indexical traces of telegraphy and phonography, which simultaneously drew attention to the materiality of the signifier as graphical marks on the page. Crucially, this shift was motivated by what Kittler conceives of as a kind of media-martial a priori—that is, a strategy of brinkmanship in which competing armies sought to outdo one another technologically through increased speed, efficiency, and connectivity. Thus, Kittler regards both the typewriter and sound recording as "by-products of the American Civil War," arguing that, after the war, the young Thomas Edison had developed his phonograph "in an attempt to improve the processing speed of the Morse telegraph

beyond human limitations."[31] The meaningless noise, or *Rauschen*, generated by these military-inspired devices, Kittler continues, engendered new objects of scientific analysis. Both psychophysics and psychoanalysis searched for insights into the human psyche and behavior through nonsensical utterances, slips of the tongue, and free associations involving meaningless syllables.[32] Thus, the emergence of psychoanalysis and recorded sound inaugurated "the epoch of nonsense, our epoch."[33]

While my study affirms the close connection between war and acoustical modernity posited in Kittler's notion of a media-martial a priori, it also seeks to complicate some of his more reductive conclusions about the emergence of recorded sound. To say that a tympanic device such as the phonograph was simply a "by-product" of the American Civil War does not do justice to the complexity of its technical evolution and subsequent deployment, nor to the cultural context from which it arose. Edison never served in the war, and his interest in automatic telegraphy, which resulted in the invention of the phonograph, was always commercial.[34] His commitment to making telegraphy faster and more efficient might expose the shared values of the military and commercial enterprises, but Edison's primary motivation was profit. More importantly, the military failed to find any compelling application for the phonograph on the battlefield, despite occasional speculation on how it might.[35] It was instead on the level of content that the device was put to use militarily, namely in the astonishing number of early recordings, both commercial and private, which brought the sounds of war to the civilian population, whether as military music, simulations of the actual experience of battle, or propaganda for mass mobilization.[36]

By placing the eardrum at the center of my study—as lived experience, technical operation, aesthetic and epistemological model—I propose an account of acoustic modernity that is at once intensely embodied and predicated on sound's perceived ability, even tendency, to generate and mark moments of conflict and violence. To follow Steve Goodman, the figure of the eardrum as both percussive surface and medium of transduction enables us to reconstruct the history of acoustic modernity as a history of *sonic warfare*, understood as both a reflection on and deployment of vibrational force "to modulate the physical, affective, and libidinal dynamics of populations, of bodies, of crowds."[37] Amid the simultaneous proliferation of noise and militarism, the period around 1900 *was* characterized by a rise in close listening, but in the most literal way: as the growing recognition of sound as physically proximate and embodied, written onto and through the tympanum. Close listening was therefore constituted not only by an attention to detail but also by the modern soundscape's imposition of sound directly onto the listener's body, which became the target of sonic projectiles such as those Plessner described in his treatise on the antiphone. Similarly, on the streets of urban centers such as Berlin and Vienna, new building projects and architectural expansion served to compress and intensify sound in ways that could be felt

12 Introduction

throughout the body and frequently provoked comparisons between civilian spaces and the battlefield.

If sonic warfare was a common tactic or mode of experiencing sound, and the tympanum its primary interface or operational principle, acoustic modernity in German-speaking Europe privileged the sonic category captured in the term *Lärm* over comparable terms such as *Geräusch* or *Rauschen*, all of which could be accurately translated into English as "noise." As the historian Peter Payer has shown, the German term *Lärm* comes from the early modern *lerman* or *larman*, which borrows from the Italian *allarme* or *all'arme*, meaning "to take up your weapons."[38] Crucially, then, *Lärm* indicates both the experience of sound as war and sonic indications of an attack still on the horizon. As Silke Wenzel points out, in the early modern period *Lermen* designated both a military signal communicated via drum and any form of imitation that suggested "the act of shooting" (als ob geschossen würde).[39] Well into the nineteenth century, the terms *Lärm*, *Alarm*, and *Trommel* remained closely bound up with one another. An "alarmist" (Alarmist) was synonymous with "noise maker" (Lärmmacher), "alarm shot" (Alarmschuß) with "noise-shot" (Lärmschuß), and "alarm drum" (Alarmtrommel) with "the noise-signal produced by the drum" (das mit der Trommel gegebene Lärmzeichen).[40]

Lärm therefore indicated the *possibility* of a violent encounter, not only the result of an actualized assault, giving expression to the dread and anxiety that preceded war, impending violence that remained unverified and perpetually deferred to the future.[41] Goodman calls this aspect of sonic affect "the virtuality of the tremble," referring to the surplus of affect emitted by perceptible vibrations in the metropolis, whether from a car engine or a machine gun, to the performance of historically actualized instances of violence and anxious anticipation of their return. To experience and describe *Lärm* was to sound an alarm announcing some still uncertain violent potential. Whether or not an attack occurred was beside the point, as the term confirmed the soundscape's ability to generate affective states of fear and dread comparable to experiences of war. While the battlefields of the Franco-Prussian War and World War I witnessed an astonishing intensification of mechanical noise,[42] noise in the city was perceived as an expression of growing political, nationalist, and class conflicts on the streets of European cities. "Part of the clamor of modernity," Martin Cloonan and Bruce Johnson have observed, "is a public sonic brawling, as urban space becomes a site of acoustic conflict."[43] This was especially true in German-speaking Europe at the turn of the century, as both the sounds of war and a war of sound migrated between the battlefield and urban spaces.

What, against the backdrop of the tympanic regime and the rise of urban noise, I am calling "sonic warfare" therefore draws attention to sound's role in the *militarization of everyday life* and to demarcating oppositions and shaping social antagonisms particularly in urban centers—a dynamic of modern sound reinforced by the etymology of the term *Lärm* as a "call

Writing Sound across the Modernist Divide

to arms."[44] From the battlefield to city streets at the turn of the century, techniques of sonic warfare, as Goodman defines them, "percolated into the everyday" as a "war of mood, sensation, and information" between rival sonic regimes. A turn to the history of sonic warfare and the tympanic regime enables us to challenge long-standing accounts of music as modernity's privileged sonic category, uncovering modes of acoustic experience not reducible to traditional, Romantic understandings of sound as inherently transcendent, immaterial, and therapeutic. In its invocation of both a beaten drum and the anatomy of vibrational transduction, the figure of the eardrum indicates a listening body literally and figuratively assaulted by sound, one more at home in the trenches than in the concert hall.

Literary Modernism: The Beginnings and Ends of the Tympanic Regime

Eardrums interrogates the *cultural* underpinnings of the tympanic regime and corresponding iterations of sonic warfare. War itself, scholars have argued, already implies a certain aesthetic or performative dimension embodied in terms such as "the art of war" (Kriegskunst) or "theater of war" (Kriegsschauplatz). As William McNeil observes, performance was essential to both the corporeal training of modern European soldiers and the commemoration of past military victories during peacetime. It enabled the military to "rehearse their past successes" and "make actual performance in the field more predictable."[45] Conversely, sonic elements from the battlefield could be modified and performed during peacetime, offering formal and thematic resources for modes of cultural production ranging from literature and theater to cabaret and early sound art.

It is here that the media history of sonic warfare is shown to be inextricably bound up with its cultural history. If, as Sterne claims, tympanic media such as the phonograph and telephone were "embodiments and intensifications of tendencies that were already existent elsewhere in the culture," it is essential that we look not only to the histories of science and technology but also to concurrent cultural and aesthetic iterations of the tympanic regime. In tracing the intermingling of civilian and martial soundscapes, *Eardrums* exposes the historical coevolution and dissemination of tympanic figures and tactics of sonic warfare across the battlefield, recording industry, and contemporaneous domains of cultural production. Specifically, the book takes seriously the *literary archive* and its intermedial articulations, questions of textual representation and performance, suggesting that it is there, alongside articles in scientific journals and technical diagrams, that we find some of the most revealing and complex articulations of an ear in historical flux. "During the heyday of the avant-garde," Douglas Kahn writes, "some of the most provocative artistic instances of sound came from literature and other

writings and were distant from the development of the arts or aurality of the time."[46]

Drawing on Kahn's insight and media theory's close connection to literary studies—a tradition going back at least as far as Marshall McLuhan and continuing through Jacques Derrida, N. Katherine Hayles, Friedrich Kittler, Lisa Gitelman, Matthew Kirschenbaum, Bernhard Siegert, and Laura Otis—the book brings fictional literary representations of sonic experience to bear on what up to this point has been reconstructed largely through technical sources and scientific literature, reading the signs of a dramatically altered ecology of sound from formal experiments to textually encode noise in the pages of literary modernism.[47] Giving preference to neither aesthetic works nor the heterogeneous collection of nonliterary sources beside which they circulated, the study instead testifies to the inextricability of acoustic modernity and German modernism, to the discursive and material networks that sutured one to the other. The book insists on rigorously historicizing a group of literary texts that have been chosen selectively for the depth and complexity of their representations of acoustic modernity as well as the richness and multiplicity of their discursive links to relevant nonliterary discourses. Fictional representations are then positioned alongside related representations in popular newspapers, technical and literary journals, sociological and medical reports, war journals, cabaret performances, and staged phonographic sketches.

Combining the resources of (German) media theory, sound studies, and literary analysis, *Eardrums* adopts a thoroughly interdisciplinary approach that merges historical and archival research and close literary analysis with conceptual resources borrowed from media theory and the history of science, situating works of fiction alongside nonliterary discourses and material practices. The result is a detailed examination of how modernist aesthetic practices and the technical and scientific histories of acoustic knowledge in the German-speaking world coevolved, interacted, and rendered one another intelligible. By foregrounding the literary, I argue, and by subjecting nonliterary sources to close reading, we are able to excavate a more heterogeneous network of figures and representational strategies, which, on the one hand, facilitated the rise of the tympanic regime and its attendant modes of sonic warfare and, on the other, propelled their circulation and appropriation across various domains of knowledge and artistic production.

The literary sources mobilized in this reconstruction of the tympanic regime cut across a variety of artistic movements and programmatic positions. In the German context, the term *modernism* has traditionally been used to designate literary works produced in the early twentieth century by a small cadre of male authors, most notably Hugo von Hofmannsthal, Arthur Schnitzler, Franz Kafka, Thomas Mann, Robert Musil, and Alfred Döblin, whose subject matter often dealt with changing social norms, urban life, and the industrialization of space and time, and who were compelled to interrogate the limits

of representation and experience, exchanging the narrative transparency of the realist tradition for modes of self-reflexivity attentive to communicative breakdowns.[48] Several of these authors are featured prominently in my study. However, using the tympanic regime and sonic warfare as frames, I also seek to expand the modernist tradition to authors, works, themes, and historical periods not typically included in scholarly accounts of the movement. In this way, my approach resonates with recent work in so-called New Modernist Studies, which, taking *expansion* as a keyword, focuses on mapping out a "longer critical history of modernism in the arts,"[49] one attuned to media history and the importance of the movement's engagement with "novel technologies for transmitting information" as well as promotional strategies," which often relied on the same technologies.[50]

At the same time, I am concerned to show a significant break, both formal and thematic, that emerged within this broader swath of literary production. I locate this moment of disjuncture in the move from naturalism, impressionism, and the historical avant-garde, on the one hand, to the more canonical works of later modernists such as Franz Kafka and Robert Musil, on the other. I relate this rupture to both changes in the material infrastructure of sound—namely, the shift from phonograph to radio, indexical inscriptions to electromagnetic waves—and changing conceptions of the mechanics of hearing focused on either the eardrum or the inner ear. In the process, representations of sound in the 1920s became increasingly untethered from any recognizable human body. While, as Robert Brain remarks, "early modernism was by, for, through, and about the body," Devin Fore observes how, beginning with the interwar period, modernists shifted their focus to "conditions of perception and consciousness outside of what is customarily arrogated to the human."[51] The lesson learned in this later period, Fore continues, was that human beings must learn to "comport with parameters of experience that are calibrated to scales alien to the human body."

As the intense corporeality of the first half of the modernist period gave way to a fascination with the nonhuman, the tympanic regime gradually faded from view. Thus, a concern with writing sound and textually representing sonic experience became uncoupled from the tympanic paradigm and corresponding strategies of literary transduction. When Sterne writes that "you can take the sound out of the human, but can take the human out of the sound only through an exercise in imagination," he might as well be describing the split between these two halves of literary modernism.[52] His assertion that nonhuman modes of listening only become legible "through an exercise in imagination" additionally lends validity to my own project of recovering the sonic past through a combination of fictional and scientific, or technical, sources.

The same shift from the first to the second half of literary modernism entailed a change in how sonic warfare was conceived and implemented, with the registration of physical violence by and through the body replaced

by its virtualization and an ear folded back onto itself. Here, I borrow from Peter Szendy's gloss on the writings of Roland Barthes, who explored the relationship between "cultivated musical listening" and a "primitive level of alert overhearing and the surveillance at a distance between the predator and prey."[53] This mode of "listening on the alert" was integral to the tympanic regime, as nonmusical sound began to be conceived as a weapon with physical and affective consequences.[54] At the same time, Szendy's insight that alert hearing was connected to overhearing and surveillance helps illuminate the lingering effects of the tympanic regime well into the era of high modernism, as the proximate registration of vibrational force via the eardrum now took the form of paranoid auditory hallucinations and confused self-auscultations of an assault yet to come. The alleged "high modernism" of Kafka and Musil, although seemingly uninterested in the eardrum, remains tethered to the physical structure of the ear and shot through with military connotations. What distinguishes the two periods of modernism in terms of sound and listening is the displacement of sonic warfare from the source of sonic production to the listener, with the registration of "sonic projectiles" replaced by an ear mobilized in active pursuit of sonic bodies.

Eardrums not only contends that modernist texts drew on increasingly pervasive techniques of sonic warfare as compelling source material; more provocatively, it suggests that literature actively contributed to the spread of sonic warfare. On the one hand, modernist authors pursued new modes of literary sonification, whereby the same written works were adapted to phonograph recordings, musical compositions, cabaret performances, and oral recitations. On the other, they developed a set of representational strategies that aimed to enact or reproduce the physical and affective force of the urban soundscape through the materiality of the textual medium itself.

Overview of Chapters

The book begins by analyzing literary representations of the martial soundscape by the now largely forgotten poet and author Detlev von Liliencron, with an ear to his appropriation of elements from the martial soundscape as a catalyst for formal experimentation. Drawing on his personal experiences on the battlefields of the Wars of German Unification (1864–71), Liliencron evinces an unusual sensitivity to the changing soundscape of war, its violent potential and modulation of affect, as well as its implications for the written word in postwar civilian life. In the second half of the chapter, I show how the live performance of these new literary strategies thematized the increasing militarization of everyday life in the postwar period as sonic spectacles of military power, parades, and war commemorations.

The second chapter turns from naturalism to Viennese impressionism, situating literary works by the author Peter Altenberg alongside contemporaneous

discourse on growing urban noise as a transfer of sonic warfare from the battlefield to the city. At the center of my analysis is a close reading of Altenberg's short prose poem "The Drummer Belín" (1896). In a virtual citation of Liliencron, the piece renders the noise of war as the unstable oscillation between conventional linguistic structures and onomatopoeic bursts of nonsense, invoking the eardrum at the same time as the textual inscription of sound takes the form of onomatopoeic modes of writing. Despite the brutal and visceral effects of noise depicted in the text, Altenberg highlights the performative nature of sonic warfare and its independence from personal experiences of war as a broader cultural imaginary of violence both on and off the battlefield.

If Altenberg draws connections between the military drum and the human eardrum as a site of martial transduction, avant-garde artists such as Luigi Russolo sought to disseminate the cacophony of war by constructing new musical instruments based on stretching taut diaphragms over drum frames and manipulating the skins with wires to vary their pitch. With radically different political aims, the Dadaist performer Richard Huelsenbeck arrived at the Zurich Cabaret Voltaire wielding a large tom-tom and dispensing bruitist sound poems, which integrated the same onomatopoetic exclamation of "rataplan rataplan" that had appeared in Liliencron's and Altenberg's earlier texts. The third chapter examines this largely overlooked aspect of Dadaist literature: the movement's conceptions of hearing and the ear. As I show, Dadaism bridges the divide between naturalism and modernism, presenting an ear that is invested with the ability to indexically register sound as nonlinguistic bursts of nonsense but which is nonetheless active and autonomous, never merely the passive instrument of aggressive noise. In this way, literary techniques of onomatopoeia and the accompaniment of oral recitation by means of percussion both assume a transgressive, satirical function and point to the widespread effects of acoustic mobilization in civilian spaces.

Chapter 4 highlights the discontinuity opened up by canonical modernism in literary representations of hearing, with representations of the martial soundscape found in the diaries and literary writings of Robert Musil at its center. Drawing on his training as an experimental psychologist as well as his personal experiences as a soldier on the cacophonous battlefields of World War I, Musil's literary representations of sound and hearing suggest, in stark opposition to those found in works by Altenberg, a highly active and spatially oriented hearing subject. For Musil's acoustically sensitive protagonists, in contrast to the passive listeners of Altenberg and Kafka, the ear became a mobile organ capable of moving through space and actively searching out the source of a sound. Moreover, sounds themselves assumed corporeal characteristics and a sense of three-dimensionality unthinkable a hundred years earlier, which by the interwar period had become both a technical reality and a productive literary figure driving modernist experiments with narrative form.

18 Introduction

The book's fifth chapter analyzes the juxtaposition of sonic warfare and modes of embodied listening in Franz Kafka's penultimate text, "The Burrow" (1923–24). By concluding the book in the year 1924, I indicate a split in literary modernism that I see as deeply entangled with the figure of the eardrum. The chapter examines Kafka's fascination with silence and its auditory side effects as a way to elaborate modes of auditory experience beyond the tympanic regime and to begin to speculate on their relationship to war and violence. As I show, despite the thematic resonances with earlier authors such as Liliencron and Altenberg, Kafka's thematization of sonic warfare differs in significant ways that are not simply formal or stylistic but instead entail the excision of the eardrum as a figure from what is generally considered to be modernism's mature period in the 1920s.

My periodization is not meant to suggest that the corporeality of listening disappeared in the 1920s. On the contrary, "The Burrow" takes us deeper into the ear and confronts us with its physicality and architectonics, only to deny the embodied nature of listening. In Kafka, the transduction of sonic warfare extends into the realm of *imperception*, as internalization and outward projection, with the assault on the eardrum from without replaced by instantiations of inaudibility, paranoid hallucinations, and modes of auditory self-observation that externalize, suppress, and listen through the once-vibrating membranes of the tympanic regime. In conclusion, I examine the significance of tympanic figures and deployments of sonic warfare in the Third Reich and their legacy in postwar culture: from Ernst Jünger's aesthetics of horror and Hitler's early self-fashioning as a mere "drummer" (Trommler) of the National Socialist movement, through Günther Grass's *Tin Drum*, to the antifascist, anticapitalist musical aesthetics of early punk and industrial music.

Chapter 1

✦

Liliencron, Captain of the Nineteenth Century

Naturalism as Martial Phonography

> Klingkling, bumbum and tschingdada.
> —Liliencron, "The Music Is Coming" (1882)

In a letter dated February 29, 1896, Detlev von Liliencron announced to his publishers that he had recorded three of his own poems onto the phonograph, ostensibly the first author to do so in the German-speaking context.[1] "Gentlemen, I've just become 'immortal,' "[2] he declared in the letter's opening lines, thereby invoking one of the most common tropes surrounding the device's early exhibition and reception—namely, that it offered a way to resurrect the dead and preserve the voice for eternity.[3]

For Liliencron, phonographic immortality was a fortuitous by-product of sound's commodification. In the letter he speculated how the recordings he made might be utilized as a new form of literary advertising (Liliencron, *Briefe in neuer Auswahl*, 292). One year later, he wrote to invite a friend to meet him near the Streit's Hotel in downtown Hamburg to hear his "delightful, delightful-sounding voice" (köstlich, köstlich klingende Stimme) read two of the previously recorded poems, "At the Cash Desk" and "The Music Is Coming," through the phonograph. He explained that the recordings, advertised as "spoken by the author" (gesprochen vom Verfasser), were now available for public consumption (298).[4]

Because no further details about the arrangement exist, we can only speculate about how the recordings were consumed. It is possible that they were put on display by someone in the business of selling phonographs, or that they were used as content for some coin-operated device.[5] Either way, they bely Georg Simmel's claim ten years later that, in contrast to the visible, sound was incapable of being owned (besitzen) or becoming property (Eigentum), a view that critically neglects the technical and economic breakthrough of commodified sound and its implications for cultural production in the final decades of the nineteenth century.[6] In the ten years that followed Liliencron's phonographic recitations, at least another three of his poems would

19

20 Chapter 1

be recorded by theater actors, including Ludwig Wüllner, Carl von Zeska, Max Devrient, and Marcell Salzer.[7] In 1903, Salzer recorded a version of "The Music Is Coming" for the Gramophone Company.[8] Around the same time, a recording of Oscar Straus's musical setting of the same poem became a surprise commercial hit.[9] It was also during this period that "The Music Is Coming" became a regular part of Liliencron's reading tours, which, similar to his use of the phonograph, served to commodify the authorial voice by simultaneously monetizing and rendering audible works previously restricted to the silent page.[10]

Formal Experimentation in Literary Naturalism

"The Music Is Coming" was Liliencron's first published work. It appeared in 1882 on the front page of the Munich-based satirical magazine, *Fliegende Blätter*, set beneath an illustration of a military parade (see figure 4). In the three decades that followed, Liliencron published numerous collections of poetry and war novellas as well as literary and autobiographical novels.[11] Today he is most closely associated with the German naturalists,[12] a movement defined by its embrace of materialism, modern science, social Darwinism and social democracy, and for its appropriation of mechanical, scientific modes of disinterested observation unencumbered by personal bias or belief.[13]

Acknowledging the heterogeneity and internal contradictions that make up any artistic movement, it is nonetheless important that we position Liliencron's literary output in relation to the aesthetic program outlined by the naturalists. While Liliencron and other contributors to the movement disagreed on crucial issues, they overlapped to a remarkable extent in their common pursuit of formal innovations that highlighted the interplay between sound and text, reading, performing, and listening. What, in 1900, one critic termed "a new technology of writing" (eine neue Technik der Schrift) encompassed the naturalists' integration of spoken dialects, onomatopoeia, alliteration, free verse, *Sekunden-* or *Telegrammstil*, "middle axis centering" (Mittelachsenzentrierung), and other experiments with typography, punctuation, and mise-en-page.[14] While Liliencron's "The Music Is Coming" utilized a mimetic mode of writing to portray the cacophony of a passing marching band, the prominent naturalist theorist and poet Arno Holz incorporated alliteration, assonance, onomatopoeia, and free verse into his poetry as a way to invest the silent page with sonic qualities, creating what he called an "ear image" (Ohrbild) or "typographic music" (typographische Musik)."[15] Efforts to write sound textually and to transduce text into vocal performances informed core questions about what it meant to work with texts around 1900, to read and write poetry and prose during a period characterized by the dominance of silent reading as well as the proliferation of new sound reproduction technologies and the rise of mechanical noise.

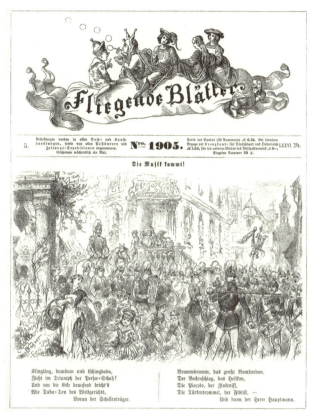

Figure 4. Original publication of Liliencron's "The Music Is Coming" with corresponding illustration of the raucous parade the poem describes. From Detlev von Liliencron, "Die Musik kommt," *Fliegende Blätter* 76, no. 1905 (1882): 33.

The naturalists' "new technology of writing" aimed to revise the generally assumed representational limits of the textual medium at a moment in which the phonograph was seen to intervene in the literary market. As an article published in 1900 in the *Phonographic Journal* (*Phonographische Zeitschrift*) predicted, the phonograph would restore "the verse as a sensuous stimulation, as a sound effect, as a rhythmic and metric note" (der Vers als sinnlicher Reiz, als Klangwirkung, als rhythmische und metrische Note).[16] As physical vibrations of sound, it would give the ear back to poetry. Others predicted that the phonograph would overtake the print market, with publishers releasing phonograph records of authors reading their own work, much like Liliencron would do two decades later. Instead of reading an author's memoir, "which one could barely decode" (das man kaum entziffern kann), one critic speculated, in the age of the phonograph we would have access to the

22 Chapter 1

authorial voice, which, recorded and played back, "speak[s] to us directly" (unmittelbar zu uns rede[t])."[17] The phonograph, in other words, promised to correct the medial shortcomings of print, replacing the ambiguities of textual analysis, difference and deferral with the authority and immediacy of the recorded voice.

Liliencron and the naturalists sought answers to the question of medial change by focusing their attention on form. In their programmatic writings, they argued that form was not only the most effective path to modernizing German literature but, even more dramatically, the only option available to the modern author and poet. Heinrich Hart offers the most lucid account of the conditions that motivated the movement's conspicuous turn to form at the time:

> But was it not possible to go farther than their naturalism [that of Tolstoy, Zola, Ibsen, and Dostoyevsky], to mirror reality more faithfully, to harmonize the artistic mode of expression even more intimately with the phenomena of life? It had to be possible, then how else could one impress [imponieren] audiences who want to be surprised with the new and the unfamiliar? Theoretically one scorned the audience's favor, but in practice it was desired even more fervently. The most beautiful rhyming verses had faded away in the wind, new ideas and a new Weltanschauung were not on offer; that little bit of socialism was already almost used up, and Nietzsche hadn't been discovered yet. Since new content could not be captured, the bewildering and the impressive [das Verblüffende, Imponierende] had to grow out of a new form and a new technique [neuer Technik].[18]

Naturalism's preoccupation with form, Hart contends, answered to an alleged void of ideas that characterized the end of the nineteenth century. In this way he confirms Friedrich Kittler's claim that material changes to the processing, storage, and transmission of information over the course of the nineteenth century engendered a radical reconceptualization of language and literature in both theory and practice. As Kittler argues, the media revolution ushered in by the gramophone, film, and typewriter undermined the Romantic privileging of signifieds around 1800, giving rise to modernist preoccupations with the materiality of writing.[19] As Hart makes clear, the naturalists began their literary activities at a time when there simply were no new ideas, only new techniques or technologies (*neue Technik*).

Hart's statement also reveals the extent to which the naturalist commitment to formal innovation functioned as a response to the pressures of the modern literary market and the rise of the professional writer. Burdened with economic considerations, the modern writer could no longer ignore the general reading public's tastes. As consumers of an increasingly diverse but ephemeral range of media products, readers perpetually craved the new and

the unusual. Beauty was no longer sufficient to hold their attention. They wanted to be surprised and amazed, "impressed" (imponiert). Any adequate literary response would require the development of a new technology of writing capable of standing out to distracted media consumers, who were now confronted with a seemingly infinite array of options.

Phonographic Writing

Because the naturalists conceptualized writing as a kind of technology, and because so many of their formal innovations were oriented toward imitating sound, scholars have come to speak of a "phonographic method" (phonographische Methode) at the heart of their literary program.[20] Taking Liliencron as my primary case study, in what follows I offer a corrective to existing accounts of naturalism by demonstrating how critics have made both too much and too little of the technical model of phonography in order to understand parallel literary developments. On the one hand, scholars of German modernism have conceived of phonographic writing as the literary appropriation of a single feature from the technical device—namely, its heightened mimetic capabilities. In this view, naturalism is "phonographic" because it uses onomatopoeia to bypass the symbolic and corresponding linguistic conventions in favor of the mimetic and quasi-indexical. What gets overlooked is the fact that, in both theory and practice, naturalist literature shared an even greater and more varied set of interests, aspirations, and formal characteristics with technical phonography, most notably monetization, the visualization of sound as graphical marks, questions of readerly legibility, the distinction between signal and noise, and processes of conversion and transduction between lines, letters, and audible sounds.

When readers opened one of Liliencron's books, they found not only words but material marks, nonlinguistic symbols, and monosyllabic fragments with no clearly established meaning or referential value, organized spatially along the vertical and horizontal axes of the page and imbued with temporal qualities that exceeded those dictated by an internal narrator. In the process of allegedly reproducing sounds mimetically, onomatopoeia drew attention to the text's visual qualities, to the symmetry, repetition, and uniformity of written marks positioned within the space and temporal unfolding of the page. Although aimed at conjuring up a sense of semiotic and perceptual immediacy, Liliencron's mimetic writing in fact intensified conscious awareness of its textual mediation, drawing attention to the materiality of written language, to script as script, and to the surface of the page as a space unto itself.

On the other hand, the singular focus on the phonograph as a technical device has led scholars to miss perhaps the most important factor in the evolution of Liliencron's formal techniques—namely, his personal experience of modern warfare during the Wars of Unification and, in particular,

the semiotic, physical, and affective repercussions of the martial soundscape. Indeed, his use of onomatopoeia predates Edison's invention of the phonograph by nearly a decade, stemming instead from his war diaries, in which he attempted to capture the sounds of telegraphic signals and the cacophony of machine guns, exploding grenades, and crashing trains as text.[21] While still technologically motivated, Liliencron's literary phonography did not require the technical counterpart codified in Edison's subsequent invention. The literary author's formal innovations arose from auditory techniques cultivated on the battlefield, from efforts to distinguish signals from meaningless noise: an early iteration of what, outside a literary context, Jonathan Sterne and Tara Rodgers have called "the poetics of signal processing."[22]

The formal techniques and narrative structures that inform Liliencron's writings are shown to arise from efforts to parse the martial soundscape, to extract signal from noise, an activity simultaneously associated with the forward progression of both the armies described in the text and the text itself. In his poetry and prose, Liliencron elevates the signal to the status of a poetic utterance, replacing the complexities of literary language and textual interpretation with unambiguous military commands.

Although attuned to the physicality of sound and its transcription as writing, Liliencron's reduction of sound to signal largely occludes the fleshiness of the ear, opting instead for a model of stoic masculinity and an image of the auditory organ as an insensitive, reflective surface or quasi-technological signal processor. So while his war writings are pervaded by the sound of drums, they do not make use of the *eardrum* as an epistemological figure or model of listening, as later authors would. What his texts expose is an intimate relationship between vibrational force and the materiality of writing, between textual mimesis and the percussive effects of the martial soundscape. Liliencron, in other words, binds the ear and drum but stops short of collapsing them into the single figure of the eardrum.

The same strategies of mimetic writing born on the battlefield would subsequently aid Liliencron in disseminating elements of the martial soundscape and processes of literary transduction throughout the civilian population. It is here that a formal literary device such as onomatopoeia intersects with the broader culture of militarism in newly unified Germany. Onomatopoeia indicated a mode of listening largely outside of interpretation and devoid of concepts, one focused instead on the mere registration, or transduction, of a transmitted signal. Although at first glance incompatible, naturalism figured mimetic writing as a kind of *transduction* between various semiotic registers, registering sound's physical force beyond language while at the same time rendering audible experience legible as linguistic marks on the page.

Similarly, the turn to mimetic writing coincided with the spread of military protocols and power structures throughout civilian spaces, all of which encouraged uniformity and obedience rather than critical thinking and individualistic resistance to imposed norms. In being actualized as sound, whether

as oral recitation, popular song, or phonograph recording, Liliencron's texts helped transmit the communicative strategies, perceptual experiences, and affective states associated with war's sonic dimension to the civilian population, now functioning as a kind of multimedial contagion unmoored from the actual battlefield.

The culture of militarism that arose after the war—expressed most pointedly in contemporaneous military parades, war commemorations, and poetic works—functioned to spread these same mimetic, multimedial impulses across German-speaking Europe. While Liliencron's literary texts contributed to, and reflected upon, their role in the expansion of martial mimesis to unlikely aspects of ordinary life, critics pointed to a veritable contagion of martial *Ohrwürmer*, or "earworms." The omnipresence of military music and other simulations of the martial soundscape was described by contemporary observers as a form of sonic coercion, forcing unwitting citizens to adopt military rhythms and melodies seemingly against their will.[23] Following the popular adaptation of "The Music Is Coming" as a phonograph recording and a staple of Liliencron's live performances, the sounds of the marching band it described appeared to be everywhere. Indeed, when Liliencron visited Prague in 1904 he stumbled upon an impromptu musical performance of his own poem in a local bar. Due to its incredible popularity, as one witness recalled, the singer was forced to perform the song again and again ("musste es sogar wiederholen"). Amid this repetition, the performance spread beyond the stage, drawing in members of the audience, who were compelled to sing along to each iteration ("summten alle").[24]

Even silent readers of "The Music Is Coming" felt compelled to join in. As one critic wrote of the popular poem, "There is an intoxicating tonal fullness in these words and rhymes and it is a true feast for the ears to read aloud these magnificent, strapping verses, which seem as if they were taken from a mold."[25] In an age dominated by silent reading, the author continued, Liliencron's poem demanded to be read aloud, mobilizing the voice in the service of actualizing a perceived sonority.

Yet within this same context of medial contagion and compulsion to sonification, Liliencron fell victim to his own voice. The authorial persona he sought to cultivate in his written works was undermined by the author's physical presence before an audience and the noise of his voice in the act of performance, now vulnerable to mispronunciations, vocal tics, and dialectal idiosyncrasies. At the same time, the effort to capture the maelstrom of war in the medium of print pushed Liliencron to virtuosic vocal performances in which the articulatory apparatus was called upon to simulate the complex cacophony of acoustic modernity, provoking questions of what a human voice was capable of, what could be read, and what types of graphical marks were impervious to sonification despite the acoustic impetus behind their initial inscription. This effort to rethink literature in relation to the noise that surrounded language and enabled its transmission across a multitude

26 Chapter 1

of medial formats constitutes Liliencron's modernist impulse and the great
legacy of the naturalist project more broadly.

Naturalism and Modern Noise: Sonic Warfare around 1900

Liliencron's earliest literary efforts to write sound occurred during his time
as a lieutenant and captain in the German Wars of Unification. His status as
a high-ranking member of the Prussian army made him especially palatable
to an audience conditioned by the dominant culture of militarization in the
wake of national unification, something the naturalists were quick to exploit.
"Our age stands under the banner of the lieutenant," begins an 1888 essay
about Liliencron published in the naturalist journal *Die Gesellschaft* (Soci-
ety), by the writer and editor Otto Julius Bierbaum. "That is the dominant
star in the sky for young ladies and our young men," Bierbaum continues.
"To him they rave and run, they imitate him."[26]

For Bierbaum, Liliencron was uniquely suited to propel German litera-
ture forward, a figure capable of modernizing a stale poetic tradition too
long dominated by traditionally feminine themes of domesticity and eager to
replace them with those of heroic masculinity culled from the battlefield.[27] In
the essay, Bierbaum labeled Liliencron a "lyrical captain" (lyrischer Haupt-
mann) and expressed the hope that his works would find "many recruits . . .
who learn to sing from him" (viele Rekruten . . . , die von ihm lernen, zu sin-
gen).[28] According to this narrative, Liliencron, the soldier-bard-poet, arrived
on the scene as the the male-author-creator and savior of German letters. If
Walter Benjamin famously read the nineteenth century through the figure
of the flâneur and the urban masses, Bierbaum highlighted the ascendency
of the soldier and military leader.[29] While Benjamin privileged the city, Bier-
baum foregrounded the battlefield. Where one found a cultural capital, the
other found its captain.

Liliencron's poetry and prose offer a veritable encyclopedia of the bat-
tlefield's evolving acoustic composition, the intensity of which, medical
scientists soon discovered, was enough to cause ear pain, deafness, and
subjective noises among soldiers.[30] Against the backdrop of this aggressive
white noise, or what the narrator of Liliencron's first published collection
describes as "infernal noise" (Höllenlärm), his literary protagonists hear the
isolated sound of military drums and marching songs, infantry signals and
the voices of commanding officers, clattering telegraphs and railway signals,
the screeching of approaching trains and the relentless mechanical firing of
machine guns and exploding grenades.[31]

Liliencron not only mined the experience of war for subject matter; war
provided the material conditions and narrative impulse for becoming a writer.
The journals Liliencron kept as a soldier during the 1860s and '70s furnished
him with the raw material from which he continually drew for his subsequent

Liliencron, Captain of the Nineteenth Century
27

poems and novellas, and inspired the formal innovations that would come to characterize his mature work and earn him a reputation as a distinctly modern writer. These early forays into writing bear the traces of war's evolving media infrastructure and register the pressure exerted on writing by the speed and efficiency of technical media.[32] Entire sections of his diaries contain nothing but dots and dashes, a kind of "secret code" (Geheimschrift), "private shorthand" (Privatkurzschrift), or "Morse code" (Morseschrift).[33] Entries are composed in the present tense and tend to truncate words and phrases, suggesting that the act of writing had been performed under considerable time constraints.

To emphasize the temporality of war, Liliencron often employed onomatopoeia as a mode of real-time narration. In contrast to later authors such as Ernst Jünger and Robert Musil, who, in borrowing material from their war journals, filtered out onomatopoeic utterances contained in the original, Liliencron added more.[34] For Liliencron, onomatopoeia was not a mode of writing that needed to be excised from the final printed version but rather was intensified and made conspicuous as a valued remainder of the narrative's origins in the diary. When critics encountered reworked literary versions of his diary entries decades later, they immediately recognized their origin, labeling them "diary poetry" (Tagebuch-Poesie) and "scraps of life . . . recorded in a war diary" (Fetzen des Lebens . . . ins Kriegstagebuch eingetragen).[35]

Adapted from his diary entries, Liliencron's later prose works present the noise of war and specifically the filtering of signals from noise as a kind of aesthetic experience. His debut collection even concludes with musical notation for an infantry call to charge, a single crystal-clear signal teeming with sonic potential that cuts through the battlefield's "infernal noise" (see figure 5). Liliencron conceived of the musical score as a disruption to contemporary poetry, explaining to his editor in a letter from 1883 that the "sober horn blast" would effectively "paralyze" the prevailing "lyrical wish-wash" of his age.[36] The musical appendage, in other words, was intended as an attack on poetry's stale forms and thematic preoccupations. It was a signal to advance, a call to arms against the tired conventions of the age, looking to the soundscape of war as a source of poetic renewal. At the same time, the notation invites the reader to imagine auditory equivalents for nontextual, graphical inscriptions on the printed page. The introduction of nonlinguistic symbols serves to accentuate the underlying sonority of the textual representations that precede it. As the signal exceeds the domain of textuality, readers are asked to summon the sound of the trumpet from its musical transcription and heed its call to action.

Elsewhere, Liliencron presents the sounds of war and corresponding modes of listening as an exercise in aesthetic appreciation. The key to modernizing German literature, these passages suggest, lay in recognizing the hidden poetry of combat and training the ear to isolate individual sounds amid the unique maelstrom of the modern battlefield. In a text from 1891,

Zum Sturm, zum Sturm! Die Hörner schreien! Drauf!
Es sprang mein Degen zischend aus dem Gatter.
Und rechts und links, wo nur ein Flintenlauf,
Ich riß ihn mit ins feindliche Geknatter.
Lerman, Lerman! Durch Blut, Gewehrgeschnatter,
Durch Schutt und Qualm! Schon fliehn die Kugelspritzen.
Der Wolf brach ein, und matter wird und matter
Der Widerstand, wo seine Zähne blitzen.
Und Siegesband umflattert unsre Fahnenspitzen.

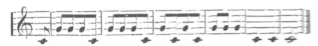

Figure 5. Musical notation for the infantry call to charge, as it appears on the final page of Liliencron's *Adjutantenritte*. From Liliencron, *Adjutantenritte und andere Gedichte* (Leipzig: Wilhelm Friedrich, n.d.), 156.

one of Liliencron's protagonists recounts how, as the sounds of marching French troops "struck our ears more and more clearly" (unser Ohr deutlicher und deutlicher trafen), "only signals rang out to us from our cavalry, those signals that hold a poetry within them."[37] Earlier in his literary debut, Liliencron elaborated on the martial soundscape's poetic potential, presenting the acts of listening and parsing sound as models for structuring the narrative. During a moment of visual blindness, the protagonist conjures up a complex mixture of musical signals, gunfire, verbal commands, and inscrutable noise:

> The cavalry signal "to trot" frequently rang out behind us. We couldn't see the squadrons, but it seemed as if I heard their stomping, wheezing, and clanking. Commands reached my ear: Ha—hlt . . . Ha—hlt . . . becoming weaker and weaker: Ha—hlt . . . Ha—hlt. Everything rang out, which makes the cavalry regiment's movements so highly poetic, especially when one is "right in the middle of it." I heard all of that clearly and yet a single boom of thunder surrounded us. In between the piercing sound of artillery fire rang out, which I had just picked up.[38]

In claiming to find poetry on the battlefield, the passage glorifies war as an object of aesthetic contemplation, if not beauty. Here, Liliencron recasts literary expression and interpretation as the communication of, and adherence to, military cues through the surrounding noise. As Liliencron suggests, signal processing was a crucial skill on the battlefield. But it also contained aesthetic possibilities, indicating a mode of literary production predicated on a

perceived affinity among nonverbal auditory cues, military orders, and poetic expression.

The passage portrays the protagonist as a highly attentive listener capable of analyzing the battlefield by means of the ear alone. The soundscape he hears is highly volatile and heterogeneous, with cavalry signals fading into nonverbal stomping and clattering, before giving way to a single discernible word, which grows weaker as it recedes into the distance. Despite the persistent "boom of thunder" (Donnerton) that punctuates the scene, the protagonist confidently moves from one sound to the next, zooming in and out with his ears, which isolate relevant acoustic qualities and identify their source without the aid of visual data. "I heard all of that clearly" (Ich hörte das Alles deutlich), he remarks amid the white noise and intermittent bursts of gunfire. The protagonist's scanning of his surroundings is not a disinterested activity aimed simply at cataloging what he hears. He is listening *for* specific sounds, repeatedly distinguishing between meaningful signals and meaningless noise.

The passage's most striking formal feature is its onomatopoeic rendering of the word *Halt* as "Ha—hlt," which elongates the word across the page by means of a nonstandard spelling and an interceding dash. The onomatopoeic rendering of the military command *Halt* invests the medium of writing with spatial and temporal qualities that simulate sound's real-time duration and extension in space. Placed in the middle of the word, the dash serves to stretch the word across the page in a manner that imitates the sound's duration in real time, collapsing narrated and narrative time into one. The same dash also tracks the sound of the voice as it moves through space. Liliencron's insertion of the dash and a second *h* reproduces changes to the sound based on the spatial distance between its source and the listener. As the distance between the commanding officer and acoustically attuned protagonist increases, the voice growing "weaker and weaker" (schwächer und schwächer) in intensity, the middle vowel gradually becomes inaudible, leaving only the intervening silence of the dash, as one would hear the utterance live under similar conditions.

Liliencron's unconventional spelling helps formalize and textually enact a set of auditory techniques that might accurately be described as a *literary poetics of signal processing*. The protagonist's auditory scan of the battlefield imposes order on the narrative, dictating the sequence and content of an otherwise chaotic event, which, in the process, exposes the scene's hidden poetry. The listener is compelled to distinguish meaningful signals from the competing din of the relentless "boom of thunder." The word's unique form highlights the cry's significance, implying that the listener hears this sound differently from others. Yet the form it takes on the page also suggests that the word has been scrutinized more closely than others, broken down into individual units of sound that the standard spelling would otherwise obscure. Thus, what we might call the "literary poetics of signal processing" involves

the activity of both differentiating signal from noise and dissecting meaningful signals into their constitutive parts.

In using onomatopoeia, Liliencron is not merely cataloging the sounds he hears but describing them as they unfold in real time. Elsewhere in "A Summer Battle" we find an onomatopoeic rendering of gunshots, which are compared to the mechanical clattering of a telegraph office. "In this moment, the first gunshots cracked. Soon we had reached a small forest and we spread ourselves out on the other side behind the trees. Tak, tak, tak, it said, tak, tak—tak—taktak—taktaktaktak—taktak—taktaktaktak. . . . It sounded like a large telegraph office."[39] The convergence of gunfire and messages communicated via technical media is portrayed through onomatopoeic clusters of nonsense syllables, with the incorporation of interceding dashes and various groupings of two or four iterations reproducing the rhythm of the shots heard on the battlefield. The passage conforms to what critics have traditionally termed *Sekunden-* or *Telegrammstil*, which reduced narrative description to its most basic linguistic units to convey the simultaneity of perception and textual inscription.[40] The fact that the narrator invokes the telegraph in the passage seems to reinforce the connection between naturalist form and the emergence of technical media.

Yet in an important twist, what is being foregrounded here is not so much the content of telegraphic messages as the *sound* of the device in operation, its mechanical clattering rather than the truncated modes of expression arising from its monetization of language, or what Bernhard Siegert calls the telegraph's unique "symbol economy."[41] In Liliencron, by contrast, it is the noise of the device itself and not the form its messages take that inspires the use of onomatopoeia, establishing an equivalency between gunfire and the rhythms of electrically encoded signals hammered out in the telegraph office. Indeed, the onomatopoeic writing inspired by the noise coincides with the recognition of a voice in the machine. As the sound of modern media blurs together with the noise of war, the sound of gunfire takes on communicative powers. "Tak, tak, tak, *it said*," Liliencron writes, implying that the telegraph's mechanical clattering actually speaks in a voice. Expanding on the source material taken from his diary, Liliencron figures the noise of war as a voice unto itself, recorded as a kind of nonlinguistic dictation from the technological soundscape.

Elsewhere in the novella Liliencron portrays the sound of an exploding grenade according to a similar onomatopoeic strategy. Now the repetition of single letters and nonlexical elements occurs alongside an unconventional use of typography: "Da . . . bssssssssst—bum! the first grenade."[42] As a way to lend material form to the grenade's trajectory through space, individual letters of the onomatopoeic utterance gradually become darker and larger as the sound approaches the listener and culminates in an explosion (see figure 6). In a prefiguration of formal techniques employed by the futurists twenty years later, Liliencron invests letters on the page with the potential to encode sonic properties beyond the purely linguistic, tracking the sound's movements

Da . . . bffffffft — **bum!** die erſte Granate.

Figure 6. Onomatopoeic rendering of a grenade explosion. From Liliencron, *Eine Sommerschlacht* (Leipzig: Wilhelm Friedrich, 1887), 337.

through space and time. In the process, letters of the alphabet come into focus as material marks on the page, signifying through their very materiality rather than functioning as imperceptible, neutral conduits for ideas.

Liliencron's use of onomatopoeia was anything but random. Although there were exceptions, the overwhelming majority of the sounds he selected to record onomatopoeically stemmed from martial and technological sources. In other writings, we find onomatopoeic renderings of a French machine gun ("Rrrrrrrt—Rrrrrrt"),[43] the sound of a single bullet striking a wooden fence ("Klapp"), an entire round of bullets hitting a tree trunk ("Klipp, klapp"), the stutters of a dying soldier ("batbatbatbatbat"), and the "bim, bim, bim"[44] of a mechanical train signal, perhaps hallucinated due to physical damage inflicted on the ear by an intense explosion (Liliencron, *Adjutantenritte*, 145, 148, 152). These are sounds that seem to speak urgently to Liliencron's protagonists, demanding to be attended to, analyzed, and transduced according to a distinct symbolic regime. They are signals to be processed and obeyed: the unquestioned command of a superior officer or other auditory cues that might mean the difference between life and death. In this way, it is their very meaningfulness, perceived through the din of the surrounding *Höllenlärm*, that provokes the listener to transcribe them with an ear to their purely acoustic qualities, to identify and convey their position in space and time. Onomatopoeia is adapted to parse and dictate the diverse voices of the mechanical soundscape. In the process of rendering signal and noise as a series of competing written marks, the materiality of language assumes a life of its own, formally encoding sonic characteristics of space and time ordinarily excised from the printed page.

Binding Ear and Drum

As Liliencron explained shortly before the publication of "The Music Is Coming," his goal was to develop a literary "fire language" (Feuersprache) characterized by precision and a sense of dynamic movement, or, as he put it, "endless progress (thus no boring filler) in it."[45] The emphasis on movement and dynamism in his programmatic statements resonates with military tactics developed by the Prussian army in conjunction with electrical telegraphy. As one German captain remarked in the aftermath of the Franco-Prussian War: "Victory today derives from marching and maneuvering, that is, in [the

infantry's] legs."[46] "This willingness to *move* on the battlefield," the historian Geoffrey Wawro argues, "was a key difference between the French and Prussian armies in 1870," and one that depended on a telegraphic network to change tactics minute by minute.[47]

It is hard to overstate just how pervasive this sense of forward momentum and dynamism is in Liliencron's writings, which the historian Karl Lamprecht referred to as "technical poetry, like a counterpart to the technical strategy of a Moltke" (technische Dichtung, wie ein Gegenstück zur technischen Strategie eines Moltke).[48] Almost every page of Liliencron's war narratives includes some command to move forward, whether an infantry call to charge or simply the order "Forward!" (Vorwärts!). As a result, one gets the sense that his protagonists are perpetually in motion, propelled forward by some auditory cue. Chief among these sonic signals is the nearly ubiquitous beat of the drum. And it is through the depiction of the drum that Liliencron intimates the physical effects of sound on the bodies of soldiers, who elsewhere engage the martial soundscape with calm detachment and the steel nerves of an armored male body.

With few exceptions, the listener's ear in Liliencron's depictions of war remains impervious to noise, serving as a deflective surface rather than a sensitized flesh open and vulnerable to physical assaults from without.[49] Thus, when Liliencron describes the auditory organ's relationship to sound, he typically employs the preposition *an* rather than *in*, such as in the formulations "There a sound rang across to my ear" (Da klang ein Ton herüber an mein Ohr) and "Calls from the command sounded upon my ear" (Kommandorufe klangen an mein Ohr).[50] Elsewhere he goes so far as to invest the ear with a kind of defense mechanism capable of keeping out unwanted sounds. A poem told from the perspective of a soldier yearning to return to battle but left only with the military music of peacetime recounts, "I kept my ears shut against the drumming and whistling."[51] It was likely this tendency that, as early as 1902, earned Liliencron's work the designation "hard, nerves-of-steel impressionism" (harte[r], stahlnervige[r] Impressionismus),[52] a phrase that anticipates Joseph Goebbels's notion of "steely Romanticism" (stählerner Romantik)[53] and Ernst Jünger's aesthetics of the armored body.[54]

While Liliencron makes no mention of the eardrum per se, his representations of the military drum serve to bind the ear of an otherwise impervious body to sound's violent potential. Moreover, the instrument's propulsive force is frequently rendered by means of onomatopoeia, which reduces language to repeatable, nearly identical monosyllabic units of sound devoid of semantic value. "The beating of the drum is incessant," the protagonist of "A Summer Battle" remarks as he and his company march along enemy lines, "plum—bum, plum—bum, plum—bum, the following beat always after the initial synchronized one."[55] As the onomatopoetically rendered sound of the drum continues, rhythmically alternating between louder and softer hits, enemy forces suddenly ambush the party with grenades and kill several of the

plum—bum, plum—bum, plum—bum,

Figure 7. First onomatopoeic rendering of the drum. From Liliencron, *Eine Sommerschlacht*, 344.

Plum=bum, plum=bum, plum=bum.

Figure 8. Second onomatopoeic rendering of the drum, with each beat now separated by a shorter equal sign. From Liliencron, *Eine Sommerschlacht*, 344.

men, leaving behind a gruesome pile of mangled bodies, now just "intestines" (Eingeweide) and "large pieces of meat" (große Fleischstücke). Seemingly impervious to the carnage, the company's captain "continues to order a forward march, yelling: don't look back, don't look back!" (läßt sich Avancieren blasen und ruft: nicht umsehn, nicht umsehn!). Against the backdrop of the verbal command and the horn's signal to advance, the drum "beats once more [schlägt wieder]: Plum=bum, plum=bum, plum=bum," with each onomatopoeic phrase now separated with an equal sign rather than a dash, as if to register a shorter interval between each beat (see figures 7 and 8). Then, in a new paragraph all its own, the words "Forward! Forward!" (Vorwärts! Vorwärts!) echo across the page.[56] Spurred on by the verbal and musical signals, the party moves forward with no further mention of the dismembered bodies of their fellow soldiers.

What is most striking about the scene is the way it links the onomatopoeic sound of the drum to the unhesitating forward motion of the remaining soldiers, a trajectory that seems to nullify past events the second after they occur. The detailed description of death and mangled body parts is immediately followed by a command to look away and simply move forward without acknowledging its horrors. This is not intended as a moralistic critique of Liliencron's inability to mourn or his insensitivity to violence: it is the clear depiction of a life-or-death moment. Amid the chaos of exploding grenades, a soldier would have few other options than to move forward away from the carnage. The point is that the drum appears especially effective in encouraging the unceasing forward momentum of war.

Zooming out, we can begin to see how the text as a whole utilizes the drum as a way to establish connections between sound and physical violence. First, the monosyllable *bum* used to designate the sound of the drum is the same one employed earlier in the novella to describe the sound of an exploding grenade. By employing the same onomatopoeic utterance to represent both, the text portrays the drum, a percussive instrument long associated with war, as a kind of musical weapon, highlighting sound's percussive force. Within the

text's general economy of signs, *bum* is a unique collection of letters capable of capturing both an explosion and a drumbeat on the printed page.

Liliencron then underscores this affinity by distributing variations of the verb *schlagen*, "to beat," throughout his textual account of the scene. While the grenade "bursts . . . in the middle of my men" (schlägt . . . mitten in meine Leute), with the fatal outcome of twelve men being "slain" (erschlagen), the drum "beats once more" (schlägt wieder). The verb's semantic range, along with the circulation of onomatopoeic elements between musical and martial contexts, foregrounds the drum's physical effects, which mobilize, coerce, and direct.

Sound, Liliencron's onomatopoeic linkage implies, was tactile and percussive, embodied in both the direct contact of drumstick and drumhead and the physical force of a nearby grenade explosion. It did not simply operate on the mind or spirit, as Romantic tropes of music as madness and transcendence would have it. Indeed, explosions on the battlefields of the Wars of Unification, medical scientists soon discovered, were capable of rupturing eardrums and inflicting temporary deafness. Liliencron does not go this far. He instead restricts sound's effects to the body's exterior and leaves the eardrum intact. Yet, more subtly, his literary depictions of war link the drum's physical force with a kind of "soft violence," one commensurate with actual warfare; bullets, bombs, fists, and clubs.

"The Music Is Coming": Sonic Warfare and the Orientalist Other

Having surveyed the role of sound in his war novellas and diaries, we can now analyze the ways Liliencron sought to transfer elements of the martial soundscape to civilian spaces after the war. At the center of my analysis is Liliencron's poem "The Music Is Coming" (1882), which, as we noted above, was one of the three pieces he read aloud into the phonograph in 1896, subsequently becoming a staple in his reading tours and the source of countless musical adaptions by other performers. In the poem we are no longer situated on the battlefield but rather on a town street during peacetime. More specifically, the piece describes the passing of a military parade and the cacophony produced by various drums, cymbals, and horns, which are registered onomatopoeically.

If the poem centers on a military parade—that is, an aestheticized performance of military power, values, and codes of conduct—it also dwells self-reflexively on issues of representation and performance. By comparing the poem's depiction of sound with Liliencron's war novellas, we can begin to identify aspects of a common sonic aesthetic that circulated across martial and civilian spaces, with music, poetry, and oral performance all calibrated to fit the surge of militaristic energy released into the culture in the wake of Germany's victory in the Franco-Prussian War.

As historical studies of the period have shown, the four decades leading up to the outbreak of World War I witnessed an unprecedented saturation of the public sphere with military parades, war commemorations, anthologies of war poetry, military songs, and soldiers' memoirs, as well as immersive panorama paintings depicting key battle scenes, often accompanied by mechanical marching music.[57] Within this culture of war came calls to reorient primary education around training future soldiers and fostering a sense of self-sacrificial duty to the nation-state. To this end, school officials and political leaders proposed more physical education, marching drills, and lessons in modern military history.[58] From the classroom, through the streets, to emerging sites of mass culture, the unified German nation coalesced around the figure of the soldier and a victorious German army.

Turning to "The Music Is Coming," we can now begin to flesh out how Liliencron envisioned and enacted this fusion of literary modernization and the aesthetics of war. As its title announces, it is specifically the aesthetics of sound that animates the poem, borrowing both its objects of representation and formal devices from the soundscapes of war and its commemoration:

> Klingkling, bumbum and tschingdada,
> is the Persian shah coming in triumph?
> And around the corner it thunders and cracks,
> Like the sound of Last Judgment's tubas,
> At the front the Turkish crescent bell carrier.
>
> Brumbrum, the great bombardon,
> The crash of cymbals, the helicon,
> The piccolo, the cornettist,
> The Turkish drums, the flutist,
> And then the captain.
>
> The captain approaches with a sense of pride,
> A strap beneath his chin,
> Strung around his lean body,
> By Zeus! That's no waste of time,
> And then the lieutenants.
>
> Two lieutenants, rosy red and brown,
> The flags protect them like a fence,
> The flag is coming, take off your hat,
> For we're loyal to death!
> And then the grenadiers.
>
> The grenadier in rigid step,
> Step by step, and step by step,

It stomps and booms and clacks and whirs,
The streetlight glass and windows rattle,
And then the little girls.

All the girls, head to head,
Blue eyes and blond braids,
From door and gate, yard and home,
Mine, Trine, and Stine look out,
The music is gone.

Klingkling, tschingtsching and a kettledrum crack,
It still sounds gently from the distance,
very quietly bumbumbumbum tsching:
Is that a colorful butterfly coming,
tschingtsching, bum, around the corner?

Klingkling, bumbum und tschingdada,
zieht im Triumph der Perserschah?
Und um die Ecke brausend bricht's
wie Tubaton des Weltgerichts,
voran der Schellenträger.

Brumbrum, das große Bombardon,
der Beckenschlag, das Helikon,
die Pikkolo, der Zinkenist,
die Türkentrommel, der Flötist,
und dann der Herre Hauptmann.

Der Hauptmann naht mit stolzem Sinn,
die Schuppenketten unterm Kinn,
die schnürt den schlanken Leib,
beim Zeus! das ist kein Zeitvertreib,
und dann die Herren Leutnants.

Zwei Leutnants, rosenrot und braun,
die Fahne schützen sie als Zaun,
die Fahne kommt, den Hut nimm ab,
der sind wir treu bis an das Grab!
und dann die Grenadiere.

Der Grenadier im strammen Tritt,
in Schritt und Tritt und Tritt und Schritt,
das stampft und dröhnt und klappt und flirrt,

> Laternenglas und Fenster klirrt,
> und dann die kleinen Mädchen.
>
> Die Mädchen alle, Kopf an Kopf,
> das Auge blau und blond der Zopf,
> aus Tür und Tor und Hof und Haus
> schaut Mine, Trine, Stine aus,
> vorbei ist die Musike.
>
> Klingkling, tschingtsching und Paukenkrach,
> noch aus der Ferne tönt es schwach,
> ganz leise bumbumbumbum tsching;
> zog da ein bunter Schmetterling,
> tschingtsching, bum, um die Ecke?

One part children's rhyme, one part military kitsch, and one part avant-garde sound poem, "The Music Is Coming" narrates and formally encodes the aesthetics of war and their domestication as military spectacle. Its depiction of the parade's participants and spectators is clearly intended to be humorous but, especially when one considers the formal and thematic elements of his war writings, the poem undoubtedly celebrates the intrusion of militaristic sounds into civilian life and delights, playfully, in their description.

Somewhat paradoxical for the patriotic fervor that defined the period in which it was written, the sounds of war are clearly borrowed from Persian and Ottoman musical traditions, and thus from outside of newly unified Germany or even Europe. The onomatopoeic rendering of the military band with which it begins leads the narrator to speculate that the sounds signal the arrival of a certain "Persian shah" (Perserschah). This conjecture is then followed by references to musical instruments closely associated with "Turkish" or "Janissary" music, including the bass drum, triangle, piccolo, cymbals, Turkish crescent bells (Schellenträger), and so-called Turkish drums (Türkentrommel).

The Orientalist inflection of the band's instrumentation would not have been lost on Liliencron's readers. Janissary music was all the rage in nineteenth-century Europe, inspiring compositions by Mozart, Beethoven, and Johann Strauss, among others, as well as being introduced into European military bands beginning around 1740. Pianos produced in the nineteenth century even began to include pedal attachments called "Janissary stops," which imitated the sound of a bass drum and other "realistic battle sounds."[59]

Indeed, it was precisely the vast array of percussion instruments used in Janissary music that was most striking to European listeners, who not infrequently encountered it as aggressive noise. German and Austrian critics of the nineteenth century variously characterized it as a "wild, noisy music that works more by beat than melody" (wilde, lärmende, mehr auf Tact als

38 Chapter 1

Melodie arbeitende Musik),[60] whose "violent effect . . . confused the listener's senses" (gewaltigen Wirkung . . . sinnverwirrend auf die Hörer wirken).[61] The emphasis on rhythm and frequent designation of *Lärm* were clearly linked to a sense of cultural superiority that relied on othering the Ottomans as simplistic, uncivilized, and inscrutable. European critics did recognize the music's power, its "violent effect," but that threat was neutralized by a rhetoric of primitiveness and the privileging of a bodiless European intellect over the exotic Other's more corporeally attuned aesthetic.

It is tempting to interpret Liliencron's poem as a work intended to demean Turkish and Persian musical traditions in the wake of Germany's rise to military dominance. When one looks closer at the text, however, and positions it alongside Liliencron's other published works and his programmatic statements on literature, a more complicated picture emerges. As we have seen, he conceived of his own literary project as injecting the dynamism and violence of war into modern literature. His texts not only celebrate but seek to formally reproduce the rhythmic coordination and automatic bodily responses demanded in combat, which he saw as inextricably bound up with the sounds of the horn and drum. He found "poetry" in the act of filtering signals from noise and positively coded the visceral effects of both. Considering this commitment to the aesthetics of war, Liliencron would have likely regarded the European obsession with "Turkish music," which was essentially synonymous with "military music," as a positive development.

One could argue that Liliencron's poem in fact subverts clear distinctions between Europe and its Other by revealing the interconnectedness of their military and musical cultures. The proximity of East and West is already intimated in the poem's first stanza through its allusion to the "Last Judgment" (Weltgericht), a religious narrative shared by Christianity and Islam down to the trumpet call, which, in both cases, is understood to announce the Last Judgment by means of a physically piercing sound. But one could go a step further, reading the seamless juxtaposition of Occident and Orient not simply as an illustration of coincidental structural similarities but rather as an indictment of Europe's perceived cultural superiority. The same music Europeans deemed "foreign" and "wild" regularly filled their streets and concert halls. If Liliencron here uses the onomatopoeic *tschingdada* as an invocation of Turkish music, in another text he uses it to invoke Offenbach.[62] Moreover, the complex of aggression, physicality, and devaluation of the intellect that Europeans identified as marks of cultural inferiority actually described their own panmilitaristic culture, which was constructed "under the banner of the lieutenant" (im Zeichen des Leutnants).

In this way, Liliencron comes closer to critics who derided European appropriations of Eastern music not necessarily because the traditions from which they borrowed were inferior to their own, but because European works were mere *imitations*. In a text from 1875, one critic contended that the pervasive influence of Turkish music in Europe was the result of an "imitation fervor"

(Nachahmungseifer), which sought to integrate "these sounds, by which [European soldiers] had been so often alarmed," as a part of their own military tool kit.[63] Seen in this light, Liliencron's use of onomatopoeia—a means of textually imitating sound—as well as his foregrounding of the parade's mimetic force among spectators and participants, mirrors the tradition of European imitations of Turkish music. The poem's onomatopoeic rendering of the music in the first and last stanzas functions less as a strategy of othering Turkish music and more as a self-reflexive commentary on the fact and manner of this cultural appropriation.

When Liliencron returned to the topic of Turkish music later in his life, he chose to highlight precisely this issue of imitation, now elevating the music to a kind of contagion and demonstrating its power to influence the behavior of nearby listeners. As the poem's protagonist sits at a window listening to the sound of a military band "in step with the janissaries" (im Schritt der Janitscharen), he casts a highly eroticized gaze on a lone woman caught up in the music's infectious power: "From afar the music, klingklang rumbum // she dances and dances and dances, to the right and to the left / charming like the hovering of angels // Hither and thither and hither, she's alone / showered by the first sunshine / completely given into the urge."[64] Here the listener is forced out of her role as detached spectator and seemingly coerced into synchronizing her bodily movements with the music's alluring rhythm. This abdication is underscored through the poem's rhyming of the onomatopoeic *rumbum* and the frenetic movements of the dancer "to the right and to the left" (rechtsum, linksum), as if to suggest on the level of language the body's increasing conformity to the beat of the drum.

Although especially pronounced in European accounts of Turkish music, the compulsion to conform and imitate was not restricted to these encounters but rather was a commonly perceived effect of military music more generally. In a letter published in the official journal of the German antinoise movement one year after Liliencron's later poem, a resident of Berlin recounted a remarkably similar experience of musical contagion. Every morning, and sometimes up to eight times a day, the author lamented, he was forced to listen to "the penetrating noise caused by military music" (die durchdringenden Lärm verursachende Militärmusik) outside his window. "Every time, naturally, with a loud tsching and bum" (Selbstverständlich jedesmal mit lautem Tsching und Bum), he continued, using the same onomatopoeic phrases that appear throughout Liliencron's writings. The effect of the music was so relentless and pervasive, he explained, "that one, completely desperate, finally whistles along to the well-known, highly patriotic melodies."[65] Drawing on a common set of onomatopoeic phrases, both the letter and Liliencron's poem attest to the mimetic power of civilian military music, whether recognizably non-European or otherwise, which provoked listeners to coordinate their movements to its rhythms or whistle along against their will.

40 Chapter 1

The Birth of the Symbolic out of the Mimetic

It is indeed striking how thoroughly issues of mimesis and imitation pervade "The Music Is Coming"—from its rhythm, imagery, and representational strategies to descriptions of characters and events in the text. Most conspicuously, the poem utilizes onomatopoeia to reproduce the sound of the approaching band. Rather than describing the sounds of the glockenspiel, bass drum, and cymbals using lexically defined nouns and verbs, the poem begins with the phrase "klingkling, bumbum und tschingdada," which bypasses the lexicon in favor of mimetic modes of writing. Letters congeal into simple monosyllabic units and are repeated across the page in clusters of two or four, in imitation of the music's sonic properties and their unfolding in real time.

The poem continues by exposing the mimetic forces governing the interaction between music and spectators. In the penultimate stanza, the narrator turns from the parade's participants to its onlookers. "All the girls," he observes, positing a highly gendered conception of spectatorship, are essentially indistinguishable in their physical appearance: "blue eyes and blond braids."[66] They not only look the same, he continues in the fourth line, but also possess nearly identical names: Mine, Trine, and Stine. Unlike the poem's portrayal of those marching, who are singled out individually, each allotted their own stanza and differentiated according to rank, the crowd of spectators form a homogenous mass of blue eyes, blond braids, and interchangeable names.

Liliencron's emphasis on the interchangeability of female onlookers becomes more complex in the stanza's concluding line, which uses the unconventional spelling *Musike* instead of the standard *Musik*. One might speculate that the word's irregular spelling is simply an attempt to imitate its pronunciation in a Berlin dialect. More significant, however, is the way Liliencron's spelling extends the similarities among the three female spectators to the language of the poem itself, as if to imply that the mimetic contagion of the girls' names has spread to the scene's poetic narration. In this view, music and spectator do in fact exist in a state of mimetic exchange. But the nature of their relation does not operate according to a unilateral model of influence. Music does not single-handedly dictate the behavior of the spectator, as it would the dancing figure in Liliencron's later rewriting of the scene. Instead, the girls' uniformity appears to be impressing itself onto the text, forcing the poem's language to be altered in a manner that is consistent with Mine, Trine, and Stine. While the poem leaves the source of the influence ambiguous, it emphasizes the commensurability of the parade and the spread of mimetic forces throughout the poem's form and content.

If the first five stanzas portray the dissemination of mimetic forces, from the onomatopoeic description of the music's abrupt entrance, through its rhythm, to the parade's spectators and even the poem's linguistic material, the

poem's conclusion stages their retreat and the restoration of the symbolic. In the final stanza we read: "Klingkling, tschingtsching and a kettledrum crack / it still sounds gently from the distance / very quietly bumbumbumbum tsching / is that a colorful butterfly coming / tschingtsching, bum, around the corner [bum, um die Ecke]." Similar to the first stanza both structurally and thematically, the poem's final lines weave together onomatopoeic reproductions of sound with more conventional language. The result is, once again, the formulation of a question about the sound's source. Whereas in the first stanza the sound of the approaching band gave rise to speculations about the arrival of the Persian shah and his convoy, even possibly an army, the final stanza produces the image of a harmless butterfly.

The contrast between the two conjectures demonstrates the extent to which space and directionality have altered listeners' perceptions of the music. In the first stanza, the fact that the noise's source was still unknown yet headed in the spectators' direction imbued it with a certain menace, which the poem invokes through the imagery of a triumphant foreign army on the approach and blaring trumpets that signal the end of the world. In the final stanza, by contrast, having made itself visible and facilitating a collective experience of national pride, the fading sound takes the form of a mere butterfly fluttering into the distance.

The disparity between the two responses draws its logic from the battlefield, where stasis meant vulnerability and a sound's directionality could mean the difference between enemy and friend, dread and reprieve. By bookending the poem with two wildly divergent affective states, Liliencron overlays the parade and the idyll of peacetime with the threat of war and its memory as lived experience. "The war will last for eternity," he wrote in a letter in 1888.[67] In other words, the music came and the music went, but the state of war persisted. To attend to the sounds of the military band as they moved through space was both a reminder of past wars and an anticipation of those to come.

As the sounds of war fade into the distance, the mimetic regime of onomatopoeia gives way to the symbolic. While the manifestation of the butterfly indicates an end to the threat of war, it also marks a semiotic shift. By embedding the appearance of the butterfly between onomatopoeic clusters of the syllable *tsching*, which emulate the sound of cymbals, Liliencron activates the word's broader semantic field and etymological associations, conjuring up associations between the living organism butterfly (*Schmetterling*), on the one hand, and the verb *to blare* (*schmettern*) or its adjectival form, *blaring* (*schmetternde*), on the other. Perhaps most frequently used in phrases like "blaring fanfare" (schmetternde Fanfare) to describe the sound of brass instruments, the term is equally applicable to the metallic crash of cymbals, such as the formulation "blaring crash of cymbals" (schmetternder Beckenschlag). Seen in this light, the onomatopoeic representation of the cymbal crash sets in motion an associative chain that leads the narrator to settle on

42 Chapter 1

the butterfly as a fitting conclusion to the event. Crucially, the connection cannot be drawn without recourse to conventional language and the lexicon. To convey the sound of a cymbal crash one could use the onomatopoeic *tsching* or the adjective *blaring* (*schmetternd*). But while the latter contains suggestive traces of the noun *butterfly* (*Schmetterling*), the same word would have no conceivable connection to the sound's mimetic registration as *tsching*. The butterfly only makes sense in this particular context, in other words, if one abandons the mimetic for the arbitrariness of traditional language. Without the word *Schmetterling*, the sound of the cymbal could not materialize as the butterfly.

What I am suggesting, then, is that as the music of war vanishes, so too does the primacy of the mimetic over the linguistic. To reinforce this point, we must look no farther than the poem's next and final line, which contains another onomatopoeic rendering of the cymbal crash along with the second half of the question it temporarily interrupted: "Tschingtsching, bum, around the corner" (Tschingtsching, bum, um die Ecke). By positioning the lexical preposition *um* (around) immediately after the onomatopoeic *bum* of the drum, the poem stages a transition from mimetic to symbolic registers. The preposition *um* grammatically completes the question beginning in the preceding line. But to do so it introduces a lexically defined word made up of the last two letters of the preceding onomatopoeic utterance. The passage from *bum* to *um* flips the switch between two distinct semiotic orders. That transition occurs at the same time as the lexical *um* is extracted or filtered out of the preceding onomatopoeic phrase, *bum*. The music's explosive entrance into the poem as onomatopoeic noise; the highly mimetic relations that dominated the parade as it was happening; the alteration of *Musik* to *Musike* in adherence with the carbon copies Mine, Trine, and Stine—all of this comes to an end as the noise of war dissipates and the butterfly takes flight.

Coda: Circulating the Voice

In 1893 Liliencron began to undertake extensive reading tours to earn money and promote his work in Germany and abroad. He would continue the practice until his death in 1909, performing in towns and cities including Düsseldorf, Köln, Bonn, Vienna, Brünn, Teplitz, Leipzig, Weimar, Essen, and Mühlheim, among others. As scholars have noted, he was one of the earliest German authors to approach touring and poetry readings as a commercial enterprise.[68] Though the tours were crucial for Liliencron and his family's financial survival, they were also unpleasant affairs and a source of embarrassment and anxiety for the author.

Predictably, to alleviate his fears Liliencron approached oral performance as a military activity. "I must admit, I'm really afraid of it," he stated in a letter at the beginning of 1898. "And I would rather approach a battery loaded

with case-shot."[69] If the audience represented a threat more pernicious than an army loaded with live ammunition, he would subordinate them by drawing on his experiences as a soldier. Specifically, it would be his voice, his "loud commander's voice" ([s]eine laute Kommandostimme), trained on the battlefield, that would provide the necessary antidote to his encounters with the public. Recounting a performance given that same year, he proudly noted how "the first word came out, rasping with my croaking lieutenant's voice" (das erste Wort heraus[kam], schnarrend, mit meiner krächzenden Leutenantsstimme).[70] By forcing the author into contact with his reading public, each performance became the site of a potential conflict, with the author assuming the role of a commanding officer and the audience that of his subordinates or, even more dramatically, enemies. In his essay on Liliencron, Otto Julius Bierbaum had asked whether it was possible to be both a poet and an army captain, to simultaneously possess the sensitivity required for poetry and the severity demanded of a drill sergeant. For Liliencron, deprived of the comforts of textual mediation and nonpresence, it was not only possible but necessary.

In addition to the vocal demands on performers, touring overlapped with the experience of the battlefield by requiring constant movement from the author, who was compelled to quite literally "mobilize" his work as a circulating amalgam of voice, body, and written text. Thus, when Liliencron performed "The Music Is Coming," he was not only harnessing his voice to subdue the audience with his alleged authority or confronting them with the sounds of war; he was describing his own circulation through an expanding media ecology of coin-operated phonographs, financially driven reading tours, and recorded music—the same networks that provided the opportunity to disperse his aestheticized depictions of war, and especially its noise, throughout the fabric of civilian life. In the process, whether consciously or unconsciously, he was enacting his own transformation from Liliencron the soldier to just another marcher in the parade.

What he performed onstage, and what spectators saw and heard from the audience, was a far cry from the unambiguous transmission and reception of a military command. The act of reading aloud for an audience produced a surplus of sensory data and affect that exceeded linguistic meaning and wrested control over the work and its reception away from the author, even a "lyrical captain" (lyrischer Hauptmann) such as Liliencron. To borrow the language of the battlefield and its technological infrastructure, performance generated both signal and noise. Liliencron himself boasted of the wide range of vocal techniques and expressive registers that made up his act. In an 1889 letter to his publisher, he offered the following list: "I bellowed, murmured, cooed, laughed, cried, purred, growled, wailed, whimpered, cajoled, grumbled, sang [schnadahüpfelte], giggled, grunted, whined."[71] While the expressive repertoire he claims to possess resembles the basic tool kit of any dramatic actor, it is the sheer quantity and diversity of articulatory possibilities that is striking,

the presumed malleability and plasticity of the voice that Liliencron is able to read into and out of his own work. Without changing a word on the page, the manner in which the text was articulated could mean the difference between assaulting or cajoling the audience.

The range of expressive registers Liliencron outlined in his letter exemplifies what scholars have variously called "the materiality of the voice" or "the trace of the body in the voice"—that is, the audibility of the body's modulation of sound and affect during processes of articulation.[72] Rather than helping to sustain fantasies of self-presence in the Derridean sense of the term, the corporeality of speech undermines any alleged immediacy by highlighting the channels through which it must pass on the way from text to vocal actualization.

This fleshiness of the voice frequently undermined Liliencron's fantasy of self-possession and the authoritative force of his "lieutenant's voice" (Leutenantsstimme) to control the audience and its reaction. "If Liliencron doesn't have teeth, he should put in fake ones," one unimpressed member of a Prague audience remarked after a reading in 1904.[73] Similarly, Max Brod remembered, "He spit the verses. Something seemed not to be in order with the teeth of the old man. Sputtering and hissing, the Elysian constructions burst forth. . . . It struck our ears in a way that was not completely understandable, the North German pronunciation alone made the words unfamiliar."[74]

When in 1901 Liliencron became the director and a regular performer at Victor Bausenwein's cabaret Überbrettl, a professional move once again prompted by economic considerations, audience members hissed at him due to his unsteady voice and demeanor.[75] After witnessing one such performance, the writer Alfred Kerr was reminded of an African prince forced to beat the drum at a European carnival.[76] "A whore sells only her body," Liliencron wrote to a friend, "but I have to sell my name and soul in addition."[77] When Liliencron said "soul," he meant "voice."[78] But the voice also had a body that left traces on his work in the process of its circulation from city to city and transduction from page to oral performance.

Onomatopoeia assumed importance within German literature during a period of dramatic changes to the ways in which sounds were recorded, disseminated, and embodied. But German naturalism's interest in the formal device was also motivated by questions specifically related to writing and its representational capacities. Onomatopoeia facilitated new connections between sound and the medium of print in the era of the phonograph and silent reading. It summoned the reader to voice what appeared on the page not only as words or ideas but as visual marks situated in time and space. The result of their intermingling was not the perfect commensurability of voice and text but a greater sensitivity to the noise that pervaded both. What could be sounded could not always be written; what could be written could not always be sounded. Indeed, when attempting to explain to a friend in 1898 why his performance of "The Music Is Coming" had failed at a recent

reading, Liliencron concluded simply, with a hint of desperation: "I simply *cannot* read it."[79]

Liliencron could, of course, read the poem aloud. He did so before the phonograph's recording horn only years earlier and countless times on his reading tours, both before and after the letter. What is significant about the remark is that it identifies a disparity between written works and their oral performance. Although critics praised his published works as teeming with acoustic potential and as inspiring the reader to recite them aloud in an age dominated by silent reading, many of the same formal qualities also obstructed their seamless transition to sound. In attempting to render audible the onomatopoeic representation of the marching band in "The Music Is Coming," the authorial voice came up against its limit. What at first glance mitigated the limitations of print, reconfiguring printed marks as real-time reproductions of sound, in the end exposed the limitations of the voice. The textual reproduction of sound, in other words, required a more sophisticated medium of playback than the ordinary human voice. Yet this was hardly the last time Liliencron attempted to perform the piece at a live reading, suggesting a perpetual process of training the voice to move beyond its ordinary capabilities. Naturalist phonography implied not only a mode of writing but a new way of utilizing the voice, with the text as both instructor and impetus for vocal innovation.

Chapter 2

✦

Bringing the War Home

Tympanic Transductions from the Battlefield to Fin-de-siècle Vienna

> Rrrrátaplan rrrráta rrrráta rrrráta rrratatatá tá tá tá tá——— trrrrrrrrrrá!
>
> —Altenberg, "The Drummer Belín" (1896)

> Affects are projectiles like weapons.
>
> —Deleuze and Guattari, *A Thousand Plateaus* (1980)

Peter Altenberg's 1896 prose poem "The Drummer Belín" describes a peculiar performance at a theater in downtown Vienna, one whose textual registration contains clear resonances of Liliencron's earlier depictions of the Wars of Unification. Following a tightrope-walking act and a pantomime striptease, a certain "drum virtuoso Belín" (Trommel-Virtuose Belín) takes the stage and is greeted by the audience in French. Equipped with only a drum, he launches into an aggressive performance of percussive music, which transports spectators from downtown Vienna to an imagined battlefield. As drumrolls blur into machine-gun fire and explosions, the performance becomes an all-out assault on audience members, who register the force of the noise as physical blows to their bodies:

> A little drum sits lopsided on a little rack.
> [The drummer] comes out in a tailcoat and white tie. He has grey hair.
> "The Battle!":
> Rataplán ra ra ra ra - - - out of the distance countless troops come running, millions, ever more, ever more, more, more, more. More - -! They sneak, slide, scurry, fly - - -. Pause.
> A volley of gunfire - - - ratá! Pause. Fire, fire, fire - - - rătătătá!
> The battle sings its song, it shouts, shrieks, roars, groans and exhales - - - - -.

48 Chapter 2

Pause. Suddenly a terrible whirlwind of sound - - - - Rrrrátaplan rrrráta rrrráta rrrráta rrratatatá tá tá tá tá - - - trrrrrrrrrá! The death throes of life: "The Battle!"

Hurricane roll!

He rapes the ear, stretches it, rips it apart, shakes it, brakes it, penetrates into the soul and causes tremors. A terrible whirlwind, an awful, unrelenting, brutal, bloody-eared drumroll! Won't he stop it? He won't stop, rrrratá, pelts, tears the nerves, rrrátatatá! Roll! Roll - - -!! Rrrratá!

Everything is blown across the floor, mowed down, obliterated!

Bang - - bang - - - - - - bang! Rrrrrrrrrát - - - - -. The battle dies down.[1]

Auf einem kleinen Gestelle liegt schief eine kleine Trommel.

[Der Trommler] kommt herein, in Frack und weisser Kravatte. Er hat ergrauende Locken.

'Die Schlacht!':

Rataplán ra ra ra ra - - - von ferne ziehen unabsehbare Schaaren in Eilschritt heran, Millionen, immer noch, immer noch, noch, noch, noch. Noch - -! Sie schleichen, gleiten, huschen, fliegen - - -. Pause.

Geschütz-Salve - - - ratá! Pause. Salve, Salve, Salve - - - rătătătá!

Die Schlacht singt ihr Lied, jauchzt, kreischt, brüllt, stöhnt, athmet aus- - - - -. Pause. Plötzlich beginnt ein furchtbarer Wirbel - - - - Rrrrátaplan rrrráta rrrráta rrrráta rrratatatá tá tá tá tá - - - trrrrrrrrrá! Der Todeskampf dieses Lebens 'Schlacht'!

Orkan-Wirbel!

Er nothzüchtigt das Ohr, spannt es, treibt es auseinander, schüttelt es, bricht es, dringt in die Seele ein und macht erschauern - - ! Ein fürchterlicher Wirbel, ein entsetzlicher, nachsichtsloser, grausamer, blutohriger Wirbel! Wird er nicht aufhören?! Er hört nicht auf, rrrratá, prasselt herum, zerfetzt die Nerven, rrrátatatá! Wirbel! Wirbel - - !! Rrrratá!

Alles wird über den Boden geblasen, gemäht, vertilgt!

Schuss - - Schuss - - - - - - Schuss! Rrrrrrrrrát - - - - -. Die Schlacht ist gestorben.

Borrowing many of the same onomatopoeic phrases Liliencron had used to capture the noise of war, most notably long strings of the letter *r* and variations of *ratatata*,[2] Altenberg overlays the internal spaces of the theater with elements from the martial soundscape, effectively transforming an act of popular culture into an act of war.[3] As masses of soldiers materialize on stage and rush into combat, onomatopoeic interjections such as "rrrrátaplan rrrráta rrrráta" repeatedly disrupt more conventional modes of literary narration dominant in the first half of the text, as the rhythmic pounding of the

Bringing the War Home

performer's drum batters the crowd with virtual bullets. The abrasive noise of the drum is described as slashing the crowd's nerves; it rattles, breaks, and even rapes the ear, as the percussive sounds penetrate deeper into the body on their way to the soul. In the end, audience members are left wondering whether the performance has ruptured their eardrums (*zerreisst das Trommelfell*).

Altenberg's reference to the eardrum in these final lines underscores the act's physical impact on listeners by drawing on the double meaning of *Trommelfell* as both the skin of the drum and the ear's tympanic membrane. In drawing attention to the sound's violent effects but refusing to resolve this semantic ambiguity, the text superimposes the figure of the eardrum onto the surface of the percussive instrument. Viewed alongside this superimposition, the onomatopoeic fragments of noise appear to be not so much the description of auditory phenomena as their physical registration through the listener's body, with the drumstick striking both the skin of the drum and the ear itself.

This invocation of the eardrum as a site of acoustic experience epitomizes the transition from naturalism to impressionism at the end of the nineteenth century. While Altenberg's text clearly appropriates Liliencron's mimetic strategies of writing sound, deploying nearly identical onomatopoeic utterances, the extent to which the Viennese writer highlights sound's physical impact on the body would have been unusual for any naturalist text. Despite a pronounced interest in onomatopoeia and "auditory images" (Ohrbilder), the naturalists paid little attention to the fleshiness of the ear, which they conceived of as a unified and largely neutral conduit for external sounds—a disembodied signal processor. Although intimated in Liliencron's coupling of the ear and the drum, and in the power of military music to influence bodily movements, the corporeality of sound plays virtually no role in either the theory or practice of naturalist literature. While in Liliencron the cacophony of war was confined to the ear's surfaces, "the overcoming of naturalism" (die Überwindung des Naturalismus), according to Hermann Bahr, lay in the integration of the perceiving body into literary aesthetics. In contrast to Liliencron's "hard, nerves-of-steel impressionism" (harte[r], stahlvervige[r] Impressionismus)—which was just another name for naturalism—Bahr advocated "a nervous Romanticism" (eine nervöse Romantik) and a "mysticism of the nerves" (Mystik der Nerven).[4]

The shift from Liliencron's armored ear to modes of embodied listening ran parallel to changes in the author function in fin-de-siècle Vienna. Whereas in the age of the lieutenant, Liliencron went to great lengths to convey his cool detachment amid the pandemonium of battle, in the age of nervousness and neurasthenia as cultural capital, Altenberg's published writings celebrated nervous sensitivity, including the author's own, as a modern virtue. Diagnosed at the age of twenty-four with "hypersensitivity of the nervous system" (Überempfindlichkeit des Nervensystems), Altenberg's parents were informed

50 Chapter 2

by the medical establishment that their son would be incapable of ever fulfilling the norms of bourgeois life. Doctors at the time encouraged his family to protect their son from undue stress.[5] As a result, Altenberg became, in the words of the medical doctor and fellow modernist author Arthur Schnitzler, a "professional neurasthenic" (berufsmäßiger Neurastheniker) only too happy to flaunt his personal idiosyncrasies and nervous sensitivity for the Viennese press and reading public.[6] When in 1913, Alban Berg premiered two texts by Altenberg set to music, the ensuing riot that broke out in the audience was less the result of the music's dissonance and more an expression of moral outrage at the text's mentally ill author, whose stay at the Steinhof psychiatric hospital at the time was highly publicized.[7]

Yet even in light of popular discourse on nerves and the neurasthenic as artist, today "The Drummer Belín" appears almost anachronistic, its style and content much more closely aligned with expressionism or even Dadaism. "The poet is a person who does not yet exist," the critic Egon Friedell wrote in his 1912 study of Altenberg.[8] Similarly, for Theodor Adorno, Altenberg's great contribution to literature and humanistic critical theory lay in his heightened sensitivity and attunement to the body's physical needs, which, documented in his published writings, Adorno argued, productively offered readers "a subjective technique for anticipating better social conditions" (eine subjective Technik zur Vorwegnahme besserer gesellschaftlicher Zustände).[9] Altenberg's unusual sensitivity to sensory data in his writings, Adorno suggested, helped those in the present to envision conditions for a humanity still to come. Or, to reformulate Adorno's observations in terms of Spinoza-inflected affect theory, "What a body can hear is a question, not a forgone conclusion."[10] Whereas some heard only a drum, Altenberg perceived the traumatic consequences of past and future wars whose audible traces could be gleaned from the everyday sounds he heard in a single neighborhood of Vienna, to which he confined himself for most of his life. Altenberg was not a prophet, of course, and his texts did not swing free of the discursive constraints that shaped the work of his contemporaries. But the sensitivity with which he observed the emerging soundscape of Vienna provided him with unusual insight into the physical, affective, and aesthetic implications of modern noise, both on and off the battlefield. It is worthwhile to reconstruct and historicize some of the factors that enabled him to hear what he did in this historical moment.

Drawing on Altenberg's work and its reception during his own lifetime, this chapter charts the migration of sonic warfare from the battlefield to the city of Vienna at the fin de siècle. As we saw in the previous chapter, Liliencron's "The Music Is Coming" self-reflexively commented on, but nonetheless contributed to, the spread of military behavior, power structures, and sensory experiences throughout civilian culture in the wake of German unification. Altenberg's "The Drummer Belín" helps to illuminate how, in Vienna and other German-speaking cities, the proliferation of sonic elements from the

Bringing the War Home

modern battlefield intensified around 1900. Along with military music as an everyday occurrence on the streets of Vienna, even sounds not explicitly related to war or its commemoration came to be viewed as quasi-military assaults on a physically vulnerable population.

In the process, a clear distinction between the urban and martial soundscape became untenable, with the noise of the city imposing acoustic elements once confined to the battlefield onto ordinary life. As one author noted in a 1908 article dedicated to the issue of "Viennese Noise" (Wiener Lärm), the nature and intensity of the city's soundscape suggested that residents were outfitted with "a Turkish eardrum" (einem türkischen Trommelfell), a formulation that, similar to Altenberg's text, confounds anatomical structures inside the ear with the surfaces of a drum.[11] Another author, writing in Vienna's *Neue Freie Presse* one year earlier, asserted that "the concert of the street has become an encouraging accompaniment to our daily work, just like marching music for soldiers."[12] In its sheer positivity, the article demonstrates the extent to which, by the first decade of the twentieth century, encounters with the city's soundscape and inhabitants' conceptions of their relationship to it had been consumed by the rhetoric of war and combat. Whether aggressor or enlivening accompaniment, Vienna was an acoustic battle zone of competing political voices, social identities, and cultural values.[13]

It was around the figure of the eardrum that this perceived convergence of martial and civilian soundscapes took shape. Zooming out from Altenberg's prose poem, we find the eardrum at the center of a remarkably diverse set of issues pertaining to sound in Vienna, from urban noise and noise abatement, through growing social and political antagonisms, to the nature of mechanical sound reproduction and the scientific understanding of hearing in the emerging field of otology (see figure 9).[14] "The Drummer Belín" marks the expansion of this "tympanic regime" into literary aesthetics amid the eardrum's broader circulation across various domains of knowledge and practice. Its role was by no means restricted to technical and scientific contexts. Rather, as an epistemological figure and material artifact, the eardrum spread to contemporaneous political discourse, cultural criticism, and artistic production. One of the most significant consequences of this widespread circulation lay in binding the experience of war to everyday life in Vienna, bringing the sounds and acoustic relations of combat to bear on encounters with modern urban noise.

Performing War, Writing Sound

"The Drummer Belín" appeared in 1896 along with sixty-six other prose poems and short narrative sketches in Altenberg's debut collection, which bore the somewhat paradoxical title *As I See It* (*Wie ich es sehe*). The prose poem recounts a young married couple's visit to the Ronacher "entertainment

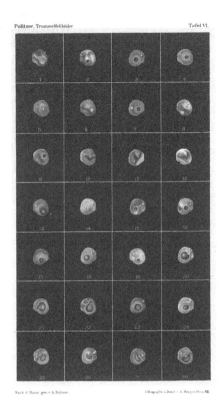

Figure 9. Adam Politzer's lithographic reproductions of perforated eardrums, from *Atlas der Beleuchtungsbilder des Trommelfells im gesunden und kranken Zustande: Für praktische Ärzte und Studirende* (Vienna: Wilhelm Bräumüller, 1896), table 6.

venue" (Vergnügungs-Etablissement) for a series of stage performances (see figure 10). Instead of dramatic recitations of Goethe or Schiller, the theater offers its patrons a range of titillating attractions and circus antics illuminated by "a thousand lightbulbs" (tausend Glühlampen; *Wie*, 60).[15] From the start, the married couple express a combination of discomfort, condescension, and fascination toward the establishment and its offerings. The husband defends his visit to the theater by explaining that he too is interested in the "tendrils of art" (Zwischenglieder der Kunst) and the entertainment found in "booths at the Prater."[16] His wife, by contrast, expresses a sense of moral outrage after each performance.

The highlight of the show is the drumming virtuoso Belín, whose performance reproduces the sensory conditions of the modern battlefield. In contrast to earlier acts, the drummer's performance is not innocuous, amusing, or erotic entertainment, but rather a violent assault on members of the audience, whose ears are bloodied and "raped" by a whirlwind of vibrations emanating from the percussive instrument. While Altenberg's text makes no mention of specific historical events, the war it depicts bears indelible traces of the modern battlefield as it evolved over the course of the second

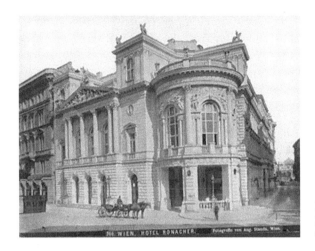

Figure 10. Facade of the Etablissement Ronacher, ca. 1899.

half of the nineteenth century. More specifically, the text should be read as a creative reimagining of the battlefields of the Franco-Prussian War, filtered through preexisting literary depictions and collective memory surrounding the war in German-speaking Europe.[17] Evidence for such a claim comes, first, from Altenberg's use of many of the same onomatopoeic clusters, including long strings of the single letter *r* and the phrase *ratatat*, which appeared in Detlev von Liliencron's textual renderings of the Wars of Unification. Second, the female protagonist identifies the drummer with Napoleon in a manner that subtly thematizes the recent deposal of Napoleon III in the wake of the Franco-Prussian War. After muttering the name Napoleon to herself, the woman expresses concern that "maybe he'll be fired" (er wird vielleicht entlassen werden) because "he got so little applause" (er hat wenig Applaus gehabt). Her husband then comforts her by explaining that this is highly unlikely, as the performers are all "on contract" (fix engagirt; *Wie*, 62).

This final exchange can be read as a satirical allegory of French politics on the eve of the Third Republic. Napoleon was in a sense "fired" by the French people, overthrown and forced into exile, just as the young woman fears that the lackluster response from the crowd means the end of the drummer's tenure at the club. Her husband's response that the performer's job is most likely not in jeopardy because he is under contract can be seen, in turn, as a cynical acknowledgment of the Napoleon family's dominance over French politics throughout the nineteenth century. Even if booed from the stage tonight, both the Napoleonic dynasty and the unpopular drummer will surely be back tomorrow.

But it is the sheer speed and intensity of Altenberg's textual representation of war that most clearly positions it in the second half of the nineteenth century. The transition in the text from the pantomime striptease to war is marked by the sudden appearance of countless troops, who storm the

battlefield and burst through every obstacle in their path, as they "sneak, slide, scurry, fly" (schleichen, gleiten, huschen, fliegen). "Millions," the narrator observes, "ever more, ever more, more, more."[18] Amid the noise, punctuated by abrupt exclamations of "Pause," the audience members struggle to find reprieve from the seemingly relentless advance of the soldiers. "Won't he stop it?!" the narrator pleads, "He won't stop."[19]

As we saw in the last chapter, the Franco-Prussian War was one of the first to make extensive use of railways and telegraphs to transport troops and information quickly over long distances. Altenberg's literary text gives voice to this temporal acceleration and spatial expansion at the level of both form and content. At the same time as it describes "millions" of soldiers pouring forth onto the battlefield, on a formal level it repeats individual words in uniform, rapid succession: "More, more, more" (Noch, noch, noch); "Rata-ta, rata-ta, rata-ta"; "Bang - - bang - - - - - - bang!" (Schuss - - Schuss - - - - - - Schuss!); "Roll! Roll - - - !!" (Wirbel! Wirbel - - - !!; *Wie*, 62)

The recurrence of individual words and the deployment of a restricted assortment of onomatopoeic syllables simultaneously invokes the uniform repetition and explosive firing of the French *mitrailleuse*, a machine gun first used during the Franco-Prussian War. In a text from 1889, Liliencron had rendered the same weapon onomatopoetically as "Rrrrrrt—Rrrrrt."[20] The onomatopoeic utterances Altenberg incorporates are similarly characterized by their reduced linguistic complexity and homogeneity, consisting of only three letters and the occasional suffix *-plan*, repeated across the length of the line. When, in a text from 1912, Egon Friedell compared Altenberg's writing to the *mitrailleuse* and to the sound of "shots around the corner, amid trains of thought" (Schüsse um die Ecke, mitten in Gedankenketten), it is hard to imagine he had any other text in mind.[21]

Altenberg himself described writing as a form of military combat, or "writing battle" (Schreibschlacht), a frenetic activity that, in the process of moving the pen across the paper, produced a "whirlwind" (Wirbelwind), "ekrasit bombs" (Ekrasitbomben), and "a powerful wave" (eine Sturzwelle) in addition to recognizable marks on the page. "Go, go, go, just go" (Vor, vor, vor, nur vor), he wrote in the voice of a commanding officer, "The pen must advance" (Die Feder muss durch).[22] Thus, while Altenberg had no personal contact with war, both he and his critics recognized affinities between his writing and the experience of combat. Still in the shadow of Liliencron and the glorified soldier-poet, in the final decades of the nineteenth century the act of writing was difficult to disentangle from war.

Similar to Liliencron, "The Drummer Belín" turns to onomatopoeia as a formal device well suited to the textual representation of the modern battlefield. Bursts of onomatopoeic noise such as "rrrrátaplan rrrráta rrrráta" are embedded amid sentence fragments, isolated verbs, sudden stops, and typographical markers of silence. In a manner analogous to the sound's physical

infiltration of the listener's ear, the textual noise of the "ratata" invades and periodically interrupts more standard modes of literary language. But even these more conventional utterances are expressed under the duress of noise: rushed, truncated, and never fully articulated. In attempting to reproduce the temporal flow of sounds as they emerge in real time, the narrator succeeds in evoking a sense of simultaneity between the act of narration and the physical impressions of the sounds on his own body. But he is forced to do so by oscillating between a more distant and stable perspective, on the one hand, and a seemingly more immediate recording of the real, on the other, rendering an image of a speaker struggling for air in order to be heard over a cataract of noise.

While the narrative's fragmented sentences and strings of single verbs are directly linked to the narrator's difficulties in sustaining his narration in the face of the violent drum performance, they also articulate a sense that he is being rushed along too quickly to finish his thoughts. The text's real-time narration therefore both registers and competes with these sonic disruptions, with the details of the performance repeatedly broken apart by clusters of sound not yet fully translated into traditional linguistic forms. The tympanic body in the text functions as a quasi-indexical surface of inscription that does not so much perceive sound as transduce its physical vibrations into precognitive, nonlexical bursts. The ear thus inscribed is figured as a vehicle for sonic vibrations, but these vibrations are merely transduced as force. The sheer force of these vibrations, highlighted in the question of whether the eardrum has been ruptured, is shown to arrest the processing of sound at a point prior to its conversion into meaningful, lexically defined utterances on the page.

That the percussive performance exceeds the ear's perceptual capacity is underscored by Altenberg's use of the phrase "terrible whirl" (furchtbarer Wirbel) to describe the physical force of the drum. The term *Wirbel* denotes the sustained sound of a drumroll by means of rapidly alternating strokes with the right and left hand, a technique commonly employed in military music. Thus when the text refers to the performer's "bloody-eared drumroll" (blutohriger Wirbel) and "hurricane roll" (Orkan-Wirbel), it gestures toward a set of percussive effects and the sheer physical force of vibrations produced by the drum, not all of which are perceived as sound by the ear. The auditory experience Altenberg depicts appears to take place before the perception of acoustic vibrations as sound, testifying instead to a purely physical registration of vibrational force dispersed throughout the audience. In this way, the production of negative affect (erschauern) is achieved tympanically, that is, prior to the eardrum's communication of sonic vibrations to the cochlea and auditory nerve, where they can be converted into perceptions of sound.

Members of the audience bombarded by the drum's vibrational power complain that the performance "tears the eardrum," again testifying to its

56 Chapter 2

sheer physicality as a mode of corporeal inscription. Interestingly, this invocation of the ear's anatomy and its superimposition onto the drumhead by virtue of its dual meaning appear in the text's only impersonal third-person construction, "one thinks" (man denkt), which invests the highly embodied experience with an element of abstraction and severs its connection to a single identifiable body. In what follows, Altenberg undercuts the impersonal construction through the highly gendered responses of the husband and wife. While the male spectators remark coldly on the "genius of the wrist" (Genie des Handgelenkes), the lone female figure in the audience appears "pale" (bleich) and traumatized. "You look scared to death" (Du bist ganz geschreckt), her husband observes, positing a clear distinction between their reactions. She answers by repeating the name Napoleon, as if still reeling from the repetitive nature of the performance, but also signaling an inability to process the event (*Wie*, 62). The explicit reference to the sound's "rape" of the ear further suggests that the drum enacts a form of sexual violence directed at the female spectator.[23] The gendered depiction of listening figures the violence inherent in the martial soundscape as the penetration of an open and vulnerable ear, which in the end affects only the female spectator negatively (*geschreckt*).

The at first glance homogenous response to the performance is undermined by this accentuated contrast between male and female spectators. In the end, the eardrum does not yield a single affective response. Tympanic transduction does not operate uniformly or eradicate difference. As a cultural artifact, the tympanum of the literary imagination around 1900 bore the traces of contemporaneous discourse surrounding sexual difference and sexual violence, engendering wildly divergent affective responses to a performance portrayed as so proximate as to materialize as violent physical contact with the eardrum.

The violent drum performance registers significant modifications to earlier notions of sound and hearing in circulation around 1800. According to Herder, for example, sound was epitomized by its ability to penetrate the soul without violating it, with the ear functioning as what he called "the actual door to the soul" (die eigentliche Tür zur Seele).[24] In Altenberg's text, the open ear continues to serve as a doorway to the soul. The sound of the drum "storms into the soul" (dringt in die Seele ein). However, in contrast to Herder, this metaphysical destination can only be reached through abuse of the listener's body, which must first be traversed in all of its anatomical and physiological detail. On the way to the soul—that most incorporeal of all substances—the ear must first be beaten, broken, and bloodied, the nerves slashed and torn apart. Sound's penetration of the soul in this manner does not lead to an experience of illumination, nor does it plant the seeds of language, as Herder would have it. It instead provokes a feeling of terror in the listener. The terror expressed in the narrator's response registers the ear's growing vulnerability around 1900. No longer merely a recipient of melodic

tones or the beauty of spoken language, within the span of less than a hundred years the perpetually open ear has become the site of physical violence leading to linguistic failure.

War in the City

In referencing the Ronacher by name and comparing its attractions to those found at the Prater, Altenberg anchors the text in a recognizable part of downtown Vienna. In the prose poem that immediately follows "The Drummer Belín," Altenberg then takes us to the Prater, where "thirty thousand people" (dreissig tausend Menschen) flood its exhibition grounds. The juxtaposition of the two texts not only reinforces the fact that we are in a distinctly urban space; by positioning an image of "millions" of soldiers swarming the battlefield in "The Drummer Belín" alongside a description of the masses converging on the Prater, Altenberg indicates analogies between the battlefield and the metropolis.[25]

Elsewhere in *As I See It*, Altenberg documents the blurring of martial and urban spaces as a defining feature of the Viennese soundscape, portraying the easy transformation of ordinary nonlethal sounds into military projectiles and violent explosions. To convey the vibrational force of a passing vehicle, for example, he writes in one text: "The windows tremble from the cars that drive by, they shake, startle, do like a cannon shot from afar, calm themselves down again. Then, they quiver and hum like flies in the summer——"[26] Elsewhere, Altenberg depicts a "hate-filled" (hasserfühlt) underclass of domestic servants, who return to the city to wage war on their employers by means of domestic sound, describing the house as a cacophonic "battlefield" (Schlachtfeld) of stomping feet and slamming doors, which culminates in a figurative "thunder of artillery" (Donner der Geschütze; *Wie*, 38).

Reading these texts alongside "The Drummer Belín," we can begin to see how Altenberg's representations of Vienna resonate with contemporaneous discourse on the hostile noise of city life. This was the same period in which medical scientists began to examine the physical and psychological consequences of noise, a period that saw a wide range of commercial services and products entering the market, while middle-class citizens in Europe and America formed antinoise groups to combat its further spread. As the historian Peter Payer has shown in meticulous detail, within only a few decades at the end of the nineteenth century the sonic composition of Vienna changed dramatically.

Between 1850 and 1910, the city's population increased from 431,000 to over two million, while the surface area dedicated to traffic expanded from 2.7 million to 15.7 million square meters.[27] Noise was particularly bad in Vienna because its streets were still largely paved with cobblestone rather than quieter surfaces such as macadam or asphalt, and the tires of

most vehicles were still made of steel or iron rather than rubber. Trams ran aboveground, unlike the underground systems of Paris and Berlin, often until 10 p.m., and the night hours were used to repair tracks and cobble streets. Horsecar and steam tramways were much louder than electrical lines, the first of which only appeared in the city in 1897. The first automobiles arrived around 1892, bringing with them sounds so intense they could be heard a half kilometer away.[28] After being away from Vienna for five years, one commentator remarked in 1899 that, even before having a chance to take in its visual transformation, he "became acquainted with the city by way of [his] auditory nerves" (den Wandel der Wienerstadt an den Gehörnerven erfuhr).[29]

New architectural structures only exacerbated the problem, as the height and spatial layout of buildings compressed and further amplified the noise of the street. This amplification of existing noise by new architectural structures was especially palpable in Vienna's Innere Stadt (city center), where the Ronacher was located and where Altenberg spent most of his life. Due to an inability to expand horizontally, this part of the city could be further developed only by building up. As a result, one Viennese commentator remarked, buildings began to form a "stone vessel . . . out of which noise can no longer escape" (steinernen Gefäße, . . . aus dem der Lärm nicht mehr entweichen kann).[30] Other observers highlighted the way the tall buildings "bind and amplify" (zusammenhalten und verstärken) the city's noise, which, even from a distance, was perceived as a roaring ocean.[31] Another Viennese commentator lamented that "the great sea of houses, out of which the muffled noise of the metropolis came" (das große Häusermeer, aus dem der Großstadtlärm dumpf herüberdrang), caused him "terror and horror" (Schrecken und Entsetzen), citing in particular the noise from a relentless stream of passing vehicles, which was so "oppressive" (niederdrückend) as to prevent him "from finding [his] bearings in this hustle and bustle" (sich in diesem Leben und Treiben zurechtzufinden).[32]

This is what Steve Goodman has in mind when he refers to the modern city's "ecology of vibrational affects." For Goodman, even before sound is perceived, it has the capacity to "modulate the physical, affective, and libidinal dynamics of populations" through an "array of automatic responses," which contribute to "an immersive atmosphere or ambience of fear and dread" prior to any cognitive processing.[33] "The Drummer Belín" had already gestured toward this dimension of sonic phenomena by connecting the act of striking the drum with a vortex of vibrational force (Wirbel), registered by the body but not yet perceptible to the ear or cognitively decoded into language and thought. Another telling example of the rebuilt environment's ability to trigger automatic responses and generate negative affect can be found in contemporaneous accounts of animal responses to the soundscape of Vienna. The noise and speed of passing automobiles, residents noted, terrified the horses hitched to trams and carriages, causing countless accidents

as frightened animals jumped against carriages, attempted to flee, blocked streets, and trotted backwards.[34]

The modern soundscape's ability to elicit "terror and dismay" (Schrecken und Entsetzen) among humans and animals registered this historically specific intensification of sound's vibrational force, transduced by and between bodies and the built environment. Thus, parallel to the discourse on nervous sensitivity, which was becoming popular among members of the middle class, the material structure of the city underwent significant changes. These architectural transformations would have directly altered the character and intensity of sonic vibrations as well as their physical effect on the bodies of Vienna's inhabitants. The vehement response to noise in the city cannot be reduced to discourse, nor to the idiosyncrasies of a few sensitive individuals. By expanding and transforming its material surfaces, new architectural strategies and construction projects in Vienna altered sound's physical properties and their corresponding affective powers.

Seen in this light, there is something deeply ironic about the nature of the performance depicted in "The Drummer Belín" and its setting in downtown Vienna. Instead of finding refuge from the cacophony of the street on the other side of the theater's doors, patrons enter the performance space to have their eardrums ruptured and nerves mutilated by the drum, greeted by the same onslaught of noise that characterized public spaces in Vienna. Without explicitly referring to the abrasive sounds on the other side of the theater doors, Altenberg's text draws attention to the growing overlap between the urban and martial soundscape around 1900. The performance staged inside the theater replicates a common set of mental and physical effects characteristic not only of the battlefield, which the text explicitly invokes, but also the proximate city streets, whose noise was increasingly described in analogous terms of physical violence and martial combat.

As we saw in the previous chapter, this convergence resulted partly from the use of sounds related to the battlefield in commemorations and celebrations of war staged in public spaces. Marching bands and field exercises, among other types of performance, quite literally brought the sounds of war to the metropolis. Emperor Franz Joseph never forgot the importance of the military in both his ascension to the throne and the successful quelling of liberal forces in 1848.[35] One of the ways he acknowledged this debt and perpetuated his military-backed authoritarian rule was through the constant accompaniment of political rituals of state power by military music. At the fiftieth anniversary of his coronation, for example, the emperor organized seventy thousand children to march "along the Ringstrasse in wide, crowded columns and in most beautiful order, accompanied by the sound of military music" (in breiten, gedrängten Kolonnen auf der Ringstraße in schönster Ordnung beim Klange von Militär Musicken).[36] Stefan Zweig remembers military music as a constitutive part of the urban soundscape he experienced as a child in Vienna,[37] as did fellow resident and adoring Altenberg fan Felix

Salten, who recounted the "drumrolls" (Trommelwirbel), "metallic sound of trumpets" (metalischem Trompetenklingen), and "thundering kettledrums" (donnerndem Paukenschlagen) of imperial parades.[38]

Throughout his journalistic writings, Salten in particular exposed the increasing militarization of everyday life via music and sound, not only parades and regular performances of the Kaiserwache (imperial guard) but also military exercises staged within the city. "The canons open the skirmish," he wrote of one such performance. "Suddenly, other noises. Like a weak crack of the whip, like the bursting of leaking eggshells, like the crumpling of strong paper. Infantry under rapid fire. Intermediately a loud, surprising beating, impatient, as if someone full of anger were knocking on the door: the machine guns."[39] Although they were pure theater, the guns nonetheless produced a thundering noise, "which one felt in the pit of the stomach, the intestines, which flashed through the entire body, so to speak," often sending unsuspecting passersby, who mistook it for the real thing, running in fear and "general excitement" (allgemeine Erregung)—effects that were only intensified by the ensuing "drumroll" (Trommelwirbel).[40] Whether parades, military rituals, or field exercises, Vienna's "ecology of vibrational affects" was shot through with the acoustic effects of war, which imposed themselves physically on the city's residents and contributed to an ambience of anxiety and dread.

Salten's great insight was how such efforts to aestheticize war and political power through "splendid, unsurpassable direction" (glänzende, unübertreffliche Regie) served to blur distinctions between urban and martial soundscapes.[41] "And military, military, military. Everywhere on the streets," he observed. "Everywhere were people commanding and complying."[42] "One should be able to imagine that it is a real war."[43] Even when one heard it for what it was, the theater of sonic warfare "struck one with an involuntary, sudden awe" (einem unwillkürlich jähe Ehrfurcht einwirbelt), which, after the performance had ended, bled into the perception of everyday life in the Habsburg capital.[44]

The sound of war in the city, in other words, interpellated the spectator into the logic of authoritarian rule and panmilitarism, engendering a sense of reverence and awe through the visceral registration, or *einwirbeln*, of sound's physical force, which lingered long after the spectacle had ended and its affective powers had been dispersed into an immersive atmosphere of dread. Behind every trumpet fanfare and drumroll loomed the figure of the monarch, "whose presence, like a restless pulsation in all those moving masses present, is palpable."[45] Listening to the acoustic organization of political power as theater, Salten claimed, engendered insights about its functioning. At the same time, the theater of military power provided a conceptual tool for understanding the city into which its sonic signature had been extended: "More vivid than ever before, the militaristic-monarchical thought appears. No longer enveloped by the fray of the bourgeois big city, it becomes in this small place here tangibly close, more purely audible without disrupting background noise."[46]

In attending to the sounds of military drums and trumpets, Salten simultaneously perceives its counterpart, a "bourgeois vortex of urban noise" (bürgerlichen Großstadtwirbel), a concept he is credited with introducing.[47] The term has come to be understood as the background noise of any city, the blurred amalgamation of individual sounds common to urban spaces. What has been overlooked, however, is the extent to which the concept emerged coextensively with the theorization of the martial soundscape. By turning his ear to the performance of military and political power, Salten noticed things about the way ordinary life in Vienna sounded. In the passage, *Großstadtwirbel* is presented as a veil that obscures the auditory traces of militarism's persistent intervention in the civilian soundscape. Salten describes the performance as a revelation exposing a previously concealed acoustic undercurrent to the city. Suddenly, the true functioning of political power becomes "clearer and more intelligible, without disruptive background noise" (ohne störende Nebengeräusche reiner vernehmlich). Salten's language figures the interaction between the martial and civilian soundscape as a technical process filtering signal and noise, of listening to the message through the static of a telephone receiver or gramophone record. Additionally, while he portrays "the vortex of urban noise" as an obstruction to understanding the mechanics of power, the common linguistic element, *Wirbel*, critically reveals continuities between the soundscapes of war and the city, invoking both the military drumroll and the vibrational force of the battlefield as ways to conceptualize the sound of the city.

It is here that both Altenberg's literary representation of a "bloody-eared vortex of sound" (blutohriger Wirbel) and Salten's commentary on the martial underpinnings of Vienna's soundscape intersect with the broader etymology of the term *Lärm*, which carries militaristic connotations as the signal for soldiers to take up their weapons.[48] The fear and dread elicited by drums and staged military performances in the city sound an alarm facilitated by the bodily transduction of sonic affect. This is not to suggest that vibrational force offered the inhabitants of Vienna a portal to some inevitable future or necessary historical trajectory leading to the battlefields of World War I. Rather, the sensitivity to noise and the theatrical staging of sonic warfare in the metropolis registered ongoing and very real threats of violence and political power not limited to those directly related to the events of World War I. To formulate the point more provocatively, it was not a coincidence that so many of the figures sensitive to noise and ostentatiously committed to its abatement, including Peter Altenberg, Arnold Schönberg, Franz Kafka, Felix Salten, Theodor Lessing, Lily Braun, Emil Marriot, Hugo von Hofmannsthal, Kurt Tucholsky, Grete Meisel-Heß, Alfred Kerr, Franziska Mann, and Franz Blei, were feminists, Jewish, politically liberal, or all three.[49]

Around 1896, when Altenberg composed "The Drummer Belín," there was plenty of evidence to suggest that violence might break out at any moment in a variety of forms, against women as well as ethnic and political minority

62 Chapter 2

populations. This was, after all, the era of anti-Socialist laws, Darwinist-inflected racial anti-Semitism, the Dreyfus affair, the overthrow of Liberal rule in Vienna, and the rise of openly anti-Semitic politicians such as Karl Lueger and Georg Ritter von Schönerer, who organized rallies, riots, and spontaneous acts of violence against Jewish residents and Jewish property in Vienna, as well as fistfights and brawls in conjunction with various Viennese elections.[50]

Indeed, while reporting on the political crisis in Vienna spearheaded by Georg Ritter von Schönerer and the German Nationalist Party at the end of 1897, the American author Mark Twain emphasized both the literal and figurative cacophony of Viennese political life. Describing a political rally on the street and its ultimate suppression by the army, Twain wrote: "It gets noisy—noisier—still noisier—finally too noisy; then the persuasive soldiery come charging down upon it, and in a few minutes all is quiet again, and there is no mob."[51] The din inside Parliament was even worse. "Yells from the Left, counter-yells from the Right, explosions of yells from all sides at once," Twain reported of the shouting between political antagonists, later recalling a "roaring cyclone of fiendish noises" issued by Christian Socialists and "a storm of applause which rose and fell, rose and fell, burst out again and again and again, explosion after explosion, hurricane after hurricane, with no apparent promise of ever coming to an end" (Twain, "Stirring," 209, 221, 230). "The ceaseless din and uproar," he continued, "the shouting and stamping and desk-banging, were deafening" and, as he put it elsewhere, "ear-splitting" (226, 212). Amid the sound of whistles, trumpets, drums, and bells used to drown out speakers from competing parties, Twain remarked: "When that House is legislating you can't tell it from artillery practice" (238).[52] Indeed, the violent rhetoric already permeating the proceedings in the form of vitriolic anti-Semitism eventually erupted into a fistfight, with members of the House punched, choked, and hammered over the head.[53]

Writing Silence: Altenberg's Antiphone

While the melding of martial and domestic soundscapes did not disappear from Altenberg's writings, the works he published after his debut collection were increasingly marked by a simultaneous, seemingly contradictory preoccupation with silence as both a modern virtue and an aesthetic ideal. Surveying these later works, there is simply no text comparable to the formally experimental, frenetic portrayal of war found in "The Drummer Belín," although, as I show below, the militarization of the Viennese soundscape did not disappear entirely from his work. As if to protect the eardrum of both reader and author, the violent force of the modern soundscape in these subsequent works is suppressed and replaced by soothing melodies and the sounds

Bringing the War Home 63

of nature. In a text from 1908 titled "Noises" (Geräusche), Altenberg again demonstrates a heightened sensitivity to sound but now focuses exclusively on the natural soundscape. In place of machine guns and ruptured eardrums, the text focuses on slight acoustic differences among trees rustling in the wind, animal cries, and the "inaudible" (unhörbar) breathing of a baby in its cradle.[54]

Although already present in his debut collection, Altenberg's subsequent literary works tend to conjure up an idyllic world rapidly vanishing before its author's ears, one in which the forces of industrialization can be effectively subdued, slowed down, or exorcised entirely from the page. Far from passively recording "all the noises of the modern world" (alle Geräusche der modernen Welt) like a gramophone, as Egon Friedell had claimed, Altenberg was highly selective in choosing which sounds to represent and which to filter out.[55] Amid the historically documented rise of noise in Vienna, Altenberg opted to ameliorate rather than intensify the existing mood of sensory overload, insulating readers from the more pernicious sounds of the city and presenting them instead with literary soundscapes characterized by a sense of calm and acoustic tranquility.

To this end, Altenberg explicitly marked moments of silence on the page through a combination of dashes and the insertion of the word *silence*. Take, for example, the following passage from another sketch included in *As I See It*, which reports not only what is said but also the absence of sound:

> Silence.
> She sighs.
> Silence - - - .
> "You're a fine lot. Fine as silk. I'm really gonna miss you - - - - - ." Silence.
> "Nothing to be done - - - . Tell Max."
> "Tell him what?!"
> "Nothing - - - - - ."
> Silence.
>
> Stille.
> Sie seufzt auf.
> Stille - - - .
> "Ihr seid feine Menschen. Wie Seide. Es thut mir sehr leid - - - - - ." Stille.
> "Man kann Nichts Machen - - - . Sage dem Max."
> "Was denn?!"
> "Nichts - - - - - ."
> Stille. (*Wie*, 144)

The repetitive use of the word *silence* (Stille) evokes a highly sentimental atmosphere pervaded by unspoken thoughts and emotions, one in which a simple sigh gains communicative power. Moments devoid of sound are also

inscribed textually by means of dashes, typically placed at the end of a spoken utterance but also in the middle of individual sentences as interruptions or pauses. This strategy was already on display in "The Drummer Belín," where the onomatopoeic repetition of *ratata* was periodically interrupted by the word *Stille* and clusters of dashes of varying lengths as a way to accentuate the shock of the drum's sudden eruption into sound. The significance of the dashes, here and elsewhere, is ambiguous, even overdetermined.[56] At times, they seem to indicate that something has been left unspoken. In other cases, they simply mark the passage of time as it unfolds across the page in the act of reading or scanning a line from left to right.

Taken together, these varied uses of the dash express an effort to make room for silence within the semiotic economy of the text, temporalizing and rendering material a reduction of auditory stimuli that is at times coded as an active repression of speech. Altenberg's texts are short, and his characters laconic. But this thematic and formal tendency toward brevity is underscored on the page through linguistic and typographic reminders of what has remained unspoken or unsounded. "What one 'prudently keeps silent about,'" he observed in a text from 1902, "is more artistic than what one 'loquaciously speaks aloud.' . . . I love the 'abbreviated method,' the telegram style of the soul!"[57] Already in his introduction to the second edition of *As I See It* (1898), Altenberg characterized the prose poem, a form he pioneered and championed throughout his career, as "the garrulous art reduced to a restrained silence" (geschwätzige Kunst reduziert auf ein zurückhaltendes Schweigen).[58] Elsewhere he criticized pedagogical strategies aimed at getting children to write longer essays in school: "It is the terrible ability to hold conversations for hours instead of being able to remain silent for hours."[59] By contrast, Altenberg asserted, "I would like to depict a person in one sentence, a soul's experience on one page, a landscape in one word."[60] Ideally, he stated near the end of his life, "I finally would like to say nothing more. That will be best."[61]

For Altenberg, silence served as both an ethical ideal and an aesthetic model for the modern writer. As is well established, the notion of silence as an ethical and aesthetic ideal gained currency across a wide range of discursive fields at the fin de siècle—from Maurice Maeterlinck's mystical notion of "active silence,"[62] through the linguistic quagmire faced by the protagonist of Hofmannthal's influential "Chandos Letter," to Wittgenstein's early philosophy of language. This celebration of silence, scholars have argued, was, among other things, a response to various social changes and cultural anxieties, including the rise of mass media and expansion of the reading public. Yet these accounts neglect the historical interaction of this privileging of silence and the emergence of a more obstreperous and abrasive auditory environment around 1900. What might at first glance appear to be a purely linguistic concern was in fact closely bound up with the rise of modern noise and attempts to control and contain it.

In refraining from speaking, and by marking linguistic restraint on the printed page, Altenberg and others offered a critique of the omnipresence of language and noise in the modern era that was simultaneously being articulated by the German antinoise movement and its founder, the philosopher and cultural critic Theodor Lessing. In his 1908 polemic, *Noise* (Der Lärm), Lessing argued that "culture is the development toward silence" (Kultur ist Entwicklung zum Schweigen), a quote that could have been taken from any of Altenberg's texts.[63] Similar to Plessner, who identified the eardrum as a site of class-based acoustic conflict, Lessing referred to the "thickening" (verdicken) of the eardrum as the physical manifestation of class difference. Those who worked amid the incessant noise of hammering or grinding, "distant shotgun fire or drumrolls" (ferner Flintenschüsse oder Trommelwirbel), he argued, developed a less sensitive eardrum than those who worked with their minds and in silence.[64] Somewhat paradoxically, he continued, although silence signaled cultural progress, nervous sensitivity became an evolutionary liability under modern conditions. "Whoever has the thickest eardrum," he wrote, "has an advantage in the struggle for existence.[65]

According to Lessing and other members of the antinoise movement, those with thicker, less sensitive eardrums were also insensitive to thought, poetry, and art.[66] The group described noise as not only "boorish" and "lacking sense," but, due to its capacity to inflict "physical pain" (einen physischen Schmerz), "unaesthetic" (unästhetisch).[67] The group identified language as a potential site for acoustic reform and praised linguistic concision as a sign of cultural progress. Elsewhere in his polemic, Lessing contrasted the primitive loquaciousness of the Polynesians with the linguistic sophistication of the British: "The parlance of a Polynesian island tribe in daily interactions involves more words, images, tropes, and metaphors than the concise and bare language of the great, modern English thinkers."[68]

He extended his critique of spoken language to print media, portraying the flood of newspapers and other serial publications as linguistic noise burdening society with their aggressive, polemical tone and compulsion to cover even the most insignificant of topics. "One shouts in magazines, newspapers, and journals," Lessing argued, "for these are nothing more than the continuous, public beating of carpets and beds"—activities, it should be noted, that were frequently listed as some of the more irritating and invasive noises in the metropolis.[69] Lessing apologized for the fact that his own text expressed its ideas perhaps "too loudly and tumultuously" (zu laut und tumultuös gehalten). Yet, appealing to a distinctly militaristic set of terms, he justified its polemical tone as a matter of necessity. The noise imposed by one's "enemies" (Feinde) could only be countered "with their own weapons" (mit ihren eigenen Waffen). "And whosoever combats noise, he must also beat the noise. He who desires to be heard amid the general tumult must seek to outscream and outsound it."[70] Modern life was a war of sound, and the text an invaluable weapon for both antinoise combatants and their enemies.

66 Chapter 2

No doubt impressed by the perceived overlap between their own aesthetic concerns and Lessing's advocacy of silence and acoustic constraint, the antinoise movement received support from a number of literary authors, including perhaps the most influential theorist of the modernist "crisis of language" (Sprachkrise), Hugo von Hofmannsthal.[71] As early as 1905, Altenberg himself had used his published writings to advertise acoustically insulated hotel rooms and Maximilian Plessner's antiphone.[72] While Plessner had conceived of it as a way to protect the eardrums of "brain workers" (Kopfarbeiter) from "massive acoustic projectiles" (massenhafter akustischer Projektile) launched by members of the urban lower classes, Altenberg's advocacy for the device drew on a similar set of military concepts and images.[73] Only by plugging one's ears with the antiphone, he explained to readers, could one be "completely armed for the battle of waking life" (völlig gerüstet für den Kampf der Stunden).[74]

In light of this enthusiasm for noise abatement, it is not surprising that two of Altenberg's texts appeared in Lessing's antinoise journal, *Das Recht auf Stille* (The right to silence).[75] It is not known whether Altenberg actually submitted the texts to the journal with the intention of having them published there, or whether Lessing took the initiative to include them himself.[76] Regardless of their exact publication history, the discursive similarities the two texts shared with other articles in the antinoise journal show, at the very least, that Lessing had come across them and recognized their resonance with the movement.

The first of the two texts, titled "Sanatoriums for the Mentally Ill" (Sanatorien für Nervenkranke), criticized the acoustic conditions pervasive in modern sanatoriums, a topic that was frequently discussed in the journal.[77] Couched in economic terms of "bankruptcy" (Konkurs), "deficit" (Defizit), and "additional expenditure" (Mehrausgabe), Altenberg's text presented the hypersensitive individual as someone helplessly bombarded by his neighbors, whose bad manners and superfluous speech "destroyed the nerves" (sind nervenzerstörend) of the patient and intensified his illness. Stretching far beyond the borders of the city but replicating the social and spatial structure of neighboring apartments, even spaces explicitly dedicated to mental and physical well-being were shot through with social antagonisms aggravated by sound. According to Altenberg and other contributors to the journal, no space was untouched by the increasingly hostile sonic relations, a phenomenon that was perhaps intensified in the city but by no means restricted to it.

In "The Neighbor" (Der Nebenmensch), the second piece published in Lessing's journal, Altenberg reiterated feelings of resentment and misanthropy caused by the unwanted intimacy of adjacent dwellings. In a formulation nearly identical to the one used in his earlier piece, he condemned the neighbor as a source of physical and psychological ailments: "Ninety percent of our life energy is robbed from us by the rudeness and impropriety of the

neighbor. Every inappropriate word destroys our tender and sensitive nervous systems."[78] The unsophisticated behavior of his neighbors, he continued, subjected the hypersensitive author to an inescapable attack on the nerves: "The inability to distance oneself from the world of the other, whom one cannot comprehend, murders the nerves."[79]

Noise was unavoidable, but it was the otherness inscribed onto these sounds that provoked pain and mental distress in the listener, the incapacity to relate to the person making the noise because of social, cultural, or economic differences. In contrast to the neighbor's inherent lack of class or manners, the refined man of culture was unobtrusively silent: "To do no one any harm, unless it is absolutely necessary, is the natural effect of spiritual culture."[80] Here Altenberg's language and rhetoric closely resembled arguments put forth by Lessing and other advocates of the antinoise campaign, who equated cultural progress with the gradual silencing of the external world.

Altenberg's commitment to a poetics of silence informed his work on both formal and thematic levels. While he privileged the prose poem and more stripped-down modes of literary narration, the content of those same formally condensed works were often characterized by idyllic fantasies of a bygone soundscape outside of industrialization and at odds with the lived realities of urban life in Vienna. His poetics of silence offered a solution to the vulnerable eardrums of Vienna's inhabitants, which had taken center stage in "The Drummer Belín." At the same time, he used his platform as a published author to intervene in reforming the modern soundscape, advocating the use of the antiphone and other noise-abatement strategies in his literary works and excerpts published, with or without his approval, in the antinoise movement's official journal. Altenberg therefore brings into focus previously neglected points of contact between an aesthetic program celebrating silence and linguistic constraint and precision, on the one hand, and Lessing's cultural movement and legal fight against noise, on the other.

Beating the Drum of War Once More:
Noise, Propaganda, and Mass Mobilization

Despite this privileging of silence, Altenberg's exorcism of noise from the printed page was not absolute. Later on in his career, even after he had articulated his programmatic views on the culture and poetics of silence, he remained attentive to the gradual militarization of the civilian soundscape of Vienna. There was nothing contradictory about this position; in fact, Altenberg's commitment to an aesthetic and ethical ideal of silence fed directly into his perception of the modern soundscape as a kind of war zone. Along with Lessing and Plessner, he came to regard those who violated the ideal of silence as enemy combatants.

68 Chapter 2

Similarly, in turning to the antiphone and acoustically insulated architectural spaces to find peace and quiet, Altenberg became even more sensitive to acts of sonic transgression. The neighbor was transformed into a paradigmatic aggressor who, by merely speaking, inflicted physical harm and mental distress on the listener-author. The antiphone might have helped to mitigate this perceived assault. Yet, in plugging his ears with the device, Altenberg also presumed he was preparing for battle, "completely armed," thereby only accentuating the perceived differences between himself and potential aggressors in anticipation of some inevitable acoustic attack.

Against the backdrop of this anticipated aggression, which, as Altenberg implied, had come to define everyday acoustic relations, he documented the migration of militaristic elements from the battlefield to civilian spaces. In line with "The Drummer Belín," he identified military music and percussion, in particular, as especially conspicuous manifestations of war's infiltration of the everyday. In two short texts from 1905, each of which immediately followed positive assessments of Plessner's antiphone, Altenberg portrayed an unusual exercise routine predicated on calibrating civilian bodies to military music. "Exercises to drumrolls" (Freiturnen nach Trommelwirbeln), he wrote sarcastically of the march's kinesthetic effects as played through a mechanical orchestrion. "Exercising is supposed to be a kind of moving battle. Go, go, just go, give your all!" (Freiturnen sei eine Art Bewegungs-Schlacht. Vor, vor, nur vor, gebt euer Letztes!)[81]

Three years later he published a text foregrounding the somatic effects of military music. Now popular marches by the composers Louis Ganne, Julius Fučík, and John Philip Sousa were shown to engender "a terrible illness" (eine schreckliche Krankheit) that seized the listener's brain and nervous system.[82] In the text's conclusion, Altenberg drew familiar connections between the force of a drum and the anatomy of the ear, remarking with more than a hint of sarcasm: "Roll, you small flat drum, so that listeners' eardrums burst" (Wirble, kleine, flache Trommel, dass die Trommelfelle der Hörer bersten).[83] As in "The Drummer Belín," here the surface of the drum is shown to stand in close relation to the tympanic membrane. The text's invocation of military percussion is followed by the organ upon which it is registered, using their linguistic resemblance to highlight a more pernicious entanglement of war and sound. Once again, the listener does not emerge physically unscathed, but is afflicted by a terrible illness and ruptured eardrums. Finally, the somatic and affective consequences typical of war are revealed to circulate far beyond the battlefield, through theatrical performances and patriotic marches, exercise routines and mechanical music.

When the First World War broke out in 1914, Altenberg's attentiveness to the militarization of ordinary life, along with his underlying conception of tympanic listening, enabled him to hear through the propaganda distributed among the civilian population. In his poem "War Hymns" (Kriegshymnen; 1915), he offered a powerful indictment of frenzied support for the conflict

Bringing the War Home

perpetuated by print media, which, he argued, interpellated readers by bombarding them with "word trumpets" (Worttrompeten), "word drums" (Wortetrommeln), and "word clattering" (Wortgeratter).[84]

This melding of the written word and military music, he continued, was responsible for the ease with which mass mobilization had occurred. According to Altenberg, the flood of print propaganda rendered actual drums and bugles superfluous, perhaps an allusion to the gradual disappearance of military music from the battlefield beginning at this time. Although he ultimately suggested that "the war already inspires everyone on its own" (der Krieg begeistert jeden schon von selbst), and therefore did not need military marches, his characterization of print media as imbued with noise and percussive effects implied that such sounds had simply been transferred or displaced to another medium. This interaction between the battlefield and print culture at home was underscored in the poem's concluding lines, which call upon poets and philosophers to counter the population's enthusiasm for future wars by spreading the values of "honesty" (Lügelosigkeit), "simplicity" (Einfachheit), and "asceticism" (Askese) during peacetime. Through this textual counterattack, he speculates, the next war as well as its "terror noise" (Schreckenlärm) would become impossible. In this way, the text was presented as both the cause of and antidote to war. If text functioned as a tool of mass mobilization similar to trumpets and marching drums, the same medium also had the power to spread pacifism, which Altenberg figured in his poem as the silencing of the martial soundscape.

Around the fin de siècle, Altenberg's Vienna became a privileged site for conceptualizing the martial soundscape and its proliferation throughout the civilian population. Both the author and his contemporaries drew attention to the pervasive sounds of war in their hometown. In addition, they began to depict sounds not directly related to war as militaristic, thereby blurring distinctions between the city and battlefield, often with explicit reference to class difference. Urban noise was regarded as the salvo of a new and different kind of war, one occurring during peacetime, composed of acoustic projectiles launched in performance halls, city streets, and parliament.

The hinge upon which this transfer of martial elements depended was the eardrum and its tympanic qualities. The figure's circulation was the result of not only discourse but also the materiality of Vienna's built environment, which changed radically within a short period in ways that intensified sound's physical effects and affective powers. Altenberg's early text, "The Drummer Belín," already exposes striking continuities between the sounds of war and the urban soundscape on the other side of the theater doors. But it also announced the extension of the tympanic regime into print culture and literary form. While Liliencron had pointed to the circulation of percussion across the martial and civilian soundscapes, he had done so in conjunction with a notion of the human listener as largely impervious to the somatic consequences of noise, opting instead for a militaristic model of an armored

body whose surfaces, even those of the ear, registered acoustic signals but were unaffected by sound's physicality.

By contrast, Altenberg opened up the internal spaces of the ear to sensory stimuli from without, portraying the eardrum as a site of corporeal vulnerability and a metaphor for the subject's often violent encounter with modern sound and the various social and cultural antagonisms with which it was inflected. Whereas Liliencron's ear was a flat surface that deflected sound as soon as it distinguished signal from noise, Altenberg presented an ear open to attack, capable of being infiltrated, and susceptible to physical harm. Yet the eardrum also functioned as a catalyst for formal innovation and a productive model for unmooring textual representation from linguistic conventions and the realm of the strictly symbolic. As a figure encompassing both the transduction of sound and the nonlinguistic inscription of its physical force, the eardrum pointed to a mode of writing that was simultaneously technological and deeply subjective, quasi-indexical or phonographic yet firmly tethered to the body in all of its sensitivity and vulnerability. In this way, Altenberg's phonographic writing retained traces of the living body after which the technical device was fashioned and shed light on the precise means of its abstraction.

In conceiving of the eardrum as the privileged ground of modern auditory experience, Altenberg simultaneously exposed the need to modify the sonic environment to ensure its protection. Yet, as his allusion to "word drums" indicates, the pernicious effects of noise were not limited to audible sound but also applied to the domain of textual representation. To this end, Altenberg abandoned the aesthetic of hyperstimulation that had characterized "The Drummer Belín," championing as a literary antidote more concise modes of narration and the succinct form of the prose poem, while also excising noise from the page in favor of idyllic fantasies and depictions of a sonic environment no longer tenable. His textual eradication of noise went hand-in-hand with his advocacy of Plessner's antiphone and contributions to Lessing's antinoise movement, all three of whom sought to subdue the aggressive urban soundscape and its impact on the body.

However, the notion that the antiphone functioned as a kind of military armor for the ear only accentuated the author's assumption that the modern soundscape was a war zone surrounded on all sides by insidious and obstreperous enemies. As a result, everyday social interactions came to be coded as battles between competing camps. According to a text Altenberg had published in Lessing's antinoise journal, the neighbor was "an adversary" (Gegenmensch). Sound's presumed ability to generate antagonism in even the most mundane social interactions would become the operating program of the Dadaists, whose own "word drums" (Wortetrommeln) and corresponding performance practices aimed to batter the civilian population with noise against the cacophonic backdrop of the First World War.

Chapter 3

✦

Drumming Literature into the Ground
Dada's Tympanic Regime

> Reach for the tympanum in your ear and pull the coffin from
> your nose; because no one knows what it's good for.
> —Huelsenbeck, "A Visit to Cabaret Dada" (1920)

Rather than beginning and ending with Peter Altenberg, the tympanic principle outlined in "The Drummer Belín" and other writings migrated to the avant-garde movements of Italian futurism and early Dada, where it was taken up and modified to develop modes of cultural production more closely attuned to modernity's unprecedented proliferation of noise and the signal's submersion in it. Drawing on experiences in Libya and later World War I, the futurists' chief theorist, the author and performer F. T. Marinetti, proposed a literary aesthetic according to which writing was reimagined as the passive reproduction of vibrations and noise elevated to the status of a poetic model (*vers libre*). Marinetti's work strategically integrated onomatopoeic arrangements to provide "the highest number of vibrations," to render all the noises and sounds, even the most raucous "onomatopoetic cacophony" of modern life, as a means of investing the printed page with the dynamism of war and the aggression of modern urban noise.[1] "Listen to engines," Marinetti wrote, "and reproduce their conversations."[2] Marinetti's onomatopoetically rich texts were also accompanied by typographical experiments with font size and mise-en-page, combining strings of nouns and limited punctuation with onomatopoeic invocations of war (see figure 11). "Tatatata rifle-fire pic pac pun pan pan tangerine tawny-wool machine guns," he wrote in the literary appendage to his "technical manifesto."[3] Not surprisingly, oral performance became a privileged medium for spreading the futurist aesthetic, opening up spaces for actual violent exchanges between audience members and attacks against the performer himself.[4]

At the same time, Marinetti's literary program was adapted to musical aesthetics, in which elements from the urban and military soundscape became resources for exploding the restrictive conventions of classical harmony (*l'arte*

Figure 11. A page from Marinetti's 1914 sound poem "Zang tumb tumb," which used onomatopoeia and typographical experimentation to portray the cacophony of the First Balkan War. From Marinetti, *Zang tumb tuuum: Adrianopoli ottobre 1912; Parole in libertà* (Milan: Edizioni futuriste di "Poesia," 1914), 122.

dei rumori). Inspired by Marinetti's poetic project, the composer Luigi Russolo produced musical works aimed at unsettling conventional distinctions between sound and noise by capturing what he saw as the rich harmonics of electric trams and machine-gun fire:

> This evolution toward "noise sound" was not possible before now. The ear of an eighteenth-century man could never have endured the discordant intensity of certain chords produced by our orchestras (whose members have tripled in number since then). To our ears, on the other hand, they sound pleasant, since our hearing has already been educated by modern life, so teeming with variegated noises. But our ears are not satisfied merely with this, and demand an abundance of acoustic emotions.[5]

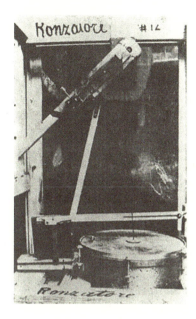

Figure 12. The inside of one of Luigi Russolo's percussive noise instruments, ca. 1913.

For Russolo, futurist music satiated an audience that had been reared on noise. The modern listening public, he contended, desired to hear harmonic structures that were more intricate than those generated by traditional instruments, because their senses had been educated through the varied noises of modern life. In this way, Russolo's programmatic statements presumed a sense of historicity previously denied to hearing, positing a connection between the emergence of modern soundscapes and new techniques of listening, his own musical aesthetic and an ear irrevocably altered by nineteenth-century industrialization.[6]

To actualize his new aesthetic program, Russolo dispensed with traditional instruments and constructed special noisemakers with names such as the "crackler," "hummer," "rubber," and "burster."[7] Crucially, each instrument was constructed in accordance with the tympanic principle: taut diaphragms were stretched over ordinary drum frames whose pitch could be varied via tension and wires (see figure 12).[8] Similar to Marinetti's poetic recitations, futurist music provoked aggressive confrontations between performers and the listening audience, with the latter pelting the former with fruit and garbage. "The public seemed driven insane," another futurist composer, Francesco Balilla Pratella, wrote of two performances from 1913, "and the frantic mass boiled and from time to time exploded in rage resembling a mass of burning lava during a volcanic eruption." "Some laughed and enjoyed themselves," he continued, "others quarreled and started rows, with frequent blows between friends and enemies."[9]

74 Chapter 3

Three years later the Dadaist writer Richard Huelsenbeck arrived at the Cabaret Voltaire in Zurich wielding a tom-tom and dispensing futurist-inspired, bruitist poems with onomatopoetic exclamations such as "rataplan rataplan." Fellow Dadaist Hugo Ball noted in a diary entry from February 11, 1916: "Huelsenbeck has arrived. He argues for the intensification of rhythm (the negro rhythm). He would like above all to drum literature into the ground."[10]

Huelsenbeck's use of the drum signaled a challenge to traditional, hermetic poetic forms and modern rationality, an elevation of the physical over the cerebral, and an attempt to incorporate African rhythms and the sounds of mechanized warfare into aggressive oral recitations. "The symbolic associations of the drum for the avant-garde are powerful and enduring," Adrian Curtin remarks, "conjuring in the first instance, a notional Other (the 'primitive') in contradistinction to 'modern man,' who was supposedly encumbered by civilizing structures and disconnected from his primal roots."[11] As we have seen, this impulse was not limited to Western imaginaries surrounding Africa but also encompassed the percussion-driven noise of so-called Turkish music. In their assessments of non-Western musical traditions, European commentators established connections among noise, alterity, and the drum, emphasizing a common sonic force that was both physically threatening and easily dismissed as the culturally inferior cacophony of less developed civilizations.

By anchoring his literary aesthetic in tympanic processes and percussive effects, Huelsenbeck outlined the means for conducting a sonic assault on prevailing cultural institutions, one capable of no less than obliterating literature. In the process, he gave material form to, and helped render legible, the physical violence inflicted on the ear by the noise of the modern battlefield, the factory, and the streets of urban centers such as Berlin and Vienna. As Walter Benjamin observed, the aesthetic practices developed by the Dadaists transformed the artwork "into a projectile. It jolted the viewer."[12] In portraying Dadaist artworks in terms of a "projectile" (Geschoß) and "jab" (Zustoß), Benjamin highlighted the movement's reliance on percussion and percussive effects in renegotiating the relationship between audience and performer. As Tobias Wilke has shown, Benjamin's analysis of Dadaist tactility was linked to what he saw as modern art's training of the human sensorium, a program propelled by the avant-garde's appropriation of nonlethal military tactics and their extension into the domain of modern media such as film. "Film creates tactile effects within the optical sphere," Wilke observes in his reading of Benjamin, "generating bulletlike impressions without actually exposing the viewer to the risk of bodily harm."[13] As a result, the physical violence of war could be rechanneled into "a series of figurative bullets."[14]

Both Benjamin and Wilke conceptualize this quasi-militaristic yet ultimately nonlethal alternative to technological carnage with reference to vision and the medium of film. The detachment allowed by the eye, so the argument

Drumming Literature into the Ground

goes, enables a paradoxical mode of visual haptics, whereby a spectator watching a cinema screen becomes enervated by the moving images but is never physically harmed. The situation becomes more complicated, however, when one considers the ear's relation to these same simulations of violence and attempts to redirect the energies of war. While by no means comparable to the threat of real death or mutilation on the battlefield, the sounds of futurist noise instruments or Dadaist drumming did in fact affect the listener's body through physical vibrations. Moreover, in the context of oral performance, the separation between audience and performer was never as stable as that between cinematic spectator and movie screen. Not only could oral performances incite crowds to carry out violent acts against their fellow audience members, but such performances were also the result of feedback loops between the offending party onstage and his or her response to crowds in real time, with the aggressive noise aimed at the audience modified and intensified by the boos, shouts, and whistling of disgruntled spectators.

As sound, the figurative bullets dispensed by the avant-garde retained some of the sting of the real thing. The auditory simply could not be contained, or "enframed," as Wilke would have it, in a manner analogous to the visual. The taut diaphragms of Russolo's noisemakers and Huelsenbeck's drum not only exposed the underlying aims of related visual practices; they also rendered manifest a mode of physical contact facilitated by sound, which, against the cacophonic backdrop of the real war, helped reconfigure the relations between performers and civilian spectators, noise and writing, perception and percussion.

This chapter analyzes the historical avant-garde's deployment of the tympanum and tympanic figures within an emerging sonic aesthetic and an acoustically oriented poetics. More specifically, it examines the work of the Dadaist writer and performer, later historian and psychoanalyst, Richard Huelsenbeck, as one of the most complex and forceful articulations of the tympanic regime on the eve of its disappearance into high modernism.[15] In doing so, I provide a corrective to existing studies of Dadaist sound art, which tend to focus on Huelsenbeck's collaborator Hugo Ball but, perhaps more importantly, privilege orality over aurality.

Indeed, while there has been no lack of scholarship on Dadaist conceptions of the voice, articulatory processes, and the physiology of speech, the ear and issues of auditory perception have remained almost entirely absent from these accounts.[16] The Dadaists, especially Huelsenbeck, were concerned not only with the production of speech and mutations of the voice into noise but also with the *reception* of sound by the ear. Moreover, the model of hearing that the Dadaists adopted and mapped onto textual practices was tympanic in nature. I demonstrate how, in moving from oral performance to writing, the figure of the tympanum came to exert pressure on the economy of signs that appeared on the page and shaped the transductive processes according to which these graphic marks materialized and signified. A closer

look at Huelsenbeck reveals an astonishing range of tympanic figures distributed throughout his work with varying poetic functions.

My analysis will underscore the extent to which such tympanic modes of textual representation largely swung free of the phonograph, although Huelsenbeck's work does occasionally include references to the technical device. Unlike the futurists, who committed themselves to recording their poems and musical compositions on the phonograph and reportedly listened to recordings of bodily noises and other sonic detritus during the earliest phase of their activity, the Dadaists appear to have had little interest in mechanical sound reproduction.[17] As Arndt Niebisch points out, one practical reason for this exclusion was that phonograph and gramophone recordings simply lacked the volume and intensity the Dadaists sought for their live performances. A drum or the noise of an enraged audience, Niebisch suggests, was therefore "the much more successful noise artist."[18]

If one accepts the proposition, as this book does, that the phonograph was simply one among many manifestations of an underlying tympanic regime—one not to be privileged over nontechnical articulations—the Dadaists' omission is neither surprising nor a simple confirmation of the group's premodern impulses. The phonograph was merely one way among others that the tympanic principle could be put to use. New textual strategies and performance practices were another. There is no reason to assume that both forms will line up each step of the way. Indeed, it is the fact of their divergence that makes them worthy of attention. Positioned alongside one another, technical and the nontechnical actualizations of the tympanic regime reveal the extent to which functionally and conceptually analogous modes of transduction could be appropriated for distinct cultural, political, and aesthetic ends.

Dada Primitivism

Huelsenbeck's interest in sound poetry and the aesthetics of noise coevolved with that of his Dadaist colleague Hugo Ball. Huelsenbeck met Ball in Munich in 1912 as the Blue Rider group and expressionism were beginning to rise to prominence. Ball was especially influenced by Russian artist Wassily Kandinsky, whose experimental theater piece, "The Golden Sound" (Der goldene Klang; 1912), Ball attempted, unsuccessfully, to bring to the stage in Munich shortly before the war.[19] In the 1912 Blue Rider almanac, Kandinsky introduced the first published version of his "Golden Sound" by emphasizing its purely sonic qualities, which, he boasted, were unmoored from linguistic meaning. "The sound of the human voice was . . . applied in pure fashion," Kandinsky wrote, "without being darkened by the word, by the meaning of the word."[20] He was also rumored to have alerted Ball to parallel experiments with sound among the Russian *zaum* poets.[21]

By the time the Cabaret Voltaire opened its doors, the Dadaists had absorbed expressionism and Russian and Italian futurism, and discovered the onomatopoeic nonsense poetry of Christian Morgenstern's *Gallows Songs* (1905) and Paul Scheerbart, the latter of whom Huelsenbeck credited as "the first sound poet" (der erste Lautdichter).[22] Peter Altenberg was also in contact with Walter Serner and the emergent Dadaists. Yet while it would have been perfectly consistent with their aesthetic program, there is no evidence that "The Drummer Belín" was one of the texts read aloud at the group's early meetings in Zurich.[23] Taken together, these writers offered the inchoate Dadaist movement alternative modes of writing that were multisensory and liberated from the imperatives of meaning making. Their specifically aural qualities were foregrounded through the incorporation of onomatopoeic phrases and the textual reproduction of nonsense syllables. Kandinsky, Morgenstern, and Altenberg were also closely connected to cabaret culture, suggesting that their engagement with sound on the page emerged from considerations of the work's initial or eventual oral performance.

There was no lack of noise in expressionist poetry, which seemed especially concerned with capturing industrialized Europe's radically altered soundscape and, later, the cacophony of war. Huelsenbeck's early poem, "Last Nights," which was published in 1915 in the preeminent expressionist journal *Die Aktion*, testifies to the author's expressionist roots through its pronounced attention to modern noise, juxtaposing the sounds of "bright war bugles" (helle Kriegstrompeten), thundering machines, the crack of horsewhips, and the "noise of coffins, beds, corpse-saturated" (Lärm von Särgen, Betten, leichensatten).[24] Yet we would be hard pressed to find anything in the poem resembling the work Huelsenbeck would perform a year later at the Cabaret Voltaire.

For his work to assume any of the characteristics we now associate with Dadaist sound poetry, Huelsenbeck would have to look beyond Europe to the so-called primitive cultures of Africa. Or perhaps more accurately, what was required for Dadaist sound poetry to emerge was the mobilization of colonialist imaginaries pertaining to African music and its emphasis on percussion. It was this imaginary encounter with, and subsequent appropriation of, African musical traditions that transformed Huelsenbeck into the Dadaist and artistic provocateur we know today.

When Huelsenbeck first arrived in Zurich in 1916, he was credited with bringing "negro rhythms" with him. His earliest documented engagement with African art had occurred one year earlier, in May 1915 at the Berlin Expressionist Evening hosted by Ball and himself. It was there that Huelsenbeck would first perform his so-called negro songs, which incorporated the exclamation *umba* and the crack of a drum to punctuate the end of each poetic line.[25] No textual record of the "songs" as they were performed at the time exists today, but it is likely that the snippets of African languages which appeared later in *Phantastische Gebete* (Fantastic Prayers) borrowed from these early performances.

78 Chapter 3

Huelsenbeck's incorporation of the drum into his poetic performances occurred at a historical moment in which "the booty of imperial powers [was] filling up warehouses in the capitals."[26] As European cities stockpiled and displayed the artistic spoils of colonialist expansion, they also served as sites for exhibiting living indigenous peoples in fabricated villages and "human zoos."[27] At the same time, visual artists throughout Western Europe began to embrace African "primitivism" as an antidote to the failings of Western rationality and traditional European art.[28] Pablo Picasso discovered African art at the Palais du Trocadéro in 1907, Paul Klee traveled to Tunisia in 1914, while Carl Einstein curated exhibitions in Germany that brought together cubist artworks and African sculptures in a single space.[29] During the same period, Marinetti continued to mine his experiences of colonial warfare in delineating a distinctly futurist aesthetic.[30] In 1910 he published the novel *Mafarka the Futurist*, a violent and misogynist fantasy of colonial conquest set in Africa, to which Huelsenbeck's *Fantastic Prayers* would explicitly refer.[31]

Huelsenbeck's performance of "negro songs" at the Berlin Expressionist Evening was therefore coextensive with a colonialist logic of expansion and accumulation, whose cultural consequences were increasingly palpable in the German metropole. While Tristan Tzara's familiarity with contemporaneous studies of non-Western cultures has been well documented, Huelsenbeck espoused a programmatic disregard for ethnographic sources.[32] As he later recalled in his account of the evening: "I read negro poems of my own invention, umba-umba-umba, the negroes dance on raffia mats, though I don't give a damn about the negroes and I really only know them from books. You see how dishonest all poetizing is."[33] When Jan Ephraim, the owner of the Cabaret Voltaire, gave Huelsenbeck examples of "genuine" African poems he had collected as a sailor, the Dadaist decided that they would be more authentic if he added "umba" to the end of each line, despite Ephraim's vehement criticism of the alteration.

The story, which Huelsenbeck himself happily perpetuates in his autobiographical writings, indicates that he was not simply uninformed but willfully ignorant. By his own admission, the "songs" were "of [his] own invention" (selbstverfertigt) both before and after his encounter with a self-appointed European expert. They were invented, not found, the product of a European artist's vision of what a "negro song" should contain and sound like.

Even more problematically, Huelsenbeck explains his artistic decision to modify the songs by emphasizing his indifference to the human beings responsible for their cultural transmission. "Though I don't give a damn about the Negros," he pronounces in a formulation unintentionally validating colonialist violence, for which the renunciation of the indigenous other's humanity was often the first step toward justifying their subjugation and annihilation. In this way, criticisms that Huelsenbeck was deeply ignorant of non-European languages and that he "clearly shows a tendency toward

exoticism" do not go far enough.[34] At issue is more than just the Dadaist's ignorance or the exoticism required to establish a distinctly European avant-garde. Uninformed cultural appropriation occurs, indeed becomes possible, through the effacement of the human actors from whom that culture arises. On this view, cultural practices circulate independently of human subjects, waiting only to be picked up by European colonizers as products for consumption or catalysts for individualist projects of self-fashioning. The question of hearing the Other, of confronting truths about one's own society through intimate engagement with another, simply falls away, replaced by an extension of the colonial logic of total mastery and dehumanization into the cultural sphere.

However, one should be beware of taking Huelsenbeck's comments at face value. A closer look at his writings and life trajectory portrays a figure more sympathetic to the African Other. Huelsenbeck went so far as to link the Dadaist vision of a more just European society with the eradication of whiteness. "Under the gray sky of war" and "with military music in our ears," he explained in a letter around 1918, "we want a new style of life, we want a new kind of activity, we want a new skin color."[35] While Marcel Janco's African masks provided the semblance of a new, nonwhite identity, with performers temporarily freed from their European skin, George Grosz went one step further, performing various American step dances and jigs labeled "sincopations" at Dada events around 1919, at least one of which was reportedly in blackface.[36] Huelsenbeck drew an explicit parallel between the ascendency of steps and rags to the "national music" (Nationalmusik) of the United States and the rise of *bruit* in Europe during the same period.[37] Such remarks once again expose the naïveté of the Dadaists' racial politics, positing a European body capable of perpetually remaking itself in the image of the Other without considering the asymmetrical power relations that made such fantasies possible.

But Huelsenbeck's comments also intimate a more complex engagement with African culture than his previous comments would lead us to believe. Although he continually repressed the violent realities of colonial rule, genocide, and slavery, his desire to change his skin color shows that his appropriation of African culture was about more than simply plundering indigenous cultures; it was also about becoming black, trading out the European body for another. "Negro music," fellow Dadaist George Antheil explained, "made us remember at least that we still had bodies which had not been exploded by shrapnel."[38] In 1928 Huelsenbeck published an account of his travels as a doctor for a steamship circumnavigating the African continent under the title *Africa in Sight*. The book chronicles the author's frustrated efforts to find the Africa of his colonialist fantasies, which, whatever truth they may have contained, he came to realize, had been obliterated by European intervention. The final chapter of his travel narrative then shifts its focus from the European colonial project in Africa to the Americanization

80 Chapter 3

of Berlin, or what Huelsenbeck perceives as a kind of capitalist colonization within Europe.[39]

No doubt, the book moves too easily from an acknowledgment of European colonialism's devastating legacy to a narrative of European victimization. But it does so by confronting the harsh realities of colonial rule and its economic base with a self-reflexivity and compassion absent from the more flippant and naïve comments made by Huelsenbeck in the early stages of the Dadaist movement. In any case, the travel narrative complicates the author's statements regarding his alleged indifference toward the origins of his artistic borrowings and their embeddedness in a culture that was far from frozen in time.

The book's final chapter contains a rare reference to the source that inspired Huelsenbeck's broader engagement with African culture. As a child, he explains to readers, he had dreamt of becoming an Africa explorer, inspired by his grandfather's library of travel and exploration literature.[40] As a result, Huelsenbeck's earlier admission that he knew African culture "only from books" takes on greater significance, indicating the role of textual mediation in his subsequent appropriations. Literary representations of German Africa, Sebastian Conrad argues, were indispensable articulations of what might be termed "the colonial imagination," which brought fictionalized encounters with indigenous populations to curious audiences in the European metropole.[41]

Although Huelsenbeck does not list the specific authors he read as a child, we can gain some sense of what he might have encountered by turning to colonialist texts by popular authors such as Gustav Frenssen and Frieda von Bülow. In Bülow's novel *Tropical Frenzy: Episode from German Colonial Life* (1905) the sounds of everyday life in the African colonies are invested with the capacity to inflect physical harm and produce negative affect among European listeners. Early in the novel the narrator observes "a shrill, screeching warbling" (ein schrilles, krieschendes Wirbeln) from a nearby palm grove, which becomes "more and more piercing and earsplitting" (immer gellend und ohrenzerreißend) before exploding with "booming drumrolls issuing from tin kettles" (dröhnender Trommelwirbel auf Blechkesseln).[42] Amid the overwhelming noise, which threatens to tear apart the listener's ears, the two Europeans lock eyes "in pale fear" (in bleichem Schrecken).

Indeed, the author goes out of her way to highlight the pervasive sense of dread engendered in Europeans by the African soundscape. As "the noise continued on at full force" (der Lärm dauerte ungeschwächt fort), one protagonist reflects on the personal transformation experienced by long-term colonial inhabitants: "How nervous he's gotten! He was never so terribly sensitive and excitable before. Everyone gets nervous here, even men who laughed in disbelief at the word 'nerves.'"[43]

The passage makes reference to discussions of nervousness and neurasthenia in German-speaking Europe, which had informed both Altenberg's

literary impressionism and contemporaneous cultural criticism on urban noise. In Bülow's text, the colonialist is depicted as at least initially impervious to such cultural patterns, contrasting the strong, healthy male body of the colonizer with the effeminate and hypersensitive disposition of the impressionist or neurasthenic. Yet even these men, who would have derided the growing sensitivity of European men at home, cannot defend themselves from the perpetual anxiety of the colonizer abroad. Surrounded by the incessant noise of the indigenous population, the European subject listens with dread and eventually succumbs to an analogous nervous condition. While denied a voice of their own in Bülow's novel, colonial subjects mobilize their percussive arsenal, the otherness of their musical tradition, as a weapon of dread and anxiety against European occupiers. The noise may at times be perceived as physically harmful to the European listener, but beyond this more literal assault, colonizers find themselves subjected to a consistent and subtle form of sonic warfare. The African drums do not merely inflict harm on the listener but help to establish an immersive environment of anxiety that exceeds even the obstreperous European cities at the time.

As Florian Carl observes, ethnographic studies of African cultures during the period were filled with descriptions of drumming, often portraying percussion as an especially pernicious threat to European colonizers.[44] Predictably, the sonic category privileged by colonizers in their descriptions of African percussion was noise (*Lärm*), which served to code their auditory encounters with the indigenous population in terms of military aggression. One colonial observer spoke of the "deafening noise" (betäubende Lärm) produced by fifty drummers outside his hut in the Libyan town of Murzuk around 1866.[45] The same commentator was later compelled to introduce the neologism "coercion of the ears" (Ohrenzwange) to capture the colonialist's helplessness in the face of aggressive sonic assaults.[46]

This unique German term helps expose the power dynamics implicit in even the most mundane sonic events in the colonies. On the one hand, these accounts expressed anxieties about the drum's unique capacity to organize the indigenous population to take violent action against colonial intruders.[47] On the other, Europeans felt threatened and excluded by their inability to parse meaning from percussive patterns, which were presumed to be a form of communication among colonial subjects. The noise of the drumming was simultaneously deafening and impossible to ignore, both physically pernicious and psychologically demoralizing. It pointed to elements of the colonial environment outside of European control, a manifestation of indigenous solidarity and agency that could not be silenced or subdued.

Yet the centrality of percussion, which reportedly battered the ears of European listeners, led colonialist commentators to conclude that the ear and the sense of hearing were devalued by Africans and played little role in their musical traditions. Instead, ethnographers and musicologists from

82 Chapter 3

the European continent argued, the African ear was made superfluous and subordinate to percussion's tactile dimension. The ethnomusicologist and experimental psychologist Erich Moritz von Hornbostel argued in 1928 that "African rhythm is ultimately founded on drumming. . . . What really matters is the act of beating; and only from this point can African rhythms be understood. . . . This implies an essential contrast between our rhythmic conception and the Africans'; we proceed from hearing, they from motion."[48] Here Hornbostel drew a distinction between music consumed through the ear and more percussively oriented musical traditions involving the entire body, from the act of beating on a drumhead to produce vibrations to their registration through movements of the muscles. Reliance on the drum meant that African cultural practices were excluded from the category of music proper. By distributing its sensory effects across the entire body and not restricting itself to the ear, African percussion entailed a set of sonic practices proximate to, but ultimately outside, the European classical tradition due to its physicality.

It is not difficult to see what would have been appealing about African percussion to Huelsenbeck and the Dadaists, who were mounting an attack against the impoverished sensory regimes of European culture and the isolation of art from ordinary life in western Europe. If one takes these fictional and ethnographic accounts seriously, African music was valuable to the Dadaists for two reasons. First, it was a music freed from the abstractions of musical notation and harmonic theory, both a direct expression of, and catalyst for, bodily movements and the physicality of sonic contacts. The body addressed by African music retained its coherence, unlike its fragmented European counterpart.

Second, through the physicality and threatening illegibility of its percussive effects, African music could produce terror in bourgeois European subjects, perhaps to an even greater extent than the overstimulation of domestic urban spaces. Embodied and anxiety producing, percussively driven African music offered productive resources for the Dadaists' sonic war against the prevailing cultural order in Europe.

Turning now to Huelsenbeck's published works, we can see how his incorporation of African languages and percussion served to destabilize an economy of conventional linguistic signs and gave rise to a more heterogeneous range of utterances and onomatopoeic modes of textually reproducing auditory phenomena. While ultimately falling short of issuing a coherent critique, the text's dissolution of boundaries between signal and noise occurs amid repeated references to the European colonial project that emerge from the decontextualized linguistic detritus of the period. Take, for example, the following excerpt from "Plane" (Ebene), the opening poem of Huelsenbeck's *Fantastic Prayers*, which juxtaposes the names of colonial cities with a thoroughly destabilized economy of written signs, alliterative nonsense, and onomatopoeic repetition.[49]

Drumming Literature into the Ground

Tschupurawanta burruh pupaganda burruh
Ischarimunga burruh his pá-ant fly his pá-ant fly
kampampa kamo his pá-ant fly his pá-ant fly
katapena kamo katapena kara
Tschuwuparanta da umba da umba da do
da umba da umba da umba hihi
his pá-ant fly his pá-ant fly
Mpala the glass of the canine tooth trara
Katapena kara the poet the poet katapena tafu
Mfunga Mpala Mfunga Koel[50]

Among identifiable German words such as *poet* (Dichter) and *glass* (Glas), as well as the elongated *pant fly* (Hosenlatz), the attentive reader or listener discovers an array of allusions to actual places in Africa. Kampampa, Katapena, Mpala, and Mfunga are all locations in the Belgian Congo, while Umba would have been recognizable at the time as the name of a river, which since the 1880s had separated German East Africa from British East Africa.[51] *Umba* was also the word Huelsenbeck had used to punctuate his earliest "negro songs," for which the former Dutch sailor and owner of the Cabaret Voltaire chastised him on the grounds of their inauthenticity. In addition to designating a strategically important river dividing European colonial territories, *umba* was one of the few lexically defined utterances from an existing African language that Huelsenbeck used in the poem—the Swahili word for "to create" or "mold."

The word's referent and Huelsenbeck's intention in using it remain, of course, open. Based on textual evidence, its ambiguity cannot be resolved. Yet it is this indeterminacy that helps illuminate the larger poetic strategy at work in the poem. The utterance could be a proper name, one with great political significance at the time. It could also refer to the Swahili word for "create," a metareflexive incorporation of disparate languages and elements to emphasize a linguistic state of coming into being, or a marker for linguistic possibility. Or the word functions as nothing more than a meaningless stand-in for "African culture," whereby its sound is meant to invoke the stereotypical properties of a non-Western language as conceived by a European observer.

It is important to note the simple fact of this indeterminacy. For a reader or spectator, the effect was a heightened sense of not knowing—an exclusion from meaning as a result of one's limited linguistic background as well as the word's decontextualized state. Through the noise of seemingly meaningless utterances, the reader or listener glimpses something recognizable, perhaps the name of a colonial city pulled from the latest newspaper. But the moment of referential stability lasts only a few seconds, immediately followed by the nonsense syllables *da* and *do*. The process of parsing meaning from noise is made even more difficult in the text through the rapid succession of phonetically similar phrases. One might read the word *katapena* as a reference to the

African town of the same name. But the same line of Huelsenbeck's poem also situates this recognizable place name alongside phonetically comparable but utterly nonsensical linguistic fragments such as *kamo* and *kara*. In this way, the insertion of colonial references is a strategy that becomes implicated in the incessant modulation of linguistic elements, a process of mutation set in motion by reference to the colonial project, which takes the *kata* in *Katapena* and transforms it into the sonically related variants *kamo* and *kara*.

It is not only on the level of a single line that these deviations from recognizable speech occur. The final section, which contains an unprecedented abundance of references to European colonialism, also marks a broader shift away from lexically defined German words. Although the poem oscillates between languages throughout, the final lines exhibit a more permanent departure from any possible legibility for a European audience member. It is significant that one of the last words in the poem is the German *Hosenlatz*, which functions as its refrain. In its first appearance, the word is recorded with an emphasis on its oral qualities: the first syllable is marked with an accent over the *o*, and its pronunciation is drawn out through the use of a hyphen. Between this first iteration and its reappearance in the same line, Huelsenbeck inserts the onomatopoeic reproduction of a drum, "rataplan rataplan." The addition is intended to underscore the shocking nature of the line's content, which intimates a priest in the process of zipping up his pants fly. The onomatopoeic drum, in other words, is intended to punctuate the audience's shock at the poem's content by simultaneously assaulting them with the physical shock of percussive vibrations.

When the term reemerges in the poem's final section, it occurs amid allusions to European colonialism and snippets of African languages incomprehensible to most spectators and likely to the poem's author himself. The shock of an irreverent depiction of the European church is transferred to the colonial context, with (to this European ear) African-sounding words such as *umba* now taking the place of the onomatopoeic reproductions of the drum. In this way, Huelsenbeck links the drum to the dissolution of referential specificity at the same time as he places the spectator in the position of the colonizer, immersed in the sounds produced by colonial subjects, both percussive and articulatory, momentarily legible but ultimately inscrutable.

Dada Battleground

In the year 1916 Huelsenbeck's use of the drum would have been read as more than an invocation of musical traditions stemming from non-Western cultures, cut off entirely from events then taking place in Europe. As texts by Liliencron, Altenberg, and others foregrounded, percussion was inextricably associated with war, despite the fact that by 1916 the sound of drums was gradually disappearing from the actual battlefield and becoming obsolete as

the result of new communication technologies such as the telephone and corresponding military tactics like trench warfare. When Huelsenbeck arrived in Zurich, pounding his giant drum against the backdrop of World War I, audiences would not have failed to miss the instrument's more immediate connotations of mass mobilization and marching soldiers.[52]

While the Dadaists disseminated noise as a nonlethal assault on the European body, they also drew attention to the coercive role of sound in the mobilization of those same bodies for war. Indeed, Dada's most notable break with the acoustic conditions of mobilization lay in their intentional disruption of forms of what Carolyn Birdsall calls, in her study of the Nazi soundscape, affirmative resonance, "a practice or event when a group of people communally create sounds that resonate in a space, thus reinforcing the legitimacy of their group and its identity patterns."[53] At the start of the war, affirmative resonance became useful for structuring the acoustic relations among soldiers, politicians, and the civilian population during military send-offs and nationalistic parades. The cheers bidding farewell to departing soldiers, one German newspaper reported in September 1914, were virtually omnipresent on the streets.[54] A commercial sound recording titled "The Mass Mobilization on August 1, 1914" (Die Mobilmachung am 1. August 1914; ca. 1915) proves the point.

While by no means a documentary recording of events, the historical value of such recordings lies in their depiction of *idealized* acoustic relations amid mass mobilization, or as Daniel Morat observes, a "retrospectively constructed prototype for the patriotic demonstrators and ceremonies for departing troops in August 1914."[55] The recording depicted an often repeated scenario of troops leaving their hometown to great fanfare.[56] After a rousing speech celebrating the nobility of military service, the crowd responds in unison: "Hurrah! Hurrah! Hurrah!" They then break into the patriotic hymn "The Watch on the Rhine" (Die Wacht am Rhein), concluding with another round of "Hurrah! Hurrah! Hurrah!" and a rendition of "Hail Thou in Laurel Wreath" (Heil dir im Siegerkranz).

In provoking the audience through noise, the Dadaists disrupted the dominant ideal of sonic resonance and consensus regarding the war, inciting the audience to contest the sounds imposed on them and perhaps even attack the stage. Recognition of the performance as noise helped make clear to audience members that they were positioned on one side of a sonic conflict and the performers on another. In *Fantastic Prayers*, Huelsenbeck integrates many of the same sonic cues found in patriotic phonograph recordings intended to encourage mass mobilization.[57] There, spectators sing "The Watch on the Rhine" (*PG*, 24), while in *Germany Must Perish* Huelsenbeck observes how "the public must shout hurrah on command" (das Publikum auf Kommando Hurrah brüllen muss), thereby underscoring how the imperative of affirmative resonance was handed down from above.[58] "'Germany above All' drums again through the hellish noise," he wrote in the same text, "indeed it is the bassline they have never lost."[59]

86 Chapter 3

Huelsenbeck's deployment of sonic elements associated with mass mobilization not only provides satirical fodder for the Dadaists' protest of World War I. The strategy also helps illuminate their attempt to reconfigure the relations between performers and audience members through the proliferation of noise. The Dadaists' use of noise as a medium of social interaction drew on the term's close association with aggression, otherness, and the destabilization of order. Noise could be harnessed not only to incite audiences to a state of pandemonium but, in the process, to delineate alternative modes of acoustic interaction. Affirmative resonance was only one form such interactions might take. Another was confrontation between performers and audience members in a feedback loop of acoustic opposition. It is here that Huelsenbeck and the Dadaists deviated most clearly from dominant strategies of sonic warfare as coercion, consensus, and acquiescence. In place of affirmative resonance, the sonic practices they developed resembled a mode of political discourse that Bernhard Siegert and others have come to identify as a kind of media "war." Exploiting the "abyss of nonmeaning" inherent in technological noise, such media strategies run counter to Habermasian communicative reason and dialogical models predicated on the exclusivity of the signal.[60] For the Dadaists, dialogue and reason were to be replaced by aggressive press campaigns and the affective modulation of the population toward dread and anxiety. Dadaism initiated a media war with pronounced sonic elements, with the physical and affective enervation of the audience taking the place of rhetorical persuasion.

Dada's Tympanic Regime

We have now seen the extent to which Dada's sonic aesthetic relied on the figure of the drum and its perceived connection to both so-called primitive music and the cacophony of modern warfare. We have noted that, through this appropriation, the drum came to function as a means for upending the linguistic order at the same time as it opened up new possibilities for what could be spoken by human voices and enacted through performance. By borrowing elements from the soundscapes of war and mass mobilization, the Dadaists engaged in a form of sonic warfare that was simultaneously physically aggressive and nonlethal, aimed at producing percussive effects among spectators, which in turn produced negative affect. The concluding pages of this chapter examine how the figure of the eardrum, or tympanum, played into the linguistic and performative practices outlined above and ultimately provided the hinge for transducing sound into text and text into sound, leaving neither fully intact. In adherence with the tympanic regime, these transductive processes depend on establishing connections between the ear and the drum, exposing not only the physical force exerted by sound on the body but also its capacity to disturb, even derange, preexisting modes of textual representation.

Drumming Literature into the Ground 87

Let us begin by entering the Cabaret Dada with an ear to recovering key elements of its performative soundscape. This will be possible only through recourse to textual sources, often intentionally distorted and self-mythologizing, as no sound recordings from the period exist. Huelsenbeck's "A Visit to the Cabaret Dada" (1920) gives readers an exaggerated version of a typical night at the titular venue. As the text opens, we are led down a long hallway illuminated by candles held by arriving audience members. The group's guide, dressed in a white fur coat and mitre (a traditional Christian headdress) addresses the crowd as they begin their allegedly two-hour journey through the passageway: "Put your hands up and let your gut fall. Reach for the tympanum in your ear and pull the coffin from your nose; because no one knows what it's good for."[61] The guide's command dictates a series of seemingly nonsensical exercises targeting bodily organs corresponding to each of the five senses, excluding vision. After ordering the visitors to raise their hands and let down their stomachs, the guide shifts his attention from the tactile and gustatory to the auditory and olfactory, as he now instructs the crowd to reach into their noses and ears to pull out a coffin and drum, respectively.

The implied malleability of the body in these scenes—the blurring of inside and out, organic and inorganic matter—recalls the photomontages of fellow Dadaists Hannah Höch and John Heartfield, who, as Matthew Biro argues, portrayed the human subject as a "collection of heterogeneous components, a material-informational entity whose boundaries undergo continuous construction and reconstruction."[62] Elsewhere in the text we find descriptions of hot water pouring out of an ear and teeth falling from the mouth in the process of speaking. Images of the body invoked in Huelsenbeck's text suggest a human subject in a perpetual state of dissolution and reconstitution, both open to and continuous with the inanimate. Here, the body is not merely subjected to sensory training but instead shown to undergo mutation in a state of constant flux, a hollow storehouse of foreign objects, permeated, stretched, and turned inside out.

The drum that is fantastically pulled out of the ear can be interpreted as an allegory for Huelsenbeck's poetic program. The drum is not merely one among any number of objects capable of being perceived by the ear; it is a constitutive part of the auditory apparatus itself and a reminder to readers of the tympanic processes that underlie the act of hearing. Indeed, unlike the coffin, which never reappears, the text is pervaded by figures of the drum and related invocations of sound's materiality and the physical force of percussive effects. In the sentence that immediately follows the guide's instructions to club attendees, we watch as he "pushed air . . . into his victory conch, such that the plaster fell from the walls" (stieß . . . in sein Muschelhorn, dass der Kalk von den Wänden fiel; BCD, 6). While not technically percussive, the guide's activation of the conch shell's sonic potential is expressed in terms of an "impact" (Stoß), which causes the surfaces of nearby walls

88 Chapter 3

to crumble. Again, Dada's production of tactile impressions, which Benjamin and others have linked to visual techniques, is attributed here to sonic vibrations.

In the second half of the text, the focus shifts from the oral production of sonic tactility to its registration via the ear and more specifically the eardrum. "The propaganda marshal [George] Grosz came with the tympanum," Huelsenbeck explains, "the sign of Dadaist world domination" (*BCD*, 7). Grosz's pounding of the giant drum is followed by the sounds of "children's trumpets and ratchets" (Kindertrompeten and Knarren) with the noise of the parade growing in intensity to the point that it begins to physically affect those in attendance, including the performers. "The noise became so great that our eardrums wailed like little children. The osteoporotic plaster crumbled from the roofs. Nobody knew what it was all good for."[63]

The passage's similarity to the guide's opening instructions to the audience is striking. There, as here, recognition of the ear's proximity to the drum gives rise to a depiction of sound's physical impact on the material environment before concluding with a nearly verbatim expression of resignation and futility. Now, rather than pulling the drum out of the ear, the drum remains lodged within it. Whereas the first scene presents the *oral* production of noise as the cause of the physical disturbance, the second focuses on its aural registration. Impressed upon the eardrum, the sound now triggers an embodied experience of vibrational force previously restricted to architectural structures in the surrounding environment. The uniformity of sound's physical effects on the human body and inanimate matter is underscored in the phrase "the osteoporotic plaster crumbled from the roofs," which superimposes the image of weakened bones onto the surfaces of the crumbling architectural space.

Huelsenbeck compares the eardrum's transduction of noise to the wailing of little children. His choice of words simultaneously underscores the sound's production of negative affect on human listeners and downplays the severity of its effects. Perhaps most important is the fact that the eardrum assumes a voice—that of a defenseless child. A visit to the Cabaret Dada entails the listener's submersion in a vibrational ecology that, converging around the figure of the eardrum, destructively shakes both walls and bodies. At the same time, the text repeatedly resists popular conceptions of the ear as merely passive. Noise assaults the ear from without, but this does not mean that passage through the ear is unidirectional. If the ear is impinged upon by external forces, it also functions as a conduit leading from inside to outside. A drum could be pulled from it and hot water poured out of it. In the end, the eardrum even takes on the powers of articulation, crying back at the source responsible for the violent vibrations it transduces.

Returning to the poem "Plane," we can now see how Huelsenbeck frames the work by invoking the sights and sounds of a live performance, one shot through with elements of a religious ritual or incantation.[64]

Drumming Literature into the Ground 89

plane
pig's bladder kettle drum cinnabar cru cru cru
theosophia pneumatica
the great spiritual art = *poème bruitiste* performed
for the first time by Richard Huelsenbeck DaDa
or or birribum birribum the ox whizzes around in a circle or
orders to drill for light mines scraps of metal 7.6 cm chauceur
share of sodium carbonate 98/100%
hunting dog damo birridamo holla do funga qualla di mango damai da
dai umbala damo
brrs pffi commencer Abrr Kppi commence begin begin
sei hei fe da asked home
work
work
brä brä brä brä brä brä brä brä brä
sokobauno sokobauno sokobauno
. .
behold how the vicar closes his fly fro-hont rataplan rataplan the fly fro-
hont and the hair it grows from his ears
from the sky the ram catapult fa-aalls the ram catapult
and the grandmother lifts her breasts
we blow the flour from our tongue and cry and the head ends up
on the tympanum
behold how the vicar closes his fly fro-hont rataplan rataplan the fly fro-
hont and the hair how it grows from his ears

Ebene
Schweinsblase Kesselpauke Zinnober cru cru cru
Theosophia pneumatica
die große Geistkunst = poème bruitiste aufgeführt
zum erstenmal durch Richard Huelsenbeck DaDa
oder oder birribum birribum saust der Ochs im Kreis herum oder
Bohraufträge für leichte Wurfminen-Rohlinge 7,6 cm Chauceur
Beteiligung Soda calc. 98/100 %
Vorstehund damo birridamo holla di funga qualla di mango damai da
dai umbala damo
brrs pffi commencer Abrr Kpppi commence Anfang Anfang
sei hei fe da heim gefragt
Arbeit
Arbeit
brä brä brä brä brä brä brä brä brä
sokobauno sokobauno sokobauno
. .
es schließet der Pfarrer den Ho-osenlatz rataplan rataplan den Hó-

90 Chapter 3

> osenlatz und das Haar steht ihm au-aus den Ohren
> vom Himmel fä-ällt das Bockskatapult das Bockskatapult und die
> Großmutter lüpfet den Busen
> wir blasen das Mehl von der Zunge und schrein und es wandert der
> Kopf auf dem Giebel
> es schließet der Pfarrer den Ho-osenlatz rataplan rataplan den Ho-
> osenlatz und das Haar steht ihm au-aus den Ohren

We know that Huelsenbeck regularly performed his early poems at the Caba-
ret Voltaire and that he often did so to the accompaniment of a "large drum,
yelling, whistling and laughter" (der großen Trommel, Brüllen, Pfeifen und
Gelächter).[65] The title of the textual version, "Plane," can therefore be read
as a reference to the club's stage, the "pig's bladder" and "tympanum" to
Huelsenbeck's infamous drum, and "cinnabar" to the colors of Marcel Jan-
co's African masks, often worn during performances there. Thus, the four
nouns quite literally set the stage for the poem. In what follows, Huelsen-
beck explicitly announces both the genre to which the work belongs (*poème
bruitiste*) and his role as performer. With the author now on stage, drum in
hand and a red mask covering his face, the poem can begin. "Brrs pffi com-
mencer Abrr Kpppi commence begin begin," we read several lines later, as if
the work is declaring its own beginning. The four nouns with which the piece
opens serve to ground the written work in the context of live performance,
gesturing beyond the printed page to the multisensory experience of its initial
articulation and reception.
 One of the drum's main purposes was to accentuate the shock caused
by the poem's controversial content. So, when Huelsenbeck describes how
"the priest closes his fly fro-hont," the irreverent, if not blasphemous, por-
trayal of the religious figure is immediately followed by an onomatopoeic,
textual reproduction of the drum as "rataplan rataplan." The poem's open-
ing lines, then, do more than simply frame the poem that follows. They also
intrude into the work at strategic moments in an effort to intensify the shock
of its contents. Whereas earlier snippets of text appear to be culled from
contemporaneous newspaper articles and other ephemeral textual sources,
advertising "beefsteak," a "mission to drill to light mines scraps of metal,"
and an abbreviation for sodium carbonate, the rendering of the drum draws
from the poem's onomatopoeic, percussive frame. The use of onomatopoeia
gestures toward the multisensory live performance from which the piece ini-
tially emerged, contrasting codified linguistic elements with more mimetic
modes of writing sound.
 The auditory dimension of oral performance is heightened by the hyphen
that extends the word *pant fly* and typographically indicates stress on the first
syllable, inscribing it on the page as "pá-ant fly." Through the sudden shift to
an auditory, oral register, the text places the shocking image of the priest in
a context consisting of a performer confronting his live audience in the act

of the text's articulation. Thus, typographical decisions and onomatopoeia draw attention to the aggressive nature of the performance. At the same time, the onomatopoeic imitation of the drum extends the logic of Altenberg's eardrum into an aesthetic of shock that is both physiological and semantically coded. With the pig's bladder stretched over the drum, as outlined in the poem's opening lines, the surface of the page takes on qualities of a vibratory surface, one that registers the percussive effects of the poem's initial oral performance.

The auditory nature of this shock, or "Stoß," is emphasized through the subsequent description that "the hair how it grows fr-from his ears," which links it formally to the preceding image of the priest's trouser fly through the use of a hyphen to extent the word *from* into "fr-from." By drawing the reader's attention to the minute details of the protruding hair, the image offers a visual close-up of the ear. The ability to visually identify the hair, in other words, implies a visual perspective in close proximity to the auditory organ. When read alongside what I take to be the poem's deployment of tympanic principles, the pair of images can be said to enact a coupling of drum and ear not far removed from Altenberg's "The Drummer Belín." There, just as here, the physical force of sound was registered textually through reference to the sound's tactile effects on the ear, to a type of auditory perception akin to beating a drumhead directly. As a refrain, the close-up of the ear pervades the text, which combines onomatopoeic noise, images of vibratory surfaces, and rapid montage to shock the reader/spectator physiologically.

Thus, in providing textual versions of works that were originally spoken and heard, Huelsenbeck did more than simply transcribe preexisting scripts. The adaptation of the tympanic model to the printed page transformed the status of, and relations between, material marks on the page. His coordination of shock and percussion during his live performances inspired a broader set of textual strategies, which drew on the drum as a means of exposing the montage principle and transductive processes operative throughout the work. The "plane," "pig's bladder," "tympanum," and "cinnabar" epitomize the Dadaists' commitment to montage, introducing an assortment of nouns in rapid succession without intervening verbs or descriptive adjectives. Elsewhere, the poem juxtaposes textual fragments in ancient Greek, German, French, and Italian with bursts of onomatopoeic nonsense and mutations of African words and place names. Mystical and religious terminology appear alongside allusions to modern military weaponry, as language from the Bible collides with that of modern advertising and newspaper reporting.

Huelsenbeck would later describe this strategy of heterogeneous appropriation as "a direct return to reality" (ein direktes Zurückkehren zur Realität), which "symbolizes the *bruit*, the screeching of brakes that assaults anyone sunk in a melody and supplies the broad backsides of the bourgeoisie with pepper."[66] For Huelsenbeck, what was to be gleaned from the futurists was that noise offered "a violent indication of life's colorfulness" (ein gewaltsamer

92 Chapter 3

Hinweis auf die Buntheit des Lebens), "the direct indication to action" (der direkte Hinweis auf die Aktion). "Music is one way or another a harmonic business," he continued, "an art, an activity of reason—bruitism is life itself, which one cannot judge like a book, and which much more represents a part of our personality, assaults and persecutes and tears us to shreds."[67] The rapid oscillation between various languages and linguistic registers was intended to confront the reader or spectator with physical reality stripped of idealism and aestheticized fantasy. The work offered the screech of a brake instead of melodic beauty. The goal was to shock bourgeois consumers out of their oblivious disregard for the world that surrounded them. Detritus culled from everyday life, Huelsenbeck implied, could serve as a peppery slap on the behind, a figure that combined physial intimacy between audience and performer with an element of physical pain.

Yet the drum not only functions as a figure facilitating radical textual montage; in addition, it points to processes of transduction between conventional linguistic elements and onomatopoeic reproductions of sound. By the end of the first line of "Plane," lexically defined German nouns give way to the seemingly nonsensical phrase "cru cru cru." The term *cru* could be an onomatopoeic reproduction of the drum or voice. But it also corresponds to the French adjective for "raw" and the past participle of the French verb *croire*, meaning "to believe."

The connotation of linguistic "rawness" plays off the idiomatic meaning of *cinnabar*, which usually refers to a mineral but was above all a symbol of failed alchemy; the German idiom *Zinnober reden* denotes a meaningless or nonsensical phrase or statement. In Huelsenbeck's poem, the invocation of cinnabar, along with tympanum and pig's bladder, results not in gold but rather in the meaningless phrase "cru cru cru." As we saw above, the utterance corresponds to the French past participle meaning "has believed," but the word could also refer to the French adjective for "raw," a description very much in line with the poem's aesthetic strategies, its use of unaltered source material from newspapers and advertisements as well as onomatopoeic reproductions—that is, sonic fragments not yet processed into language proper.

The ambiguity of the word's origin—either a lexically defined French verb or a nonlexical onomatopoetic phrase with no identifiable referent—again draws attention to the role of multilingualism in Huelsenbeck's construction of textual noise. Because the poem shifts unexpectedly and repeatedly between languages, it becomes difficult to distinguish between lexically defined elements of a codified language and onomatopoeic imitations of noise with no unified meaning. For auditors at the Cabaret Voltaire, the identification of such linguistic units would have been difficult, bombarded as they were by a rapid succession of languages, found phrases, and nonsense clusters, all of which were accompanied by the jarring strike of the drum.

The task becomes more manageable once the oral performance is fixed on the page, enabling the reader to pinpoint potential overlap with other

languages through the word's static graphical form. Once written down, the instability of the word's reference would have been even more pronounced due to these competing correspondences across languages. In this way, the phrase highlights the work's hybrid medial identity as a textual transduction of a live, largely auditory performance. At the same time, the rapid oscillation between languages shows how what at first glance appears to be a codified linguistic sign may in fact be intended as the onomatopoeic reproduction of sound in print. Thus, early in his text Huelsenbeck reminds readers of the auditory dimension underwriting his text, in which each utterance refers simultaneously to an arbitrary graphical sign and the quasi-mimetic reproduction of sonic experience, to both signal and noise. For Hugo Ball, one of the advantages of the onomatopoeic "words-in-freedom" (*parole in libertà*) of the futurists was that, rather than pointing directly to a sound source in the world, it "rubb[ed] against a hundred ideas at the same time, without naming them."[68] In Huelsenbeck's poem, this referential indeterminacy is intensified by its use of multilingualism, which renders every recognizable sign a potential onomatopoeic imitation and, conversely, every onomatopoeic phrase a possible lexically defined item in another language.

Transferred to the medium of print, the means of sonic warfare take the form of textual juxtaposition, with the drum serving as a transducer between diverse linguistic registers, languages, and meaningless noise, which, in their rapid succession, are intended to shock the reader or spectator through the sheer force of their heterogeneity. The percussive instrument both solicits and renders legible the shock resulting from radical montage. In the poem "The Tympanum" (Die Kesselpauke), also included in *Fantastic Prayers*, the drum is shown to be the hinge that makes textual montage possible. Based on its title, one might expect to find references to the drum in the text that follows. However, the reader searches in vain for any clear connection between the poem's content and its title. The first paragraph begins and ends with the phrase, "HOHOHOHOHO," which, in light of the work's title and the phrase's repetitive structure and use of capitalization, might be intended to refer to the sound of the drum. Huelsenbeck offers little on the level of content to support such a reading. Immediately before the final onomatopoeic phrase, we find the line "The green pistons jab out of my head farting and rumbling" (Der grüne Kolben stößt aus meinem Kopf furzend und polternd; *PG*, 16). The fact that the noises of bodily and mechanical processes immediately precede the onomatopoeic phrase suggests that what follows might be some form of sound reproduction.

The poem's reference to the drum can therefore be read as an indication of the formal strategies by which it is composed. As Karin Füllner observes, the poem "plays with and juxtaposes various distorted manners of speaking."[69] In particular, the text blurs biblical language with descriptions culled from the present. "I am the beginning of the world insofar as I am its end," we read in a sentence following the final onomatopoeic phrase.[70] The subsequent line

94 Chapter 3

then retains this biblical language but now adds references to the modern world: "Have you ever seen the car in pajamas" (Saht ihr je das Auto in einem Pyjama; *PG*, 16). Through the rapid oscillation of onomatopoeic nonsense, mechanical noise, and modern and biblical imagery, the poem's title takes on new significance. Rather than materializing on the level of content, the drum informs the work's formal structure. If elsewhere Huelsenbeck inserts onomatopoeic references to the drum at moments of heightened heterogeneity and shocking content, here the drum remains largely in the background, facilitating the text's radical montage of disparate elements without any direct reference to the instrument.

The Ear as Architectural Space

In being described as protruding out of the auditory organ, the close-up of hair in Huelsenbeck's "Plane" highlights the ear's spatial, almost architectural, dimension, depicting it not as a flat surface of sensorial registration but as a three-dimensional vessel open to infiltration from without. According to Huelsenbeck, the ear was a spatial structure from and into which objects could be pulled or poured, whether a drum or the stray hairs of an unkempt priest.

The text's thematization of the ear's spatial structure resonates with its subsequent extension of the tympanic principle to the architectural structures in which sound occurs. Before repeating the refrain about the priest, the drum, and the ear, Huelsenbeck inserts the following sequence of images, which point to a merger of sound and architectural space: "We blow the flour from our tongue and scream and the head ends up on the tympanum [Giebel]."[71] At first glance, the passage is just another example of Huelsenbeck's hybrid montage aesthetic, exploring new configurations of human flesh and inorganic materials against the backdrop of World War I and the dismembered bodies of dead and returning soldiers. Yet, upon closer examination, it depicts a human body merging with an architectural surface, one that moreover carries associations with both drum and ear. Indeed, according to contemporaneous architectural lexica, the "Giebel" included in the image caption below was closely related to the tympanum. The "Giebelfeld," or gable field, at this time was practically synonymous with the architectural tympanum, a vaulted structure adorning the tops of ancient portals in the shape of an upside-down drum (see figure 13).[72] Positioned immediately before the refrain involving the "rataplan" of the drum and close-up of the ear, the passage transfers the tympanic principle to the built environment. In doing so, the text utilizes formal and thematic elements to make legible the physical power of sound transmitted both through the human body and nearby architectural structures.

In drawing attention to the physical resemblance between the drum and the built environment, Huelsenbeck once again portrays architectural

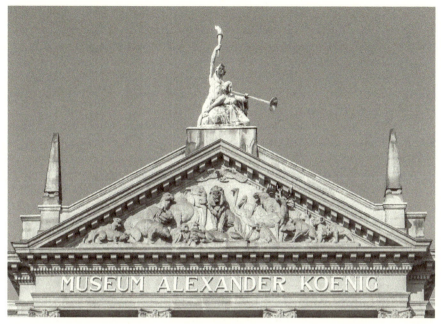

Figure 13. Architectural tympanum (*Giebel*), from the Museum Alexander Koenig, Bonn.

structures as media of sound's physical force. In this way, he establishes continuities among the vibratory surfaces of buildings, bodies, and texts. Elsewhere in *Fantastic Prayers* he emphasizes sound's physical force through the biblical figure of the battle of Jericho, perhaps one of the earliest instantiations of sonic warfare. "The Walls of Jericho great wind instruments" (Die Mauern von Jericho grosse Blasinstrumente; *PG*, 16), Huelsenbeck writes in his poem "Fantastic Litany" (Phantastische Litanei). In what follows, the violent, low-frequency vibrations pervade the surrounding environment, washing over architectural surfaces and affecting the listener's body: "Very solemn exceptionally solemn the blackness the unending the bass horn tone that glides over the wide plains glides over the broken plain glides with the wood smashes with a blast smashes wood smashes it smashes something with a blast increased a thousandfold the bellies the taut-stretched beautiful all-too-beautiful brown bellies burst HAHAHA."[73] The violence of noise takes the form of low-frequency trumpet tones, which move across "the wide plains" (die weiten Flächen) in a process of material destruction. The damage inflicted by sound soon spreads to the body, specifically the stomach, which, in a language reminiscent of stretched membranes and drum heads, ultimately "burst" (platzen) under the sonic pressure.

In this single image Huelsenbeck highlights the diverse proliferation of tympanic principles across the form and thematic content of the poems,

according to which bodies, buildings, and semantic codes become susceptible to the pressure of noise. If the ear was intimately linked to the drum, the body as a whole became a medium of vibration. In turn, the transduction of these vibrations across the one-dimensional surfaces of the text left formal alterations in their wake, whether through the sudden eruption of laughter in capital letters (HAHAHA) or the onomatopoeic reproduction of drums and non-Western languages.

In 1919 Huelsenbeck's fantastic prayers were answered when, amid the Spartacus Uprising, the city in which he lived took on characteristics of a Dadaist performance. "There is a reigning nervousness that one must have lived through in order to grasp it," he wrote. "Someone needed only shout a loud word in the street and immediately most people fled into the entrances of the houses, it's a run for your life, at any moment a machine gun concealed in a hatchway can start hammering or a hand grenade falls from a roof and its fragments rip open your guts . . . it is a joy to be alive."[74] For Huelsenbeck, the political violence on the streets of Germany functioned as a kind of affective equalizer, distributing fear and anxiety into previously impermeable areas of society: "The bourgeois pig that during the entire four years of murdering only cared for his stomach cannot withdraw from the situation, it stands with firm legs in the center of hell. And hell rests: it is a pleasure to be alive."[75] While during World War I many of the bourgeois citizens (whom the Dadaists blamed for bringing the country into the war in the first place) were able to maintain a safe distance from the violence, during the Spartacus Uprising the chickens had, so to speak, come home to roost. The pervasive sense of dread, which Huelsenbeck connects directly to the city's soundscape, now encompassed even the most privileged and protected. It is in this sense that the Spartacus Uprising not only brought war back to the city but also helped disseminate the sensory effects and affective ecologies of the Cabaret Voltaire, which now materialized on city streets as an amalgamation of dread, violent aggression, and auditory shocks. Amid the sonic brawling in urban spaces, listeners caught a glimpse of the true nature of life and the physicality of modern noise.

Huelsenbeck's tympanic poetics utilize the power of sound to mutate preexisting linguistic codes and make legible the sonic force underlying the work's articulation as sound. At the same time, the analogies he establishes between literary form and sonic vibrations serve to present the ear as an architectural structure onto itself, a storehouse of tympanic instruments, an eardrum capable of vocal expression, or simply the subtle traces of old age and personal disrepair. It is the figure of the ear as a quasi-architectural space that animates the high modernism of Musil and Kafka.

Chapter 4

Toward a Modernist Ear

Robert Musil and the Poetics of Acoustic Space

> Binaural sounds are more clearly defined; they are things acoustically perceived, which, stationary or in motion, are in the same space as the things one sees.
> —E. M. von Hornbostel, "Observations on Monaural and Binaural Hearing" (1923)

> War is the same as the "other condition."
> —Musil, *The Man Without Qualities* (1930/43)

By the early 1920s, an alternative to the tympanic regime was becoming visible across a number of scientific, technical, and artistic fields. Literature was no exception. With the rise of so-called high modernism, literary authors such as Franz Kafka and Robert Musil abandoned strategies of tympanic transduction, simultaneity, and violent tactility. This competing literary aesthetic of sound, which I would like to designate from the outset as the uniquely "modernist ear," was characterized instead by an attentiveness to the spatiality of sound, narrative and temporal disjuncture, a turn away from the quasi-indexical, or onomatopoeic, and a reaffirmation of the symbolic. Whereas texts and oral performances by Peter Altenberg and the Dadaists figured sound as a projectile, and the listening body as a percussive surface and target of sonic attacks, Musil and Kafka positioned sonic elements within a dynamic, three-dimensional auditory space composed of auditory bodies that were capable of entering the ear but lacked the assaultive characteristics of tympanic projectiles.

Not only did modernist authors banish onomatopoeia and other figurations of indexicality from their published works; gone too was the spatial proximity ensured by the tympanum, whether as violent contact or the ear's infiltration on the way to the soul. In Altenberg's "The Drummer Belín" the perception of sound was equated with the beating of a percussive instrument

and a series of direct blows to listeners' bodies, while Detlev von Lilien-cron tended to present the ear as a kind of deflective shield, a move arising from the immersive cacophony of battle. The Dadaists, by contrast, offered a bridge to the modernist ear, not only in their conception of live performance as a reciprocal feedback loop or salvo of noise between audience members and performers. In addition, Richard Huelsenbeck portrayed the ear as a three-dimensional space, with objects falling into, sticking out of, and being pulled from it. His bruitist poem "Plane" even extended the figure of the tympanum beyond anatomy and percussion and into the built environment, making reference to a semicircular or triangular structure common to decorative façades, also known as a tympanum.

Texts by Musil and Kafka depicted the ear as a space to be entered and inhabited by other bodies. Characteristic of these works is a perpetual oscillation between spaces inside and outside the ear. At the same time, they envision a more active subject compelled to listen to the world, to meet sounds halfway, even to hallucinate or project imagined bodies into the external world rather than remain the passive target of unilateral assaults, coercion, or mimetic pressures from without. In Musil's 1924 short prose text "The Believer" (Der Gläubige) the architectonics of the ear become the site of an erotic union between a male protagonist and a female passerby.[1] As the woman walks past the protagonist's window, her footsteps audible but all other sensory information excluded, his ear extends out into the street to become an open doorway ready to receive her. As the ear takes to the street and meets the stranger halfway, her footsteps enter the ear's cavernous spaces, not as projectiles or percussive blows but as sexually charged bodies of sound situated in three-dimensional space.

The corporeality of sound emphasized in "The Believer" bears a striking resemblance to Musil's firsthand account of the the martial soundscape during his time as a soldier in World War I. It was there that he began to document sound's three-dimensionality and movement through space, describing in his notebooks the sound of an enemy projectile as "rising" (anschwellendes) and "falling" (abschwellendes),[2] or becoming "more corporeal" (wurde körperlicher)."[3] By repeatedly highlighting sound's positionality in three-dimensional space and imbuing it with characteristics of a living organism, Musil's war writings, and later "The Believer," indicate a break with the tympanic regime, which operated according to a logic of spatial proximity and violent contact. Whereas Altenberg portrayed the encounter with noise as almost always violent, intrusive, and destabilizing, Musil's sonically attuned protagonists appear remarkably confident and active, eager to engage with sonic elements, to interrogate their spatial and temporal contours, to participate in their repeated deformation and reconfiguration, and to remain open to the perceptual insights engendered in the process of attending to sonic detail. If, within the tympanic regime, sounds acquired thing-like characteristics only in the moment of physical contact, Musil suggested that they

assumed a kind of solidity in the spaces between the listener's ear and their point of origin, between states of passive receptivity and concentrated close listening, imaginative speculation and corporeal registration.

Musil's spatialization of sound bears clear traces of his exposure to scientific research at the Berlin Institute for Experimental Psychology between the years 1903 and 1908, where figures such as Wolfgang Köhler, Max Wertheimer, and Erich Moritz von Hornbostel studied what they variably termed "auditory space" (Hörraum), "the ear's sense of space" (Raumsinn des Ohres), and "spatial hearing" (räumliches Hören). Whereas Hermann von Helmholtz, the foremost authority on the science of sound in the nineteenth century, either ignored or denied the ear's perception of space, early twentieth-century experimental psychologists, most notably Musil's colleagues in Berlin, argued that the ear, just as much as the eye, possessed the ability to perceive space, and that sounds, just as much as visual objects, exhibited qualities of thingness, solidity and directionality.[4] The same research and terminology would later be extended to the aesthetics of early radio, giving rise to related notions of "plastisches Hören" (plastic hearing) and "stereoakustisches Hören" (stereo-acoustic hearing),[5] while also providing conceptual resources for thinking about the aesthetics of acoustic space for monaural radio art and the Weimar *Hörspiel*.[6]

In contrast to their predecessors, Wertheimer and Hornbostel concluded that the ability to locate a sound's position in space depended not on differences of phase or intensity but rather on a relative difference in wavelength, or the temporal difference between the moments at which a single sound was registered by each of the two ears. "All previously reported test results suggest that the side angle at which the sound is heard depends as a rule on the time difference with which the same stimulation acts upon one ear and then the other."[7] According to their theory, expanding the distance between the two ears would increase the temporal difference between sensations registered by each of the ears and thereby increase the listener's accuracy in locating a sound source.

While in cases of ordinary auditory perception, they argued, the distance between the two ears and the temporal disparity that followed enabled a listener to distinguish the approximate location of a sound's source, mechanized warfare demanded an unprecedented degree of precision. Based on this theory of temporal difference, Hornbostel and Wertheimer proposed an apparatus that would artificially extend the listener's ears away from the body and out into space. At the end of May 1915, they appeared before the War Ministry to present the device they had devised in adherence with their research on spatial hearing.[8] Their directional listening device, or *Richtungshörer* as it came to be called, consisted of two tubes for each of the ears and multiple horns for the reception of sound, all of which was typically situated on a movable base (see figure 14). The device not only allowed soldiers to focus on the nuances of a single sound's acoustic composition but

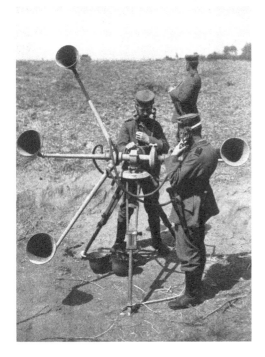

Figure 14. Hornbostel and Wertheimer's *Richtungshörer* in action during World War I.

additionally framed each sound in a stereophonic field with perceptible right and left sides. "In this way you heard distinctly the individual blasts gliding from left to right," one former member of a German sound-ranging unit recalled.[9] By the beginning of 1916 the *Richtungshörer* had entered the war as a tool for sound-ranging units assigned the task of determining the coordinates of enemy forces and compiling maps based on the sounds of artillery fire and distant explosions.

High Modernism and the End of the Tympanic Regime

Scientific research on auditory localization and spatial listening was conducted under the artificial conditions of a laboratory outfitted with the latest acoustic media. Hornbostel and Wertheimer specified that the stimulus for their initial experiments consisted of a knocking sound amplified by two microphones or sound cones (*Trichter*) and communicated across several rooms by telephone lines.[10] The telephone in turn enabled researchers to establish narrow temporal differences, which would have been impossible without the aid of electro-acoustic technologies. Amplifier tubes and tube transmitters, Hornbostel explained in a subsequent essay, enabled researchers to transmit tones of extraordinary consistency, the frequencies of which

Toward a Modernist Ear

Figure 15. Diagram of Alexander Graham Bell's telephonic setup for his experiments on binaural hearing.

could be changed across the entire audible range, while various electric filters helped eliminate specific overtones.[11]

Seen from a media historical perspective, one might assume that the reliance on acoustic technologies such as the telephone would have only reinforced the basic premises undergirding the tympanic regime. The telephone was, after all, the tympanic medium par excellence, initially incorporating the internal bones and drum of an actual human ear. Moreover, the device transmitted speech and other noises via a series of transductive relays, transforming speech into electricity on one end and electricity back into audible speech on the other. However, Hornbostel and Wertheimer's telephonic experiments were predicated on *multiplying* the tympanum, on examining the interaction between the two ears, rather than taking monaural hearing as their starting point, as had been the case for most nineteenth-century scientific studies of sound.[12] When Alexander Graham Bell set out to investigate questions of auditory localization in 1879, he constructed a binaural telephone system modeled on the measurements of the human body. As he noted in his report, "The instruments were so arranged that the diaphragms were about as far apart as the drum-membranes of the two ears" (see figure 15).[13]

Yet the phenomena he examined and the methods he employed had little in common with other contemporaneous figurations of tympanic transduction. The physical contact and spatial proximity embodied in the eardrum gave way to the binaural audition of solidity and positionality in external space. Rather than impinging upon the listener, the stereophonic telephones produced "a mental conception of the direction from which [the sound] comes, and the sound seems to proceed steadily from that point all the time the source of sound is travelling round the telephones A, B."[14] Although relying on tympanic media, the process of doubling the eardrum ironically undermined the underlying assumptions of the tympanic regime. In subsequent work carried out by Musil's Berlin colleagues (and explicitly indebted to Bell's earlier experiments), the figure of the eardrum vanishes almost entirely, as do other specific anatomical features, replaced by general references to *das Ohr* as the basic, albeit doubled, unit of analysis. When, in a rare instance, Hornbostel did mention the eardrum, it was merely as one among many "reflective boundaries" (reflektierende Begrenzungen), which also included walls and ceilings, the "external ear" (die Ohrmuscheln), and the "walls of the auditory canal" (Gehörgangwände).[15]

Musil's modernist ear borrows from this contemporaneous work in experimental psychology to outline a mode of listening distinct from the tympanic regime in the years leading up to World War I. Though idiosyncratic within the domain of literature, Musil's poetics of acoustic space becomes comprehensible in light of the scientific research to which he was exposed in Berlin and with which he continued to engage long after leaving the institute.[16] Yet we should be careful not to overestimate the extent of experimental psychology's impact on Musil's writings. The works he composed in the years immediately following his time at the institute but before he became a soldier bear little to no trace of the modernist ear he would cultivate over the course of the next decade. The two novellas he published in 1911 under the title *Unions* (Vereinigungen), although remarkably attentive to sound, remained bound to a paradigm of acoustic space defined by permeability and diffuseness, not solidity or positionality.[17]

It was only after a near-death experience as a soldier in northern Italy in 1915 that we begin to see anything resembling his depiction of listening in "The Believer." The cause of the near-fatal episode was a so-called aerial dart (*Fliegerpfeil*), a six-inch piece of carved metal dropped from a passing aircraft. In a diary entry recorded soon after, Musil described the experience as an intense exercise in close listening. The sound of the dart and the surrounding battlefield stayed with Musil, who over the next fifteen years would draft various versions of the event and integrate its language and imagery into texts such as "The Believer." In short, Musil's uniquely modernist ear was bound up with the experience of war.

In "The Believer," Musil self-reflexively thematizes the ongoing imposition of his martial past onto the present through a bewildering juxtaposition of

conflicting temporalities. From one window the protagonist sees night, and from the other, morning. His frantic movements between the two windows subsequently give way to his extension of the ear out into the street, where he receives the footsteps of the female passerby in a fleeting moment of ecstatic union. In this way, the temporal difference at the core of Hornbostel and Wertheimer's theory of spatial hearing informs more than Musil's portrayal of an active listener or the ear's ability to perceive auditory bodies.

It also corresponds to a diffuse intermingling of past and present, war and civilian life. Musil's 1928 novella "The Blackbird" (Die Amsel) scatters the distinct sounds of the author's near-death experience on the battlefield across subsequent, seemingly related moments of the protagonist's life.[18] As sounds and imagery from different points in his life migrate into stories, so too do moments of spatial listening in which the protagonist perceives sounds as corporeal entities. These later iterations of the martial soundscape therefore link the repetition of the martial past with narrative strategies aimed at holding open conflicting temporalities, which facilitate ecstatic moments of spatial listening amid the proliferation of sonic warfare at home.

Musil's texts exhibit continuities with earlier modes of sonic warfare, in that they take the convergence of martial and civilian soundscapes as an impetus for literary innovation. But they do so not as a response to, or provocation of, social antagonisms dominant in civilian life. Familiar with scientific theories of spatial hearing and the imperatives of close listening on the battlefield, Musil elaborates a new mode of listening attentive to spatial characteristics and sound's status as a quasi-autonomous thing. In doing so, "The Believer" signals a break with earlier forms of tympanic literature, transforming the textual medium from a surface of percussive registration into a medium of materialization and encounter between subjects and things, or what Musil would later call "the Other Condition" (der andere Zustand).

Drumfire

Techniques of spatial listening, both with and without the help of Hornbostel and Wertheimer's *Richtungshörer*, were a response to the unprecedented visual obscurity of World War I, resulting from, among other things, the trenches, tear gas, airplanes, underground warfare, and night combat.[19] The ability to distinguish sounds on the battlefield and locate them in space by means of the ear alone became indispensable tools of survival, while information gathered from purely acoustic data offered strategic advantages.

By most accounts, however, World War I was the last place one would expect to find a break with the tympanic regime. The unprecedented deployment of heavy artillery and use of "drumfire" (*Trommelfeuer*)—a tactic by which one side relentlessly shelled the trenches of another to kill as many of the soldiers as possible and demoralize the others—resulted in a dramatic

104 Chapter 4

increase in ruptured eardrums and psychological disorders affecting the ear.[20] "Detonations rang out continuously like a monstrous kettledrum-roll [*ungeheurer Paukenwirbel*], which drummed upon the German lilies," one observer noted. "One thought to feel the earth below trembling. The air vibrated with endless waves that brought one's nerves to a state of the highest tension."[21] Even in moments of complete silence, contended the World War I hero turned literary author Ernst Jünger, the level of anxiety on the battlefield was so high that the soldier's entire body was transformed into a single trembling tympanum. "We are nothing but ears, nothing but taut eardrums."[22]

Indeed, Jünger's 1929 collection of short prose texts, *The Adventurous Heart* (*Das Abenteuerliche Herz*), demonstrated the persistence, if not intensification, of tympanic figures in the wake of the war. While Musil drew on his war experiences to develop a literary aesthetic of acoustic space, Jünger continued to imagine both the battlefield and its migration to the city during peacetime in terms of violent contact and percussive surfaces. In a text from *The Adventurous Heart*, Jünger has his anonymous narrator describe a fantasy of hurling someone—referred to throughout with the second-person *du*—onto a stack of thin metal sheets such as those commonly used in "small theaters" (kleinen Theatern) to simulate the sound of thunder. Under the weight of the figure's body, he explains, the first metal sheet would break, then the next, and so on and so on, faster and faster with the rupture of each successive surface. "You fall, and fall upon the second sheet, which also shatters, with an even more violent sound."[23] In the process, the clatter of successive sheets colliding with one another begins to take on the sound of "detonations" (Detonationen), "beats of the drum" (Paukenschläge), and "continuous, intense drum rolls" (ununterbrochen verstärkten Trommelwirbel), until finally the "terrifying noise blows open the limits of consciousness" (fürchterlicher Lärm die Grenzen des Bewusstseins sprengt).[24] Beyond mere "terror" (Schreck), "anxiety or fear" (Angst oder die Furcht), the protagonist's stated goal in the scene is to engender a more intense feeling of "horror" (Entsetzen), presumably in both the hapless participant and imagined audience members.[25]

Somewhere between punishment, performance, experiment, and martial training, Jünger depicts the figure's descent in recognizably tympanic terms of surface, contact, clinamen, and explosions. The juxtaposition of bursting metal and percussive blows invokes the image of an eardrum's rupture. At the same time, allusions to the drum, especially when read alongside the preceding "detonations," conjure the sounds of heavy artillery fire. In a sadistic twist on Altenberg, who portrayed the drum as an acoustic weapon battering spectators' eardrums from the stage, Jünger has the subject generate the noise to assault his own body.

Published in 1929 and explicitly set in Berlin, the text can be read as a staging of Jünger's broader political and aesthetic program at the time, which here and elsewhere called for the militarization of Germany's urban spaces in the name of reestablishing the nation's power and influence in the wake

Toward a Modernist Ear

of its defeat in World War I. "It is with pleasure that I note," Jünger wrote in another short text from *The Adventurous Heart*, "how cities are starting to fill up with armed persons and how even the dullest system, the most tedious of approaches can no longer do without armed representatives."[26] The key to this revitalization through war, Jünger contended, could already be gleaned in the mechanical noise of the city, in the "street noise, signals and squeals of transportation vehicles" (Straßenlärm, Signalen und Aufschreien der Verkehrsmaschinen), which carried within them "the immediate threat of death" (die unmittelbare Androhung des Todes).[27] Similarly, the noise generated by a machine in an ordinary basement in the city gave expression to insatiable anger and "the attraction of more dangerous games" (den Reiz gefährlicherer Spiele), which would be required to obliterate the idyll of peacetime and the comfort of some preindustrial past.[28] What was needed, Jünger suggested, was something more than the fake thunder of a conventional drama. The sounds of nature were to be transformed into the cacophony of war, thunder into heavy artillery fire, and the passive spectator into a weaponized projectile. Jünger's aesthetics of horror therefore appropriated elements from the martial soundscape and technological modernity in an effort to remilitarize the civilian population, extending the tympanic regime into a historical moment marked by economic and political crises, urban street fighting, Communist antifascism, and the increasing audibility of marching SA units.[29]

But whereas Jünger sought to conjure the sounds of war through two-dimensional surfaces and the taut tympanic membrane, Robert Musil depicted the same soundscape as a dynamic, three-dimensional space inhabited by solid, corporeal sounds. The battlefield's visual obscurity, Musil observed during the war, demanded that soldiers cultivate new modes of listening attuned to the location of sound in space. As he explained in a text composed shortly after his near-death experience in northern Italy, "One quickly learns to listen like an animal in the forest."[30] He specified that "plunging fire" (Steilfeuer), "bursts of artillery fire" (Artilleriegarbe), and "rifle fire" (Gewehrfeuer) all had their own sonic signatures, which communicated the level of danger they posed to listeners. "There is singing above our heads, deep and high," he wrote in a diary entry during the war. "One can differentiate the batteries by sound. tschu i ruh oh—(pim) puimm. When it hits nearby: tsch—sch—bam. It spits and snarls once, twice, and leaps at you."[31] Recalling the work of Detlev von Liliencron, Musil turns to onomatopoeia as a way to record textually the sound of enemy fire. But more radically than Liliencron, subtle differences between the two onomatopoeic renderings correspond to the position of each sound in space, with individual shots and explosions identified as "low" (tief), "high" (hoch), and "nearby" (in der Nähe). Similarly, the sound of a projectile passing above could be distinguished by its lack of a certain "ei-sound" (ei-Laut).[32]

In texts by Liliencron, Altenberg, and Huelsenbeck, onomatopoeia is tied to sound's inscription on a two-dimensional plane, a drumhead, or the

surface of the eardrum. The literary device could draw attention to the spatiality of material marks on the page, but it failed to reflect minor differences in a sound's spatial position. Musil's diaries exhibit a familiar compulsion to translate the inscrutable and inarticulate noise of the battlefield into spatially fixed graphical marks, a gesture to something beyond the symbolic but also encoding information about the sound's spatial properties. Thus, a mode of writing predicated on bypassing the arbitrariness of conventional signs and standing outside the lexicon comes to guarantee the written sign's indexical relationship not only to its source in the external world but also to its position in space. In other words, Musil's war diaries proffer a mimetic mode of writing not just sound but sound *space.*

In the same passage, Musil underscores the sound's extension in three-dimensional space by describing it as "swelling up" (anschwellendes) and "contracting" (abschwellendes) in correspondence to its position behind, above, or in front of the listener. This same imagery of a living, breathing sound, one expanding and contracting as it moves through space, appears in nearly every version of Musil's near-death encounter with the falling aerial dart. As the projectile falls from above, the narrating subject tracks not only its spatial trajectory but also its size and roundness. "It became more corporeal," he notes in another version, "it swelled, became more threatening. But it didn't lose its musicality."[33] The path from air to ground, from enemy aircraft to human target, is figured as a space inhabited by sounds with corporeal features, equipped with bodies that swell and expand like living creatures. This personification of sound as an animate body is underscored by Musil's use of the pronouns *he* (er) and *him* (ihn), which, on one level, simply refer to the masculine noun *der Laut* but, on another, invest the sound with a sense of vitality and organic life. As the falling projectile swells and becomes "more corporeal" (körperlicher), indefinite or definite articles are abandoned in favor of personal pronouns.

This figuration of sound as an animate form resonates with Hornbostel's depiction of binaural sounds as "sharply outlined, dense, and in some circumstances, spherical bodies" (dichte, unter Umständen kugelförmige Körper)[34] and speculations about "things that are aurally perceived" (Dinge, die hörend wahrgenommen werden).[35] But Musil's text takes the dynamism and concreteness of auditory things one step farther, imbuing them with corporeal qualities: a voice that sings, a body that swells and contracts, and even the agency to choose human targets. Literary and scientific representations of auditory perception converge in their depiction of an active subject capable of listening out into the surrounding environment as a way to process sound's acoustic properties, the nature of its source, and its movement through space. According to Musil and Hornbostel, the ear did more than passively bear the brunt of a physically violent cacophony of indistinguishable sounds. Instead, the organ actively attended to sounds, rose up to meet them, and facilitated intimate connections between sound and the listener, who in the process

became deeply aware of sound's autonomy and concreteness as "spherical bodies."

For Musil, the battlefield animated sound as a living thing and invested it with spiritual power, transforming a falling projectile into a signal of divine intervention or a voice on the edge of the atmosphere speaking only to its target. The sense of acoustic isolation his protagonists experience captures the expansion of the listening body from one to two ears, concomitant with both a scientific interest in binaural audition as the basis of auditory localization and the shift from the tympanic regime to a modernist poetics of acoustic space. With both ears covered by stereophonic telephones or plugged into the dual listening tubes of the *Richtungshörer*, listeners were further isolated from the surrounding acoustic environment. In narrating the projectile's descent, Musil draws attention to a similar kind of acoustic enclosure and religiously inflected atomization. "I was surprised that the others didn't hear anything," he remarks, reading the indifferent expressions on his comrades' faces as confirmation that "only I heard something."[36] In consonance with the immersive qualities of binaural and stereophonic technologies, Musil enters an auditory space cut off from everyone around him. "Perhaps it was just that: a song that was only there for me. Chosen. On the atmosphere's border, a voice sings only for you."[37]

Musil borrows the language of visual perception to make sense of sound's movements through space. "At the same time as it approached me and became larger in perspective," he observes, "it was as if a silver beam was rising within me."[38] As the weapon descends toward the listener, it is perceived as becoming larger and larger. Conversely, the protagonist senses "a silver beam" (ein silberner Strahl) rising up within him, thereby portraying himself as not merely a target but a willing partner projecting his own energy upward, as if to meet the projectile halfway. The ray emanating from a soldier on the ground toward the approaching dart renders visible the perceived bond between them. It also reinforces the protagonist's pronounced ability to analyze and spatially track the sound he hears above him, suggesting a kind of auditory spotlight, capture, or even a retaliatory projectile from below.

Yet the moment the dart lands in the earth beside him is marked by a perceptual caesura. "No memory of a pulse of air," he recounts. "No memory of a sudden rising proximity. There must have been, though, because I instinctively threw my upper body to the side and with my feet fixed to the spot took a pretty deep bow." The passage depicts the culmination of the near-death experience as an automatic response outside of conscious perception or cognition. The sound is stripped of any acoustic property, becoming merely a "pulse of air" (Luftwelle) or "swelling proximity" (anschwellender Nähe). The projectile eludes the ear, its physical proximity postulated retrospectively based on Musil's reaction in the moment. He notes that he felt no fright or shock but was instead overwhelmed by a "very pleasant feeling" (sehr angenehmes Gefühl) of gratitude and even pride for having survived.[39]

108 Chapter 4

The account reads like a case of trauma, repressed and irretrievable. The intensity with which Musil would engage the episode in writing after rewriting lends credibility to the diagnosis. As I show below, later texts such as "The Believer" and "The Blackbird" interweave elements from Musil's war experiences with those of ordinary civilian life in the present. What emerges from these hybrid spaces and temporalities is a recognition of sound's corporeality and of the ear's spatial capacities. At the same time, the auditory bodies that materialize in space become objects of erotic desire and sites of ecstatic transcendence and possibility, or perhaps proxies for a sound previously inaudible, repressed but physically registered.

"The Believer": Spatial Hearing and the Ecstatic Echoes of War

One year after the publication of Hornbostel's "Observations on Monaural and Binaural Hearing," Musil published "The Believer." Once again, the text revolves around a powerful auditory experience in which the ear is directed outward in search of sounds figured as autonomous, three-dimensional entities. If the various versions of his near-death experience on the battlefield had implied that the sound of the falling dart was a message from the divine, baptizing the listener in an "invisible church" (unsichtbare Kirche), in "The Believer" Musil similarly gestures toward the supernatural elements and ecstatic potential underlying spatial listening and encounters with auditory things.[40] In a further elaboration of the sense of communion and intimate contact between sound and listener portrayed in Musil's war writings, "The Believer" depicts the ear not only as a spatially attuned instrument but as a kind of spatial construction or architectural structure unto itself.

Though the text's imagery of quiet streets, a colorful sunrise, and the early stirrings of everyday life conveys a sense of calm and tranquillity, "The Believer" in fact bears clear traces of Musil's experiences of war, transposing modes of close listening and spatial hearing from the battlefield to civilian life. Whereas in "The Believer" the protagonist describes the colors of the morning sky using the unusual adjective *parrot-feathery* (Papageienfedrig; *G*, 575), in the lead-up to his near-death experience on the battlefield the protagonist recounts walking between dark-green trees "like between the feathers of green night parrots" (wie zwischen den Federn grüner Nachtpapagien).[41] If in "The Believer" the protagonist looks out his window in the early morning to find "the moon's crescent . . . delicate as a golden eyebrow on the blue sheet of night" (die Mondsichel . . . zart wie eine goldene Augenbraue auf dem blauen Blatt der Nacht; *G*, 575), Musil's account of the falling projectile in "Ein Soldat erzählt" occurs against the backdrop of "the slender, girl-like crescent moon" (die dünne mädchenhafte Mondsichel) and stars drifting in the sky "like gilded maple leaves" (wie vergoldete Ahornblätter).[42] Set beneath a night sky and imbued with a sense of the fantastical, both texts

Toward a Modernist Ear

raise questions of spirituality and the possibility of divine intervention. While in "The Believer" the protagonist jokes, "God woke me up" (Gott hat mich geweckt), in his war narratives the narrator speaks of his "baptism by fire" (Feuer Taufe) and entering "the invisible church" (die unsichtbare Kirche).[43] Claiming to have been an atheist his entire life, the protagonist is forced to admit that the strange power of the falling weapon—its decision to single him out as the target and recipient of its "song"—had awakened a sense of physical communion with God. "There was a new concept in my body at the end of these few moments, one which it had never harbored before: God."[44]

In both texts the solemnity of transcendent experience is shattered by expressions of skepticism, sarcasm, and a rejection of God as the ultimate cause. In his war journal, the assertion of God's presence gives way to astrology. In "The Believer" the feeling of unity with the stranger outside his window ends abruptly after the protagonist realizes that the woman on the street is on her way to church. Thus, the two texts couch their descriptions of intense auditory experiences in a religious language whose explanatory power is, in the end, rejected. By introducing and then dismissing the possibility of divine intervention, Musil highlights the otherworldly characteristics of the two auditory experiences and their departure from the quotidian. Yet he also suggests that conventional recourse to God is insufficient in accounting for the peculiarity of each episode. Both the battlefield and the domestic sphere are represented as spaces pregnant with the possibility of transcendence. But these brief moments of allegedly authentic communication with a higher power merely serve to reinforce the inadequacy of such explanations and, while still endorsing transcendence as a noble aim, conclude by replacing the belief in God with an embrace of ambiguity, contingency, and secularity.[45]

In "The Believer" the appeal to God and divine intervention emerges out of confusion surrounding the cause of the protagonist's sudden awakening. "God woke me up," he speculates. "I was shot out of sleep. I had absolutely no other reason to wake up."[46] The passage reinforces Musil's conception of religious explanation as a last resort in the face of inexplicable phenomena. At the same time, it emphasizes the protagonist's passivity and susceptibility to forces beyond his control. For whatever reason, he cannot imagine that he awoke of his own volition but instead assumes that some external force is responsible and, more pointedly, that it is the work of God. The character describes himself as "shot out of sleep" (aus dem Schlaf geschossen), an expression with clear military overtones that portrays the protagonist as an object acted upon by others, a projectile fired from sleep into waking consciousness (G, 575).

Already in the text's opening line we find intimations of the protagonist's lack of agency. "Quickly shoved the curtain aside," he exclaims, "the soft night!"[47] The formulation is striking in its lack of a grammatical subject or specification of the agent carrying out the action. Who or what exactly pushes

the curtain aside? Is it the "soft night," or is night what the protagonist finds after he himself draws back the curtain? The ambiguity continues in the next paragraph, which posits a series of metaphors linking the protagonist with the darkness of the night sky. "I was torn out like a page from a book," he remarks.[48] Just as the subject is absent from the opening sentence, the narrator is described as being metaphorically ripped from the body of the text, like a page forcefully removed. The abruptness of his awakening, expressed in the first sentence without the use of a grammatical subject, is therefore reinforced through his metaphorical exclusion from the written work. The opening sentence and its lack of a subject can therefore be read as a formal enactment and prefiguration of this subsequent metaphorical chain, establishing a trajectory that equates the passage from sleep to waking consciousness with authorial erasure.

The lack of agency in the opening paragraphs corresponds to popular conceptions of the modern listener as passive and inherently vulnerable to the modern soundscape. As Musil would have learned from his dissertation advisor, Carl Stumpf, or virtually any contemporaneous account of urban noise, "we wake the sleeper and the daydreamer through aural impressions. The always open organ, the penetration of sound waves from all sides (one cannot see, yet can hear through a wall) and some other cases are the causes of this practical meaning."[49] Here sound's ability to disrupt sleep is regarded as an inevitable consequence of the ear's openness. According to Stumpf, the sleeper is inherently defenseless against noises from the surrounding environment, which might at any time travel through the walls of the domestic sphere and infiltrate the sleeper's ear against his will. Stumpf's comments represent the dominant view of the ear as naturally vulnerable and passive in relation to external stimuli, a view reiterated at the time by cultural critics, medical scientists, and literary authors alike.

Yet while Musil's text begins with a similar emphasis on passivity, this characterization of hearing is complicated in the concluding paragraphs, where the protagonist appears to willfully direct his ear to the sounds on the street below his window. This shift to a more active mode of hearing bears distinct traces of Hornbostel's contemporaneous writings on auditory space. But the final ecstatic moment of spatial hearing is in fact already prefigured through a series of visual experiences that appear earlier in the text, thereby gesturing toward the visual origins of scientific and technological discourse surrounding binaural hearing. Upon waking, the protagonist immediately recognizes a mysterious disparity between the images framed by each of the two windows in his room. From one he sees the moon and the night sky, while from the other he is greeted by a rising sun and the bright colors of the morning:

> The moon's crescent lies delicate as a golden eyebrow on the blue sheet of night. But on the morning side at the other window it's getting green. Parrot-feathery. The pale reddish strips of sunrise, they

Toward a Modernist Ear

too are already streaking the sky, but everything's still green, blue and silent. I jump back to the other window: Is the moon still there? She's there, as though in the deepest hour of night's secret.[50]

Moving back and forth between the contrasting views offered by the two windows, Musil's protagonist encounters a perplexing temporal disparity. As we have seen, Hornbostel and Wertheimer's primary contribution to the study of auditory space was their discovery that the decisive factor in auditory localization lay not in differences of intensity or phase, as researchers had contended up to that point, but rather in the difference between the moment at which each of the two ears registered a single sound. According to Hornbostel's 1923 essay, spatial hearing depended on "the temporal disparity of stimulations" (die zeitliche Disparation der Reize).[51]

The conflicting temporalities of the two windows can be read as an appropriation of this contemporaneous research into auditory space, one that maps the mechanism discovered to be responsible for spatially orienting the ear onto two competing visual perspectives—a move fully in line with the history of scientific research on spatial hearing, which borrowed extensively from contemporaneous studies of stereoscopic vision. From the start the text portrays visual perception as prone to disorienting illusions or distortions of the external world. "The houses stand helter-skelter," the protagonist later remarks, "curious contours, steep sloping walls; not at all arranged by the streets."[52] The temporal disjuncture between the two windows in the text's opening paragraphs has similarly disorienting effects and cannot be resolved without the aid of the ear and the exclusion of all visual impressions. So while the protagonist remains unable to visually synthesize night and day, this temporal disparity indirectly foreshadows their subsequent reconciliation and merger in the ecstatic moment of spatial hearing depicted in the text's final paragraphs. Indeed, still situated between the two windows and with his eyes willfully diverted, this temporal disparity soon gives rise to a mobile ear, which is transformed into an architectural structure: "Two legs finally come through the night. The footstep of two female legs and the ear. I don't want to look. My ear stands in the street like an entrance. I was never so unified with a woman as with this unknown one, whose steps disappear more and more deeply into my ear."[53] The passage begins by attributing to the sound physical solidity in the form of a fragmented and anonymous body. The protagonist first describes the sounds as "two legs." He not only registers the amorphous auditory impressions of the footsteps but also identifies the sounds as parts of the human body. In the following line the listener assigns gender to the invisible sounds, now describing them as "the footstep of two female legs" and further situating them in relation to "the ear" by means of a mere conjunction without the mediation of a grammatical subject. Although she remains invisible to the protagonist, the footfalls provide a remarkable amount of information about the identity of the figure producing the sounds.

Finally, reaching out from the room and resting at a point along the corporeal source's presumed trajectory through space, the protagonist situates his wandering ear at a point on the street that will enable him to effortlessly intercept the approaching footsteps. "The diotic sounds are more robustly shaped," Hornbostel remarked in his 1923 essay, "they are things that are aurally perceived, which, at rest or moving, are in the same space as those things that one sees."[54] And while in Musil's text only a single ear moves out to embrace the woman on the street, the number two pervades the text; two windows, two temporalities, two legs, the stranger on the street and her undisclosed companion.

Musil's formulation is again revealing of the particular ontology of sound the text posits, as well as the temporal conditions that structure the fleeting moment of unity. On the one hand, the mere perception of sound initiates a sexually charged experience that merges listener and sound source through a remarkable reversal of gender stereotypes, whereby the female passerby assumes the role of phallus and infiltrates the vulvar ear of the male listener. "I was never so unified with a woman as with this unknown one" (Niemals war ich mit einer Frau so vereint wie mit dieser unbekannten), he remarks (G, 575). The registration of the footsteps by means of the ear results in the comprehensive fusion of the two figures, suggesting that purely auditory impressions can stand in for a body.

On the other hand, it is specifically the *sound of* the woman's footsteps and not her body that is described as entering the ear. The genitive construction that links the sound of footsteps to a discernible source distinguishes the episode from the ideals of *musique concrète* or other modes of acousmatic listening, in that the sound is perceived not as pure sonorous material but rather with recourse to certain nonauditory characteristics of its source.[55] It is the sound *of* the woman, identified as female and lent partial physicality in the form of fragmented corporeality, that enters the ear. In this way, Musil suggests that the thingness of sound can never be severed from corporeality, on the side of both the listening subject and the sound source. The union between the two figures materializes out of intermingling metonyms, with the ear standing in for the listener's body and the sound for the woman's. It is this interaction of sound as body and body as sound, indeed their overlap and codetermination, that I am arguing constitutes the thrust of Musil's elaboration of a poetics of acoustic space.

At the same time, the materialization of the auditory thing as a quasi-corporeal merging of bodies follows from a series of spatializations at the level of both form and content: the text's mixed temporalities, the mobility of the ear, and its opening up as a kind of architectural space unto itself. Musil's text intimates a mode of perception uniquely attuned to the thingness of sound. But for the reader recognition of that perceptual shift occurs amid a series of formal disruptions to the narrated experience of space and time. The issue of narrative space and its relation to temporality is one Musil

Toward a Modernist Ear

would take up explicitly in his unfinished novel, *The Man Without Qualities* (Der Mann ohne Eigenschaften). There he voiced his criticism of narrative conventions that sidestepped "the overwhelming plurality of life " (der überwältigenden Mannigfaltigkeit des Lebens) in favor of the "unidimensional" (Eindimensionalen), a tendency that, according to Musil, relied on the temporal organization of narrative as "the orderly sequence of facts" (das ordentliche Nacheinander von Tatsachen) and was epitomized grammatically in conjunctions such as *when* (als), *before* (ehe), and *after* (nachdem).[56] "The Believer" avoids any use of grammatical markers of linear time. Instead, it displays the failure of textual simultaneity through an impossible simultaneity experienced as temporal disjuncture. Indeed, the entire text is organized around an extraordinary experience of time, in which night and day coexist in irresolvable tension.

It is telling that one of the few changes Musil made in the final published version from 1936 was to the temporal dynamic of the union experienced in the text's final lines. Whereas the original draft from 1924 uses the past tense—"was never so unified with a woman" (war [niemals] mit einer Frau so vereint)—the revised version relies on the future tense: "will never be so unified with a woman" (werde [niemals] mit einer Frau so vereint sein).[57] The past and future tenses of the two drafts enact a temporal disjuncture analogous to the diverging temporalities framed by the two windows at the text's start. Yet, in shifting the verb to the future tense for the final version, Musil opts to present the union as perpetually deferred. In this way, the revised formulation underscores the auditory thing's embeddedness in formal structures used in narrating time and, more specifically, narrative strategies of simultaneity that defer rather than circumscribe, keep open rather than close and demarcate. The diffuseness of sound, postulated by theorists of auditory experience but contested by experimental psychology, becomes, in Musil's literary texts, an expansiveness of narrative temporalities in the name of possibility.

This lack of resolution stands at the heart of Musil's figuration of listening in "The Believer." Just as the woman's footsteps become audible, the protagonist suddenly observes, "My ear stands in the street like an entrance." How exactly the ear came to rest in the street remains an open question, covered over by the abrupt transition from a listening position inside the domestic sphere to one outside on the ground.

On the one hand, the elision suggests that the ear has been solicited and drawn out by the woman below. Here it is important to note the erotized nature of the encounter, which is triggered by the sound of "the step of two female legs." The attribution of gender in the absence of vision implies that something about the sound itself communicates that its source is a woman. A gendered footstep would most likely be the result of the identifiable sound of high heels, a highly fetishized object commonly associated with wanton female sexuality. As Eduard Fuchs argued in his *Illustrated History of*

Morality from the Middle Ages to the Present (*Illustrierte Sittengeschichte vom Mittelalter bis zur Gegenwart*), the heel was suited only for a woman, "who . . . first and foremost had to fulfill the function of a sex tool" (die . . . in erster Linie die Funktion des Geschlechtswerkzeuges zu erfüllen hat), and whose sole intention was stimulating male sexual desire.[58] Thus the extension of the ear into the street is less a willful act on the part of the listener than the result of seduction, which leaves the male protagonist overwhelmed by desire and called forth by the siren song of an anonymous sexual encounter. Seen in this light, the clicking of the heel against the pavement commands the ear down to a position on the same surface, where it waits passively for the woman to enter, in a reversal of traditional gender roles and sexual anatomy.

On the other hand, the ear's elided transition from the domestic sphere to the street suggests that the protagonist voluntarily reaches out to meet the woman's footsteps halfway. Reminiscent of the *Richtungshörer*, which artificially increased the distance between the ears and extended their reach beyond the human frame, the ear in this final moment moves into previously inaccessible spaces, stretching out through the window and positioning itself on the surface of the street below. In scientific discourse, the ear's lack of mobility served as an argument against auditory space. "Supply the ear with the possibility of multifarious movements and hearing becomes a spatial sense," Arthur Henry Pierce wrote in his summary of positions held by opponents of acoustic space.[59] And at the same time as the *Richtungshörer* provided the ear with a form of prosthetic mobility, it also engendered more flexible and dynamic modes of listening. A former member of a German sound-ranging unit, for example, employed the verb *to listen outward* (lauschen hinaus) to describe his activities behind the device, thereby suggesting a more active form of listening *out into space*.[60] Musil's literary account of acoustic space testifies to precisely this dynamic quality of the ear. Once static and anchored firmly onto the sides of the listener's head, the ear now moves through space and actively seeks out its aural objects.[61]

By transferring laboratory procedures to the domestic sphere, Musil reveals the ecstatic potential of nineteenth-century science's separation of the senses.[62] The isolation of a single sense modality was no longer a technique limited to scientific practice, but rather circulated from the laboratory, through the battlefield and sites of popular culture, to the pages of literary modernism. Nor did it assume a purely negative role in aesthetic discourse, as something to fight against or reject in favor of the more integrated sensorium allegedly operative in earlier historical periods. As Musil demonstrates in "The Believer," the fragmentation of the sensorium instead provides a foundation for exploring the possibility of ecstatic experiences within the confines of modern forms of rationalization.

Both Musil and his former colleagues at the Berlin Institute for Experimental Psychology present models of a more active listener capable of navigating the spaces occupied by aural objects rather than lost in the caverns of an

auditory field perpetually open to attack. But whereas Hornbostel and Wertheimer's theory of spatial hearing seeks to outline the ways human beings ordinarily orient themselves, albeit under artificial laboratory conditions, Musil is concerned with the ear's openness to ecstatic moments of transcendence, to perceptual experiences outside the realm of the everyday. Musil's literary appropriation of contemporaneous discourse on auditory space therefore takes Hornbostel's comments one step farther, investing sound not only with a material presence in space or a kind of corporeality, but with the capacity to open up mystical, erotic moments of unification with purely auditory bodies.

Sound/Film: The Evolution of Musil's "Other Condition"

Musil's portrayal of the transcendent auditory experience in "The Believer" occurs at nearly the same time as one of his earliest formulations of the Other Condition, a notion that was intended to encompass experiences outside of instrumental reason, purposefulness, and active contemplation. The Other Condition would become an especially important category of experience in *The Man Without Qualities* (1930–42), which tells the story of transgressive love between two siblings on the eve of the Habsburg Empire's collapse.[63] There, Musil had suggested strong parallels between an alternative condition, religiosity, and the outbreak of war. In the final sections of *The Man Without Qualities*, he refers to "the religious element in the outbreak of the war" (das religiöse Element im Kriegsausbruch) and states unequivocally, "War is the same as 'the Other Condition.'"[64] As we have seen in Musil's war writings and their transposition to "The Believer," this collapsing of war and the anticipation of religious experience was facilitated by the ear and its newfound ability to track and analyze auditory bodies as they moved through space.

Although Musil had explored the intrusion of various hypnogogic and dreamlike experiences into the realm of the everyday as early as his first novel from 1906, *The Confusions of Young Törleß* (*Die Verwirrungen des Zöglings Törleß*), it was only in the early 1920s that he first attempted to flesh out the perceptual and ethical implications of this kind of nonrational, quasi-mystical state. During the period in which he composed "The Believer," Musil explicitly mentions the Other Condition in a diary entry on Ludwig Klages's mystical 1922 treatise, *Of Cosmogonic Eros* (*Vom kosmogonischen Eros*).[65] And less than one year after the publication of "The Believer" he would compose his essay "Toward a New Aesthetic: Observations on a Dramaturgy of Film," considered to be the definitive account of the Other Condition.[66]

The notion's explicit connection to the medium of film, along with later borrowings from Hornbostel's theoretical writings on visual space and optical inversion, has tended to obfuscate Musil's concurrent exploration of transcendent experiences triggered by auditory phenomena and acts of close

listening. My intention here is to introduce other sense modalities into the concept's development to complicate exclusively visual accounts. An attentiveness to the auditory dimension of the Other Condition offers a concrete example of ongoing interactions between scientific theories of hearing and literary texts. Although Hornbostel concludes his 1923 essay on binaural hearing by praising music as a "gift from the heavens" (Geschenk des Himmels) and the "strongest, because most immediate, language of the soul" (stärkste, weil unmittelbarste Sprache der Seele), Musil's emphasis on the ecstatic potential of close listening and spatial hearing is not self-evident in this and other scientific writings.[67] On the one hand, his literary appropriation remains committed to long-standing characterizations of visual perception as an objectifying force and hearing as inherently subjective and thus more prone to hallucinations, perceptual error, and the nonrational. On the other hand, Musil transforms the possibility of subjective hallucinations—portrayed in Kafka as a source of destabilizing, paranoid terror—into intimations of God's presence and divine intervention.

However, these supernatural elements are then juxtaposed with depictions of the ear gleaning information about the nature of its sound sources and tracking their movements through space. Indeed, it is the very act of following sounds through space that gives rise to these ecstatic experiences. In Musil's various accounts of his near-death experience on the battlefield, the weapon's gradual descent is accompanied by the sound's transformation into a living organism and eventually the presence of God within the listener's body. In "The Believer" the ear extends out into the street, easily locating the sound of the footsteps and allowing them to enter the protagonist's body and initiate a brief erotic union with the stranger. Methods of auditory localization and demonstrations of the ear's capacity for spatial orientation become constitutive elements in literary figurations of transcendent perceptual experiences. In migrating from the experimental laboratory to the realm of literature, Hornbostel's notion of "things . . . aurally perceived" becomes a conduit to altered states of perception and experience diverging from the everyday.

Finally, a closer examination of sound's ecstatic potential enables us to move beyond the privileging of a single sense modality as primary or most significant in Musil's writings and to begin to analyze the commonalities between ecstatic experiences grounded in vision and those tied to listening. There is even something one might call cinematic about the act of close listening portrayed in "The Believer." The ear that moves out to meet the sound of the footsteps can be said to imitate the film camera zooming in on a particular figure or object through the close-up. Béla Balázs—whose theoretical reflections on silent cinema stand at the center of Musil's filmic conceptualization of the Other Condition in his essay "Toward a New Aesthetic"—identified the close-up as the "the poetry of the cinema" (Poesie des Films), a technique that brings the viewer close to "the individual cells of life matter" (einzelnen Zellen des Lebensgewebes) and "allows us to feel the texture and substance

Toward a Modernist Ear

of life in its concrete detail" (läßt uns wieder Stoff und Substanz des konkreten Lebens fühlen).[68]

The moment of ecstatic unification experienced by the protagonist of Musil's literary narrative is likewise triggered by the isolation and magnification of the woman's footsteps, which are heard at such proximity that they actually cross over and enter into the organ perceiving them. But it is not only the movement of the ear and efforts to isolate a single sound that invoke the cinematic close-up, it is also the image of the ear itself as both detached from the listener's body and large enough to stand in the street as an "entrance" (Eingang). Both images recall Huelsenbeck's use of the close-up to draw attention to the hair jutting out of the pastor's ear in "Plane." "The pathos of the large is an effect," Balázs observed, "in which the film has no equal."[69]

More straightforwardly, Musil's representation of visually and acoustically induced altered states coincide in their isolation of a single sense modality. In "The Believer" the protagonist's union occurs in total blindness with his eyes willfully closed. The exclusion of visual impressions was a central feature of scientific research on spatial hearing. Conversely, in Musil's essay on film it is the *exclusion of sound* that renders the cinematic image a productive model for the Other Condition. According to Musil, the awakening of the symbolic face of things "in the stillness of the image" (in der Stille des Bilds) constitutes a distinctly "wordless experience" (wortloses Erlebnis), implying that it is not only sound but language too that must be barred from entering the frame.[70]

The trajectory from Altenberg and the tympanic regime to Musil and the ecstatic potential of spatial listening does not imply a resolution to the epistemic confusion, embodied vulnerability, and challenges to the symbolic that accompanied the emergence of the modern soundscape. "The Believer" portrays an almost idiosyncratic confidence and clarity on the part of the listening subject, which, as we have seen, was deeply bound up with both contemporaneous scientific research on sound space and the soundscapes of World War I. In contrast to most of his contemporaries, Musil's listener appears to willfully reach out with the ear to make contact with the external world, rather than retreating in surrender amid a barrage of unwanted sound. Moreover, the presence of the ear's physicality in the narrative does not signal an openness to attack or hypersensitivity but rather a yearning for intimacy and transcendence beyond the everyday.

At the same time, our initial understanding of the protagonist as lacking agency leaves open the possibility that he has surrendered to the sound rather than intentionally seeking it out. The connection established between the forceful clicking of the stranger's heels and the ear's subsequent position on the same surface, passively waiting for the footsteps to enter it like a doorway, hint at lingering elements of the tympanic regime, whereby sonic objects assume often devastating proximity to the listener's body. The move from Altenberg to Musil should, in any case, not be understood as a paradigm shift, according to which one mode of listening or conception of sound

is simply replaced by another. Instead, their juxtaposition gives expression to ongoing tensions between the rationalization and technological ordering of acoustic space, on the one hand, and the dismantling of spatial and conceptual boundaries amid noise and sensory overload, on the other.

Musil's poetics of auditory space in "The Believer" and his war writings outline alternatives to the unboundedness of acoustic modernity, emphasizing the ear's capacity for spatial orientation and the sense of solidity, corporeality, and localizability of spatially constrained sounds. However, such modes of listening were largely suppressed by the material realities of the modern city and the proliferation of radio technology in the domestic sphere. As Musil and the modernists signaled the end of the tympanic regime, percussive surfaces gave way to immersive spatializations of sound, a single eardrum to the binaural audition of acoustic space. The ear was opened up and readers of literary works taken deeper into its internal spaces, passageways, and labyrinths. It is here, in other words, that we can enter Kafka's underground burrow with an understanding of its historical specificity vis-à-vis the rise and fall of the tympanic regime.

Chapter 5

Into the Inaudible

Sound and Imperception in Kafka's Late Writings

> It's really nothing, I sometimes think, no one outside of me would hear it.
> —Kafka, "The Burrow" (1923–24)

> Here, through the effort to improve radio technology, a door has unexpectedly opened into a mysterious world that today we can only imagine.
> —Klötzel, "Radio" (1924)

Even among his modernist peers, Franz Kafka stands out as someone almost obsessively committed to documenting the particularities of auditory experience in his literary writings. One of his earliest publications, "Great Noise" (Großer Lärm; 1912), simply offered a narrative inventory of disruptive sounds produced by members of Kafka's family in the course of their morning routines in a shared apartment. The text, which was taken almost verbatim from his diary, begins by emphasizing the militaristic connotations of *Lärm* and the superimposition of the martial soundscape onto the domestic sphere. "I am sitting in my room in the headquarters of noise of the entire apartment," he writes from a position at the center of the alleged sonic maelstrom.[1]

Subsequent letters and diary entries are filled with complaints about the disruptive noises that surround the author as well as his ongoing efforts to find material means to subdue them.[2] As someone "persecuted by noise" (von Lärm verfolgt),[3] Kafka modified the spaces in which he lived to make them more acoustically insulated,[4] and as early as 1915 began wearing earplugs to block out noise while writing.[5] Even in rural settings at the end of his life, he spoke of a "fear of noise" (Lärmangst) and "days of noise" (Lärmtage),[6] and remarked that, as a result, the use of earplugs was a necessity.[7]

119

120 Chapter 5

Similarly, literary works such as *America* (1911–14), *The Trial* (1914–17), *The Castle* (1922), "Silence of the Sirens" (1917), "The Neighbor," "Investigations of a Dog" (1922), "The Burrow" (1923–24), and "Josephine, the Singer or the Mouse Folk" (1924) depict environments pervaded by noise, eavesdroppers, and acoustic media, which in turn provoke larger questions related to meaning and illusion, space and power. If in ordinary life noise permeated the spaces in which Kafka wrote, it also could not be kept out of the works he produced under those same acoustic conditions. What was viewed in his ordinary life as a disruption to writing became a privileged object of Kafka's fiction.

The porous domestic sphere was just one of several spaces in which Kafka encountered modern noise. As an insurance lawyer who regularly visited factories as part of his job, he was well acquainted with the cacophony of the industrial soundscape and its effects on workers.[8] "Yesterday in the factory," he wrote in a diary entry from 1912, "the girls in their unbearably dirty and tattered dresses, with messy hair as if they had just woken up, with the continuous noise of the transmission belts."[9] Two years later, as he began work on *The Trial*, he compared the disruptive noise outside his hotel room to that heard in "a machine factory" (einer Maschinenfabrik).[10] In his professional capacity, he helped introduce a safer and quieter wood-planing machine, which, as he put it, eliminated "that howling of the square shaft . . . which displays its danger formally" (jenes Heulen der alten Vierkantwellen . . . , welches förmlich ihre Gefahr anzeigte).[11] He additionally cited the safety risks posed by workers suffering from vertigo, hearing impairment, and other hearing disorders, especially after a loosening of safety standards due to the war and the return of traumatized and physically damaged soldiers to the workplace.[12]

Particularly striking to Kafka was the parallel between trauma produced on the battlefield and the psychological effects of industrial labor. He wrote in a 1916 article, "Just as in the peacetime of the last decades intensive industrial machine works have endangered, disturbed and rendered ill the nerves of those working in them incomparably more than ever before, the monstrously intensified mechanical aspect of today's wartime activities has caused the most severe risks and suffering for the nerves of our soldiers."[13] According to Kafka, the factory and the battlefield engendered a common set of medical disorders affecting, among other things, the ears of both soldiers and workers. If Kafka had earlier figured the domestic sphere as a "headquarters" of noise, in his 1916 report he indicated growing continuities between the mental and somatic consequences of war and work.

In *The Trial* Kafka appropriated elements from the industrial soundscape to illustrate that the legal process possessed the ability to enter the defendant's body through the ear. In the stifling atmosphere of a court office, the protagonist, Josef K., begins to experience symptoms of vertigo and nervous sensitivity, which give way to a mysterious, high-pitched siren that appears to come from nowhere:

Into the Inaudible *121*

In reality it would have done him well to sit down; it was like he was seasick. He thought he was on a ship that was on a rough sea. To him it was as if the water fell against the wooden walls, as if a roar came from the depths of the hall, like from breaking water, as if the hall was rocking in the way and as if the awaiting parties sank and rose on both sides. Even more unbelievable was the silence of the girl and man leading him. He was handed over to them, if they let him go he would fall down like a board. From their eyes came sharp glances here and there; K. felt their uniform steps without joining in, for he was carried almost step by step. Finally he noticed that they were talking to him, but he didn't understand them, he only heard the noise that filled everything [den Lärm der alles erfüllte], throughout which there seemed to resound an unchanging, high tone like from a siren. "Louder," he whispered with his head down and felt ashamed, for he knew that they had spoken loud enough, even if it was unintelligible to him. Finally a fresh breeze came toward him, as if the wall was torn down in front of him, and he heard someone beside him say: "First he wants to leave, but then you can tell him a hundred times that the exit is here and he won't move."[14]

In a space pervaded by dust and debris, the protagonist perceives an expansive noise "that filled everything," out of which the distinct sound of a siren can additionally be heard. Set against the maritime imagery of a ship at sea and feelings of seasickness, Kafka's allusion to the siren clearly invokes Odysseus's encounter with the sea creature of the same name. Yet in 1914 the figure of the siren would have had associations beyond the purely mythological, also recalling the sound used to demarcate the workday in a factory.[15] In this way, the sudden noise heard in the court office calls to mind both the captivating song of the mythological creature and the soundscape of the modern factory, both alluring and alarming.

While the sound of the siren as an object of auditory perception serves to bind the court and factory, the manner in which it is heard underscores the connection. Because the two court officials continue to speak to the defendant in a normal tone of voice despite his plea that they speak "louder," one gets the sense that the protagonist is the only one able to hear the sound, that the siren is a subjective noise with no referent beyond the listener's own body or mind. The concomitant onset of vertigo and subjective noises resonates with contemporaneous medical reports on factory accidents and worker illnesses involving the ear. Due to perpetual exposure to the din of industrial machinery, factory workers commonly experienced symptoms of vertigo and the sudden eruption of subjective noises. In an essay titled "Ear Medicine and the Expert Evaluation of Accidents," for example, one medical scientist noted that factory workers often complained of "ear noises of the most varied kind, temporary and continuous, buzzing, roaring, ringing," as

well as "symptoms of vertigo when bending down or looking up."[16] Describing a study on hearing loss in professional boilermakers, another researcher noted that "subjective noises appear in nearly half the cases. Vertigo appears in advanced cases now and again."[17] Other studies from the same period stated that "symptoms of vertigo and disruptions to balance are the most constant symptoms after injuries to the auditory organ," recounting various cases in which workers suffered from "attacks of vertigo and persistent subjective noises" (Schwindelanfälle und persistente subjective Geräusche) after spending extended periods of time "in an extremely loud workshop" (in einer sehr geräuschvollen Werkstatt).[18] By situating an experience of vertigo in close proximity to auditory hallucinations, Kafka's novel invokes a cluster of symptoms prevalent among factory workers to portray the coercive power of the court. As if taken from the pages of a medical study surveying the health risks of the industrial workplace, Kafka's protagonist both perceives the distinct sounds of the factory and registers its effects on the ear. In this way, the siren gestures back to a mythological past but remains anchored in the industrial present, simultaneously the epitome of auditory enchantment and sonic rationalization.

Ultrasonics and Virtual Warfare

The Trial points to the virtualization of noise arising from the protagonist's experience of acoustic embodiment. Unlike earlier authors who depicted the physical vibrations of sound as an assault from without, Kafka's noises are positioned ambiguously between the corporeal registration of sound and pure hallucination. Noise continues to persecute the modern listener but, in being tethered to the body, also erupts from within the subject. In this way, *The Trial* resonates with Kafka's later works, which are characterized by an ongoing inability to distinguish between sound and silence, with the latter offering an echo chamber for auditory hallucinations and paranoid projections of external persecution. In "The Silence of the Sirens," the narrator describes a modified version of the Odysseus myth in which, with his ears plugged, the hero paradoxically fails to hear the sound of their silence.[19] In "Investigations of a Dog," what the protagonist initially perceives as the "creation of a horrifying noise" (Hervorbringung eines entsetzlichen Lärms) and "a barely audible, yet fanfare-blaring music . . . coming from everywhere" (von überall her kommenden . . . kaum hörbar noch Fanfaren blasenden Musik) he later suspects to be nothing more than an auditory hallucination induced by hunger and hypersensitivity.[20] Finally, audience members entranced by the mouse singer, Josephine, struggle to distinguish her musicality from mere "whistling" (pfeifen), speculating that her performances may have been "silent" (stumm) all along, nothing more than the echo of "a mere memory" (eine bloße Erinnerung).[21] In all of these cases, boundaries between

Into the Inaudible 123

articulate speech, song, and noise, silence and sound, are challenged and ulti-
mately dismantled by referring back to the inherent subjectivity of listening
and ambiguities of embodied sound.

It is in Kafka's penultimate text, "The Burrow," that we find the problem-
atic of embodied listening articulated against the backdrop of the battlefield
and modernist techniques of sonic warfare. The unfinished narrative tells
the story of a sensitive mole-like creature with scientific pretensions who is
determined to maintain silence and security in its underground home and
becomes obsessed with locating the only disruption to this tranquillity: a
repetitive, almost inaudible whistling and hissing sound with no obvious
external source.[22] After conducting various investigations into the origin of
the disruptive sound using scientific modes of empirical observation and his
acute sense of hearing, the creature finally convinces itself that, despite a lack
of clear evidence, the noise must come from an antagonistic invader.

The ambiguity surrounding the sound's true source, which is exacerbated
and rendered nearly irresolvable by the text's contradictory and unreliable
first-person narration, has been widely discussed and assessed by critics.[23]
More recently, Brian Kane has utilized the text to formulate a broader rebuke
to the so-called ontological turn in sound studies, reaffirming "the relevance
of research into auditory culture, audile techniques, and the technological
mediation of sound in favor of universals concerning the nature of sound, the
body, and media."[24] However, Kane's analysis asks us to "imagine a situation
where Kafka finished the story" with the burrower discovering the source
of the sound only to find it "benign." Such an approach, while a produc-
tive counterargument to the alleged universals of sonic experience posited
by affect theory, chooses to interpret the text counterfactually without any
serious consideration of the sound's inherent ambiguity. What makes Kafka's
text so compelling, I argue, lies precisely in the sound's oscillation between
pure hallucination and documented evidence of a real intruder. To ask read-
ers to overlook this ambiguity in Kafka's depiction of sonic experience is to
miss the point.

Rather than settling once and for all whether the sound comes from a
hallucination or an actual intruder, this chapter draws on the notion of sonic
warfare to open up alternative lines of inquiry, reading Kafka's text as a move
away from the tympanic regime toward modernist modes of self-reflexivity
and second-order observation. At issue is not simply the corporeal registra-
tion of noise from without but rather modes of attending to the noise of the
body itself, listening inside the ear, and reflecting on how hearing operates,
which in turn engender a kind of sonic warfare waged from both inside and
out. At the same time, Kafka tells his tale according to a unique narrative
temporality absent from earlier iterations of sonic warfare in naturalism,
impressionism, and Dada. Neither the retrieval of collective memory and its
restaging in the present (Altenberg) nor the imposition of a simulated real
time to accentuate the aggression of a live performance (Huelsenbeck), sound

operates in "The Burrow" according to a temporal logic that both flattens past, present, and future and renders audible the sound of an always already present past. Sound in "The Burrow" does not recall some past event. Nor does it imply an inescapable present imposed on readers and spectators as a way of intensifying its effects. Instead, the coincidence of narrative and narrated time gives rise to the insight that sound in the present is simply the result of rendering audible what was formerly present but imperceptible in the past. Unlike Musil, who depicted the simultaneity of competing temporalities as enabling spatial listening and the recognition of auditory bodies, in Kafka it is the perception of an auditory body that helps to recover the past and bind it to the present.

In this way, Kafka's literary representation of sound and hearing in "The Burrow" reinforces the modernist break with the tympanic regime already intimated by Musil. Indeed, one would search in vain for any reference to the eardrum in Kafka, let alone drums, percussive force, or any trace of sonic contact with an outside. Combat occurs instead as the virtual projection of previously imperceptible sounds, the terror and paranoia engendered by an echo chamber of silence and confusion concerning the line between internal and external auditory phenomena. The historical moment in which Kafka composed "The Burrow" witnessed a newfound appreciation for sounds that were physically present but imperceptible to the ears of human listeners. Conversely, Kafka depicted sounds that were audible but perhaps nothing more than the products of the listener's own body. Between these two poles, sonic warfare constituted itself as a perpetual but indeterminate assault, the dissemination of barely audible noises or hallucinations with no identifiable source, which were nonetheless capable of modulating affect and influencing the subject's behavior. The underground burrow of Kafka's penultimate text, then, becomes a model for a new kind of battlefield, one not limited to audible vibrations and the physical force of noise but also aimed at unsettling clear distinctions between sound and its absence, enemy and the self.

At the time Kafka composed "The Burrow," the auditory imagination was not simply shaped by radio and the wireless transmission of sound. In an article published in the *Prager Tagblatt* on February 7, 1924, a certain C. Z. Klötzel reported on experiments with radio by the American engineer Phillips Thomas, who had recently introduced a supersensitive microphone capable of capturing and transmitting ultrasonic vibrations otherwise outside the range of human audibility.[25] In constructing his microphone, Thomas removed the vibrating membrane and replaced it with a mechanism involving the flow of light at high voltage between two electrodes surrounded by insulating material. Similar to the vacuum tubes and condenser microphones undergirding ordinary radio technology, which replaced notions of inscription and tympanic transduction with capacitance and thermiotic emission, Thomas's ultrasonic microphone looked beyond the tympanic regime, removing all

Into the Inaudible 125

vibrating parts in the service of capturing sounds beyond the threshold of human audibility.[26] As the article explained, Thomas had discovered

> the ability . . . to make sounds perceptible, which the human ear is not capable of registering [aufnahmefähig]. As we know, we cannot hear tones whose number of vibrations per second is over or under a certain limit. We only hear a very small part of the horrible noise [Lärm] that also fills the world whenever, for example, we find ourselves in the quiet regions of eternal snow. We hear neither the incessant sound of the snowfield, in which the small particles are in constant motion, nor the sounds created by our own bodies through the movement of the muscles."[27]

According to the article, the ultrasonic microphone would render the otherwise inaudible sounds of snow and the body perceptible to human listeners, whose ears were ordinarily limited to a range of 20 to 20,000 hertz. The field of ultrasonics attracted the attention of navy engineers who saw its potential for underwater sound transmission. In the decades that followed, scientists continued to explore ultrasonics in connection with both military and animal communication, from inaudible insect songs, through bat echolocation, to submarine technology.[28] Gustav Janouch claimed that Kafka showed an interest in the burgeoning field of "vibrations which are otherwise inaudible and unperceived." Asked what he thought of such phenomena, Kafka was said to reply, "There are of course also sound waves which are inaudible to the human ear," allegedly citing research by a French scientist who had recently investigated forms of insect communication inaudible to human ears.[29]

Inside the Ear

Instead of microphones and vacuum tubes, in Kafka's narrative it is the passage of time and the listener's gradual merger with the space in which he lives that make possible the translation of the inaudible into the audible. The burrow itself is simultaneously abstract and highly heterogeneous, a site of extreme solitude and the reduction of social life to bare life. But it also weaves together a diverse range of concrete spaces and environments—from the anatomy of the ear and infected lungs, through the scene of writing, to the battlefields of World War I.[30] As Wolf Kittler argues, the burrow reflects the historical realities of trench warfare, which Kafka knew through textual accounts.[31] Translating this historically specific battlefield into the domestic sphere, the trenches become the corridors and rooms of the mole-like protagonist's underground home, a site for the creature's scientific experiments, and eventually one-on-one combat with an unverifiable enemy.

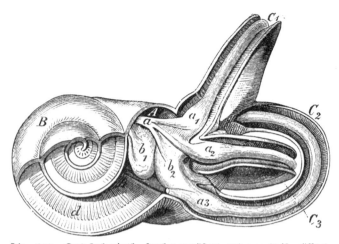

Fig. 500. Das Labyrinth, stark vergrößert und zum Teil geöffnet. A Vorhof. B Schnecke. C₁, C₂, C₃ die drei Bogengänge des Labyrinths. a Ast des Gehörnervs. a₁, a₂, a₃ Flaschenförmige Erweiterungen (Ampullen) der Bogengangsschläuche. b₁ Kugelförmiges, b₂ elliptisches Säckchen. d Spiralplatte.

Figure 16. Anatomy of the ear as a kind of "tunnel space," from a textbook Kafka encountered as a student. From Paul Wossidlo, *Leitfaden der Zoologie für höhere Lehranstalten*, 5th ed. (Leipzig: Fischer & Wittig, 1890–99?), 306.

At the same time, the burrow's spatial structure draws on a set of metaphorical terms used for the anatomy of the ear.[32] While Kafka's literary text refers to the burrow's "canals" or "passageways" (Gänge; *B*, 467), "the narrow and thin-walled canals of the labyrinth" (die engen und schwachwandigen Gänge des Labyrinthes; 485), the "labyrinth structure" (Labyrintbau; 473), and "entry labyrinth" (Eingangslabyrint; 473), medical scientists employed an almost identical set of spatial metaphors, citing the "auditory canals" (Gehörgänge) and "walls" (Wände) of the ear, as well its "stairs" (Treppen) and "circular window" (das runde Fenster).[33] They also vehemently defended their use of the metaphorical term *labyrinth* (Labyrinth) for the inner ear as "completely justified" (durchaus berechtigt) due to the region's peculiar shape and spatial layout.[34] Set in the specific context of an underground burrow, the imagery of Kafka's narrative overlaps with medical texts that described the physiology of the inner ear as a kind of "tunnel space" (Tunnelraum; see figure 16).[35]

The amalgamation of military and sonic registers is given voice in the text through repeated characterizations of the burrow as a living organism, as a "great sensitive work" (große[s] empfindliche Werk) capable of experiencing pain (*B*, 502). Analyzed alongside the burrow's heterogeneous composition of figures associated with both the modern battlefield and the ear itself, the disruptive hissing noise, which the protagonist views as a threat to his

physical safety, can be read not as a sign of madness but as an unintended and unidentified byproduct of the listener's body that underwrites the creature's paranoia. In short, what we find is that acoustic embodiment engenders a virtual battlefield that encompasses the spaces of the burrow and the listener's body. It is within this hybrid space, which dismantles clear distinctions between inside and outside, organic and inanimate, and merges the body with war, that the means of sonic warfare expand into the domains of the hallucinatory and inaudible.

Such a claim is supported by the text's thematization of self-observation, which serves primarily as a means for the creature to conduct scientific experiments and visual surveillance in anticipation of approaching intruders. The protagonist is shown carrying out various scientific activities, frequently employing notions of experiment, calculation, and observation in the construction and surveillance of the underground home. Inside the burrow the creature constructs "experimental excavations" (Versuchsgrabungen; 487) and an "experimental field" (Versuchsgebiet; 490) to corner its enemy. Elsewhere, we watch as it builds "experimental trenches" (Versuchsgraben; 478) and conducts "half and tenth experiments" (Halb- und Zehntelversuche; 478) to practice its escape just outside the entrance of the burrow. Throughout the text, the incommensurability between hypothesis and empirical evidence is cited as one of the primary reasons for the creature's anxiety and increasingly frenetic behavior. "But precisely the fact that [the noise] remains the same at all points bothers me the most, for it cannot be reconciled with my original assumption."[36] In one scene, we watch the creature's strained efforts to assume the roles of both scientific researcher and experimental subject: "I crawl into the trench, close it after me, wait meticulously calculated periods of time, long and short, at various hours of the day, then fling off the moss, come out from my hole and record my observations [registriere meine Beobachtungen]. I have the most varied experiences, both good and bad; but I have not been able to discover a universal principle or an infallible method of descent."[37] In its multiple allusions to experimentation, observation, and the detailed recording of data in the hope of establishing general laws, the text depicts the creature as an experimental scientist, one eager to incorporate its own body into the experimental protocol. Through the frantic experimental procedure the protagonist races back and forth between the trench and its observational post, oscillating between the positions of observer and observed, struggling to occupy both internal and external spaces simultaneously.

"It went so far," the protagonist remarks with regard to his surveillant activities, "that I sometimes had the childish wish . . . to spend my life in the observation of the entrance and to hold it in sight forever."[38] The desire to keep the burrow's entrance forever in sight is thus revealed to be a fantasy of uninterrupted self-observation, further confirmed in the following line: "To me it is then as if I stand not before my house, but before myself, as I sleep.[39] What had initially appeared to be the detached gaze of the scientist

128 Chapter 5

examining a specimen turns out to be a mode of visual perception aimed at the observer's own body. The text figures the animal's fantasy of assuming the roles of both experimental subject and scientific observer by conflating body and burrow. In racing between the experimental trench and its observational post, the protagonist enacts a collapsing of distinctions between subject and object, inside and outside, the body and its environs.[40]

This view of the burrow's entrance becomes implicated in the protagonist's fear that it is not alone. Still situated outside the burrow's entrance, the creature begins to suspect another reversal of the roles of observer and observed, in which the conflation of self and burrow is complete: "No," it comes to realize, "I did not observe my sleep, as I had thought, no, much more I am the one sleeping, while the destroyer watches."[41] "If I am being observed by another," Kafka stated in a diary entry from November 1921, "I must of course also observe myself."[42] In a reversal of this logic of specular codetermination, in "The Burrow" the protagonist's self-observation of its figurative body amid fears of surveillance from without engenders the materialization of an invisible enemy. Self-observation, the passage suggests, actually *produces* an enemy whose presence cannot be visually or aurally confirmed. Before even hearing the sound inside the burrow, the creature has already posited the existence of an unverifiable enemy. The disruptive noise heard later merely provides further evidence for what is already suspected—the presence of a surveillant aggressor, one generated in the act of self-observation.

Positioned alongside the text's thematization of self-observation, the burrow's corporeal connotations assume further significance. The sounds the protagonist hears, the text subtly implies throughout, may originate inside the creature's own ears. This point is hammered home in the conflation of body and burrow as the sounds resound in the passageways of a domestic sphere that is described with terminology borrowed from the ear's anatomy. It is an architectural structure evincing characteristics of the auditory organ detached from and inhabited by a listener haunted by mysterious, unlocalizable noises. The creature apprehends the sounds of its own body as emanating from the spaces that surround it in a magnificent figuration of subjective noise. It rightly perceives the sounds as coming from somewhere inside the burrow, a space that echoes the ear's anatomical structure, which in life acts as a resonator for internally occurring sounds. Subjective sound is depicted as an unlocalizable stimulus produced by and within a body we do not fully understand or control. The creature comes to awareness of its embodiment through a practice of self-observation that renders the limits of our self-knowledge legible, figuring this unknowability as a threatening foreign presence.

The protagonist's entry into the spaces of the burrow is directly implicated in the entrainment of its sensory apparatus, shaping its perceptual experiences. The animal notes the way the perceptions of its surroundings cannot be abstracted from the spaces in which they are registered: "I did not hear

Into the Inaudible *129*

[the hissing] at all when I first arrived, although it must certainly have been there; I first had to feel completely at home [völlig heimisch werden] before I could hear it; it is, so to speak, audible only to the ear of the real householder performing his duties."[43] The passage makes the claim that the homeowner is the only one able to hear the noise—namely that embodiment, the "space" in which all sensory perception is registered, is the necessary condition of being able to hear. This evinces a marked anxiety around the fact of our embodiment—unsurprising for an author who had spent the previous seven years listening to his lungs deteriorate under the ravages of tuberculosis and was only months from succumbing.

This anxiety is more clearly articulated on the following page, where the protagonist remarks, "It's really nothing, I sometimes think, no one outside of me [niemand außer mir] would hear it."[44] Such an explicit invocation of subjective noises, the multiple layers of meaning internal to the formulation "no one outside of me," demands to be taken seriously. For, in addition to suggesting that no one *other than* the protagonist can hear the sounds, the phrase contains connotations of externalization, of a space *outside* the protagonist. Again, the noise is audible to the protagonist alone and can only be heard *within* its body, a space conflated with the spaces of the burrow. The conflation that begins with the visual surveillance of the burrow is what engenders a frightening inability to distinguish between sense impressions produced by the body and those emanating from sources outside of it.

Despite the text's subtle incorporation of the ear's anatomy and intracorporeal sound into the narrative mise-en-scène, the creature repeatedly rejects the embodied nature of auditory perception, externalizing and projecting sounds onto the architecture of the burrow and experiencing the noise of the body as a liability, something to be overcome and listened through. At a particularly telling moment during its investigation into the origins of the strange noise, the protagonist pauses briefly to outline its plan for an additional architectural structure within the preexisting burrow. Ideally, it explains, the fortress's square would be further isolated from all surrounding spaces:

> One of these favorite plans of mine had been to isolate the main square from the ground that surrounded it, that is to say, to leave its walls at a thickness about my height and, in addition, to create a hollow space [Hohlraum] of the same dimensions around the central square, except for a small foundation, which unfortunately it would not be possible to detach. I had always imagined this hollow space as the most wonderful abode possible, and not without reason. To hang onto the rounded outer wall, to pull oneself up onto it, to slide down, tumble over and once again have the ground beneath one's feet, and to play all these games literally on the body of the central square [auf dem Körper des Burgplatzes] and yet not actually inside

130 Chapter 5

> it. To be able to avoid the central square, to allow my eyes a break
> from it, to defer the joy of seeing it again to a later time and yet not
> have to do without it.[45]

The construction of this ideal structure and liminal space of free play, the protagonist asserts, would release it from the panicked and obsessive visual observations that had preoccupied it outside the burrow. On an acoustic level it would no longer be forced to listen to the sounds of possible intruders or the hissing of invisible enemies, "but instead to listen in ecstasy [mit Entzücken] to something that completely escapes [it] now: the rustling of silence in the main square."[46]

Despite the sound's affinities with the internal noise of the blood,[47] the ideal scenario inside the burrow is not total and direct immersion. While the creature dreams of constructing an area even more isolated than its already remote underground burrow, it fantasizes about *not* having to occupy the space. Instead, in a revealing formulation, it longs to circle around it, "to play on the body of the central square and yet not actually inside it" (auf dem Körper des Burgplatzes spielen und doch nicht in seinem eigentlichen Raum; *B*, 491). The protagonist's use of the term *body* to describe the stronghold's square at this particular moment is no coincidence. Amid plans for further isolating itself from the external world of embodiment, the creature reinforces the conflative connections drawn throughout the narrative between its own body and the architectural structure of the burrow. Just as it watched what it mistook for its own body from an external perspective, it now imagines listening to the paradoxical but empirically grounded "rustling of silence" from a position not inside but on the margins of the central space. The passage figures the fortress square as an organic body and the dweller of the burrow as an observer listening through its walls, positioned comfortably outside its embodied borders.

Similarly, the audibility of blood thumping in the creature's ears is depicted as a sound that must be *listened through* to ensure safety. "Sometimes it seems to me as if the sound has stopped," he remarks, "there are long breaks, sometimes one misses the hissing sound, as one's own blood is pounding all too loudly in one's ears."[48] The most obvious instance of self-auscultation registers a fantasy that the noise of the body and the disruptive hissing are mutually exclusive phenomena. It is during moments in which the creature's blood becomes audible, the text suggests, that the noise cannot be heard. The noise of the body is thus described as a problem to be overcome; the blood thumps "altogether too much" (allzu sehr) in the creature's ears and this causes it to "miss" (überhören) the acoustic indications of an encroaching enemy. Masking effects produced by the body are imagined to be a risk to the listener's safety, enabling the creature to proceed as if there were no longer any danger when in fact the threat still lies hidden beneath the thumping of blood.

Rather than concentrating on the sound of its blood and engaging in more straightforward practices of self-observation, the protagonist projects the sounds of its own body onto an imagined architectural space. In doing so, it denies the embodied nature of auditory perception, envisioning instead the construction of an ideal fortress square invested with the same acoustic properties as the body, while at the same time insisting on remaining outside the prosthetic architectural body. If earlier descriptions of the burrow's physical structure indicated an externalization of the ear's physiology in the form of labyrinthine passages and entryways, here its internal architecture functions as a constitutive element in a figurative act of listening to the body, with the *Rauschen* produced by internal bodily processes transferred to the void of the stronghold's central square. The structure is an apparatus that permits self-observation but does so under the guise of having the listener listen to its hollow center. With the creature's ear against the wall of the planned space, the erasure of boundaries between the body and its underground home is complete. Although ostensibly aimed toward the murmurings of an empty center, the ear is in fact directed toward itself, compelled to listen to the subject listening amid the precarious silence of the burrow.

If *Rauschen* serves as the burrow's acoustic ideal, epitomized by the creature's fantasy of an empty container of enclosed silence capable of being listened to from without, the sound of the outside world is characterized, somewhat predictably, as *Lärm*. While the disruption to the silence believed to come from a malevolent intruder begins as "a per se barely audible hissing" (ein an sich kaum hörbares Zischen), it is subsequently identified with the more aggressive and intense sonic category *Lärm* and the imagined enemy characterized as a "noise maker" (Lärmmacher; *B*, 493). Assumed to be under attack from without, the creature laments that his treasured *Burgplatz* "has been caught up in the noise of the world and its dangers" (ist hineingerissen worden in den Lärm der Welt und ihrer Gefahren; *B*, 499). Here the designation *Lärm* refers to the intrusion of the external world into the creature's private sphere, bringing with it all the dangers assumed to lurk outside its borders. The fact that the creature appears to equate a barely audible sound with *Lärm* underscores the latter term's independence from audible qualities of sound. At first glance, the sound of an animal slowly digging with its claws through the earth bears no resemblance to a category of noise typically reserved for cities, battlefields, and factories, soundscapes distinguished by their sheer physical force and invested with the power to rupture eardrums.

Kafka's seemingly paradoxical attribution simply distills the term into its core features, highlighting a sense of alterity and a threat of physical violence that swings free of volume. Elsewhere the protagonist concludes that it is simply the sound of the suspected invader periodically breathing in before digging farther that is the root of the disturbance, "this drawing of breath, which must be an earth-shaking noise" (dieses Einziehn der Luft, das ein die

132 Chapter 5

Erde erschütternder Lärm sein muss; *B*, 501). And as the creature goes on to explain, "I hear this noise then as a soft hissing" (diesen Lärm höre ich dann als leises Zischen; *B*, 501). In a reversal of the logic underlying figurations of sonic warfare analyzed thus far, and contrary to earlier passages in "The Burrow" that present the underground structure as a medium of amplification, here Kafka focuses not on the intensification of otherwise innocuous sounds into aggressive noise, nor on the expulsion of air as a kind of military projectile; rather, the abrasive *Lärm* of inhalation is transformed into a seemingly harmless "soft hissing" (leises Zischen). The nature of this transformation implies that the sound has been subdued rather than intensified, a testament to the burrow's protective insulation and an allusion to both Kafka's diseased lungs and his use of earplugs to subdue the sounds of his immediate environment. At the same time, it is once again the sound of a living body that presents a problem for the protagonist. While he views the sound of his own blood as a dangerous obfuscation of the threatening situation, here the bare sound of continued life is a dead giveaway of the enemy's gradual encroachment on the burrow. In both cases, auditory embodiment and the sounds of life are figured as liabilities. By contrast, the protagonist's acoustic ideal involves the suppression and displacement of bodily processes onto the prosthetic vessel of the central square, where the sound of the living body can be glimpsed without requiring a recognition of the protagonist's own embodied state.

Narrative Self-Auscultation

As critics have long noted, the mode of temporality operative in Kafka's narrative offers a parallel to the creature's preoccupation with spatial enclosure. Whereas the first half of the story, before the protagonist hears the hissing sound, is marked by a pervasive use of the iterative present, in the second half past is distinguished from present. The point is that with the eruption of the noise in the second half the creature becomes locked in an expansive present that nonetheless recognizes the reality of the past. As the creature explains after first hearing the sound, "I did not hear [the hissing] at all when I first arrived, although it must certainly have been there; I first had to feel completely at home [völlig heimisch werden] before I could hear it" (*B*, 488). Later, it substantiates this speculative encounter by noting that it had in fact initially heard but chose to ignore and forget evidence of a living, breathing neighbor. "It had hardly any influence on my building plans" (auf meine Baupläne hat sie kaum einen Einfluß gehabt), the creature states—rather unconvincingly, when one considers the extent of the security measures taken in the construction of the burrow.

More importantly, in what follows the link between present and past is shown to be a void: "Between then and now," he observes of his time in the

burrow, "lies my manhood, but is it not however the case that nothing lies between the two, I'm still taking long breaks from work and listening at the wall."[49] At the same time as the creature acknowledges a clear line between past and present, youth and adulthood, thereby breaking with the habitual, iterative tone of the first half of the narrative, it also asserts that the space between the two temporalities is empty. As J. M. Coetzee notes with regard to the story's temporal structure, "with Kafka it is precisely the power of each moment to condition the next that seems to be in question." "Between the before and the after," Coetzee continues, "there is not stage-by-stage development but a sudden transformation, *Verwandlung*, metamorphosis."[50] According to this reading, past and present are bound by a caesura, replacing a model of narrative progression with one of spontaneous materialization. On the level of time, then, Kafka excises the work of transduction. The precise mechanism or medium underlying the perceived shift from *Lärm* to *Zischen*, for example, is left unspecified. The sudden eruption of hissing is attributed to the creature completing work on the burrow and settling into the role of "homeowner" (Hausbesitzer), with the underground structure serving as a kind of auditory training ground for the perception of the noise within ostensible silence. Although always already present, the sound's audibility nonetheless occurs suddenly and without explanation.

It is within this structure of atomized presents and sudden audibility that the mere sound of a suspected aggressor takes on a body moving through space. As we have seen, Kafka's text is structured around two modes of self-observation; first, the protagonist briefly listens to the sounds produced by its own body. This mode of listening is a *literal self-observation*. Second, the creature engages in *figurative self-observations*, both visual and aural, in which the architecture of the burrow merges with the observer's body, enabling the fantasy of a disembodied self-observation in which the protagonist observes itself metaphorically from a third-person perspective. However, the text presents a third, distinctly narrative form of self-observation, which functions as a metafictional iteration of self-auscultation and the noise of the body.[51]

In many ways narrative self-auscultation corresponds to what Jacques Derrida, in his reading of Husserl's phenomenology, terms "hearing-oneself-speak" (s'écouter).[52] To speak, Derrida famously asserts, is necessarily to hear oneself speak, thus "the signifier, animated by my breath and by the meaning intention . . . is in absolute proximity to me."[53] This act of listening to oneself speak enables the subject to recognize the other in already familiar terms at the same time as it prevents the possibility of knowing the other, since to hear another speaking is always to hear oneself speak. As Hans Ulrich Gumbrecht summarizes it, hearing oneself speak is necessarily bound up with the idea of a subject controlling its own actions and speech. It fosters the illusion that it is possible to attribute stable meanings to texts and words and strengthens the subject's claim to controlling a "world of objects."[54]

134 Chapter 5

In "The Burrow" hearing oneself speak introduces a gap into the process of communication, with the subject differentiated into the roles of speaker and hearer. Instead of leading to internal coherence and control, the process is represented as destabilizing. Shortly after the protagonist hears the sound of its own blood, it notes a significant shift in the nature of the allegedly external noise. Rather than staying in one location and remaining audible everywhere at the same volume, the hissing now begins to move through space. It is over the course of this development that the verb *to hiss* (zischen) and its related adjectival form *hissing noise* (das zischende Geräusch) give way to the noun form, *hisser* (der Zischer), which appears here for the first time.

The mysterious noise is now attributed to a single, living organism as opposed to architectural damage in the burrow or the mass of workers the protagonist regularly employs. "[The hissing] grows louder," the creature repeats, "it comes closer, but I wriggle my way through the labyrinth and camp out up here under the moss; it is almost as if I were already leaving the house to the hisser, content if only to have a little peace up here. To the hisser? Have I come to a new conclusion concerning the cause of the noise?"[55] The shift from "hissing" to an embodied agent, "the hisser," is so unexpected that the protagonist is forced to stop its narration abruptly in a manner that is unprecedented in the text. "To the hisser?" (Dem Zischer?), the creature asks, as if unsure of what it is saying and shocked by its own reformulation of the source of the sound.

Here it is instructive to note the trajectory that the creature's theories about the source of the sound take over the course of the narrative. Contrary to Mladen Dolar's claim that "it never occurs to the badger that the sound may be a phenomenon of inorganic origin," the creature's initial hypothesis is precisely that the acoustic disruption comes from structural damage in the burrow.[56] On one level, of course, Dolar is right to say that the sound is always connected to a hostile agency. As we have seen, the architectural structure itself is invested with organic properties: it is capable of feeling pain and is depicted as an extension or doubling of the creature's body. Yet in overemphasizing this correspondence, we run the risk of missing the significance of the protagonist's sudden assertion of a living, breathing "hisser," the ways in which its assumption about the sound source shifts from a possible architectural flaw to another autonomous body. Just as the creature's figurative self-observations outside the burrow produce the suspicion of an external enemy monitoring its every move, inside the burrow experiences of listening to the sound of its own blood and its own narration, as well as fantasies of listening to "the rustling of silence" in the stronghold's central square, produce the belief that the hissing emanates from a living body.

The shift from unlocalizable hissing to an invisible hisser indicates a schism within the protagonist.[57] Indeed, the creature's sudden realization that the sound might come from a hisser is marked by surprise. If, earlier in the text, it had pronounced, "I can trust only myself and the burrow" (Vertrauen

Into the Inaudible 135

aber kann ich nur mir und dem Bau; *B*, 481), this later passage signals a lack of trust in its own intuitions amid the commingling of bodies and questions about whom or what precisely is being evaluated as untrustworthy. Moreover, the creature's internal split is predicated on a form of narrative self-auscultation; in posing the question of whether or not the creature believes that the sound comes from a foreign body, it reacts to its own narration of events as if to another speaker, shocked by what it has just uttered or thought. The question "To the hisser?" registers surprise at the protagonist's own account of the situation, confirming that the creature not only narrates but also listens to itself in the act of narration.

Kafka develops the rhetorical form of this narrative self-auscultation to stage the experience of self-alienation as sonic warfare, a spilling over between inside and outside provoked in the recognition of the terms of acoustic embodiment. As we have seen, processes of self-observation function to *create* the threat of an antagonistic intruder. Over the course of Kafka's narrative we witness the protagonist listening to the sound of its own blood, which "beats altogether too much . . . in my ear" (allzu sehr klopft . . . im Ohr; *B* 497). It also conflates the burrow with its own corporeal being, observing what it identifies as its own body from a detached third-person perspective. "To me it is then," it remarks from an observational post outside the entrance to the burrow, "as if I stand not before my house, but before myself, as I sleep."[58] Finally, the text presents a distinctly *narrative* form of self-observation, according to which the protagonist listens to its own narration at the same time as the disruptive sound takes on a body. Visual and auditory, literal, figurative, and narrative self-observations all become implicated in the creation of an external threat that evolves from a barely audible hissing to an imagined body encroaching on the animal's underground territory.

Conclusion

✦

Nazi Soundscapes and Their Reverberation in Postwar Culture

The period spanning from German unification in the 1870s, through World War I, to the political instability and street fighting of the 1920s was characterized by a culture of panmilitarism and the perpetual appropriation of military figures and tactics in both political discourse and artistic practice. What began as a call to modernize German letters as an aesthetic correlate to Germany's military victory in the Franco-Prussian War became the traumatic repetition and virtualization of the battlefield in literary modernism.

On one hand, the turn to literature that I have advocated throughout this book allows us to see how historically specific conceptions of sound and hearing operative in technical and scientific fields correspond to traditional literary epochs such as naturalism, impressionism, the historical avant-garde, and so-called high modernism. On the other hand, literature helps us recover otherwise lost aspects of the sonic past. To do so, I have delineated an approach to textual representations of sound that are particularly attentive to their embeddedness in a range of nonliterary discourses and their reliance on figures, practices, and conceptual frameworks that circulated far beyond the literary domain. Drawing on the conceptual resources of media theory, my readings of individual works also look beyond questions of meaning to the formal techniques by which textual representations of sound come to signify their engagement with the materiality of writing and the corporeality of listening and vocal performance.

What I have called the tympanic regime of literary modernism borrowed from the transductive processes of vibrational contact, conversion, and indexical inscription that underwrote both technical media such as the phonograph and violent encounters with the soundscapes of modern warfare and urban spaces. Following the same logic that inspired the insertion of a real human eardrum into early acoustic technologies, poetic works by Altenberg, Jünger, and the Dadaists anchored narrative strategies of onomatopoeia, transduction, and montage, the aesthetics of horror and the sonic sublime, in the fleshiness of the ear's anatomical structure. In literary modernism authors such as Robert Musil and Franz Kafka took us deeper into

137

the interior spaces of the ear, highlighting the corporeality of listening and replacing figures of aggressive contact with those of immersion, spatialized sound, and erotic interpenetration. Instead of portraying sounds as acoustic projectiles assaulting the flat surfaces of the tympanic membrane, these later writers invested sounds with corporeal, animate properties and positioned them in a three-dimensional space of transcendent possibility and anxious projection.

While concerned with emphasizing the aesthetic differences and divergent sources of these modes of listening and conceptions of sound, the book makes clear that the tympanic regime was not simply subsumed or superseded by the modernist ear and a related poetics of acoustic space. The tympanic regime was still alive and well in works by Ernst Jünger that were contemporaneous with the archmodernism of Musil's "The Believer" and Kafka's "The Burrow." The account offered in *Eardrums* is not predicated on a neat correspondence between aesthetic strategies and rigidly circumscribed historical periods or a single paradigm shift, according to which one mode of listening or conception of sound was simply replaced by another. On the contrary, it attests to the plurality of listening techniques and aesthetic tactics of sonic warfare available to subjects in the early twentieth century, to the diverse social, political, and cultural motivations behind the literary appropriation of one or the other. What becomes clear is that, within this aesthetically heterogeneous sixty-year period, traditional designations used to distinguish literary movements, collectives, and aesthetic commonalities among individual authors also corresponded to consistent representations and deployments of sound and sonic aesthetics. Impressionism, for example, was characterized by its concern with nervous sensitivity and an alleged crisis of language. But it was also marked by common responses to urban noise and the militarization of the civilian soundscape, and by an engagement with the materiality of written marks and formal techniques of transduction and onomatopoeia in adherence with the tympanic regime. By contrast, high modernism was distinguished by a commitment to self-reflexivity, contingency, and alterity. But it simultaneously outlined a common aesthetic of spatialized sound and replaced noise (*Lärm*) with static (*Rauschen*) as its privileged acoustic category. At the same time as the book exposes previously ignored correspondences between representations of sound and conventional literary periodization, it also points to unlikely continuities among individual authors and groups based on an overlapping sonic aesthetic. Outside of the tympanic regime, it is hard to imagine that we would recognize aesthetic affinities among a group of writers as seemingly diverse as Peter Altenberg, Richard Huelsenbeck, and Ernst Jünger.

As I have emphasized throughout, the appropriation of sonic warfare as an aesthetic strategy was not dependent on actual experiences of war. While authors such as Detlev von Liliencron, Robert Musil, and Ernst Jünger did draw on the sounds they had heard firsthand on the battlefield, the same was

Nazi Soundscapes 139

not true of Peter Altenberg and Franz Kafka, who relied instead on mediated accounts and the migration of martial elements to civilian spaces. Indeed, issues of mediation, performance, and displacement stand at the heart of the narrative I have been pursuing here. On the one hand, literary figurations of sonic warfare appeared amid a flood of war narratives, war poetry and songbooks, panoramic paintings and phonograph recordings of battle scenes, along with the growing presence of military parades and commemorations of past wars during peacetime.

On the other hand, the organization and practice of war were shot through with aesthetic impulses and performative strategies. Mass mobilization on the scale of World War I would have been unthinkable without the infusion of civilian life with cultural ideals of panmilitarism and idealistic depictions of military heroism as well as the dissemination of propaganda across various print, visual, and acoustic media in the years leading up to 1914. During the late nineteenth and early twentieth centuries, the art of war in German-speaking Europe was both perpetuated and challenged by a concomitant literary and performative aesthetic of sonic warfare.

Drums of Total War: Percussion and Propaganda in Nazi Germany

The remilitarization of Germany and the rise of National Socialism in the late 1920s occurred alongside the escalation of sonic warfare on civilian streets. As Carolyn Birdsall has shown, the period was characterized by a violent "battle over public and social space" as well as "political strategies for acoustic presence" and "acoustic strategies for achieving sensory appeal, for demanding the attention and participation of civilians."[1] As early as 1930, Siegfried Kracauer described the looming threat of National Socialist violence on the streets of West Berlin in distinctly auditory terms.[2] In an atmosphere already shot through with fear and anxiety,[3] the scene is made even more tense by the brutal sounds of a National Socialist soldier, who, believing himself to be the subject of ridicule by customers at a café, jumps over a balustrade and "begins to rage" (beg[innt] zu toben).[4] However, the resulting "noise" (Krach) is far less insidious than "another that could not be said to have a definite origin" (einen anderen, der gar keine bestimmte Herkunft hätte haben dürfen), which the narrator believes to be hovering over the scene.[5] Over the course of the next few days, he hears various screams echoing across the city, which he takes to be the sounds of murder. In a nod to Kafka, the sounds' affective charge derives from their unlocalizability and apparent omnipresence.

According to Kracauer, the rise of National Socialism brought with it perceptible changes to the city's soundscape, one now suspected to be filled with hidden explosives and punctured by the aggressive voices of Nazi soldiers,

140 Conclusion

inarticulate screams, and the sounds of murder. In this environment, Kracauer implies, sound was not only a symbol of looming danger; it was simultaneously a tactic for actively creating an immersive atmosphere of dread and anxiety.

The same period was marked by the resurgence of tympanic figures and percussive imaginaries. Writing in 1933, the Nazi sound technician and radio director Eugen Hadamovsky called for saturating all domains of mass media with "Schlagworte" (key words) such as "freedom" (Freiheit), "equality" (Gleichheit), "blood" (Blut), "race" (Rasse), and "the Third Reich" (Drittes Reich).[6] Emphasizing the literal meaning of *Schlagwort* as a kind of "beating word," Hadamovsky explained that the repetitive use of such terms would transform language into a tool for ideological bludgeoning, not only "punching" (schlagen) and "hammering" (einhämmern) the public with a Nazi worldview but also strategically mystifying their audiences and spreading fear and uncertainty by strategically limiting descriptions of the party's political aims to a few ambiguously defined concepts. According to Haig A. Bosmajian, the goal was to use *Schlagworte* to "dull the listener's critical abilities since the listener was 'hit' or 'struck' with them."[7]

Hitler himself relied heavily on percussive figures in constructing his early political identity, presenting himself as a mere "drummer" (Trommler) for the burgeoning movement. "I'm nothing but a drummer and organizer,"[8] he wrote to the Third Reich visionary Arthur Moeller van den Bruck in a letter from 1922, while before a court in February 1924 he stated, "It is not out of modesty that I wanted then to be a drummer; that is the highest office, the other is a trifle."[9] With this designation—later the foil for the protagonist of Günther Grass's *The Tin Drum* (Die Blechtrommel; 1959), who employs his beloved drum to disrupt the formation of any and all groups—Hitler portrayed himself as a pioneer at the forefront of a vanguard movement yet to fully materialize and an early apprehender of the dangers looming over the Weimar Republic. As a mere "drummer," he presented himself not as a leader (*Führer*) or ideological architect of the movement but rather as a simple foot soldier, organizer (*Sammler*), or propagandist drumming up support for what he believed was a noble cause.

It was this earlier role in the movement that later justified the Nazis' organization of political power and Hitler's role as the nation's dictator. In an essay titled "Der Führer as Orator" (Der Führer als Redner), Joseph Goebbels highlighted Hitler's unique abilities as an orator and the power of the voice in the history of political revolutions.[10] While early in the essay Goebbels praised the "rhetorical geniuses" (diese rhetorischen Genies) of the past as "drummers of destiny" (Trommelschläger des Schicksals), later he attacked the "stupid and arrogant bourgeois idiots" (dumme und überhebliche bürgerliche Kohlköpfe) who continued to dismiss Hitler as a mere "drummer" (Trommler) with only "a middling ability for the organization of the state" (eine mindere Kunst der Staatsgestaltung).[11] Yet, as Goebbels contended, such criticism only exposed

the political ineptitude and oratorical deficiencies of those who propagated it. Such a view, Goebbels continued, obscured the fact that political disempowerment could only be corrected "with the pressure of violence" (unter dem Druck der Gewalt) through the mobilization of a militarized collective rather than an innocuous "conventicle" (Konventikel)—that is, full-scale revolution as opposed to isolated revolts. Hitler's use of the voice as a drum, in other words, signaled a prescient recognition of what was required for real political change: mass mobilization and the willingness to use military force in the service of a unified political vision that was at once inevitable and the result of collective political action.

The figure of the drum indicates a form of political discourse and collective organization that sidesteps language and thought, conscious deliberation and critical discussion, in favor of a presumed ideological consensus among subjects of the state and the effective imposition of dictatorial rule. "Because the masses only bend to those who subject them to their ruthless command," Goebbels explained, "they only obey if one understands how to command."[12] Elsewhere, he elaborated an auditory logic governing the relations between Nazi officials and their political subjects. All great leaders, and Hitler in particular, Goebbels argued, derived their influence and authority from preexisting words and thoughts, which "resonate" (Widerhall finden) in the hearts and souls of the masses.[13] "What everyone thought and felt," Goebbels asserted, "Hitler said it."[14] Thus, Hitler's words were not cognitively processed or understood but rather resonated with ideas the individual listener already possessed. The key to his political success lay in giving voice to what others were too afraid to say, yet the words the Führer did utter were described as circumventing language and traveling directly to the heart and soul, where they were registered as an echo of the already familiar. Crucially, Goebbels's account avoided any mention of the listener's body, substituting the eardrum for the heart and soul while obfuscating the role of performance and processes of mediation, both technical and linguistic, in the transmission of Nazi ideology.

The result was a kind of acoustic immediacy, and people, "whether [they] understood his words or not," responded to the "magic of their tone [Zauber ihres Tons] . . . in their heart of hearts [im Innersten seines Herzens]."[15] Yet Goebbels also acknowledged that to achieve popular support, it is necessary "that one properly brings [ideas] to the masses, that the masses become their supporters."[16] By claiming that only the manner in which ideas were disseminated among the masses was important, Goebbels was arguing for the irrelevance of truth in a political system predicated on propaganda. At the same time, his statement draws attention to the means by which Hitler's oratory was delivered or presented, implying a performative element denied elsewhere in the text. While Goebbels likely had only rhetoric in mind, the *how* to which he referred could also be extended to the elaborate public address systems, loudspeakers, and microphones that facilitated Hitler's

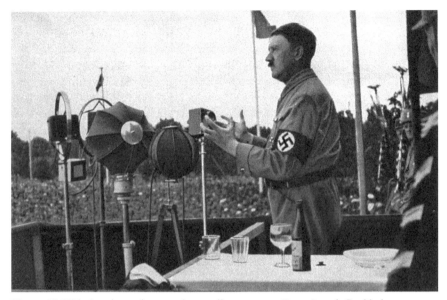

Figure 17. Hitler's voice and supporting media apparatus. From Joseph Goebbels, "Der Führer als Redner," in *Adolf Hitler: Bilder aus dem Leben des Führers* (Hamburg: Cigaretten/Bilderdienst Hamburg/Bahrenfeld, 1936), 34.

supposedly direct connection to the people (see figure 17). On one level, Goebbels's account of Hitler the orator adheres to a tympanic model of hearing in which the registration of sound was privileged over its perception, affective modulation over meaning. But, on another, it does so without reference to the fleshiness of the ear or processes of transduction, opting instead for a logic of direct connection and resonating hearts and souls.

It is this rhetoric of immediacy that, in her account of Nazi radio, Cornelia Epping-Jäger describes as the "fundamentally phonocentric" logic underlying the party's theorization and practical implementation of sound and sound technology.[17] As Goebbels's essay demonstrates, the figure of the drum was folded into Nazi phonocentrism, indicating a mode of producing and receiving speech in which the graphical basis of language was minimized and the percussive instrument invested with the capacity to activate ideas already present in the minds of listeners, thereby conjuring a sense of self-presence and immediate proximity to meaning.

The notion of phonocentrism is illuminating, but it fails to do justice to the complexity of sound's deployment in the Third Reich. The Nazis were also pioneers in *weaponizing* sound, creating several devices that harnessed the force of extreme sonic vibrations to alter the physical environment and produce negative affect in their enemies. Here one might think of the

propeller-driven sirens, or "Jericho Trumpets," mounted on Stuka dive bombers to intimidate and demoralize Allied soldiers, a strategy extended to bombs outfitted with whistles that produced a similar noise.[18]

By the end of the war, Nazi officials were exploring various applications of ultra- and infrasound in so-called *Schallkanonen, Wirbelkanonen, Wirbelringkanonen,* and *Lärmkanonen* to create subsonic vibrations capable of bursting eardrums or taking down an enemy plane.[19] It is unclear whether the inspiration for such weapons came from Hitler's experience of sound's vibrational force during an assassination attempt in July 1944, in which an explosion intended to kill him ruptured both his eardrums, caused his ears to bleed uninterruptedly, and resulted in severe hearing loss.[20]

Regardless of their inspiration, Nazi sound canons literalized both Plessner's "acoustic projectiles" and the "vortex" (Wirbel) of sonic vibrations foregrounded by Peter Altenberg and Felix Salten in their literary representations of the modern Viennese soundscape. Moreover, the Nazi development of sonic weapons attests to an interest in acoustic technology that went far beyond phonocentrism or the fetishization of the sovereign's voice, also encompassing an inchoate weaponization of noise and the subsonic in the service of modulating affect and inflecting physical harm on human bodies (see figures 18–20).

Indeed, alongside a strong penchant for acoustic presence and for flooding the airwaves and public space with recorded speeches, patriotic music, loudspeaker cars, and goose-stepping parades, the Nazis also pursued potential applications of "unsound," or the "apparently paradoxical field of inaudible audio." Imperceptible sonic weapons were only one example.

Another was the Nazi discovery of AC bias and its incorporation into magnetic tape technology. The process involved applying an alternating current of inaudible ultrahigh frequencies to the audio signal to "shake up" the tape's magnetized particles prior to recording, thereby reducing the distortion and background noise that plagued existing tape recorders.[21] At the same time, tape's malleability—the fact that recordings could be cut up and reassembled without any noticeable break in continuity—offered an invaluable resource for Nazi propaganda programs and censorship efforts.[22] Not only could unwanted utterances be cut out prior to broadcasting, but fragments of spoken language and ambient sound from different times and places could be joined to create entirely new wholes with radically different meanings and affective powers.[23] The tape recorder therefore harnessed and facilitated unsound in a variety of ways. Its superior audio quality was based on the application of ultrasonic frequencies in the process of premagnetization; its erase function could instantly overwrite recordings with silence; and finally, it enabled a type of editing that was perceived as seamless to unsuspecting listeners, rendering inaudible the cuts that bound together disparate takes, times, and locations.

Figure 18. Nazi wind gun found at Hillersleben, Germany, near the end of the war. From Leslie E. Simon, *German Research in World War II: An Analysis of the Conduct of Research* (New York: Wiley, 1947), 181.

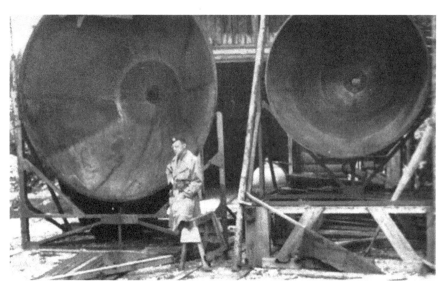

Figure 19. Nazi sound weapon incorporating large parabolic projectors. From Simon, *German Research in World War II*, 182.

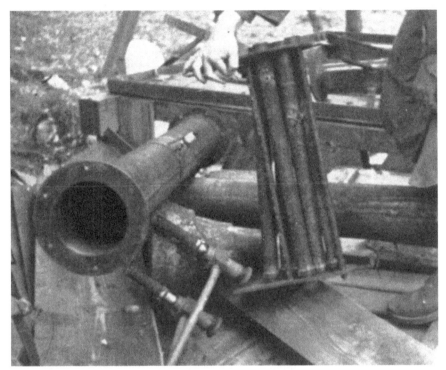

Figure 20. Firing chamber for a Nazi sound weapon. From Simon, *German Research in World War II*, 182.

Retaliation and Repetition

Discovered by the Allies at the end of the war and dispersed across Europe and the United States in modified forms, the magnetic tape recorder, initially perceived as a vital instrument for the Nazi military and propaganda efforts, soon became an instrument for new modes of cultural production in the postwar period—from the sound poems, cut-ups, and radio plays of Henri Chopin, Gerhard Rühm, William S. Burroughs, Rolf Dieter Brinkmann, Ernst Jandl, and Friederike Mayröcker, through the experimental music of John Cage, Alvin Lucier, and *musique concrète*, to the emergence of multitrack recording, psychedelic rock, and Jamaican dub.[24] If the Nazi tape recorder did indeed suggest "a total revolution in sound recording," as one observer commented at the time, by the 1960s its revolutionary potential had expanded to encompass a decidedly antitotalitarian agenda, now used to unmask propaganda, complicate conventional notions of an "authentic" identity, and restore a corporeal dimension to language and sensory experience in the sanitized spaces of capitalist culture.

146 Conclusion

According to Friedrich Kittler, such appropriations represent nothing more than the "abuse of military technology" (Missbrauch von Heeresgerät): its counterdeployment in civilian contexts to ends not intended by the ruling parties who oversaw its technological development and initially put it to use.[25] The term *abuse*, however, does not quite capture the complex cultural and technological dynamic I have outlined over the course of this study, implying a reversal from original intention to secondary appropriation. By contrast, I have emphasized the reciprocal interaction that existed between the sound-scapes of state-sponsored military action and their aesthetic imagining and performance in contemporaneous modes of sound-based cultural warfare. It is important that we also historicize and contextualize the deployment of sound technologies in relation to the political and aesthetic motivations, as well as social and corporeal imaginaries, that underwrite sonic practices broadly speaking. My point is that the use of any acoustic technology was always up for grabs, and that the literary and performative aesthetic strategies conceived of as sonic warfare offer one of the most striking examples of this dynamic interplay.

By foregrounding the concept of sonic warfare, I have sought to complement existing accounts of listening and sonic aesthetics in the twentieth century, which tend to take as self-evident that the norms, terms, and conceptual framework they employ should come from the tradition of European classical music. On the one hand, I have argued for the importance of textual representation, performance, and literary imaginaries in conceptualizing sound and auditory experience in modern German-speaking Europe. Far more than a case of intermediality, the turn to literature and other forms of cultural production enables us to import new questions and concerns not restricted to the classical tradition.[26]

According to this view, noise is not simply the Other of music; it signifies an entirely different approach to thinking about and engaging with sound, drawing on a divergent set of artistic traditions, source materials, practices, and motivations. The tympanic regime traces a trajectory that leads from Altenberg, Huelsenbeck, and Jünger, through the Nazi soundscape, to the amplified guitar rock of the 1960s counterculture, the aggressive anticapitalist spirit of American and British punk, and the pounding bass of Afro-futurist-inflected techno and contemporary hip-hop. The "logistics of imperception" thematized in Kafka's "The Burrow" take us from high modernism, through Nazi *Wunderwaffen*, to experiments with infra- and ultrasound in early industrial music,[27] William S. Burroughs's vision of social control,[28] the use of sound bombs by the Israeli army,[29] sound canons aimed by police at civil rights protesters in Ferguson, Missouri,[30] and the suspected use of a sonic weapon against U.S. diplomats at the newly reestablished U.S. embassy in Havana, Cuba.[31]

Similarly, the notion of spatial listening that informed Musil's war narratives in the 1920s reappears in the stereophonic experiments of Pink Floyd's

antiwar psychedelia,[32] Ernst Jandl and Friederike Mayröcker's 1968 radio play *Fünf Mann Menschen* (Five-man people),[33] and the free jazz poetry of Amiri Baraka's *It's Nation Time* (1972).[34] Finally, the subjective hallucinations and audibility of the body implied in Kafka's hushed, minimalist soundscapes resonate with later works by John Cage[35] and the *Magenmusik* of Berlin's contemporary experimental music scene,[36] as well as the punitive conditions of solitary confinement in the American prison system.[37] The tympanic regime cannot be reduced to musical masochism or masculinist vitriol, nor can the modernist ear be dismissed as mere avant-garde pretension, solipsism, or bourgeois fantasies of architectural enclosure. Their respective histories follow more unpredictable political trajectories and patterns of artistic appropriation than such criticisms would like us to believe.

The account I have offered is meant to complicate existing understandings of acoustic modernity and modern sonic practice by placing specific literary works in historical contexts beyond the concert hall and European classical tradition: the noise of industrialization, the cacophony of the metropolis and modern battlefield, historical research on hearing and the ear in experimental psychology, medical science, and technical domains, as well as formal experiments with writing sound in German-speaking literature and performance culture. In doing so, I have argued that conceptions, representations, and practical implementations were inseparable from contemporaneous political concerns, responses to new technologies and changes in the built environment, issues of identity and alterity, class, race, and gender. Such an approach is meant to offer new perspectives on the cultural history of listening and underscore the sonic impulses that animated literary modernism. The intention is not to glorify the aesthetics of war or musical masochism but to demonstrate the intervention of a broader palette of sonic practices in negotiations of politics, power, identity, and cultural practice at particular historical moments.

Such a historical study might also serve as a reminder of sound's critical potential in responding to our own times, a present marked by perpetual war, intense debate on the politics of voice, and the information wars facilitated by algorithmically directed news, advertising and surveillance, affective mobilization, and media contagion—all of which occurs against the backdrop of vast networks of digital sound files, growing archives of historical audio, and the once unimaginable availability and simplicity of digital tools for creating, manipulating, and distributing recorded sound. Tympanic or otherwise, sound and sonic practice offer invaluable but often overlooked resources for the political organization of listening bodies and models of cultural retaliation amid an ongoing salvo of sound and unsound, human voices and acoustic machines, music, poetics, and vibrational force.

NOTES

Introduction

1. Plessner, *Die neueste Erfindung: Das Antiphon; Ein Apparat zum Unhörbarmachen von Tönen und Geräuschen* (Rathenow: Schulze und Bartels, 1885). On the history of the earplug see John Goodyear, "Escaping the Urban Din: A Comparative Study of Theodor Lessing's *Antilärmverein* (1908) and Maximilian Negwer's *Ohropax* (1908)," in *Germany in the Loud Twentieth Century: An Introduction*, ed. Florence Feiereisen and Alexandra Merley Hill (Oxford: Oxford University Press, 2012), 19–35; *Lauter Ruhe: 100 Jahre Ohropax: 100 Jahre Luxus für die Ohren* (Wehrheim: Ohropax GmbH, 2007); Hillel Schwartz, "Inner and Outer Sancta: Ear Plugs and Hospitals," in *The Oxford Handbook of Sound Studies*, ed. Trevor Pinch and Karin Bijsterveld (Oxford: Oxford University Press, 2011), 273–97; Paul N. Edwards, *The Closed World: Computers and the Politics of Discourse in Cold War America* (Cambridge, Mass.: MIT Press, 1996), 209–38; Caroline Bassett, "Twittering Machines: Antinoise and Other Tricks of the Ear," *differences: A Journal of Feminist Cultural Studies* 22, nos. 2/3 (2011): 276–99.

2. "Lehrt mich, akustische Fernwirkungen nicht hören zu müssen." Plessner, *Die neueste Erfindung*, 7. Plessner would also publish one of the earliest texts on television. See Maximilian Plessner, *Zukunft des elektrischen Fernsehens* (Berlin: Dümmler, 1892). On Plessner and television, see Doron Galili, "Postmediales Wissen um 1900: Zur Medienarchäologie des Fernsehens," *Montage A/V 25*, no. 2 (2016): 181–200.

3. "During artillery practice, namely during the firing of canons inside a turret with the resonant qualities of a clock, shock to the eardrum occurs with such force that a long period of hardness of hearing or even total deafness can result" (Bei artilleristischen Schießübungen, namentlich beim Abfeuern von Geschützen innerhalb der, eine glockenartige Resonanz besitzenden Panzertürme, treten häufig Erschütterungen des Trommelfells von solcher Heftigkeit ein, dass eine längere Schwerhörigkeit, ja totale Taubheit die Folge sein können). Plessner, *Die neueste Erfindung*, 39.

4. Goodman, *Sonic Warfare: Sound, Affect, and the Ecology of Fear* (Cambridge, Mass.: MIT Press, 2010), 5. Goodman borrows the term from the cultural critic Kodwo Eshun, who in the 1996 essay film *The Last Angel of History* uses it to describe sonic practices that developed across the Black Atlantic. See Eshun's *More Brilliant Than the Sun* (London: Quartet, 1998); Simon Reynolds, "Wargasm: Militaristic Imagery in Popular Culture," *Frieze* (September 1995), https://frieze.com/article/wargasm/; Martin Cloonan and Bruce Johnson, *Dark Side of the Tune: Popular Music and Violence* (Burlington, VT: Ashgate, 2008); William Cheng, *Just Vibrations: The Purpose of Sounding Good* (Ann Arbor: University

149

150 Notes to Pages 5–9

of Michigan Press, 2016), 71–92; Nicola Gess, Florian Schreiner, and Manuela K. Schulz, eds., *Hörstürze: Akustik und Gewalt im 20. Jahrhundert* (Würzburg: Königshausen and Neumann, 2015).

5. "Beiläufig bemerkt wird jedes direkte Erschüttern des Trommelfells durch eine am unteren Ende des Antiphons befindliche, den äußeren Gehörgang luftdicht abschließende hohle Kugel verhindert, während das obere Ende des Instruments in der eigentlichen Ohrmuschel Aufnahme findet, und, von der Gegenleiste der Aurikel umfaßt, in einer solchen Lage erhalten wird, das sein jedes Berühren des Trommelfells ausgeschlossen ist." Plessner, *Die neueste Erfindung*, 16.

6. "Der wahre Despot unserer Zeit, der über Wohl oder Wehe der Gebildeten mit unumschränkter Macht gebietet, ist der Pöbel." Ibid., 10.

7. "Die Gebildeten [sind] nicht einmal im Stande, ihr Eigentum gegen willkürliches Beschädigen aus der Ferne zu schützen." Ibid., 10.

8. Douglas Kahn, *Noise, Water, Meat: A History of Sound in the Arts* (Cambridge, Mass.: MIT Press, 2001), 47. See also Jacques Attali's classic study, *Noise: The Political Economy of Music*, trans. Brian Massumi (1977; Minneapolis: University of Minnesota Press, 2009).

9. Plessner, *Die neueste Erfindung*, 39–42.

10. Ibid., 40, 45, 46.

11. Ibid., 46.

12. Johann Gottfried Herder, *Abhandlung über den Ursprung der Sprache*, ed. Dr. Theodor Matthias (1772; Leipzig: Brandstetter, 1901), 72.

13. "Der Weg des Ohrs ist der gangbarste und nächste zu unsern Herzen." Quoted in Peter Utz, *Das Auge und das Ohr im Text: Literarische Sinneswahrnehmung in der Goethezeit* (Munich: Wilhelm Fink, 1990), 61.

14. On the physicality of auditory experience around 1800, see John T. Hamilton, *Music, Madness, and the Undoing of Language* (New York: Columbia University Press, 2008), esp. 101–3; James Kennaway, *Bad Vibrations: The History of the Idea of Music as a Cause of Disease* (New York: Routledge, 2012).

15. "Daher können die Nerven des Gehörs, wegen der Gewalt der Stöße, die sie bekommen, ihre Würkung auf das ganze System aller Nerven verbreiten, welches bey dem Gesichte nicht angeht. Und so läßt sich begreifen, wie man durch Töne gewaltige Kraft auf den ganzen Körper, und folglich auch auf die Seele ausüben könnte." Johann Georg Sulzer, *Allgemeine Theorie der Schönen Kunste in einzeln, nach alphabetischer Ordnung der Kunstwörter auf einander folgenden, Artikeln abgehandelt 3. Theil* (Leipzig: Weidmannschen Buchhandlung, 1793), 422.

16. Edmund Burke, *A Philosophical Enquiry into the Origin of Our Ideas of the Sublime and Beautiful*, ed. Adam Phillips (1757; Oxford: Oxford University Press, 1998), 126–27.

17. Johann Gottfried Herder, "Viertes Wäldchen," in *Sämmtliche Werke* 4, ed. Bernhard Suphan (Berlin: Weidmannsche Buchhandlung, 1878), 102, 138, 105, 108.

18. See Veit Erlmann, *Reason and Resonance: A History of Modern Aurality* (New York: Zone Books, 2010), 48; Cotugno, *De aquaeductibus auris humanae internae* (Neapoli: Simoniana, 1761); Scarpa, *Anatomicae disquisitions de auditu et olfactu* (Ticini: Petri Galeatii, 1789). See also T. R. Van De Water, "Historical Aspects of Inner Ear Anatomy and Biology That Underlie the Design of Hearing and Balance Prosthetic Devices," *Anatomical Record* 295, no. 11 (2012):

Notes to Pages 9–11 151

1741–59; C. Eduardo Corrales and Albert Mudry, "History of the Endolymphatic Sac: From Anatomy to Surgery," *Otology & Neurotology* 38, no. 1 (January 2017): 152–56.

19. Jonathan Sterne, *The Audible Past: Cultural Origins of Sound Reproduction* (Durham: Duke University Press, 2003).

20. Édouard-Léon Scott de Martinville, *The Phonautographic Manuscripts of Édouard-Léon Scott de Martinville*, ed. Patrick Feaster (n.p.: FirstSounds, 2009), 10.

21. See Clarence Blake, "Über die Verwertung der Membrana tympani als Phonautograph und Logograph," *Archiv für Augen- und Ohrenheilkunde* 5 (1876): 434–39.

22. See Bernhard Siegert, "Das Amt des Gehorchens: Hysterie der Telephonistinnen oder Wiederkehr des Ohres 1874–1913," in *Armaturen der Sinne: Literarische und technische Medien 1870 bis 1920*, ed. Jochen Hörisch and Michael Wetzel (Munich: Fink, 1990), 92–94; Anthony Enns, "The Human Telephone: Physiology, Neurology, and Sound Technologies," in *Sounds of Modern History: Auditory Cultures in 19th- and 20th-Century Europe*, ed. Daniel Morat (Oxford: Berghahn, 2014), 55–57.

23. Comte Th. Du Moncel, *The Telephone, the Microphone, and the Phonograph* (London: C. Kegan Paul, 1879), 254.

24. "Die schwingende Membrane des kleinen Phonographen ist das Trommelfell der Welt." Professor Dr. David Kaufmann, "Der Phonograph und die Blinden," *Neue Freie Presse*, December 27, 1889, 4.

25. "Wie nun die im menschlichen Ohre ausgespannte runde Membrane, das Trommelfell, durch die von außen kommenden Luftwellen bewegt wird und die Bewegung durch eine Kette kleiner Knöchelchen auf die im inneren Teile das Ohrs und die darin ausgebreiteten Fasern des Gehörnervs überträgt, so gerät auch die Membrane des Grammophons in Schwingungen." R. Raab, "Das Grammophon, eine neue Schallwiederholungsmaschine," *Ueber Land und Meer* 63 (1890): 395.

26. Goodman, *Sonic Warfare*, 179.

27. Michel Serres, *The Five Senses: A Philosophy of Mingled Bodies (I)*, trans. Margaret Sankey and Peter Cowley (London: Continuum, 2008), 141.

28. See Emily Thompson, *The Soundscape of Modernity: Architectural Acoustics and the Culture of Listening in America, 1900–1933* (Cambridge, Mass.: MIT Press, 2002); Karin Bijsterveld. *Mechanical Sound: Technology, Culture, and Public Problems of Noise in the Twentieth Century* (Cambridge, Mass.: MIT Press, 2008); John M. Picker, *Victorian Soundscapes* (Oxford: Oxford University Press, 2003); Daniel Morat, ed., *Sounds of Modern History: Auditory Cultures in 19th- and 20th-Century Europe* (Oxford: Berghahn, 2014); Joseph L. Clarke, ed., "Acoustic Modernity," special issue, *Grey Room* 60 (Summer 2015); James G. Mansell, *The Age of Noise in Britain: Hearing Modernity* (Champaign: University of Illinois Press, 2017).

29. Thompson, *The Soundscape of Modernity*, 2.

30. Picker, *Victorian Soundscapes*, 6; Benjamin Steege, *Helmholtz and the Modern Listener* (Cambridge: Cambridge University Press, 2012), 1; Erlmann, *Reason and Resonance*, 307–42.

31. Kittler, *Gramophone, Film, Typewriter*, trans. Geoffrey Winthrop-Young and Michael Wutz (1986; Stanford, Calif.: Stanford University Press, 1999),

152 Notes to Page 11

190. On the centrality of war in Kittler's media-theoretical writings, see Geoffrey Winthrop-Young, "Drill and Distraction in the Yellow Submarine: On the Dominance of War in Friedrich Kittler's Media Theory," *Critical Inquiry* 28, no. 4 (2002): 825–54; Geoffrey Winthrop-Young, "De Bellis Germanicis: Kittler, the Third Reich, and the German Wars," special section on Friedrich Kittler and War, *Cultural Politics* 11, no. 3 (November 2015): 361–75.

32. Psychoanalysis might strike some readers as conspicuously absent from the study that follows. One of the main reasons for this omission is the discipline's apparent disregard for the physicality of the ear and its conception of the auditory organ as anything other than a neutral portal. As Julia Encke explains, "Strikingly, psychoanalysis has hardly noticed the ear *as ear*. The auditory organ is neither its object nor its protagonist" (Hat die Psychoanalyse das Ohr als Ohr bemerkenswerterweise kaum zur Kenntnis genommen. Das Gehörorgan wird ihr weder zum Gegenstand noch zum Protagonisten). Julia Encke, *Augenblicke der Gefahr: Der Krieg und die Sinne (1914–1934)* (München: Fink, 2006), 154. For a recent sound studies approach to Freud and psychoanalysis, see Clara Latham, "Listening to the Talking Cure: *Sprechstimme*, Hypnosis, and the Sonic Organization of Affect," in *Sound, Music, Affect: Theorizing Sonic Experience*, ed. Maria Thompson and Ian Biddle (London: Bloomsbury, 2013), 101–16.

33. Kittler, *Gramophone, Film, Typewriter*, 86.

34. See Jonathan Crary, "Dr. Mabuse and Mr. Edison," in *Art and Film since 1945: Hall of Mirrors*, ed. Russell Ferguson (New York: Monacelli Press, 1996), 262–79; Lisa Gitelman, *Scripts, Grooves, and Writing Machines: Representing Technology in the Edison Era* (Stanford, Calif.: Stanford University Press, 1999), 190–92.

35. See G. V. Fosbery, "The Phonograph and Its Application to Military Purposes," *Journal of the Royal United Services Institution* 37, no. 187 (1893): 989–99.

36. For a list of recordings of military music released commercially between 1899 and 1911, see Alan Kelly, *His Master's Voice: The German Catalogue: A Complete Numerical Catalogue of German Gramophone Recordings Made from 1898 to 1929 in Germany, Austria, and Elsewhere by the Gramophone Company Ltd* (Westport, Conn.: Greenwood Press, 1994), 7–48. For staged phonographic recordings of war, see "Eine Szene aus der Schlacht bei Sedan am 1. September 1870" (1890), Archivnummer 2612004, X130, Deutsches Rundfunkarchiv (DRA) Frankfurt am Main; "Die Beschießung von Paris (Dezember 1870)" (1890), Archivnummer 2612004, X130, DRA Frankfurt am Main; "Szene aus dem Kampf mit den Hereros" (c. 1904/1905), Archivnummer 2822470, X130, DRA Frankfurt am Main; "Die Schlacht bei Sedan" (1905), Archivnummer 2763459, X130, DRA Frankfurt am Main; "Abschied von Regiment" (c. 1910), Archivnummer 4607987, A0163 Edison, DRA Frankfurt am Main; "Im Lager vor Paris" (1914), Archivnummer 2590065, X130, DRA Frankfurt am Main; "Im Lazarett" (1914), Archivnummer 2842528, X130, DRA Frankfurt am Main; "Feldgottesdienst nach der Schlacht vor Maubeuge" (1914), Archivnummer 2590065, X130, DRA Frankfurt am Main; "Schlacht in den Karpaten" (1915), Archivnummer 2832507, X130, DRA Frankfurt am Main; "Die Erstürmung einer russischen Stellung" (1915), Archivnummer 2832507, X130, DRA Frankfurt am Main; "Die Mobilmachung am 1. August 1914" (c. 1915), Archivnummer

Notes to Pages 11–14

2570043, X130, DRA Frankfurt am Main; "Die Erstürmung von Lüttich (August 7, 1914)" (c. 1917), Archivnummer 2570043, X130, DRA Frankfurt am Main.

37. Goodman, *Sonic Warfare*, 10.

38. Peter Payer, "Vom Geräusch zum Lärm: Zur Geschichte des Hörens im 19. und frühen 20 Jahrhundert," in *Der Aufstand des Ohrs: Die neue Lust am Hören*, ed. Volker Bernius (Göttingen, Vandenhoeck & Ruprecht, 2006), 115.

39. Silke Wenzel, "Das musikalische Befehlssystem von Pfeife und Trommel in der Frühen Neuzeit," in *Paradestück Militärmusik: Beiträge zum Wandel staatlicher Repräsentation durch Musik*, ed. Peter Moormann, Albrecht Riethmüller, and Rebecca Wolf (Bielefeld: transcript, 2012), 292.

40. See J. Meyer, ed., *Meyer's Conversations-Lexicon*, 1. Band (A–Alexandreum) (Hildburghausen: Verlag des Bibliographischen Instituts, 1840), 652; *Meyers Konversations-Lexikon*, 1. Band (A–Atlantiden) (Leipzig: Verlag des Bibliographischen Instituts, 1890), 276.

41. Goodman, *Sonic Warfare*, 82.

42. On the soundscapes of the German wars, see Christoph Hoffmann, "Wissenschaft und Militär: Das Berliner Psychologische Institut und der I. Weltkrieg," *Psychologie und Geschichte 5*, nos. 3/4 (April 1994): 261–85; Encke, *Augenblicke der Gefahr*, 162–93.

43. Martin Cloonan and Bruce Johnson, "Killing Me Softly with His Song: An Initial Investigation into the Use of Popular Music as a Tool of Oppression," *Popular Music 21*, no. 1 (January 2002): 31. See also Carolyn Birdsall, *Nazi Soundscapes: Sound, Technology and Urban Space in Germany, 1933–1945* (Amsterdam: Amsterdam University Press, 2012).

44. On German militarism and its influence on civilian life, see Nicholas Stargardt, *The German Idea of Militarism* (Cambridge: Cambridge University Press, 1994); Ute Frevert, *Die kasernierte Nation: Militärdienst und Zivilgesellschaft in Deutschland* (Munich: Beck, 2001); Ute Frevert, ed., *Militär und Gesellschaft im 19. und 20. Jahrhundert* (Stuttgart: Klett-Cotta, 1997). For an account of the reverse line of influence, that is, the impact of German culture and politics on the military, see Isabel V. Hull, *Absolute Destruction: Military Culture and Practices of War in Imperial Germany* (Ithaca, N.Y.: Cornell University Press, 2013), 93–196.

45. William H. McNeill, *Keeping Together in Time: Dance and Drill in Human History* (Cambridge, Mass.: Harvard University Press, 1995), 30.

46. Kahn, *Noise, Water, Meat*, 101.

47. Marshall McLuhan, *The Literary Criticism of Marshall McLuhan, 1943–1962*, ed. Eugene McNamara (New York: McGraw-Hill, 1969); Jacques Derrida, *Paper Machine*, trans. Rachel Bowlby (Stanford, Calif.: Stanford University Press, 2005); N. Katherine Hayles, *Writing Machines* (Cambridge, Mass.: MIT Press, 2002); Friedrich Kittler, "Unpublished Preface to *Discourse Networks*," trans. Geoffrey Winthrop-Young, *Grey Room 63* (Spring 2016): 91–107; Kittler, "Literatur und Literaturwissenschaft als Word Processing," in *Germanistik Forschungsstand und Perspektiven*, ed. Georg Stötzel (Berlin: Walter de Gruyter, 1985), 410–19; Gitelman, *Scripts, Grooves, and Writing Machines*; Matthew Kirschenbaum, *Track Changes: A Literary History of Word Processing* (Cambridge, Mass.: Harvard University Press, 2016); Laura Otis, *Networking: Communicating with Bodies and Machines in the Nineteenth Century* (Ann Arbor: University

154 Notes to Pages 15–19

of Michigan Press, 2001); Bernhard Siegert, *Relays: Literature as an Epoch of the Postal System*, trans. Kevin Repp (Stanford, Calif.: Stanford University Press, 1999).

48. On the configuration modernism/modernity, with an emphasis on the German context, see Hans Ulrich Gumbrecht, "Modern—Modernität—Moderne: Ein irritierender Begriff," in *Geschichtliche Grundbegriffe*, ed. Otto Brunner (Stuttgart: Klett Cotta, 1978): 93–131; Eugene Lunn, *Marxism & Modernism: An Historical Study of Lukács, Brecht, Benjamin and Adorno* (Berkeley: University of California Press, 1982); David Bathrick and Andreas Huyssen, eds., *Modernity and the Text: Revisions of German Modernism* (New York: Columbia University Press, 1989); Dorothee Kimmich and Tobias Wilke, *Einführung in die Literatur der Jahrhundertwende* (Darmstadt: WBG Wissenschaftliche Buchgesellschaft, 2006); Andreas Huyssen, *Miniature Metropolis: Literature in an Age of Photography and Film* (Cambridge, Mass.: Harvard University Press, 2015).

49. Douglas Mao and Rebecca L. Walkowitz, "The New Modernist Studies," *PMLA* 123, no. 3 (2008): 737. See also Sean Latham and Gayle Rogers, *Modernism: Evolution of an Idea* (New York: Bloomsbury, 2015).

50. Mao and Walkowitz, "The New Modernist Studies," 742, 745.

51. Robert Brain, *The Pulse of Modernism: Physiological Aesthetics in Fin-de-siècle Europe* (Seattle: University of Washington Press, 2015), xxii; Devin Fore, *Realism after Modernism: The Rehumanization of Art and Literature* (Cambridge, Mass.: MIT Press, 2015), 3, 19.

52. Sterne, *The Audible Past*, 11.

53. Peter Szendy, *All Ears: The Aesthetics of Espionage*, trans. Roland Végsö (New York: Fordham University Press, 2017), 40.

54. Ibid., 33.

Chapter 1

1. Detlev von Liliencron, *Briefe in neuer Auswahl*, ed. Heinrich Spiero (Stuttgart: Deutsche Verlags-Anstalt, 1927), 292. The three poems were "The Music Is Coming" (Die Musik kommt; 1881), "At the Cash Desk" (Auf der Kasse; 1888), and "On a Winter Night" (In einer Winternacht; ca. 1888). Ernst von Wildenbruch followed suit in 1897 and Ferdinand von Saar and Marie von Ebner-Eschenbach in June 1901. See Heinz Hiebler, "Weltbild 'Hörbild': Zur Formengeschichte des phonographischen Gedächtnisses zwischen 1877 and 1929," in *Die Medien und ihre Technik: Theorien—Modelle—Geschichte*, ed. Harro Segeberg (Marburg: Schüren, 2004), 173.

2. "Meine Herren, eben bin ich 'unsterblich' geworden." Liliencron, *Briefe in neuer Auswahl*, 292.

3. "Speech has become, as it were, immortal." Edward H. Johnson, "A Wonderful Invention—Speech Capable of Indefinite Repetition from Automatic Records," *Scientific American*, November 17, 1877, 304. Helmut von Moltke similarly remarked, "The phonograph allows a man who has long rested in the grave to once again raise his voice and greet the present" (Der Phonograph ermöglicht, dass ein Mann, der schon lange im Grabe ruht, noch einmal seine Stimme erhebt und die Gegenwart begrüßt). See "Der Phonograph bei Feldmarschall Moltke," *Schlesische Zeitung*, October 22, 1889, 2.

4. Letter to Jakob Löwenberg from early 1897.

Notes to Pages 19–20

5. See "Phonographen-Automaten," *Phonographische Zeitschrift* 3, no. 9 (1902): 105.

6. Georg Simmel, *Soziologie: Untersuchungen über die Formen der Vergesellschaftung Soziologie* (Leipzig: Duncker & Humblot, 1908), 653, 654.

7. See "An Hugo Wolf" (1906), Archivnummer 2874478, X130, DRA Frankfurt am Main; "Cincinnatus" (1906), Archivnummer 2874478, X130, DRA Frankfurt am Main; "Bruder Liederlich" (June 27, 1906), Archivnummer 2600328, X130, DRA Frankfurt am Main; "Bruder Liederlich" (November 2, 1910), Archivnummer 2600328, X130, DRA Frankfurt am Main; "Cincinnatus" (1915), Archivnummer 2600328, X130, DRA Frankfurt am Main.

8. See Alan Kelly, *His Master's Voice.*

9. The commercial success of Straus's piece is referred to in Harold B. Siegel, *Turn-of-the-century Cabaret: Paris, Barcelona, Berlin, Munich, Vienna, Cracow, Moscow, St. Petersburg, Zurich* (New York: Columbia University Press, 1987), 145.

10. See Richard Tgahrt, ed., *Dichter Lesen: Von Gellert bis Liliencron*, vol. 1 (Marbach am Neckar: Deutsche Schillergesellschaft, 1984), 271–82; Lothar Müller, *Die Zweite Stimme: Vortragskunst von Goethe bis Kafka* (Berlin: Klaus Wagenbach, 2007). Müller contends that Liliencron was "one of the first to undertake reading tours for commercial purposes" (einer der ersten, der in gewerblicher Absicht Lesereisen unternimmt; 122).

11. Scholarship on Liliencron's literary output has declined dramatically since 1945. For an overview of recent approaches to his work, see Günther A. Höfler, "Das neue Paradigma des Krieges und seine literarischen Repräsentationen: Dargestellt an Detlev v. Liliencron, Ernst Jünger und Thor Goote," in *Intimate Enemies: English and German Literary Reactions to the Great War 1914–1918*, ed. Franz Karl Stanzel and Martin Löschnigg (Heidelberg: Universituatsverlag C. Winter, 1993), 277–91; Barbara Burns, "The Influence of Ivan Turgenev's *Sportsman's Sketches* on the Stories of Detlev von Liliencron," *Orbis Litterarum* 56 (2001): 106–20; Marc Föcking, "Drei Verbindungen: Lyrik, Telefon, Telegrafie 1900–1913 (Liliencron, Altenberg, Apollinaire)," in *Die schönen und die nützlichen Künste*, ed. Knut Hickethier (Munich: Fink, 2007), 167–80; *Detlev von Liliencron (1844—1909): Facetten eines bewegten Dichterlebens: Ausstellung 21. Juni—28. August 2009* (Kiel: Schleswig-Holsteinische Landesbibliothek, 2009); Volker Griese, *Detlev von Liliencron: Chronik eines Dichterlebens* (Muenster: Monsenstein und Vannerdat, 2009); Maik Bierwirth, "Detlev von Liliencron und das Verlags- und Urheberrecht von 1901," in *Turns and Trends der Literaturwissenschaft: Literatur, Kultur und Wissenschaft zwischen Nachmärz und Jahrhundertwende im Blickfeld aktueller Theoriebildung*, ed. Christian Meierhofer and Eric Scheufler (Zurich: Germanistik.ch, 2011), 129–46.

12. Liliencron's relationship to the movement was conflicted. On the one hand, he regarded naturalism as "a colossal revolution in the literary world" (eine ganz kolossale Revolution in der Dichterwelt), and confirmed his allegiance in dramatic military terms ("I march with them" [ich marschiere mit]); "A new generation of poets storms forward with flying flags" (Eine neue Dichtergeneration stürmt mit fliegenden Fahnen vorwärts), he wrote in a glowing review of *The Book of Time* (*Das Buch der Zeit*) by perhaps the group's most prominent poet and theoretician, Arno Holz. Likewise, Holz praised Liliencron as the lone

156 Notes to Pages 20–21

German predecessor to his own formal experiments with rhythm and sound. Several of Liliencron's texts, including his literary debut, *Rides of the Adjutant and Other Poems* (*Adjutantenritte, und andere Gedichte*; 1883), were published by naturalism's preeminent publisher Wilhelm Friedrich, while others appeared in the leading naturalist journal, *Society* (*Die Gesellschaft*). Liliencron was also involved in the fight to revise copyright laws for working authors at the turn of the century and belonged to the Cartel of Lyrical Authors (Das Kartell lyrischer Autoren), along with Holz and Otto Julius Bierbaum. On the other hand, Liliencron responded critically to Holz's more experimental cycle of poems *Phantasus* (1898/99). He later ridiculed the naturalist movement in his poem, "Farewell to My Deceased Friend, Herr Naturalism" (Lebewohl an meinen verstorbenen Freund, Herrn Naturalismus). See Liliencron's letter to Hermann Friedrich, July 5, 1885, in Liliencron, *Briefe in neuer Auswahl*, 85; Liliencron, review of *Das Buch der Zeit* by Arno Holz, *Das Magazin für die Literatur des In- und Auslandes: Organ des Allgemeinen Deutschen Schriftsteller-Verbandes* 54, no. 31 (August 1, 1885): 483–84; Arno Holz, "Selbstanzeigen: Phantasus," *Die Zukunft* 23 (1898): 217; Bierwirth, "Detlev von Liliencron und das Verlags- und Urheberrecht von 1901"; Liliencron's letter to Arno Holz, May 19, 1898, in *Briefe in neuer Auswahl*, 321, 322; Liliencron, "Lebewohl an meinen verstorbenen Freund, Herrn Naturalismus," in *Gute Nacht: Hinterlassene Gedichte* (Berlin: Schuster & Loeffler, 1909), 134–35.

13. On naturalism, see Hanno Möbius, *Der Positivismus in der Literatur des Naturalismus: Wissenschaft, Kunst und soziale Frage bei Arno Holz* (Munich: Fink, 1980); Peter Bürger, *The Decline of Modernism*, trans. Nicholas Walker (University Park: Penn State University Press, 1992), 95–136; Irene Albers, *Sehen und Wissen: Das Photographische im Romanwerk Émile Zolas* (Munich: Fink, 2002); Ingo Stöckmann, *Der Wille zum Willen: Der Naturalismus und die Gründung der literarischen Moderne, 1880–1900* (New York: De Gruyter, 2009); Peter Sprengel, "Fantasies of the Origin and Dreams of Breeding: Darwinism in German and Austrian Literature around 1900," *Monatshefte* 102, no. 4 (Winter 2010): 458–78.

14. See Adalbert von Hanstein, *Das jüngste Deutschland: Zwei Jahrzehnte miterlebter Literaturgeschichte* (Leipzig: R. Voigtländer, 1900), 158.

15. Holz, *Das Buch der Zeit*, in *Werke 5*, ed. Wilhelm Emrich and Anita Holz (Neuwied am Rhein: Luchterhand, 1961–64), 94. Holz goes on to lambast the German reading public for their neglect of poetry's sonic dimension, quoting from Friedrich Nietzsche's *Beyond Good and Evil* (*Jenseits von Gut und Böse*, 1886), "The German does not read aloud, rather only with the eyes: he has left his ears lying in the drawer" (Der Deutsche liest nicht laut, sondern bloß mit den Augen: er hat seine Ohren dabei ins Schubfach gelegt; 102).

16. Heinrich Pador, "Die Phonographie im Dienste der Dichtkunst und Rhetorik," *Phonographische Zeitschrift*, November 28, 1900, 59; Pador, "Die Phonographie im Dienste der Dichtkunst und Rhetorik (Schluss)," *Phonographische Zeitschrift*, December 12, 1900, 67–68. See also Pador's criticism of the modern reading public's 'visual bias,' which he believed had problematically obscured the fact that language was "first and foremost a sound, not a symbol" (in erster Linie ein Laut, nicht ein Zeichen)—something for the ear, not the eye. Pador, "Schrift-Poesie," *Neue Litterarische Blätter* 3, no. 10 (July 1, 1895): 255.

Notes to Pages 22–24

17. Paul von Wielen, "Plaudereien am Kamin," *Ueber Land und Meer* 40:20, no. 47 (October 1877/78): 980.

18. "Aber war es nicht möglich, über ihren Naturalismus noch hinanzukommen, die Wirklichkeit noch treuer widerzuspiegeln, die künstlerische Ausdrucksweise mit den Erscheinungen des Lebens noch weit inniger in Einklang zu bringen? Es musste möglich sein; denn wie sollte man sonst dem Publikum, das mit Neuem, Ungewohntem überrascht sein will, imponieren? Theoretisch verachtete man die Gunst der Masse, praktisch suchte man sie um so brennender. Die schönsten Reimverse waren achtlos im Winde verhallt, neue Ideen, eine neue Weltanschauung hatte man nicht zu bieten; das bisschen Sozialismus war beinahe schon verbraucht, Nietzsche war noch nicht entdeckt. Da mithin ein neuer Gehalt nicht aufzubringen war, so musste das Verblüffende, Imponierende aus neuer Form und neuer Technik herauswachsen." Heinrich Hart, "Wir Westfalen," in *Gesammelte Werke* 3, ed. Julius Hart and Wilhelm Bölsche (Berlin: E. Fleischel, 1907), 67–68.

19. See Friedrich A. Kittler, *Discourse Networks,1800–1900*, trans. Michael Metteer and Chris Cullens (1985; Stanford, Calif.: Stanford University Press, 1989); Kittler, "Unpublished Preface to *Discourse Networks.*"

20. See Helmut Schanze, "Der Experimentalroman des deutschen Naturalismus: Zur Theorie der Prosa um 1890," in *Handbuch des deutschen Romans*, ed. Helmut Koopmann (Düsseldorf: Bagel, 1983), 464; E. M. Siegel, "Das Sprechen des kulturellen Archivs: Sieben Thesen zur phonographischen Schreibweise des Naturalismus," in *Phono-Graphien: Akustische Wahrnehmung in der deutschsprachigen Literatur von 1800 bis zur Gegenwart*, ed. Marcel Krings (Würzburg: Königshausen & Neumann, 2011), 179–88; Gerhard Plumpe, *Epochen moderner Literatur: Ein systemtheoretischer Entwurf* (Wiesbaden: Springer Fachmedien, 1995), 135; Susanne Hauser, *Der Blick auf die Stadt: Semiotische Untersuchungen zur literarischen Wahrnehmung bis 1910* (Berlin: Reimer, 1990), 138. All references to the naturalists' "phonographic method" ultimately lead back to an afterword by the Germanist Fritz Martini, who claimed that Holz himself had employed the phrase to describe his writings. However, Martini provides no reference to support his claim, and one would be hard pressed to find even a single mention of the phonograph in any text or letter by a naturalist writer other than Liliencron. See Fritz Martini, "Nachwort," afterword to Arno Holz and Johannes Schlaf's *Papa Hamlet und Ein Tod* (Stuttgart: Reclam, 1972), 113. See also Thomas Forrer, "Phonograph, Symbolic: Acoustic Evidence in Arno Holz' *Phantasus*," *Journal of Sonic Studies* 13 (December 2016), https://www.researchcatalogue.net/view/322719/322720/0/0.

21. My account of Liliencron's unpublished war journals relies exclusively on Else Hordzewitz's 1938 study, *Liliencrons ungedruckte Kriegstagebücher und ihre Bedeutung für seine Kriegsdichtung* (Würzburg: Konrad Triltsch, 1938). Hordzewitz states that, at the time she was writing, the journals belonged to the Hamburger Staats- und Universitätsbibliothek. I have been unable to find any information regarding their current location.

22. Sterne and Rodgers use the phrase to refer to "the figural dimensions of the process itself [of manipulating sound in a transduced state] as well as the modes through which the process is represented in audio-technical discourse." Jonathan Sterne and Tara Rodgers, "The Poetics of Signal Processing," *differences: A Journal of Feminist Cultural Studies* 22, nos. 2/3 (2011): 35.

23. See "Militärmusik," *Das Recht auf Stille* 2, no. 5 (May 1910): 28. On audio contagion, see also Goodman, *Sonic Warfare*, xix–xx, 129–32.

24. Oskar Wiener, *Mit Detlev von Liliencron durch Prag* (Frankfurt am Main: H. Lüstenöder, 1918), 41.

25. "Es liegt eine berauschende Tonfülle in diesen Worten und Reimen, und eine wahre Ohrenweide ist es, sich diese prächtigen, strammen, wie aus einem Guss gearbeiteten Verse vorlesen zu lassen." Hugo Greinz, *Detlev von Liliencron: Eine literaturhistorische Würdigung* (Berlin: Schuster & Loeffler, 1896), 7.

26. "Unsere Zeit steht im Zeichen des Leutnants. Das ist das herrschende Gestirn am Himmel unserer jungen Damen und unserer jungen Männer. Ihm schwärmen jene zu, ihm streben diese nach." Otto Julius Bierbaum, "Ein lyrischer Hauptmann," in *Liliencron* (Munich: G. Müller, 1910), 3.

27. On discussions surrounding gender and poetry at this time, see Günter Häntzschel, "Geschlechterdifferenz und Dichtung: Lyrikvermittlung im ausgehenden 19. Jahrhundert," in *Hansers Sozialgeschichte der deutschen Literatur vom 16. Jahrhundert bis zur Gegenwart. Band 7. Naturalismus, Fin de siècle, Expressionismus 1890–1918*, ed. York-Gothart Mix (Munich: Carl Hanser, 2000), 53–63.

28. Bierbaum, "Ein lyrischer Hauptmann," 15.

29. Walter Benjamin, "Paris, die Hauptstadt des XIX. Jahrhunderts" (1935), in *Gesammelte Schriften 5*, book 1, *Das Passagen-Werk*, ed. Rolf Tiedermann (Frankfurt am Main: Suhrkamp, 1991), 45–59; Benjamin, "Paris, the Capital of the Nineteenth Century," in *The Work of Art in the Age of Its Technological Reproducibility, and Other Writings on Media*, ed. Michael W. Jennings, Brigid Doherty, and Thomas Y. Levin (Cambridge, Mass.: Harvard University Press, 2008), 96–115.

30. See Joachim Radkau, "Die wilhelminische Ära als nervöses Zeitalter, oder: Die Nerven als Netz zwischen Tempo- und Körpergeschichte," *Geschichte und Gesellschaft* 20, no. 2 (April–June 1994): 237; August Lucae, *Zur Entstehung und Behandlung der subjectiven Gehörsempfindungen* (Berlin: Otto Enslin, 1884), 19; *Traumatische, idiopathische und nach Infektionskrankheiten beobachtete Erkrankungen des Nervensystems bei den deutschen Heeren im Kriege gegen Frankreich 1870/71* (Berlin: Ernst Siegfried Mittler und Sohn, 1886), 292, 299, 367, 416, 454.

31. Detlev von Liliencron, *Adjutantenritte und andere Gedichte* (Leipzig: Wilhelm Friedrich, 1883), 32, 148.

32. On telegraphy and nineteenth-century literature, see Friedrich Kittler, "Im Telegrammstil," in *Stil: Geschichten und Funktionen eines kulturwissenschaftlichen Diskurselements*, ed. Hans Ulrich Gumbrecht und K. Ludwig Pfeiffer (Frankfurt am Main: Suhrkamp, 1986), 358–70; Siegert, *Relays*, 165–85; Christian Erik Thomas, "'Ich werde ganz einfach telegraphieren'—Subjekte, Telegraphie, Autonomie und Fortschritt in Theodor Fontanes Gesellschaftsromanen" (PhD diss., University of British Columbia, 2002); Richard Menke, *Telegraphic Realism: Victorian Fiction and Other Information Systems* (Stanford, Calif.: Stanford University Press, 2008), 1–28. On Liliencron and telegraphy, see Föcking, "Drei Verbindungen."

33. See Hordzewitz, *Liliencrons ungedruckte Kriegstagebücher und ihre Bedeutung für seine Kriegsdichtung*, 15, 16.

Notes to Pages 27–31 159

34. On Musil, Jünger, and onomatopoeia, see chapter 4.

35. Karl Bleibtreu, *Revolution der Lyrik* (Leibzig: W. Friedrich, 1886), 49; Heinrich Spiero, *Detlev von Liliencron* (Berlin: Schuster & Loeffler, 1913), 258.

36. "Nüchterner Hornstoß," "paralysieren," "lyrisches Wischwasch." Heinrich Spiero, ed., *Neue Kunde von Liliencron: Des Dichters Briefe an seinen ersten Verleger* (Leipzig: Xenien-Verlag, 1911), 32.

37. "Klangen von unserer Kavallerie nur Signale zu uns, jene Signale, die eine Poesie in sich bergen." Liliencron, "Der Richtungspunkt," in *Krieg und Frieden: Novellen* (Leipzig: W. Friedrich, 1891), 29.

38. "Hinter uns klang häufig das Kavallerie-Signal Trab. Wir konnten die Schwadronen nicht sehen. Aber es war mir, als hörte ich das Stapfen, Schnaufen, Klirren. Kommandorufe klangen an mein Ohr: Ha–hlt . . . Ha–hlt . . . und immer schwächer und schwächer werdend: Ha–hlt . . . Ha–hlt. Alles das klang her, was die Bewegungen eines Reiterregiments so hoch poetisch macht; erst recht, wenn man 'drin steckt.' Ich hörte das Alles deutlich, und doch war um uns ein einziger Donnerton. Dazwischen klangen schrill die Schüsse der Batterie, die ich eben herangeholt hatte." *Adjutantenritte*, 152.

39. "Nun knallten die ersten Gewehrschüsse. Bald hatten wir ein Wäldchen erreicht, und breiteten uns hier am andern Rande hinter den Bäumen aus. Tak, tak, tak, sagte es, tak, tak—tak—taktak—taktaktaktak—taktak—taktaktaktak. . . . Wie in einem großen Telegraphen-Büreau hörte sichs." Detlev von Liliencron, "Eine Sommerschlacht," in *Kriegsnovellen* (Berlin: Schuster & Loeffler, 1896), 51.

40. The term *Sekundenstil* was first introduced in 1900 by Adalbert von Hanstein in his *Das jüngste Deutschland* in his analysis of the formal techniques employed in Arno Holz and Johannes Schlaf's *Papa Hamlet* (1889). Von Hanstein described the work's second-by-second descriptions as an "inner technology" (innere Technik) and "diaristic poetry" (tagebuchartige Dichtung). He then draws attention to the technique's grounding in the materiality of the writing scene from which it arose. Referring now to a "new technology of writing" (neue Technik der Schrift), von Hanstein notes that during a visit to Holz's house he had seen original manuscripts of his work, which were not only covered with dots and dashes but also written down with Chinese ink wash paints, which in comparison with ordinary ink (*Tinte*) produced much bolder and tonally varied marks on the page. Without explicitly mentioning the telegraph or Morse code, von Hanstein explained that, while dots and dashes had long been used to mark moments of intense inwardness in literary history, Holz and Schlaf differentiated themselves from their precursors by their quantitative precision, counting them out exactly to align them with the readerly passage of time.

41. Siegert, *Relays*, 182.

42. Liliencron, "Eine Sommerschlacht," in *Kriegsnovellen*, 50. For the original diary entry on which the novella is based, see Hordzewitz, *Liliencrons ungedruckte Kriegstagebücher und ihre Bedeutung für seine Kriegsdichtung*, 8.

43. Liliencron, "Umzingelt" (1889), in *Kriegsnovellen*, 262.

44. Liliencron, "Das Wärterhäuschen" (1891), in *Kriegsnovellen*, 236.

45. "Energie, Feuer, unaufhörlicher Fortgang (also kein langweiliger Zwischenkram) darin. Eine Feuersprache!" Letter to Helene von Bodenhausen from June 12, 1881, in Liliencron, *Briefe in neuer Auswahl*, 143.

46. "Denn der Sieg liege heute im Marsch und Manöver, also in ihren Beinen." Ernst Schmedes, "Die Taktik der Preussen beim Ausbruche des Feldzuges 1870 und ihre Änderung im Laufe desselben," *Österreichische militärische Zeitschrift* 12 (1871): 194.

47. Geoffrey Wawro, *The Franco-Prussian War: The German Conquest of France in 1870–1871* (Cambridge: Cambridge University Press, 2003), 55.

48. Karl Lamprecht, *Zur jüngsten deutschen Vergangenheit, 1. Band, Deutsche Geschichte, Erster Ergänzungsband* (Berlin: R. Gaertners Verlagsbuchhandlung, 1902), 215, 217.

49. One notable exception is among Liliencron's *Kriegsnovellen*; "Das Wärternhäuschen" describes a soldier plagued by auditory hallucinations and vertigo following a violent explosion during combat—symptoms commonly associated with a damaged ear. Interestingly, the sound that he hallucinates comes from a device used to communicate signals to locomotive conductors.

50. Liliencron, "An der Mittagstunde," in *Kriegsnovellen*, 152, 156.

51. "Gegen Trommeln und Pfeifen mein Ohr hielt ich dicht." Liliencron, "Mit Trommeln und Pfeifen" (1888), in *Ausgewählte Gedichte*, 9th ed. (Berlin: Schuster & Loeffler, 1905), 99.

52. Lamprecht, *Zur jüngsten deutschen Vergangenheit*, 219.

53. Joseph Goebbels, "Die deutsche Kultur vor neuen Aufgaben," speech given on November 15, 1933, reproduced in Goebbels, *Signale der neuen Zeit: 25 ausgewählte Reden* (1934; Munich: Zentralverlag der NSDAP, Franz Eher Nachfolger, 1940), 332.

54. On Jünger, see Andreas Huyssen, "Fortifying the Heart Totally: Ernst Jünger's Armored Texts," *New German Critique* 59 (Spring/Summer 1993): 3–23.

55. "Der Tambour schlägt unausgesetzt, plum—bum, plum—bum, plum—bum, immer nach dem zusammenfallenden ersten Schlag der nachfolgende einzelne." Liliencron, "Eine Sommerschlacht," in *Kriegsnovellen*, 57.

56. Ibid.

57. See Fritz Schellack, "Sedan- und Kaisergeburtstagsfeste," in *Öffentliche Festkultur: Politische Feste in Deutschland von der Aufklärung bis zum ersten Weltkrieg*, ed. Dieter Düding, Peter Friedemann, and Paul Münch (Reinbek bei Hamburg: Rowohlt, 1988), 278–97; Jakob Vogel, *Nationen im Gleichschritt: Der Kult der 'Nation in Waffen' in Deutschland und Frankreich, 1871–1914* (Göttingen: Vandenhoeck & Ruprecht, 1997); Frank Becker, *Bilder von Krieg und Nation: Die Einigungskriege in der bürgerlichen Öffentlichkeit Deutschlands 1864–1913* (Munich: Oldenbourg Wissenschaftsverlag, 2001); Frank Becker, "Augen-Blicke der Größe: Das Panorama als nationaler Erlebnisraum nach dem Krieg von 1870/71," in *Das 19. Jahrhundert als Mediengesellschaft*, ed. Jörg Requate (Munich: Oldenbourg, 2009), 178–91.

58. See Heinz Lemmermann, *Kriegserziehung im Kaiserreich* (Lilienthal: Eres, 1984); Alfred Kelly, "War and Unification in German History Schoolbooks," in *1870/71–1989/90: German Unifications and the Change of Literary Discourse*, ed. Walter Pape (New York: Walter de Gruyter, 1993), 37–60. Poems such as "Fife and Drum" (Mit Trommeln und Pfeifen; 1888) and "The Music Is Coming" also appeared in an edition of Liliencron's poetry intended for young readers. See Detlev von Liliencron, *Liliencrons Gedichte: Auswahl für die Jugend:*

Zusammengestellt von der Lehrervereinigung zur Pflege der künstlerischen Bildung in Hamburg (Berlin: Schuster & Loeffler, 1901).

59. See Harrison Powley, "Janissary Music (Turkish Music)," in *Encyclopedia of Percussion*, ed. John H. Beck (New York: Routledge, 2007), 228; Gunther Joppig, "*Alla Turca*: Orientalismen in der europäischen Kunstmusik vom 17. bis zum 19. Jahrhundert," in *Europe und der Orient 800–1900*, ed. Gereon Sievernich and Hendrik Budde (Gütersloh: Bertelsmann Lexikon Verlag, 1989), 295–304.

60. Oscar Teuber, *Die österreichische Armee von 1700 bis 1867* (Vienna: Emil Berté & C. and S. Czeiger, 1895), 705.

61. "Janitscharen-Musik," in *Musikalisches Conversations-Lexikon: Eine Encyklopädie der gesammten musikalischen Wissenschaften 5*, ed. Hermann Mendel (Berlin: Robert Oppenheim, 1875), 362.

62. Liliencron, "Portepeefähnrich Schadius," in *Unter flatternden Fahnen: Militärische und andere Erzählungen* (Leipzig: W. Friedrich, 1888), 138. For examples of onomatopoeia in musical works by Offenbach and others during the same period, see Thomas S. Grey, "*Eine Kapitulation*: Aristophanic Operetta as Cultural Warfare in 1870," in *Richard Wagner and His World*, ed. Thomas S. Grey (Princeton, N.J.: Princeton University Press, 2009), 87–122.

63. "Diese Klänge, durch die [europäische Soldaten] so oft in Schrecken versetzt worden waren." "Janitscharen-Musik," 363.

64. "Fern die Musik, klingklang rumbum / Sie tanzt und tanzt, rechtsum, linksum / Reizend, wie Engel schweben // Her, hin und her, sie ist allein / Umblitzt vom ersten Sonnenschein / Dem Trieb ganz hingegeben." Liliencron, "Die Macht der Musik," *Nord und Süd* 127, no. 379 (October 1908): 479.

65. "Dass man schließlich voller Verzweiflung die altbekannten hochpatriotischen Melodien mitpfeift." "Militärmusik," 28.

66. "Die Mädchen alle, Kopf an Kopf / das Auge blau und blond der Zopf."

67. "Der Krieg wird ewig dauern." Letter from Liliencron to Friedrichs, August 10, 1888, in *Detlev von Liliencrons Briefe an Hermann Friedrichs aus den Jahren 1885–1889* (Berlin: Corcordia Verlags-Anstalt, 1910), 285.

68. See Müller, *Die zweite Stimme*, 122; Tgahrt, *Dichter Lesen*, 271–82.

69. "Ich muss gestehn, ich habe eine recht große Angst davor. Und lieber ginge ich gegen eine mit Kartätschen geladene Batterie an." Liliencron to Margarethe Stolterfoth, January 11, 1898, in *Briefe in neuer Auswahl*, 312.

70. Liliencron letter to Gustav Falke, January 25, 1898, in *Briefe in neuer Auswahl*, 314.

71. "Ich brüllte, säuselte, girrte, lachte, weinte, schnurrte, knurrte, heulte, winselte, schmeichelte, grollte, schnadahüpfelte, kicherte, grunzte, greinte." Liliencron's letter to his publisher Schuster & Loeffler, November 26, 1899, in *Ausgewählte Briefe*, vol. 2 (Berlin: Schuster & Loeffler, 1910), 276.

72. See Sigrid Weigel, "Die Stimme als Medium des Nachlebens: Pathosformel, Nachhall, Phantom: Kulturwissenschaftliche Perspektiven," in *Stimme: Annäherung an ein Phänomen*, ed. Doris Kolesch and Sybille Krämer (Frankfurt am Main: Suhrkamp, 2006), 17; Sybille Krämer, "Die 'Rehabilitierung der Stimme': Über die Oralität hinaus," in *Stimme*, 275.

73. "Wenn Liliencron keine Zähne hat, soll er sich falsche einsetzen lassen." Wiener, *Mit Detlev von Liliencron durch Prag*, 56.

162 Notes to Pages 44–50

74. "Er spuckte die Verse. Mit dem Gebiß des alten Herrn schien etwas nicht in Ordnung zu sein. Sprudelnd und zischend brachen die elysischen Gebilde hervor. . . . Nicht ganz leicht verständlich klang das unseren Ohren, schon die norddeutsche Aussprache machte uns die Worte fremd." Max Brod, *Streitbares Leben* (Munich: Kindler, 1960), 198.

75. See Peter Jelavich, *Berlin Cabaret* (Cambridge, Mass.: Harvard University Press, 1993), 52.

76. "An das Gedicht vom Mohrenfürsten, der auf den Jahrmärkten die Trommel schlagen muss." Alfred Kerr, "Fluch der bösen Tat" (1901), in *Gesammelte Schriften* 4 (Berlin: S. Fischer, 1917), 337.

77. "Die Hure verkauft doch nur ihren Leib, ich aber noch dazu meinen Namen und meine Seele." Liliencron's letter to Maximilian Fuhrmann, December 15, 1901, in *Briefe in neuer Auswahl*, 369.

78. "Aber die Stimme, so las ich neulich ganz richtig, ist 'ein Theil unsrer Seele.' " Liliencron's letter to Margarethe Stolterfoth, January 11, 1898, in *Briefe in neuer Auswahl*, 312.

79. "Das *kann* ich einfach nicht lesen" (author's emphasis). Liliencron's letter to Gustav Falke, January 25, 1898, in *Briefe in neuer Auswahl*, 314.

Chapter 2

1. Peter Altenberg, "The Drummer Belín" (Der Trommler Belín), in *Wie ich es sehe: In der Fassung des Erstdrucks* (Berlin: Fischer Taschenbuch Verlag, 2009), 61, hereafter cited as *Wie* followed by the page number.

2. "And now several hundred angels: a calvary brigade, wedged together, like a thunderous wind: Ratatata!" (Und nun viele hundert Engel: eine Kavalleriebrigade, zusammengekeilt, wie der Donnerwind: Ratatata!). Liliencron, "Eine Sommerschlacht" (1887), in *Kriegsnovellen*, 58.

3. Altenberg was well acquainted with Liliencron's writings. See, for example, his contribution to *Detlev von Liliencron im Urteil zeitgenössischer Dichter: Dem Dichter der 'Adjutantenritte' und des 'Poggfred' überreicht*, ed. Fritz Böckel (Berlin: Schuster & Loeffler, 1904), 15.

4. Hermann Bahr, "Die Überwindung des Naturalismus" (1891), in *Kritische Schriften II*, ed. Claus Pias (Weimar: VDG, 2004), 130.

5. See Andrew Barker, *Telegrams from the Soul: Peter Altenberg and the Culture of Fin-de-siècle Vienna* (Columbia, S.C.: Camden House, 1996), 8, 10.

6. Arthur Schnitzler, *Jugend in Wien* (Vienna: Fritz Molden, 1968), 212. See also Gemma Blackshaw, "Peter Altenberg: Authoring Madness in Vienna circa 1900," in *Journeys into Madness: Mapping Mental Illness in the Austro-Hungarian Empire*, ed. Gemma Blackshaw and Sabine Wieber (New York: Berghahn Books, 2012), 109–29.

7. Hissing and whistling, those in attendance called for both composer and author to be sent to the asylum before what started as a scuffle between Adolf Loos and anti-Schönberg hecklers became a full-blown riot. During the ensuing legal trial, the composer Oscar Straus, who had set Liliencron's "The Music Is Coming" ten years earlier, commented that the thud of a punch thrown by the concert organizer at a heckler that night had been the most harmonious sound he heard. The report of the trial took up almost an entire page in a local Vienna newspaper, pushing aside an ongoing murder trial. See Martin Eybl, ed., *Die*

Notes to Pages 50–52 163

Befreiung des Augenblicks: Schönbergs Skandalkonzerte 1907 und 1908: Eine Dokumentation (Vienna: Böhlau, 2004), 26; Werner J. Schweiger, "Das Skandalkonzert im Wiener Musikverein," in *Peter Altenberg-Almanach: Lese-Heft des Löcker Verlags* (Vienna: Löcker, 1987), 34, 35; Barker, *Telegrams from the Soul*, 173.

8. "[Der Dichter] ist ein Mensch, den es noch nicht gibt." Egon Friedell, *Ecce Poeta* (Berlin: S. Fischer, 1912), 27.

9. Theodor W. Adorno, "Physiologische Romantik" (1932), in *Noten zur Literatur*, ed. Rolf Tiedemann (Frankfurt am Main: Surhkamp, 1974), 635.

10. Goodman, *Sonic Warfare*, 188.

11. Max Winter, "Wiener Lärm," *Arbeiter-Zeitung*, May 20, 1908, 1–3.

12. "Das Konzert der Strasse ist uns bei unserer täglichen Arbeit eine aufmunternde Begleitung geworden, wie die Marschmusik für die Soldaten." Oskar Blumenthal, "Das Konzert der Strasse," *Neue Freie Presse*, February 7, 1907, 2.

13. Connections between the city and the battlefield have traditionally been analyzed in the context of World War I and its aftermath. See Maria Tatar, *Lustmord: Sexual Murder in Weimar Germany* (Princeton, N.J.: Princeton University Press, 1995), 68–97; Klaus Theweleit, *Male Fantasies* (1977/78), vols. 1 and 2, trans. Stephen Conway, Erica Carter, and Chris Turner (Minneapolis: University of Minnesota Press, 1987/89); Huyssen, *Miniature Metropolis*, 222–36.

14. Medical research on the eardrum and its application to early sound reproduction was inextricably bound up with Vienna. In the 1860s, Alexander Graham Bell's collaborator Clarence Blake worked as an assistant to Adam Politzer, the first chair of otology at the University of Vienna and one of the earliest medical researchers to use human eardrums in the construction of modified versions of the phonautograph. The same year that Altenberg's "The Drummer Belín" appeared in his debut collection, Politzer published his *Atlas of the Eardrum in Health and Disease* (Atlas der Beleuchtungsbilder des Trommelfells, 1896), which included hundreds of chromolithographic prints of damaged eardrums as an aid for medical diagnosis. Politzer's work had already gained international recognition at the Centennial Exhibition in Philadelphia in 1876, where, along with furniture and pottery, his plaster models and watercolor sketches of the eardrum were chosen to represent the achievements of the Austro-Hungarian Empire. By the end of the nineteenth century, as Sigmund Freud published his studies of aphasia and continued to develop his talking cure, the Viennese eardrum became an international export and prized object of display. See Adam Politzer, *Atlas der Beleuchtungsbilder des Trommelfells im gesunden und kranken Zustande: Für praktische Ärzte und Studirende* (Vienna: Wilhelm Bräumüller, 1896); Sylvan E. Stool, Marlyn J. Kemper, and Bennett Kemper, "Adam Politzer, Otology and the Centennial Exhibition of 1876," *Laryngoscope* 85, no. 11 (1975): 1898–904; Sterne, *The Audible Past*, 31–40. On the unique availability of human corpses for medical dissection in Vienna at this time, see Tatjana Buklijas, "Cultures of Death and Politics of Corpse Supply: Anatomy in Vienna, 1848–1914," *Bulletin of the History of Medicine* 82, no. 3 (Fall 2008): 570–607.

15. On the history of the Ronacher around this time, see Lutz Eberhardt Seelig, *Ronacher: Die Geschichte eines Hauses* (Vienna: Hermann Böhlaus, 1986), 26–30. For Altenberg's reflections on the theater, which he associated with "the formal beginning of a new era of aesthetic freedom" (der feierliche Anfang einer

164 Notes to Pages 52–57

neuen Ära ästhetischer Freiheit), see his "Etablissement Ronacher," in *Märchen des Lebens* (Berlin: S. Fischer, 1908), 64–65.

16. The tour of Vienna's urban spaces continues in the text immediately following "The Drummer Belín," which depicts a visit to the Prater theme park Venice in Vienna (Venedig in Wien). Opened in 1895, the park included, among other things, an array of new technologies such as photographs, electric lighting, phonographs, and films. See Norbert Rubey and Peter Schoenwald, *Venedig in Wien: Theater- und Vergnügungsstadt der Jahrhundertwende* (Vienna: Ueberreuter, 1996).

17. The reference is by no means obvious. A critic as sharp as Michael Cowan, for example, reads the text as an invocation of the Napoleonic Wars of the early nineteenth century. To do so is to miss the text's commentary on the perceptual changes that accompanied the rise of mechanized warfare and the extent to which its auditory effects were appropriated and formally encoded in late nineteenth-century literature. See Michael Cowan, "Imagining Modernity through the Ear: Rilke's *Aufzeichnungen des Malte Laurids Brigge* and the Noise of Modern Life," *Arcadia* 41, no. 1 (2006): 134.

18. "Millionen, immer noch, immer noch, noch, noch, noch." *Wie*, 61.

19. "Wird er nicht aufhören?! Er hört nicht auf." Ibid., 62.

20. Liliencron, "Umzingelt" (1889), in *Kriegsnovellen*, 262.

21. Friedell, *Ecce Poeta*, 167.

22. Peter Altenberg, "Der Schreibunterricht," in *Bilderbogen des kleinen Lebens* (Berlin-Westend: Erich Reiss Verlag, 1909), 84. Altenberg also notes in the same piece that his remarkable penmanship comes from writing "from the wrist" (aus dem Handgelenke), a formulation that establishes further connections between his own textual practices and the percussive techniques used by the drummer Belín, who is described in the text as a "genius of the wrist" (Genie des Handgelenkes).

23. In his essay on the tympanum, Jacques Derrida similarly emphasizes "the sexual investments which, everywhere and at all times, powerfully constrain the *discourse of the ear*." See his "Tympan," in *Margins of Philosophy*, trans. Alan Bass (Chicago: University of Chicago Press, 1982), xiv (Derrida's emphasis). On sexual violence in Vienna at this time, see Larry Wolff, *Child Abuse in Freud's Vienna: Postcards from the End of the World* (New York: New York University Press, 1988), 204–6; Scott Spector, *Violent Sensations: Sex, Crime, and Utopia in Vienna and Berlin, 1860–1914* (Chicago: University of Chicago Press, 2016).

24. Johann Gottfried Herder, *Abhandlung über den Ursprung der Sprache*, ed. Dr. Theodor Matthias (1772; Leipzig: Brandstetter, 1901), 72. See also Jürgen Trabant, "Herder's Discovery of the Ear," in *Herder Today: Contributions from the International Herder Conference*, ed. Kurt Mueller-Vollmer (New York: de Gruyter, 1990), 358.

25. "Three thousand people climb up and down the wooden bridges, flow in and out of the landings, get backed up on the bridges" (Dreissig tausend Menschen steigen die Holzbrücken hinauf, hinab, fliessen auseinander auf den Plätzen, stauen auf den Brücken). *Wie*, 63.

26. "Die Fenster zittern von vorüberfahrenden Wagen, schütteln sich, fahren zusammen, machen wie ein Kanonenschuss von ferne, beruhigen sich wieder. Dann beben sie, summen wie Sommerfliegen—." *Wie*, 137.

27. Peter Payer, "The Age of Noise: Early Reactions in Vienna, 1870–1914," *Journal of Urban History* 33, no. 5 (July 2007): 775–77.

28. Payer, "Der Klang von Wien: Zur akustischen Neuordnung des öffentlichen Raumes," *Österreichische Zeitschrift für Geschichtswissenschaften*, no. 4 (2004): 119.

29. Ludwig Abels, "Das neue Wien," *Die Zeit* 247 (June 24, 1899): 205.

30. Heinrich Werner, "Rückkehr in die Stadt," *Neues Wiener Tagblatt*, October 2, 1911, 1.

31. August Silberstein, *Die Kaiserstadt am Donaustrand: Wien und Wiener in Tag- und Nachtsbildern* (Vienna: Moritz Perles, 1873), 55.

32. Ferdinand Hanusch, *Aus meinen Wanderjahren: Erinnerungen eines Walzbruders* (Reichenberg: Selbstverlage des 'Textilarbeiter,' 1904), 9–10.

33. Goodman, *Sonic Warfare*, xviii, 10.

34. See Payer, "Der Klang von Wien," 120.

35. Simon Kotter, *Die k. (u.) k. Militärmusik: Bindeglied zwischen Armee und Gesllschaft?* (Augsburg: Universitätsbibliothek, 2015), 56.

36. Letter from Emperor Franz Joseph to Katharina Schratt, June 26, 1898, in *Briefe Kaiser Franz Josephs an Frau Katharina Schratt*, ed. Jean de Bourgoing (Vienna: Ullstein, 1949), 363.

37. Stefan Zweig, *Die Welt von Gestern: Erinnerungen eines Europäers* (Frankfurt am Main: S. Fischer, 1952), 29.

38. Felix Salten, "Frühjahrsparade," in *Das Österreichische Anlitz: Essays* (Berlin: S. Fischer, 1910), 240. For Salten's views on Altenberg, see, in the same collection, "Peter Altenberg," 97–113.

39. "Die Kanonen eröffnen das Gefecht. Plötzlich andere Geräusche. Wie schwaches Peitschenknallen, wie das Bersten auffliegender Eierschalen, wie das Knittern von starkem Papier. Infanterie im Schnellfeuer. Dazwischen eine lautes, überraschendes Pochen, ungeduldig, als ob jemand voll Zorn an eine Tür klopfen würde: die Maschinengewehr." Salten, "Kaisermanöver," in *Das österreichische Anlitz*, 246.

40. "In den man in der Magengrube, in den Eingeweiden wahrnimmt, der den ganzen Körper gleichsam durchzuckt." Salten, "Kaisermanöver," 250; Salten, "'Gewehr heraus!,'" in *Das österreichische Anlitz*, 231.

41. "'Gewehr heraus!,'" 232.

42. "Und Militär, Militär, Militär. Überall, auf den Straßen. Überall wird nur befohlen und Gehorsam geleistet." Salten, "Kaisermanöver," 248.

43. "Man sollte sich's einbilden können, daß es ein wirklicher Krieg ist." "Kaisermanöver," 245.

44. "'Gewehr heraus!,'" 231.

45. "Dessen Gegenwart, wie ein ruheloser Pulsschlag in all den Massen, die sich hier bewegen, fühlbar ist." "Kaisermanöver," 247.

46. "Anschaulicher als sonst jemals tritt hier der militärisch-monarchische Gedanke in die Erscheinung, wird in dem kleinen Ort hier—vom bürgerlichen Großstadtwirbel nicht mehr verhüllt—greifbar nahe, wird gleichsam ohne störende Nebengeräusche reiner vernehmlich." "Kaisermanöver," 248.

47. See Payer, "Vom Geräusch zum Lärm," 107.

48. Ibid., 115.

166 Notes to Pages 61–64

49. See "Antilärm-Enquete," *Das Recht auf Stille* 1, no. 3 (January 1909): 34–38; "Antilärmiten," *Das Recht auf Stille* 1, no. 4 (February 1909): 53–57; "Antilärm-Umfrage," *Das Recht auf Stille* 1, no. 6 (April 1909): 105–8; Theodor Lessing, "Der Verein gegen Lärm," *Die Zukunft* 51 (September 1908): 440; Lessing, "Die Lärmschutzbewegung," *Dokumente des Fortschritts* 1 (1908): 958; *Der Lärmschutz* 6, no. 53 (February 1914), 550.

50. John W. Boyer, *Culture and Political Crisis in Vienna: Christian Socialism in Power, 1897–1918* (Chicago: University of Chicago Press, 1995); Boyer, *Political Radicalism in Late Imperial Vienna: Origins of the Christian Social Movement, 1848–1897* (Chicago: University of Chicago Press, 1981), 73, 379; Steven Beller, *Vienna and the Jews, 1867–1938: A Cultural History* (Cambridge: Cambridge University Press, 1989), 196–97.

51. Mark Twain, "Stirring Times in Austria" (1898), in *In Defense of Harriet Shelley, and Other Essays* (New York: Harper & Brothers, 1918), 203.

52. Carl Dolmetsch, *Our Famous Guest: Mark Twain in Vienna* (Athens: University of Georgia Press, 1992), 71.

53. "[Deputies of the House] are religious men, they are earnest, sincere, devoted, and they hate the Jews." Twain, "Stirring," 223. For a continuation of Twain's discussion of anti-Semitism in Vienna, see his "Concerning the Jews" (1899), in *In Defense of Harriet Shelley, and Other Essays*, 263–87.

54. Altenberg, *Märchen des Lebens*, 102.

55. Friedell, *Ecce Poeta*, 166.

56. Andrew Barker interprets the marks as an invitation for the reader "to fill in the gaps, to finish off the work of the writer in an individual way and ultimately to become a poet," while Per Simfors sees them as a reiteration of a skepticism toward language: "There always seems to be something more to give, something not spoken aloud, which language might not want to express." Barker, *Telegrams from the Soul*, 46; Per Simfors, *Extrakte des Schweigens: Zu Sprache und Stil bei Peter Altenberg* (Tübingen: Stauffenburg Verlag, 2009), 169.

57. Peter Altenberg, *Was der Tag mir zuträgt: Fünfundfünfzig neue Studien* (Berlin: S. Fischer, 1901), 2.

58. Altenberg, *Wie ich es sehe* (Zürich: Manesse Verlag, 2007), 8. The statement is attributed to J. K. Huysmans's classic decadent novel, *À rebours* (1884), which makes frequent references to the sickly protagonist's acoustic sensitivity and efforts to construct soundproof rooms to protect himself against noise. Interestingly enough, while Altenberg's text is otherwise an accurate quotation of Huysmans, the passage in the original novel makes no mention of silence. It was one of the few changes that Altenberg makes in his borrowing, but a revealing one, in that it demonstrates a preoccupation with silence embodied in the genre of the prose poem at the end of nineteenth century. For Huysmans's depiction of acoustic sensitivity, see his *À rebours*, trans. John Howard (Hales Corners, Wis.: Voasha Publishing, 2008), 12, 19, 20. On the prose poem at this time, see Huyssen, *Miniature Metropolis*; Dirk Göttsche, "'Geschichte, die kleine sind': Minimalisierung und Funktionalisierung des Erzählens in der Kleinen Prosa um 1900," in *Kafka und die kleine Prosa der Moderne*, ed. Manfred Engel and Ritchie Robertson (Würzburg: Königshausen & Neumann, 2010), 17–33; Wolfgang Bunzel, *Das deutschsprachige Prosagedicht: Theorie und Geschichte einer literarischen Gattung der Moderne* (Tübingen: Niemayer, 2005); Eckhardt

Köhn, *Strassenrausch: Flanerie und kleine Form: Versuch zur Literaturgeschichte des Flaneurs bis 1933* (Berlin: Das Arsenal, 1989). On Baudelaire's development of the prose poem in relation to the nineteenth-century Parisian soundscape, see Aimée Boutin, *City of Noise: Sound and Nineteenth-Century Paris* (Urbana: University of Illinois Press, 2015), esp. chapter 4.

59. "Es ist die schreckliche Fähigkeit, stundenlang Konversation zu führen, statt stundenlang schweigen zu können und in einer Minute das Erschöpfende sanft mitzuteilen!" Peter Altenberg, *Prodromos* (Berlin: S. Fischer, 1906), 73. Altenberg is criticizing specifically what was known as the "German essay" (der deutsche Aufsatz). For more on the German essay, see Kittler, *Discourse Networks 1800/1900*, 180.

60. "Ich möchte einen Menschen in einem Satze schildern, ein Erlebnis der Seele auf einer Seite, eine Landschaft in einem Worte." Altenberg, *Was der Tag mir zuträgt*, 2.

61. "Zum Schluss werde ich gar nichts mehr sagen. Das wird das beste sein." Altenberg, *Nachfechsung* (1916; Berlin: S. Fischer, 1919), 104.

62. "From the moment that we have something to say to each other," Maeterlinck wrote, "we are compelled to hold our peace: and if at such times we do not listen to the urgent commands of silence, invisible though they are, we shall have suffered an eternal loss that all the treasures of human wisdom cannot make good; for we shall have let slip the opportunity of listening to another soul, and of giving existence, but if only for an instant, to our own." Maurice Maeterlinck, "Silence," in *The Treasure of the Humble*, trans. Alfred Sutro (1896; New York: Dodd, Mead & Company, 1899), 5.

63. Theodor Lessing, *Der Lärm: Eine Kampschrift gegen die Geräusche unseres Lebens, Grenzfragen des Nerven- und Seelenlebens* 54 (Wiesbaden: Verlag von J. F. Bergmann, 1908), 20.

64. Lessing, *Der Lärm*, 33.

65. "Wer das dickste Trommelfell [. . .] hat, besitzt einen Vorteil im Erhaltungskampf." Lessing, *Der Lärm*, 49.

66. Lessing, "Über den Lärm," *Nord und Süd* 97 (1901): 71.

67. Ella Asumfix, "Auf dem Stadtperron," *Das Recht auf Stille* 1, no. 9 (July 1909): 167–68; Dr. Pudor, "Die unterirdische Verkehrsstrasse," *Das Recht auf Stille* 2, no. 1 (January 1910): 2. See also Dr. Erwin Silber, "Ein Brief," *Das Recht auf Stille* 1, no. 5 (March 1909): 82, 83.

68. "Der Sprachgebrauch eines polynesischen Inselstammes verwendet im täglichen Umgang mehr Worte, Bilder, Tropen und Metaphern als die konzise und schmucklose Sprache der grossen, modernen englischen Denker besitzt." Lessing, *Der Lärm*, 22.

69. "Man schreit in Zeitschriften, Zeitungen, Journalen, denn diese sind nicht anderes als fortgesetztes, unaufhörliches öffentliches Betten- und Teppichklopfen." Lessing, *Der Lärm*, 16. See also the text by Mark Twain published in Lessing's journal, titled "Knipst, Brüder, knipst," *Das Recht auf Stille* 2, no. 7 (July 1910): 37–38. The story recounts the pernicious effects of an infectious rhyme published in a daily newspaper. After reading the silly verse Twain is distracted from his task of writing a eulogy for his friend's funeral, as the rhyme leaves room for no other thoughts. The situation worsens after Twain boards a train and begins to listen to the repetitive rattling of the wheels on the track, which

168 Notes to Pages 65–67

the author presents as the onomatopoeic "klack-klack-klack-klack-klack!" (37). He is ultimately unable to give his eulogy, which increasingly follows the rhythm of the verse and the sound of the train, and the piece concludes with the author warning his readers to stay away from the verse at all costs. The repetitive noise of the train, rendered using onomatopoeia, is thus connected to the medium of print and the publication of contagious, frivolous writings, which overpower the reader's conscious thoughts and pressure all modes of writing to adhere to the uniform pulse of mechanical sound.

70. "Wer also gegen den Lärm kämpft, der muss Lärm schlagen. Wer in dem allgemeinen Geschreie und Getöse gehört will werden, der muss es noch zu überschreien and zu überlärmen suchen." Lessing, *Der Lärm*, 91.

71. "'Antilärmiten,'" 53.

72. Altenberg, *Prodromos*, 78. For additional comments on noise abatement, see *Prodromos*, 79, 84, 141; Altenberg, *Fechsung* (Berlin: S. Fischer, 1915), 21, 66; Altenberg, *Vita Ipsa* (Berlin: S. Fischer, 1918), 306–8. On Altenberg and hygiene, more broadly, see Viktor Zmegac, "Die Geburt der Gesundheit aus dem Geist der Dekadenz: Somatische Utopien bei Peter Altenberg," in *Ideologie und Utopie in der deutschen Literatur der Neuzeit*, ed. Bernhard Spies (Würzburg: Königshausen & Neumann, 1995), 88–99.

73. Plessner, *Die neueste Erfindung*, 12. For a more satirical Viennese perspective on the antiphone at the time, see Eduard Pötzl, "Die Antiphonerln," in *Wien, Bd. 1: Skizzen* (Leipzig: Philipp Reclam, 1885), 72–76.

74. Altenberg, *Prodromos*, 84.

75. Altenberg, "Sanatorien für Nervenkranke," *Das Recht auf Stille* 1, no. 11 (October 1909): 213; Altenberg, "Der Nebenmensch," *Das Recht auf Stille* 2, no. 2 (February 1910): 10.

76. Longer versions of each also appeared in published collections of Altenberg's work around the same time. However, the fact that an excerpted version of the second text was published in *The Right to Silence* before it appeared in print elsewhere suggests that Altenberg had been in contact with Lessing and given his consent. See Altenberg, "Sanatorien für Nervenkranke," in *Bilderbogen des kleinen Lebens* (Berlin-Westend: Erich Reiss Verlag, 1909), 23–27; Altenberg, "Der Nebenmensch" (1911), in *Neues Altes* (Berlin: S. Fischer, 1919), 68, 69.

77. See, for example, Silber, "Ein Brief"; Theodor Lessing, "Ruhe-Hotels: Ein neuer Vorstoß des Antilärmvereins," *Das Recht auf Stille* 1, no. 9 (July 1909): 157–58; Dr. Siegmund Auerbach, "Sechs Forderungen an Kurhotels," *Das Recht auf Stille* 1, no. 9 (July 1909): 158–59; Dr. Lothar Meyer, "Die Blaue Liste," *Das Recht auf Stille* 1, no. 9 (July 1909): 160; Dr. Gerber, "Lärm in Kurorten," *Das Recht auf Stille* 1, no. 10 (September 1909): 1771–80; Medius, "Schlafsanatorien— Traum oder Wirklichkeit?" *Das Recht auf Stille* 2, No. 4 (April 1910): 23.

78. "Neunzig Prozent unserer Lebensenergien raubt uns die Ungezogenheit, die Taktlosigkeit unseres Nebenmenschen. Jedes falsch angebrachte Wort zerstört unser zart empfindliches Nervensystem." Altenberg, "Der Nebenmensch," 10. Published three months later, Rainer Maria Rilke's 1910 novel, *The Notebooks of Malte Laurids Brigge* (*Die Aufzeichnungen des Malte Laurids Brigge*), echoes Altenberg's characterization of the neighbor as an unwanted, pernicious influence: "There is a being that is completely harmless if it passes before your eyes, you hardly notice it and immediately forget it again. But as soon as it gets into

Notes to Pages 67–73 169

your hearing in some invisible fashion it develops there, it creeps out, as it were, and one has seen cases where it penetrated the brain and thrived devastatingly in that organ, like the canine pneumococcus that enters through the nose. This being is the neighbor" (Es giebt ein Wesen, das vollkommen unschädlich ist, wenn es dir in die Augen kommt, du merkst es kaum und hast es gleich wieder vergessen. Sobald es dir aber unsichtbar auf irgendeine Weise ins Gehör gerät, so entwickelt es sich dort, es kriecht gleichsam aus, und man hat Fälle gesehen, wo es bin ins Gehirn vordrang un diesem Organ verheerend gedieh, ähnlich den Pneumokokken des Hundes, die durch die Nase eindringen. Dieses Wesen ist der Nachbar). Rilke, *The Notebooks of Malte Laurids Brigge*, trans. Burton Pike (Champaign: Dalkey Archive Press, 2008), 124; *Die Aufzeichnungen des Malte Laurids Brigge*, ed. Manfred Engel (Stuttgart: Reclam, 1997), 141. On noise in Rilke's novel, see Michael Cowan, "Imagining Modernity through the Ear: Rilke's *Aufzeichnungen des Malte Laurids Brigge* and the Noise of Modern Life," *Arcadia* 41, no. 1 (2006): 124–46.

79. "Nicht Distanzhalten von der Welt des andern, die man ja doch nicht begreifen kann, mordet die Nerven." Altenberg, "Der Nebenmensch," 10.

80. "Niemandem wehe tun, falls es nicht unbedingt notwendig wäre, ist die natürliche Wirkung geistiger Kultur." Ibid.

81. Altenberg, *Prodromos*, 79, 85.

82. Altenberg, *Märchen des Lebens*, 22.

83. Ibid., 23.

84. Altenberg, "Kriegshymnen," in *Fechsung*, 207–8. As Andrew Barker shows, Altenberg's views on the war were more complicated. Other published texts from the same period directly contradicted the pacifist tone of "War Hymns." See Barker, *Telegrams from the Soul*, 189–94.

Chapter 3

1. F. T. Marinetti, "Destruction of Syntax—Untrammeled Imagination—Words-in-Freedom" (1913), in *Critical Writings*, ed. Günter Berghaus, trans. Doug Thompson (New York: Farrar, Straus and Giroux, 2006), 127. On Marinetti's poetic project, see Jeffrey T. Schnapp, "Propeller Talk," *Modernism/Modernity* 1, no. 3 (September 1994): 153–78; Brain, *The Pulse of Modernism*, 213–20. On vibration and futurist visual art, see Linda Dalrymple Henderson, "Vibratory Modernism: Boccioni, Kupka, and the Ether of Space," in *From Energy to Information: Representation in Science and Technology, Art, and Literature*, ed. Bruce Clarke and Linda Dalrymple Henderson (Stanford, Calif.: Stanford University Press, 2002), 126–49.

2. Marinetti, "Technical Manifesto of Futurist Literature," in *Critical Writings*, 111.

3. Ibid., 118.

4. See Susan Burke, *Becoming Modern: The Life of Mina Loy* (New York: Farrar, Straus and Giroux, 1996), 155–56.

5. Luigi Russolo, *The Art of Noises*, trans. Barclay Brown (1916; New York: Pendragon Press, 1986), 24.

6. "In modern warfare, mechanical and metallic, the element of sight is almost zero. The sense, the significance, and the expressiveness of noises, however, are infinite." Ibid., 49.

170 Notes to Pages 73–76

7. Ibid., 32. On futurist music, see Rodney J. Payton, "The Music of Futurism: Concerts and Polemics," *Musical Quarterly* 62, no. 1 (Jan. 1976): 25–45; Barclay Brown, "The Noise Instruments of Luigi Russolo," *Perspectives of New Music* 20, nos. 1/2 (Autumn 1981–Summer 1982): 31–48; Kahn, *Noise, Water, Meat*, 45–67; Robert P. Morgan, "'A New Musical Reality': Futurism, Modernism, and 'The Art of Noises,'" *Modernism/Modernity* 1, no. 3 (September 1994): 129–51. For original recordings of works by Marinetti and Russolo, see *Musica Futurista: The Art of Noises* (Audio CD, Salon Recordings, 2004).

8. See Barclay Brown, "The Noise Instruments of Luigi Russolo."

9. F. B. Pratella, *Autobiografia* (Milan: Pan, 1971), 114–16; English translation from Payton, "The Music of Futurism," 33.

10. "Huelsenbeck ist angekommen. Er plädiert dafür, dass man den Rhythmus verstärkt (den Negerrhythmus). Er möchte am liebsten die Literatur in Grund und Boden trommeln." Hugo Ball, *Die Flucht aus der Zeit* (Munich: Duncker & Humblot, 1927), 78.

11. Adrian Curtin, "Vibration, Percussion and Primitivism in Avant-Garde Performance," in *Vibratory Modernism*, ed. Anthony Enns and Shelley Trower (Basingstoke: Palgrave Macmillan, 2013), 228. On Huelsenbeck and the drum, see also Karin Füllner, "Richard Huelsenbeck: 'Bang! Bang! Bangbangbang,' the Dada Drummer in Zurich," trans. Barbara Allen, in *Dada Zurich: A Clown's Game from Nothing*, ed. Brigitte Pichon and Karl Riha (New York: G. K. Hall, 1996), 89–103.

12. Walter Benjamin, "Das Kunstwerk im Zeitalter seiner technischen Reproduzierbarkeit: Erste Fassung," in *Gesammelte Schriften*, ed. Rolf Tiedermann and Hermann Schweppenhäuser (Frankfurt am Main: Suhrkamp, 1974), 463. English translation, "The Work of Art in the Age of Technological Reproducibility [First Version]," trans. Michael W. Jennings, *Grey Room* 39 (Spring 2010): 32.

13. Tobias Wilke, "Tacti(ca)lity Reclaimed: Benjamin's Medium, the Avant-Garde, and the Politics of the Senses," *Grey Room* 39 (Spring 2010): 49.

14. Wilke, "Tacti(ca)lity Reclaimed," 50.

15. On Huelsenbeck, see Füllner, "Richard Huelsenbeck"; Reinhard Nenzel, *Kleinkarierte Avantgarde: Zur Neubewertung des deutschen Dadaismus: Der frühe Richard Huelsenbeck: Sein Leben und sein Werk bis 1916 in Darstellung und Interpretation* (Bonn: Reinhard Nenzel Verlag, 1994).

16. On Dadaist sound poetry and the voice, see Reinhart Meyer-Kalkus, *Stimme und Sprechkünste im 20. Jahrhundert* (Berlin: Akademie-Verlag, 2001), 281–99; Thilo Bock, "'Negermusik und koptische Heilige': Die Unmöglichkeit des Lachens bei Hugo Balls Dadaismus," in *Avantgarde und Komik*, ed. Ludger Scherer and Rolf Lohse (Amsterdam: Rodopi, 2004), 97–115; Tobias Wilke, "Da-da: 'Articulatory Gestures' and the Emergence of Sound Poetry," *MLN* 128, no. 3 (April 2013): 639–68; W. G. Kudszus, "Translating Transition: Dada, Fort/Da, Grimm's Da," *Interdisciplinary Journal for Germanic Linguistics and Semiotic Analysis* 12, no. 1 (Spring 2007): 59–67; Rudolf E. Kuenzli, "The Semiotics of Dada Poetry," in *Dada Spectrum: The Dialectics of Revolt*, ed. Stephen C. Foster and Rudolf E. Kuenzli (Madison, Wis.: Coda Press, 1979), 51–70; Irene Gammel and Suzanne Zelazo, "'Harpsichords Metallic Howl—': The Baroness Elsa von Freytag-Loringhoven's Sound Poetry," *Modernism/Modernity* 18, no. 2 (April 2011): 255–71.

17. See Kahn, *Noise, Water, Meat*, 45–67.

Notes to Pages 76–78 171

18. See Arndt Niebisch, *Media Parasites in the Early Avant-Garde: On the Abuse of Technology and Communication* (New York: Palgrave, 2012), 126. Niebisch also points out that, when around 1922 the Dadaist Raoul Hausmann began working on a patent for a new amplification and sound pickup system for the gramophone, he did so with the aim of *reducing* the noise produced by a recording during playback. The patent, in other words, approached the technological device with aims that were directly opposed to the Dadaist's overarching artistic program, which sought to intensify and proliferate the noise that surrounded articulate speech both on the page and during live performance.

19. See Reinhold Heller, "Blaue Reiter," in *Encyclopedia of German Literature*, vol. 1, ed. Matthias Konzett (Chicago: Fitzroy Dearborn, 2000), 120. On this early phase of Dadaism, see also Füllner, "Richard Huelsenbeck," 31–74.

20. "Der Klang der menschlichen Stimme wurde . . . rein angewendet, d.h. ohne Verdunkelung desselben durch das Wort, durch den Sinn des Wortes." Wassily Kandinsky, "Über Bühnenkomposition" (1912), in *Der Blaue Reiter*, ed. Kandinsky and Franz Marc (Munich: R. Piper, 1914), 113. See also Kandinsky, *Klänge* (Munich: R. Piper, 1913).

21. See Hans J. Kleinschmidt, "The New Man—Armed with the Weapons of Doubt and Defiance: Introduction," in Huelsenbeck, *Memoirs of a Dada Drummer*, ed. Hans J. Kleinschmidt, trans. Joachim Neugroschel (New York: Viking Press, 1969), xxviii.

22. Huelsenbeck, "Dada als Literatur" (1958), in *Dada-Logik, 1913–1972*, ed. Herbert Kapfer (Munich: Belleville, 2012), 372.

23. On Altenberg and Dada, see Barker, *Telegrams from the Soul*, 204.

24. Richard Huelsenbeck, "Letzte Nächte," *Die Aktion* (September 1915): 494–95. In its initial publication the poem was falsely credited to Iwan Lassang.

25. See Füllner, "Richard Huelsenbeck," 72.

26. Jed Rasula, *Destruction Was My Beatrice: Dada and the Unmaking of the Twentieth Century* (New York: Basic Books, 2015), 10–11.

27. On "human zoos," see Nicolas Bancel et al., eds., *Human Zoos: From the Hottentot Venus to Reality Shows* (Liverpool: Liverpool University Press, 2008).

28. See the recent exhibition catalog, Ralf Burmeister, Michael Oberhofer, and Esther Tisa Francini, eds., *dada Africa: Dialogue with the Other* (Zurich: Scheidegger and Spiess, 2016).

29. See Z. S. Strother, "Looking for Africa in Carl Einstein's *Negerplastik*," *African Arts* 46, no. 4 (Winter 2013): 8–21.

30. On Huelsenbeck and primitivism, see Manfred Engel, "Wildes Zürich: Dadaistischer Primitivismus und Richard Huelsenbecks Gedicht *Ebene*," in *Poetik des Wilden*, ed. Jörg Robert and Friederike Felicitas Günther (Würzburg: Königshausen and Neumann, 2012), 393–419.

31. See Barbara Spackman, "Mafarka and Son: Marinetti's Homophobic Economics," *Modernism/Modernity* 1, no. 3 (September 1994): 89–107. Huelsenbeck refers to the novel on two occasions in *Fantastic Prayers* (11, 13).

32. On Tzara, see Christian Kaufmann, "Dada Reads Ethnological Sources: From Knowledge of Foreign Art Worlds to Poetic Understanding," in *dada Africa*, ed. Burmeister, Oberhofer, and Francini, 96–103.

33. "Ich las selbstverfertigte Negergedichte, umba-umba-umba, die Neger tanzen auf den Bastmatratzen, obwohl mich die Neger einen Dreck angehen und ich

172 Notes to Pages 79–81

sie wirklich nur aus Büchern kenne. Du siehst, wie unehrlich alle Dichterei ist." Huelsenbeck's 1918 letter to N.F., Berlin, in Kasimir Edschmid, ed., *Briefe der Expressionisten* (Frankfurt am Main: Ullstein, 1964), 70.

34. See Michael White, "Umba! Umba! Sounding the Other, Sounding the Same," in *dada Africa*, ed. Burmeister, Oberhofer, and Francini, 165; Thiérard, "Negro Poem, Sound Poem? Everyone His Own Other," in *dada Africa*, 23.

35. "Unter dem grauen Himmel des Krieges, mit der militärischen Musik in unseren Ohren"; "Wir wollen ein neues Leben, wir wollen eine neue Aktivität, wir wollen eine neue Hautfarbe." Huelsenbeck's 1918 letter to N.F., Berlin, in Edschmid, ed., *Briefe der Expressionisten*, 68–69.

36. See Jonathan O. Wipplinger, *The Jazz Republic: Music, Race, and American Culture in Weimar Germany* (Ann Arbor: University of Michigan Press, 2017), 32.

37. Richard Huelsenbeck, *En avant Dada: Eine Geschichte des Dadaismus* (Leipzig: Paul Steegemann Verlag Hannover, 1920), 7.

38. George Antheil, "The Negro on the Spiral, or A Method of Negro Music," in *Negro Anthology, 1931–1933*, ed. Nancy Cunard (London: Nancy Cunard at Wishart & Co., 1934), 350.

39. "What enslaves the world today is a ubiquitous, uniform process, which comes from a worldview that privileges the rational over the emotional" (Was heute die Welt versklavt, ist ein überall gleichmäßiger Prozess, der von einer Weltanschauung ausgeht, die das Rationale über das Gefühlsmäßige setzt). Richard Huelsenbeck, *Afrika in Sicht: Ein Resebericht über fremde Länder und abenteuerliche Menschen* (Dresden: W. Jess, 1928), 275.

40. Huelsenbeck, *Afrika in Sicht*, 280.

41. Sebastian Conrad, *German Colonialism: A Short History* (Cambridge: Cambridge University Press, 2012), 137–40.

42. Frieda von Bülow, *Tropenkoller: Episode aus dem deutschen Kolonialleben* (Berlin: F. Fontane & Co., 1905), 17–18. On Bülow, see also Lora Wildenthal, *German Women for Empire, 1884–1945* (Durham: Duke University Press, 2001), 54–78.

43. "Wie ist er nervös geworden! So übermäßig empfindlich und reizbar war er früher nicht. Alle werden nervös hier, selbst Männer, die in Deutschland bei dem Wort 'Nerven' ungläubig gelacht haben." Bülow, *Tropenkoller*, 19.

44. See Florian Carl, *Was bedeutet uns Afrika? Zur Darstellung afrikanischer Musik im deutschsprachigen Diskurs des 19. und frühen 20. Jahrhunderts* (Muenster: LIT, 2004), 25–35.

45. Gerhard Rohlfs, *Quer durch Afrika: Reise vom Mittelmeer nach dem Tschad-See und zum Golf von Guinea*, vol. 2 (Leipzig: F. A. Brockhaus, 1875), 80.

46. Ibid., 252. Maximilian Plessner similarly incorporated the language of bondage into his treatise on the antiphone, a device he saw as liberating bourgeois intellectuals from "the chains of forced listening" (den Ketten des Hörzwangs) imposed on them by the rabble. Elsewhere he lamented how the perpetually open ear condemned the sensitive listener "to the menial slavery of being forced to perceive things he doesn't want to hear" (zu der knechtischen Sklaverei, Dinge vernehmen zu müssen, welche er nicht hören will). Plessner, *Die neueste Erfindung*, 23, 9.

47. "The drum is the most important and most widely spread instrument of savage races," the Viennese musicologist Richard Wallaschek stated in his study, *Primitive Music: An Inquiry into the Origin and Development of Music, Songs, Instruments, Dances, and Pantomimes of Savage Races* (London: Longmans, Green, 1893), 108. The assumed indispensability of the drum for African cultures was so strong that it would carry over into the Jazz Age, where Europeans with little to no direct contact with the music assumed the drum's centrality in their own appropriations, despite that fact that it was virtually absent among North American practitioners at the time. See Michael J. Schmidt, "Visual Music: Jazz, Synaesthesia and the History of the Senses in the Weimar Republic," *German History* 32, no. 2 (2014): 213–18.

48. Erich Moritz von Hornbostel, "African Negro Music," *Africa: Journal of the International African Institute* 1, no. 1 (January 1928): 52–53.

49. It should be noted that the English *plane* refers to a flat surface and not an aircraft.

50. "Tschupurawanta burruh pupaganda burruh / Icharimunga burruh den Hó-osenlatz den Hó-osenlatz / kampampa kamo den Hó-osenlatz den Hó-osenlatz / katapena kamo katapena kara/Tschuwuparanta da umba da umba da do / da umba da umba da umba hihi / den Hó-osenlatz den Hó-osenlatz / Mpala das Glas der Eckzahn trara / katapena kara der Dichter der Dichter katapena tafu / Mfunga Mpala Mfunga Koel." Richard Huelsenbeck, *Phantastische Gebete* (Berlin: Der Malik-Verlag, 1920), 8. All subsequent references to Huelsenbeck's text will be taken from the 1920 edition, indicated by the abbreviation *PG* and followed by the page number. On the differences between the 1916 and 1920 editions, see Füllner, "Richard Huelsenbeck," 97–101.

51. See White, "Umba! Umba!," 165. The number of references in the poem to the Belgian Congo may have been related to the fact that, around the time Huelsenbeck began performing it, the Germans had begun their so-called East African Campaign (1914–18) as part of World War I. The thinking was that if the Germans could defeat the Belgians in World War I they would get the Congo. But the campaign ultimately functioned as a diversion strategy to keep European forces from sending more weapons and supplies back to the continent. See Ross Anderson, *The Forgotten Front: The East African Campaign, 1914–1918* (Stroud, Gloucestershire: History Press, 2014); Michelle R. Moyd, *Violent Intermediaries: African Soldiers, Conquest, and Everyday Colonialism in German East Africa* (Athens: Ohio University Press, 2014).

52. Karin Füllner argues that Huelsenbeck's drum would have been "unavoidably associated with militarism." Füllner, "Richard Huelsenbeck," 99.

53. Birdsall, *Nazi Soundscapes*, 34.

54. See Daniel Morat, "Cheers, Songs, and Marching Sounds: Acoustic Mobilization and Collective Affects at the Beginning of World War I," in *Sounds of Modern History*, 188.

55. Morat, "Cheers, Songs, and Marching Sounds," 190.

56. "Die Mobilmachung am 1. August 1914" (ca. 1915), Archivnummer 2570043, X130, DRA Frankfurt am Main. For similar recordings, see "Feldgottesdienst nach der Schlacht vor Maubeuge" (1914), Archivnummer 2590065, X130, DRA Frankfurt am Main; "Die Erstürmung einer russischen Stellung" (1915), Archivnummer 2832507, X130, DRA Frankfurt am Main; "Im Lazarett"

(1914), Archivnummer 2842528, X130, DRA Frankfurt am Main. On phonographic war propaganda in the English context, see Tim Crook, "Vocalizing the Angels of Mons: Audio Dramas as Propaganda in the Great War of 1914 to 1918," *Societies* 4 (2014): 180–221.

57. In *Fantastic Prayers*, Huelsenbeck describes "armies of phonographs" (Heere von Phonographen), thereby invoking the phonograph's newly ascribed role as a means of inciting patriotic fervor through codified recordings of military events (11).

58. Huelsenbeck, *Deutschland muss untergehen! Erinnerungen eines alten dadaistischen Revolutionärs* (Berlin: Malik, 1920), 10.

59. "Das 'Deutschland über alles' paukt schon wieder durch den Höllenlärm. . . . Ja, es ist der Grundbass, den sie nie verloren haben." Huelsenbeck, *Deutschland muss untergehen!*, 10.

60. Bernhard Siegert, *Cultural Techniques: Grids, Filters, Doors, and Other Articulations of the Real*, trans. Geoffrey Winthrop-Young (New York: Fordham University Press, 2014), 4.

61. "Nehmen Sie die Hände hoch und lassen Sie den Bauch fallen. Greifen Sie nach der Kesselpauke in Ihrem Ohr und ziehen Sie sich den Sarg aus der Nase; denn keiner weiß, wozu es gut ist." Huelsenbeck, "Ein Besuch im Cabaret Dada," *Der Dada* 3 (April 1920): 6. All subsequent references to Huelsenbeck's essay will be indicated by the abbreviation *BCD* followed by the page number.

62. Biro, *The Dada Cyborg: Visions of the New Human in Weimar Berlin* (Minneapolis: University of Minnesota Press, 2009), 13.

63. "Der Propagandamarschall [George] Grosz kam mit der Kesselpauke, dem Zeichen der dadaistischen Weltherrschaft. . . . Der Lärm wurde so groß, dass unsere Trommelfelle jammerten wie kleine Kinder. Die große Knochenerweichung fiel von den Dächern. Kein Mensch wußte, wozu das gut war" (*BCD*, 7). Huelsenbeck's fictionalized account was not far off from contemporaneous reports detailing the acoustical conditions operative during Dada performances. The writer of one review observed after a show in Dresden in January 1920: "My ears are still ringing and droning from the vilest noise ever to be heard in Dresden in a space dedicated to art and in front of an educated public" (Noch gellen und dröhnen die Ohren von dem schnödesten Lärm, der je in Dresden an kunstgeweihter Stätte vor einem gebildeten Publikum gehört wurde). Richard Huelsenbeck, *Dada siegt*: Eine Bilanz des Dadaismu (Berlin: Malik Verlag, 1920), 32.

64. On the religious dimension of Huelsenbeck's early work, see Engel, "Wildes Zürich," 414; Nenzel, *Kleinkarierte Avantgarde*, 358.

65. Ball, *Die Flucht aus der Zeit*, 83, 84.

66. "Versinnbildlichen das bruit, das Gekreisch der Bremsen, das die in die Melodie Versunkenen überfällt und den breiten Hintern der Bürger mit Pfeffer versorgt." Huelsenbeck, *Dada siegt*, 21.

67. "Musik ist so oder so eine harmonische Angelegenheit, eine Kunst, eine Tätigkeit der Vernunft—Bruitismus ist das Leben selbst, das man nicht beurteilen kann wie ein Buch, das vielmehr ein Teil unserer Persönlichkeit darstellt, uns angreift, verfolgt und zerfetzt." Huelsenbeck, *En avant Dada*, 6–7.

68. "An hundert Gedanken zugleich anstreifend, ohne sie namhaft zu machen." Ball, *Die Flucht aus der Zeit*, 102.

69. Füllner, "Richard Huelsenbeck," 128.

Notes to Pages 93–99

70. "Ich bin der Anfang der Welt, indem ich das Ende bin" (*PG*, 16). Compare with Revelations 22:13: "I am the Alpha and the Omega, the first and the last, the beginning and the end." *The New Oxford Annotated Bible with Apocrypha*, ed. Michael D. Coogan and Marc Z. Brettler (Oxford: Oxford University Press, 2010), 2180.

71. "Wir blasen das Mehl von der Zunge und schrein und es wandert der Kopf auf dem Giebel." *PG*, 8.

72. Albrecht Haupt, "Schloss Wiligrad in Mecklenburg," *Zeitschrift für Architektur und Ingenieurwesen* 49, no. 1 (1903): 5–6.

73. "Das ganz feierlich ausserordentlich feierlich das Schwarze das ganz unendliche der Basstrompetenton der über die weiten Flächen gleitet der über die gebrochenen Flächen gleitet der mit Knall zerbricht Holz zerbricht es zerbricht etwas mit vertausendfachtem Knall die Bäuche die straffgespannten schönen allzuschönen braunen Bäuche platzen HAHAHA." *PG*, 18.

74. "Es herrscht eine Nervosität, die man miterlebt haben muss, um sie zu begreifen. Es darf nur jemand auf der Strasse ein lautes Wort rufen, sogleich flüchtet die Menge in die Eingänge der Häuser, es ist ein Laufen ums Leben, gleich kann das Maschinengewehrfeuer aus einer versteckten Luke hämmern oder eine Handgranate fällt von einem Dach und ihre Splitter reißen Dir den Bauch auf.... Es ist eine Freude zu leben." Huelsenbeck, *Deutschland muss untergehen*, 7.

75. "Das Bürgerschwein, das während des ganzen vierjährigen Mordens nur seinen Bauch gepflegt hat, kann sich der Situation nicht mehr entziehen, es steht mit prallen Beinen mitten in der Hölle. Und die Hölle rast: es ist eine Lust zu leben." Huelsenbeck, *Deutschland muss untergehen*, 8. Elsewhere Huelsenbeck wrote that it was a sense of "revenge" (Rachlust) against bourgeois supporters of the war who remained safe from its violence that had motivated the Dadaist movement in the first place. It was the Dadaists' task, he continued, to "track down" (aufzustöbern) and "whip" (aufzupeitschen) these "born enemies" (geborenen Todfeinden). See Huelsenbeck, *Dada siegt*, 11.

Chapter 4

1. Musil's text was originally published in the journal *Die Lebenden*, April 6, 1924, 2–3. In what follows, all references come from "Der Gläubige," in *Gesammelte Werke*, vol. 2, ed. Adolf Frisé (Reinbek bei Hamburg: Rowohlt, 1978), 575–76, hereafter abbreviated as *G* followed by a page number. My translations draw on a later version of the text included in *Posthumous Papers of a Living Author*, trans. Peter Wortsman (New York: Archipelago Books, 2006), 17–19.

2. Robert Musil, diary entry from October 10, ca. 1915–20, in *Tagebücher*, ed. Adolf Frisé (Reinbek bei Hamburg: Rowohlt, 1976), 313.

3. Robert Musil, "Ein Soldat erzählt" (1915/16), in *Gesammelte Werke*, vol. 2, 753.

4. On von Helmholtz's lack of interest in acoustic space, see Géza Révész, "Gibt es einen Hörraum? Theoretisches und Experimentelles zur Frage eines autochthonen Schallraumes nebst einer Theorie der Lokalisation," *Acta Psychologica* 3 (1937): 150. By contrast, Musil's dissertation adviser, Carl Stumpf, had been praised as one of the few "bold enough to stand out for an auditory space," and as the director of the institute he encouraged his students to investigate the topic in greater detail. Musil would have also encountered discussions of

auditory space in writings by Ernst Mach, who was both the subject of his doctoral dissertation as well as one of the earliest figures to address the ear's spatial capabilities. See Carl Stumpf, *Tonpsychologie*, vol. 1 (Leipzig: S. Hirzel, 1883), 211. On the history of spatial hearing, see Nicholas J. Wade and D. Deutsch, "Binaural Hearing before and after the Stethophone," *Acoustics Today* 4, no. 3 (2008): 16–27; Nicholas J. Wade and Hiroshi Ono, "From Dichoptic to Dichotic: Historical Contrasts between Binocular Vision and Binaural Hearing," *Perception* 34 (2005): 645–68.

5. Matataro Matsumoto, "Researches on Acoustic Space," *Studies from the Yale Psychological Laboratory* 5 (1897): 1–75; Arthur Henry Pierce, *Studies in Auditory and Visual Space Perception* (New York: Longmans, Green, and Co., 1901); E. M. von Hornbostel, "Beobachtungen über ein- und zweiohriges Hören," *Psychologische Forschung*, Bd. 4 (1923): 64–114, esp. 114; Ernst Mach, "Bermerkungen über den Raumsinn des Ohres," *Annalen der Physik* (1865): 331–33; Hugo Münsterberg, "Raumsinn des Ohres," *Beiträge zur Experimentellen Psychologie*, no. 2 (1889): 182–234; E. M. von Hornbostel, "Das räumliche Hören," in *Handbuch der normalen und pathologischen Physiologie*, ed. G. v. Bergmann et al. (Berlin: Springer, 1926), 602–18; Manfred von Ardenne, "Plastisches Hören von Rundfunkdarbietungen," *Funk*, no. 23 (1925): 281; Gerhard Staar, "Plastisches Hören mit Doppelempfänger," *Funk*, no. 28 (1925): 340; Erwin Meyer, "Über das stereoakustische Hören," *Elektrotechnische Zeitschrift*, no. 22 (May 28, 1925): 805–7.

6. On early stereophonic sound experiments and radio, see Ludwig Kapeller, "Der stereophonische Rundfunk," *Funk*, no. 27 (1925): 317–19; Manfred von Ardenne, "Raumgetreues oder Räumliches Hören?," *Die Sendung*, March 26, 1926, 4; Hermann Schütze, "Raumhören (Stereoakustik)," *Kosmos: Gesellschaft der Naturfreunde*, no. 5 (1926): 155–57; Rudolf Leonhard, "Die Situation des Hörspiels" (1928), in *Radio-Kultur in der Weimarer Republik*, ed. Irmela Schneider (Tübingen: Gunter Narr Verlag, 1984), 161.

7. "Alle bisher mitgeteilten Versuchsergebnisse sprechen dafür, dass der Seitenwinkel, in dem in Schall gehört wird, gesetzmäßig abhängig ist von dem Zeitunterschied, mit dem der gleiche Reiz auf das eine und andere Ohr wirkt." Erich Moritz von Hornbostel and Max Wertheimer, "Über die Wahrnehmung der Schallrichtung," in *Sitzungsberichte der Preussischen Akademie der Wissenschafte* (n.p.: Preussische Akademie der Wissenschaften, 1920), 391.

8. See Hoffmann, "Wissenschaft und Militär." On Hornbostel's work in experimental psychology and ethnomusicology, see also Sebastian Klotz, ed., *"Vom tönenden Wirbel menschlichen Tuns": Erich M. von Hornbostel als Gestaltpsychologe, Archivar und Musikwissenschaftler: Studien und Dokumente* (Berlin: Schibri-Verlag, 1998); Eric Ames, "The Sound of Evolution," *Modernism/Modernity* 10, no. 2 (April 2003): 297–325.

9. "So hörte man die einzelnen Knalle deutlich von links nach rechts hinübergleiten." Martin Bochow, *Schallmesstrupp 51: Vom Krieg der Stoppuhren gegen Mörser und Haubitzen*, 2nd ed. (Stuttgart: Union Deutsche Verlagsgesellschaft, 1933), 20.

10. Elsewhere, Hornbostel recounted experiments involving identical phonograph recordings played simultaneously through separate listening tubes. "Beobachtungen über ein- und zweiohriges Hören," 77.

Notes to Pages 101–103

11. See Hornbostel, "Physiologische Akustik," *Berichte über die gesamte Physiologie und experimentelle Pharmakologie* 3, no. 1 (1922): 372.

12. In this way, the turn to acoustic space corresponds to what Jonathan Crary has identified as the discovery of the "binocular body" in the middle of the nineteenth century. This sudden interest in binocular vision coincided historically with related research on auditory localization and the incorporation of binaural listening into technological simulations of auditory space. See Jonathan Crary, *Techniques of the Observer: On Vision and Modernity in the Nineteenth Century* (Cambridge, Mass.: MIT Press, 1990), 116–29. On the coevolution of scientific research on binocular vision and binaural hearing, see Wade and Ono, "From Dichoptic to Dichotic."

13. Alexander Graham Bell, "Experiments Relating to Binaural Audition," *American Journal of Otology* 2, no. 3 (1880): 170.

14. Ibid., 171.

15. Hornbostel, "Das räumliche Hören," 618.

16. In a journal entry dated October 1, 1911, Musil writes: "At the beginning of this time together with Hornbostl [*sic*] and Wertheimer, felt a little homesick for psychology" (Zu Beginn dieser Zeit mit Hornbostl u. Wertheimer einmal zusammengewesen, ein bischen [*sic*] Heimweh nach der Psychologie bekommen; *Tagebücher*, 240). Another entry recounts a visit Musil made to the Psychological Institute in Berlin in April of 1913, where he also visited Hornbostel and his family (*Tagebücher*, 268). A 1923 letter from Martha and Robert Musil to Annina Marcovaldi indicates that Musil invited Hornbostel to what was presumably the premiere of his play, "Vincent and the Girlfriend of Important Men" (Vinzenz und die Freundin bedeutender Männer), which was held on December 4 of the same year. Robert Musil, *Briefe: 1901–1942*, ed. Adolf Frisé (Reinbek bei Hamburg: Rowohlt, 1981), 324.

17. On sound in Musil's two early novellas, see Kai Allais, "'Geräusche'— Textlichkeit und Serialität. Musils Novelle 'Die Versuchung der stillen Veronika,'" in *Robert Musils 'Kakanien—Subjekt und Geschichte. Festschrift für Karl Dinklage*, Musil-Studien 15, ed. Josef von Strutz (Munich: Wilhelm Fink, 1987), 77–95; Oliver Simons, *Raumgeschichten: Topographien der Moderne in Philosophie, Wissenschaft und Literatur* (Munich: Fink, 2007), 292–307.

18. Musil, "Die Amsel," in *Gesammelte Werke* 2, 548–62. On the treatment of sound and hearing in the novella, see Bernhard Siegert, "Rauschfilterung als Hörspiel," in *Robert Musil—Dichter, Essayist, Wissenschaftler*, ed. Hans-Georg Pott (Munich: Fink, 1993), 193–207; Christoph Hoffmann, *"Der Dichter am Apparat": Medientechnik, Experimentalpsychologie und Texte Robert Musils 1899–1942* (Munich: Fink, 1997), 187–229; Julia Encke, *Augenblicke der Gefahr: Der Krieg und die Sinne (1914–1934)* (Munich: Fink, 2006), 172–81.

19. See Hoffmann, "Wissenschaft und Militär"; Encke, *Augenblicke der Gefahr*, 162–93. Even in his classic study *War and Cinema*, Paul Virilio acknowledged that World War I was consumed by darkness and visual obscurity. "Indeed," he writes, "why should there have been any rest after dark? For the enemy's presence made itself known only through the flash of gunfire or the glow from the trenches, and daytime blindness was hardly any different from that which set in at nightfall." Paul Virilio, *War and Cinema: The Logistics of Perception*, trans. Patrick Camiller (1984; London: Verso, 1989), 70.

178 Notes to Pages 104–107

20. See Bruno Oertel, "Die Schädigungen des Gehörorgans durch Explosions- und Schalleinflüsse," in *Handbuch der ärztlichen Erfahrungen im Weltkriege 6: Gehörorgan, obere Luft- und Speisewege*, ed. Otto Voss (Leipzig: Johann Ambrosius Barth, 1921), 75–91; Sandor Ferenczi, *Hysterie und Pathoneurosen* (Leipzig: Internationaler Psychoanalytischer Verlag, 1919), 76. On *drumfire*, see Max Bauer, *Der grosse Krieg im Feld und Heimat: Erinnerungen und Betrachtungen* (Tübingen: Osiander'sche Buchhandlung, 1921), 85.

21. "Ununterbrochen tönten die Detonationen wie ein ungeheurer Paukenwirbel, der auf den deutschen Lilien trommelte. Man glaubte den Berg unter sich beben zu fühlen. Die Luft zitterte in unzähligen Wellen, die die Nerven in einen Zustand höchster Anspannung versetzten." Anton Fendrich, "Die Schlacht in der Champagne," in *Der Krieg: Illustrierte Chronik des Krieges 1914/15*, vol. 3 (Stuttgart: Frankh'sche Verlagshandlung, 1915), 542.

22. "Wir sind nichts als Ohr, als ausgespanntes Trommelfell." Jünger, *Der Kampf als inneres Erlebnis* (Berlin: E. S. Mittler & Sohn, 1922), 104.

23. "Du stürzt, und stürzt auf das zweite Blatt, das ebenfalls, und mit heftigerem Knalle, zerbirst." Ernst Jünger, *Das Abenteuerliche Herz: Erste Fassung: Aufzeichnungen bei Tag und Nacht* (1929; Stuttgart: Klett-Cotta, 2004), 15–16.

24. Ibid., 16.

25. On Jünger's aesthetics of terror, see Karl Heinz Bohrer, *Die Ästhetik des Schreckens: Die pessimistische Romantik und Ernst Jüngers Frühwerk* (Munich: Hanser, 1978).

26. "Mit Freude nehme ich wahr, wie die Städte sich mit Bewaffneten zu füllen beginnen und wie selbst das ödeste System, die langweiligste Haltung auf kriegerische Vertretung nicht mehr verzichten kann." Jünger, *Das Abendteuerliche Herz*, 112.

27. Ibid., 70.

28. Ibid., 134.

29. See Birdsall, *Nazi Soundscapes*.

30. "Man lernt sehr bald horchen wie ein Tier im Wald." Musil, "Der Gesang des Todes. Der singende Tod" (1915/16), in *Gesammelte Werke* 2, 758.

31. "Über unsern Köpfen singt es, tief, hoch. Man unterscheidet die Batterien am Klang. tschu i ruh oh—(pim) puimm. Wenn es in der Nähe einschlägt: tsch—sch—bam. Es pfaucht ein, zweimal kurz und springt dich an." Musil, *Tagebücher*, 324.

32. Ibid., 313.

33. "Ich erwartete ihn. Er wurde körperlicher, schwoll an, bedrohlicher. Aber das Musikhafte verlor er nicht." Musil, "Ein Soldat erzählt," in *Gesammelte Werke* 2, 753.

34. Hornbostel, "Beobachtungen über ein- und zweiohriges Hören," 68.

35. Ibid., 114.

36. "Ich wunderte mich, dass die andren nichts hörten . . . dass nur ich etwas hörte." Musil, "Ein Soldat erzählt," 752, 753.

37. "Vielleicht war es gerade dies: ein Gesang, der nur für mich da war. Auserwählt. An der Grenze der Atmosphäre singt eine Stimme nur für dich." Ibid., 754.

38. "Wie er sich mir näherte und perspektivisch größer wurde, war es doch zugleich als stiege ein silberner Strahl in mir auf." Ibid., 753.

Notes to Pages 107–113

39. "Von einer Luftwelle nichts erinnerlich. Von plötzlicher anschwellender Nähe nichts erinnerlich. Muss aber so gewesen sein, den instinctiv riß ich meinen Oberleib zur Seite und machte bei festehenden Füßen eine ziemlich tiefe Verbeugung." Musil, *Tagebücher*, 312.

40. Musil, "Ein Soldat erzählt," 752.

41. Ibid.

42. Ibid.

43. Ibid.

44. "Und zum Schluß dieser wenigen Augenblicke war eine neue Vorstellung in meinem Leib, die er nie zuvor beherbergt hatte: Gott." Ibid., 754.

45. As Patrizia McBride observes, "The premonition and frustrated longing for this unfathomable condition seem to be at the heart of the troubling dividedness of consciousness in modernity, for it is the juxtaposition of ordinary experience with this heightened state of being, as it surfaces in accidental moments of illumination, which makes everyday life seem worthless and inessential." Patrizia McBride, *The Void of Ethics: Robert Musil and the Experience of Modernity* (Evanston, Ill.: Northwestern University Press, 2006), 141.

46. "Gott hat mich geweckt. Ich bin aus dem Schlaf geschossen. Ich hatte gar keinen andren Grund, aufzuwachen." *G*, 575.

47. "Schob rasch den Vorhang zur Seite—die sanfte Nacht!" Ibid.

48. "Ich bin losgerissen worden wie ein Blatt aus einem Buch." Ibid.

49. "Durch Gehörseindrücke wecken wir den Schläfer und den wachen Träumer. Das allezeit offene Organ, das Eindringen der Schallwellen von allen Seiten her (durch die Wand kann man nicht sehen aber hören) und manche andere Umstände sind Ursachen dieser praktischen Bedeutung." Stumpf, *Tonpsychologie*, 67.

50. "Die Mondsichel liegt zart wie eine goldene Augenbraue auf dem blauen Blatt der Nacht. Aber auf der Morgenseite am anderen Fenster wird es grünlich. Papageienfedrig. Schon laufen auch die faden rötlichen Streifen des Sonnenaufgangs herauf, aber noch ist alles grün, blau und ruhig. Ich springe zum ersten Fenster zurück: Liegt die Mondsichel noch da? Sie liegt da, als ob es tiefste Stunde des nächtlichen Geheimnisses wäre." *G*, 575.

51. Hornbostel, "Beobachtungen über ein- und zweiohriges Hören," 65.

52. "Die Häuser stehn kreuz und quer, seltsame Umrisse, abstürzende Wände; gar nicht nach Straßen geordnet." *G*, 575.

53. "Endlich kommen zwei Beine durch die Nacht. Der Schritt zweier Frauenbeine und das Ohr. Nicht schaun will ich. Mein Ohr steht auf die Straße wie ein Eingang. Niemals war ich mit einer Frau so vereint wie mit dieser unbekannten, deren Schritte immer tiefer in meinem Ohr verschwinden." Ibid.

54. "Die zweiohrigen Schälle sind stärker gestaltet, sie sind Dinge, die hörend wahrgenommen werden, die, ruhend oder bewegt, in demselben Raum sind wie die Dinge, die man sieht." Hornbostel, "Beobachtungen über ein- und zweiohriges Hören," 114.

55. On acousmatic sound and *musique concrète*, see Brian Kane, *Sound Unseen: Acousmatic Sound in Theory and Practice* (Oxford: Oxford University Press, 2014).

56. Robert Musil, *Der Mann ohne Eigenschaften* (1930; Hamburg: Rowohlt, 1952), 665.

180 Notes to Pages 113–117

57. For the final 1936 version, see Musil, "Der Erweckte," in *Gesammelte Werke* 1, 484.

58. Eduard Fuchs, *Illustrierte Sittengeschichte vom Mittelalter bis zur Gegenwart*, vol. 2 (Munich: Albert Langen, 1910), 172–73. See also Karin Hartewig, "Klack, klack, klack: Der erotische Klang der Stöckelschuhe," in *Sound der Zeit: Geräusche, Töne, Stimmen, 1889 bis heute*, ed. Gerhard Paul and Ralph Schock (Göttingen: Wallstein, 2014), 405–9.

59. Pierce, *Studies in Auditory and Visual Space Perception*, 18. See also Silvanus Thompson, "On the Function of the Two Ears in the Perception of Space," *London, Edinburgh, and Dublin Philosophical Magazine and Journal of Science* 8 (January–June 1882): 407.

60. Bochow, *Schallmesstrupp 51*, 47.

61. Julia Encke describes Musil's war writings as "stories . . . that make the auditory organ their protagonist." This tendency, I would argue, is most clearly embodied in "The Believer," which even more than his earlier war writings presents the ear as a quasi-autonomous figure. See Encke, *Augenblicke der Gefahr*, 171.

62. On the "separation of the senses," see Crary, *Techniques of the Observer*; Sterne, *The Audible Past*.

63. On the Other Condition, see Stefan Jonsson, *Subject without Nation: Robert Musil and the History of Modern Identity* (Durham: Duke University Press, 2000), 90–96, 260–62; McBride, *The Void of Ethics*, 141–53; Bernd-Rüdiger Hüppauf, *Von sozialer Utopie zur Mystik: Zu Robert Musils* Der Mann ohne Eigenschaften (Munich: Wilhelm Fink, 1971), 121–31; Heribert Brosthaus, "Struktur und Entwicklung des 'anderen Zustands,'" *Deutsche Vierteljahrsschrift für Literaturwissenschaft und Geistesgeschichte* 39 (1965): 338–440; Werner Fuld, "Die Quellen zur Konzeption des 'anderen Zustands,'" *Deutsche Vierteljahrsschrift* 50 (1976): 664–82. For secondary literature discussing the connection between "The Believer" and the Other Condition, see Karl Corino, *Robert Musil: Eine Biographie* (Reinbek bei Hamburg: Rowohlt, 2003), 1902; Gudrun Brokoph-Mauch, *Robert Musils "Nachlass zu Lebzeiten"* (New York: Peter Lang, 1985), 59–79.

64. "Krieg ist das gleiche wie 'anderer Zustand.'" Musil, *Der Mann ohne Eigenschaften*, 1617, 1614.

65. On Musil's reading of Klages, see Musil, *Tagebücher*, 615–24.

66. Musil, "Ansätze zu neuer Ästhetik: Bemerkungen über eine Dramaturgie des Films" (1925), in *Gesammelte Werke* 1, 1137–54. On Musil and film, see Christoph Hoffmann, "*Dichter am Apparat*," 139–84; Christian Rogowski, "'Ein anderes Verhalten zur Welt': Robert Musil und der Film," *Sprachkunst* 23 (1992): 105–18.

67. Hornbostel, "Beobachtungen über ein- und zweiohriges Hören," 114.

68. Béla Balázs, *Der sichtbare Mensch oder die Kultur des Films* (1924; Frankfurt am Main: Suhrkamp, 2001), 53, 49. See also Gertrud Koch, "Bela Balazs: The Physiognomy of Things," trans. Miriam Hansen, *New German Critique* 40 (Winter 1987): 167–77.

69. "Das Pathos der Größen ist eine Wirkung, die keine andere Kunst so wie der Film ausüben kann." Balázs, *Der sichtbare Mensch*, 53.

70. Musil, "Ansätze zu neuer Ästhetik," 1144.

Notes to Pages 119–121

Chapter 5

1. "Ich sitze in meinem Zimmer im Hauptquartier des Lärms der ganzen Wohnung." Franz Kafka, "Grosser Lärm," in *Herder-Blätter: Faksimile-Ausgabe zum 70. Geburtstag von Willy Haas*, ed. Rolf Italiaander (Hamburg: Freie Akademie der Künste, 1962), 42.

2. See Kafka, *Tagebücher, 1909–1912*, ed. Hans-Gerd Koch (Frankfurt am Main: Fischer Taschenbuch Verlag, 2008), 38; Kafka, *Briefe an Felice und andere Korrespondenz aus der Verlobungszeit*, ed. Erich Heller and Jürgen Born (Frankfurt am Main: Fischer Taschenbuch Verlag, 2003), 627–30; Kafka, *Briefe, 1902–1924*, ed. Max Brod (New York: Schocken Books, 1958), 376, 390–98.

3. Kafka, *Tagebücher, 1914–1923*, ed. Hans-Gerd Koch (Frankfurt am Main: Fischer Taschenbuch Verlag, 1990), 82.

4. Kafka's letter to Felice Bauer, February 11, 1915, *Briefe an Felice*, 627.

5. Kafka's letter to Felice Bauer, April 5, 1915, *Briefe an Felice*, 632.

6. Kafka's letter to Oskar Baum, July 16, 1922, *Briefe an Felice*, ibid., 395.

7. Kafka's letter to Robert Klopstock, July 24, *Briefe an Felice*, 398.

8. See Hans-Gerd Koch and Klaus Wagenbach, eds., *Kafkas Fabriken* (Marbach am Neckar: Deutsche Schillergesellschaft, 2002); Marjorie E. Rhine, "Manufacturing Discontent: Mapping Traces of Industrial Space in Kafka's Haptic Narrative Landscapes," *Journal of the Kafka Society of America* (June/December 2005): 65–70.

9. "Gestern in der Fabrik. Die Mädchen in ihren an und für sich unerträglich schmutzigen und gelösten Kleidern, mit den wie beim Erwachen zerworfenen Frisuren, mit dem unaufhörlichen Lärm der Transmissionen." Franz Kafka, *Tagebücher 1912–1914*, ed. Hans-Gerd Koch (Frankfurt am Main: Fischer Taschenbuch Verlag, 2008), 32.

10. Franz Kafka, *Tagebücher 1914–1923*, ed. Hans-Gerd Koch (Frankfurt am Main: Fischer Taschenbuch Verlag, 1990), 24.

11. Franz Kafka, "Jahresbericht 1909," in *Amtliche Schriften*, ed. Klaus Hermsdorf (Berlin: Akademie-Verlag, 1984), 201.

12. Kafka, "Jahresbericht 1915," 489, 494.

13. "So wie im Frieden der letzten Jahrzehnte der intensive Maschinenbetrieb die Nerven der in ihm Beschäftigten unvergleichlich mehr als jemals früher gefährdete, störte und erkranken ließ, hat auch der ungeheuerlich gesteigerte maschinelle Teil der heutigen Kriegshandlungen schwerste Gefahren und Leiden für die Nerven der Kämpfenden verursacht." Kafka, "Volksnervenheilanstalt für Deutschböhmen in Rumburg-Frankenstein," in *Amtliche Schriften*, 498.

14. "In Wirklichkeit hätte es ihm aber sehr wohlgetan sich niederzusetzen; er war wie seekrank. Er glaubte auf einem Schiff zu sein, das sich in schwerem Seegang befand. Es war ihm als stürze das Wasser gegen die Holzwände, als komme aus der Tiefe des Ganges ein Brausen her, wie von überschlagendem Wasser, als schaukle der Gang in der Quere und als würden die wartenden Parteien zu beiden Seiten gesenkt und gehoben. Desto unbegreiflicher war die Ruhe des Mädchens und des Mannes, die ihn führten. Er war ihnen ausgeliefert, ließen sie ihn los, so mußte er hinfallen wie ein Brett. Aus ihren kleinen Augen giengen scharfe Blicke hin und her; ihre gleichmäßigen Schritte fühlte K. ohne sie mitzumachen, denn er wurde fast von Schritt zu Schritt getragen. Endlich merkte er, daß sie zu ihm sprachen, aber er verstand sie nicht, er hörte nur den Lärm der alles erfüllte und

durch den hindurch ein unveränderlicher hoher Ton wie von einer Sirene zu klingen schien. 'Lauter,' flüsterte er mit gesenktem Kopf und schämte sich, denn er wußte, dass sie laut genug, wenn auch für ihn unverständlich gesprochen hatten. Da kam endlich, als wäre die Wand vor ihm durchrissen ein frischer Luftzug ihm entgegen und er hörte neben sich sagen: 'Zuerst will er weg, dann aber kann man ihm hundertmal sagen, dass hier der Ausgang ist und er rührt sich nicht.' " Kafka, *Der Proceß* (Frankfurt am Main: S. Fischer, 2007), 84.

15. Around 1913, crank-operated sirens began to be introduced into fire stations and on mobile fire equipment. The aerial bombing campaigns of World War I additionally inspired the creation of air raid sirens, which were installed in numerous European and American cities following the war's end. See George Prochnik, "The Orchestra," *Cabinet* 41 (Spring 2011), http://www.cabinetmagazine.org/issues/41/prochnik.php; Alexander Rehding, "Of Sirens Old and New," in *The Oxford Handbook of Mobile Music Studies*, vol. 2, ed. Sumanth Gopinath and Jason Stanyek (Oxford: Oxford University Press, 2014), 77–108. For an account of the factory siren's function and sonic qualities from the period in which Kafka was writing, see also Jakob Schaffner, "Der eiserne Götze," in *Die goldene Fratze: Novellen* (Berlin: S. Fischer Verlag, 1912), 236–37, 265–76.

16. "Ohrgeräuschen der mannigfachsten Art, zeitweilig und kontinuierlich, Sausen, Rauschen, Klingen . . . Schwindelerscheinungen beim Bücken oder beim Blick in die Höhe." B. Baginsky, "Die Unfallbegutachtung in der Ohrenheilkunde," *Berliner Klinische Wochenschrift*, September 11, 1905, 1171.

17. "Subjektive Geräusche bestehen in annähernd der Hälfte der Fälle. Schwindel tritt in vorgeschrittenen Fällen zuweilen auf." Friedrich Röpke, *Die Berufskrankheiten des Ohres und der oberen Luftwege* (Wiesbaden: Bergmann, 1902), 23.

18. "Schwindelerscheinungen und Gleichgewichtsstörungen gehören zu den constantesten Symptomen nach Verletzungen des schallempfindenden Apparates." Adolf Passow, *Die Ohrenheilkunde der Gegenwart und ihre Grenzgebiete 5: Die Verletzungen des Gehörorganes* (Wiesbaden: Bergmann, 1905), 165.

19. Kafka, "Das Schweigen der Sirenen," in *Die Erzählungen und andere ausgewählte Prosa*, ed. Roger Hermes (Frankfurt am Main: Fischer, 2006), 351–52.

20. Kafka, "Forschungen eines Hundes," in *Die Erzählungen und andere ausgewählte Prosa*, 414, 415, 452, 453.

21. Kafka, "Josefine, die Sängerin oder Das Volk der Mäuse," in *Die Erzählungen und andere ausgewählte Prosa*, 538.

22. Kafka, "Der Bau," in *Die Erzählungen und andere ausgewählte Prosa*, 465–507. All references to the text subsequently indicated by *B* followed by a page number.

23. See Hermann J. Weigand, "Franz Kafka's 'The Burrow' ('Der Bau'): An Analytical Essay," *PMLA* 87 (1972): 152–66; Henry Sussman, "The All-Embracing Metaphor: Reflections on 'The Burrow,' " in *Critical Essays on Franz Kafka*, ed. Ruth V. Gross (Boston: G. K. Hall, 1990), 130–52; Wolf Kittler, "Grabenkrieg—Nervenkrieg—Medienkrieg: Franz Kafka und der 1. Weltkrieg," in *Armaturen der Sinne: Literarische und technische Medien 1870 bis 1920*, ed. Jochen Hörisch and Michael Wetzel (Munich: Fink, 1990), 289–309; Mladen Dolar, "The Burrow of Sound," *differences: A Journal of Feminist Cultural Studies* 22, nos. 2/3 (2011): 112–39.

Notes to Pages 123–127

24. Brian Kane, "Sound Studies without Auditory Culture: A Critique of the Ontological Turn," *Sound Studies* 1, no. 1 (2015): 3.

25. C. Z. Klötzel, "Radio," *Prager Tagblatt*, February 7, 1924, 4.

26. That Kafka was familiar with early radio technology is evidenced by his reference to "wireless telegraphy" (Funkentelegraphie), along with the telephone and telegraph, in a letter to Milena Jesenská at the end of March 1922. See Kafka, *Briefe an Milena*, ed. Jürgen Born and Michael Müller (Frankfurt am Main: Fischer, 2006), 302.

27. "Die Möglichkeit . . . Geräusche wahrnehmbar zu machen, für die das menschliche Ohr nicht mehr aufnahmefähig ist. Wir können bekanntlich Töne, deren Schwingungszahl pro Sekunde unter oder über einer bestimmten Grenze liegen, nicht mehr hören. Von dem ungeheueren Lärm, der die Welt auch dann erfüllt, wenn wir uns z.B. in den stillen Regionen des ewigen Schnees befinden, hören wir nur einen ganz kleinen Teil. So hören wir weder das ständige Geräusch eines Schneefeldes, in dem sich die kleinen Partikelchen in ständiger Bewegung befinden, noch die Geräusche, die unser eigener Körper bei Bewegung seiner Muskeln verursacht." Klötzel, "Radio," 4.

28. See George Washington Pierce, *The Songs of Insects: With Related Material on the Production, Propagation, Detection, and Measurement of Sonic and Supersonic Vibrations* (Cambridge, Mass.: Harvard University Press, 1948), 141–46; Marvin Lasky, "Review of Undersea Acoustics to 1950," *Journal of the Acoustical Society of America* 61, no. 2 (February 1, 1977): 283–97; Donald R. Griffin, *Listening in the Dark: The Acoustic Orientation of Bats and Men* (New Haven, Conn.: Yale University Press, 1958). I am grateful to Kathryn Wataha for bringing these American sources to my attention.

29. Gustav Janouch, *Conversations with Kafka*, trans. Goronwy Rees (New York: New Directions, 2012), 77.

30. See Britta Maché, "The Noise in the Burrow: Kafka's Final Dilemma," *German Quarterly* 55, no. 4 (November 1982): 528; Wolf Kittler, "Grabenkrieg—Nervenkrieg—Medienkrieg," 293; Bettine Menke, *Prosopopoiia: Stimme und Text bei Brentano, Hoffmann, Kleist und Kafka* (Munich: Fink, 2000).

31. Wolf Kittler, "Grabenkrieg—Nervenkrieg—Medienkrieg," 289–309.

32. See Encke, *Augenblicke der Gefahr*, 149; Johannes Türk, "Rituals of Dying, Burrows of Anxiety in Freud, Proust, and Kafka: Prolegomena to a Critical Immunology," *Germanic Review* 82, no. 2 (2007): 153.

33. The use of architectural metaphors in describing the anatomy of the ear goes back at least as far as Ernst Florens Friedrich Chladni's pioneering work in acoustics in the early nineteenth century. See his *Die Akustik* (Leipzig: Breitkopf und Härtel, 1802), 277–83.

34. A. Eckert-Möbius, "Mikroskopische Untersuchungstechnik und Histologie des Gehörorgans," in *Handbuch der Hals- Nasen- Ohrenheilkunde*, vol. 6, ed. A. Denker and O. Kahler (Berlin: Julius Springer, 1926), 288.

35. J. Rich. Ewald, "Zur Physiologie des Labyrinths," *Archiv für die Gesamte Physiologie* 76 (1899): 177.

36. "Aber gerade dieses Gleichbleiben an allen Orten stört mich am meisten, denn es läßt sich mit meiner ursprünglichen Annahme nicht in Übereinstimmung bringen." *B*, 490.

184 Notes to Pages 127–130

37. "Ich krieche in den Graben, decke ihn hinter mir zu, warte sorgfältig berechnete kürzere und längere Zeiten zu verschiedenen Tagesstunden, werfe dann das Moos ab, komme hervor und registriere meine Beobachtungen. Ich mache die verschiedensten Erfahrungen, guter und schlimmer Art, ein allgemeines Gesetz oder eine unfehlbare Methode des Hinabsteigens finde ich aber nicht." *B*, 479.

38. "Es ging so weit dass ich manchmal den kindischen Wunsch bekam . . . mein Leben in der Beobachtung des Eingangs zu verbringen und immerfort mir vor Augen zu halten." *B*, 477.

39. "Mir ist dann als stehe ich nicht vor meinem Haus, sondern vor mir selbst, während ich schlafe." *B*, 476.

40. Confusion over whether the creature is observing itself or the entrance to the burrow echoes more explicit formulations of an identification between the protagonist and its home, which portray the two as inseparable: "You all belong to me, I to you, we are connected, what can befall us" (Ihr gehört zu mir, ich zu Euch, verbunden sind wir, was kann uns geschehn). *B*, 487.

41. "Ich beobachte doch nicht wie ich glaubte meinen Schlaf, vielmehr bin ich es der schläft, während der Verderber wacht." *B*, 478.

42. "Werde ich von jemandem andern beobachtet, muss ich mich natürlich auch beobachten." Kafka, *Tagebücher 1914–1923*, 195.

43. "Ich habe es gar nicht gehört, als ich kam, trotzdem es gewiß schon vorhanden war; ich mußte erst wieder völlig heimisch werden, um es zu hören, es ist gewissermaßen nur mit dem Ohr des wirklichen sein Amt ausübenden Hausbesitzers hörbar." *B*, 488.

44. "Es ist ja nichts, manchmal glaube ich, niemand außer mir würde es hören." *B*, 489.

45. "Einer dieser Lieblingspläne war es gewesen, den Burgplatz loszulösen von der ihn umgebenden Erde, d.h. seine Wände nur in einer etwa meiner Höhe entsprechenden Dicke zu belassen, darüber hinaus aber rings um den Burgplatz bis auf ein kleines von der Erde leider nicht loslösbares Fundament einen Hohlraum im Ausmaß der Wand zu schaffen. In diesem Hohlraum hatte ich mir immer, und wohl kaum mit Unrecht, den schönsten Aufenthaltsort vorgestellt, den es für mich geben könnte. Auf dieser Rundung hängen, hinauf sich ziehen, hinab zu gleiten, sich überschlagen und wieder Boden unter den Füßen haben und alle diese Spiele förmlich auf dem Körper des Burgplatzes spielen und doch nicht in seinem eigentlichen Raum; den Burgplatz meiden können, die Augen ausruhn lassen können von ihm, die Freude ihn zu sehen auf eine spätere Stunde verschieben und doch ihn nicht entbehren müssen." *B*, 491.

46. "Sondern mit Entzücken etwas, was mir jetzt völlig entgeht: das Rauschen der Stille auf dem Burgplatz." *B*, 492. In his reading of the passage, Gerhard Kurz points out that, as early as Martin Luther, the Greek *ekstasis* was translated into German as *Entzückung*. Although Kurz productively highlights the term's connotations of an out-of-body experience, he at no point discusses how this relates to the text's broader thematization of the body nor does he note the irony that, at this very moment in the text, the protagonist imagines listening to an architectural structure described as the "body of the central square." Gerhard Kurz, "Das Rauschen der Stille: Annäherungen an Kafkas 'Der Bau,' " in *Zur Ethischen und ästhetischen Rechtfertigung*, ed. Beatrice Sandberg and Jakob Lothe (Freiburg: Rombach, 2002), 163.

Notes to Pages 130–134

47. "The noises of the muscles and the blood . . . have, as is well known, a deeper acoustic quality that corresponds to rustling [Rauschen], roaring, or growling" (Die Muskel- und Blutgeräusche . . . haben bekanntlich einen tieferen, dem Rauschen, Brausen oder Brummen entsprechenden Toncharakter). Gustav Brunner, "Zur Lehre von den subjectiven Ohrgeräuschen," *Zeitschrift für Ohrenheilkunde* 8 (1879): 197. On the aesthetics and cultural history of *Rauschen*, see Rüdiger Campe, "The 'Rauschen' of the Waves: On the Margins of Literature," *SubStance* 19, no. 1 (1990): 21–38; Katja Stopka, *Semantik des Rauschens: Über ein akustisches Phänomen in der deutschsprachigen Literatur* (Munich: M Press, 2005); Oliver Simons, "Botschaft oder Störung? Eine Diskursgeschichte des 'Rauschens' in der Literatur um 1800," *Monatshefte* 100, no. 1 (2008): 33–47. On the term's media-theoretical significance, see Friedrich Kittler, "Signal-Rausch-Abstand," in *Materialität der Kommunikation*, ed. Ulrich Gumbrecht and K. Ludwig Pfeiffer (Frankfurt am Main: Suhrkamp, 1988), 342–59; Friedrich Kittler and Thomas Macho, eds., *Zwischen Rauschen und Offenbarung: Zur Kultur- und Mediengeschichte der Stimme* (Berlin: Akademie Verlag, 2002).

48. "Manchmal scheint es mir, als habe das Geräusch aufgehört, es macht ja lange Pausen, manchmal überhört man ein solches Zischen, allzu sehr klopft das eigene Blut im Ohr." *B*, 497. The fact that the blood can be heard at all testifies to the remarkable low volume that prevails in the burrow. Gustav Brunner similarly observed that "under normal circumstances we do not hear the circulation of blood in the ear or its surrounding. For this, one needs especially favorable moments" (Unter normalen Verhältnissen hören wir die Blutbewegung im Ohr oder dessen Umgebung nicht, es bedarf hierzu besondere begünstigende Momente). Brunner, "Zur Lehre von den subjectiven Ohrgeräuschen," 201.

49. "Zwischen damals und heute liegt mein Mannesalter, ist es aber nicht so als liege gar nichts dazwischen, noch immer mach ich eine große Arbeitspause und horche an der Wand." *B*, 504.

50. J. M. Coetzee, "Time, Tense and Aspect in Kafka's 'The Burrow,'" *MLN* 96, no. 3 (April 1981): 575.

51. The topic of writing has received sustained attention in secondary scholarship on "The Burrow." See Stanley Corngold, *Franz Kafka: The Necessity of Form* (Ithaca, N.Y.: Cornell University Press, 1988), 282; Sussman, "The All-Embracing Metaphor," 132–35. Although my own focus in this essay has been on a constellation of scientific and literary representations of sound and hearing around 1900, I find attempts to read Kafka's literary work as an experimental protocol too reductive. See Elisabeth Strowick, "Epistemologie des Verdachts. Zu Kafkas 'Bau,'" in *The Parallax View: Zur Mediologie der Verschwörung*, ed. Marcus Krause, Arno Meteling, and Marcus Stauff (Munich: Fink, 2011), 130.

52. Jacques Derrida, *Speech and Phenomena and Other Essays on Husserl's Theory of Signs*, trans. David B. Allison (Evanston, Ill.: Northwestern University Press, 1973), 76–87.

53. Derrida, *Speech and Phenomena*, 77.

54. Hans Ulrich Gumbrecht, "A Farewell to Interpretation," in *Materialities of Communication*, ed. Hans Ulrich Gumbrecht and K. Ludwig Pfeiffer, trans. William Whobrey (Stanford, Calif.: Stanford University Press, 1994), 393.

55. "[Das Zischen] wird stärker, es kommt näher, ich aber schlängele mich durch das Labyrint und lagere mich hier oben unter dem moos, es ist ja fast, als

überließe ich dem Zischer schon das Haus, zufrieden wenn ich nur hier oben ein wenig Ruhe habe. Dem Zischer? Habe ich etwa eine neue bestimmte Meinung über die Ursache des Geräusches?" *B*, 499.

56. Dolar, "The Burrow of Sound," 115. "I recognize what it is immediately; the small fry, whom I had not monitored closely enough and had been far too easy on, had burrowed a new path somewhere during my absence, this path must have intersected with an older one, the air was caught there, and that produced the whistling noise" (Ich verstehe es sofort, das Kleinzeug, viel zu wenig von mir beaufsichtigt, viel zu sehr von mir geschont, hat in meiner Abwesenheit irgendwo einen neuen Weg gebohrt, dieser Weg ist mit einem alten zusammengestoßen, die Luft verfängt sich dort and das ergibt das zischende Geräusch). *B*, 487.

57. See Strowick, "Epistemologie des Verdachts," 123, 129.

58. "Mir ist dann als stehe ich nicht vor meinem Haus, sondern vor mir selbst, während ich schlafe." *B*, 476.

Conclusion

1. Birdsall, *Nazi Soundscapes*, 32.

2. Siegfried Kracauer, "Schreie auf der Strasse" (1930), in *Strassen in Berlin und anderswo* (Berlin: Das Arsenal, 1987), 26–28. On Kracauer and sound, see Theodore F. Rippey, "Kracauer and Sound: Reading with an Anxious Ear," in *Culture in the Anteroom: The Legacies of Siegfried Kracauer*, ed. Johannes von Moltke and Gerd Gemündenpp (Ann Arbor: University of Michigan Press, 2012), 183–98.

3. "In any case, it sometimes appeared to me as if there lay a bomb in every conceivable hiding spot, which at any moment could trigger an explosion" (Jedenfalls ist mir mitunter, als läge an allen möglichen verborgenen Stellen ein Sprengstoff bereit, der im nächsten Augenblick eine Explosion hervorrufen kann). Kracauer, "Schreie auf der Strasse," 26.

4. Ibid., 27.

5. Ibid.

6. Eugen Hadamovsky, *Propaganda und nationale Macht* (Oldenburg: Gerhard Stalling, 1933), 12.

7. Haig A. Bosmajian, *The Language of Oppression* (Washington, D.C.: Public Affairs Press, 1974), 18.

8. "Ich bin nichts als ein Trommler und ein Sammler." Quoted in Fritz Stern, *Kulturpessimismus als politische Gefahr: Eine Analyse nationaler Ideologie in Deutschland* (Bern: Scherz, 1963), 284.

9. "Nicht aus Bescheidenheit wollte ich damals 'Trommler' sein; das ist das Höchste, das andere ist eine Kleinigkeit." Adolf Hitler, "Vor dem Volksgericht, Vierundzwanzigster Verhandlungstag," in *Sämtliche Aufzeichnungen, 1905–1924*, ed. Eberhard Jäckel and Axel Kuhn (Stuttgart: Veröffentlichungen des Instituts für Zeitgeschichte, 1980), 1210.

10. Joseph Goebbels, "Der Führer als Redner," in *Adolf Hitler: Bilder aus dem Leben des Führers* (Hamburg: Cigaretten/Bilderdienst Hamburg/Bahrenfeld, 1936), 27–34.

11. Ibid., 28, 32.

12. "Denn die Masse beugt sich nur dem, der sie unter sein unerbittliches Gebot nimmt. Sie gehorcht nur, wenn einer zu befehlen versteht." Ibid., 32.

Notes to Pages 141–145

13. Ibid., 28.

14. "Was alle dachten und fühlten, Hitler sagte es!" Ibid., 31.

15. Ibid., 34.

16. "Dass man [Ideen] richtig an die Massen heranbringt, dass die Massen selbst ihre Träger werden." Ibid., 30–31.

17. Cornelia Epping-Jäger, "Stimmgewalt: Die NSDAP als Rednerpartei," in *Stimme: Annäherung an ein Phänomen*, ed. Doris von Kolesch and Sybille Krämer (Frankfurt am Main: Suhrkamp, 2006), 149.

18. See Seth S. Horowitz, *The Universal Sense: How Hearing Shapes the Mind* (New York: Bloomsbury, 2012), 227–28.

19. See Leslie E. Simon, *German Research in World War II: An Analysis of the Conduct of Research* (New York: J. Wiley & Sons, 1947), 180–84; Juliette Volcler, *Extremely Loud: Sound as a Weapon*, trans. Carol Volk (New York: New Press, 2013), 45, 46.

20. See Norman Ohler, *Blitzed: Drugs in Nazi Germany*, trans. Shaun Whiteside (Boston: Houghton Mifflin Harcourt, 2017), 155.

21. On Weber's "discovery" of AC bias, see O. Schmidbauer, "Das Magnetofon und seine physikalischen Grundlagen (Schluß)," *Funkschau*, no. 5 (1949): 90; Greg Milner, *Perfecting Sound Forever: An Aural History of Recorded Music* (New York: Farrar, Straus and Giroux, 2009), 112.

22. See William Charles Lafferty, Jr., "The Early Development of Magnetic Sound Recording in Broadcasting and Motion Pictures, 1928–1950" (PhD diss., Northwestern University, 1981), 14, 137.

23. See Erich Schwandt, "Fortschritte in Schallaufzeichnung und raumgetreuer Rundfunkwiedergabe," *Funkschau*, nos. 10/12 (1943): 91; Ansgar Diller, "Die Weihnachtsringsendung 1942: Der Produktionsfahrplan der RRG," *Rundfunk und Geschichte* 29, nos. 1/2 (2003): 47–51; Dominik Schrage, "'Singt alle mit uns gemeinsam in dieser Minute': Sound als Politik in der Weihnachtsringsendung 1942," in *Politiken der Medien*, ed. Daniel Gethmann and Markus Stauff (Zürich: Diaphanes, 2005), 267–85.

24. Chopin asserted that without the magnetophone "sound poetry . . . would not exist." Quoted in Christian Bök, "When Cyborgs Versify," in *The Sound of Poetry / The Poetry of Sound*, ed. Marjorie Perloff and Craig Dworkin (Chicago: University of Chicago Press, 2009), 132. On Burroughs and tape, see Robin Lydenberg, "Sound Identity Fading Out: William Burroughs' Tape Experiments," in *Wireless Imagination*, ed. Douglas Kahn and Gregory Whitehead (Cambridge, Mass.: MIT Press, 1992), 409–37; N. Katherine Hayles, *How We Became Posthuman: Virtual Bodies in Cybernetics, Literature, and Informatics* (Chicago: University of Chicago Press, 1999), 207–21. On Brinkmann, see Kai-Uwe Werbeck, "Walking the Corridors of Mass Media: Rolf Dieter Brinkmann's 1973–1974 Cologne Tape Recordings and the Poetics of Disruption," *Seminar* 50, no. 2 (May 2014): 216–30. On Rühm and sound within the Wiener Gruppe, see documents collected in Peter Weiber, ed., *Die Wiener Gruppe: Ein Moment der Moderne 1954–1960* (Berlin: Springer, 1998), esp. 317, 320, 388, 427, 621; Roland Innerhofer, "Stimm-Bruch: Akustische Inszenierungen der Wiener Gruppe," in *verschiedene sätze treten auf: Die Wiener Gruppe in Aktion*, ed. Thomas Eder and Juliane Vogel (Vienna: Paul Zsolnay Verlag, 2008), 99–118; Bernhard Fetz, "'ihre stimme klingt manchmal als wären es sie'—Zur

Vielstimmigkeit der Wiener Gruppe," in *verschiedene sätze treten auf: Die Wiener Gruppe in Aktion*, 119–32. On the emergence of the multitrack recording studio, see David Morton, *Off the Record: The Technology and Culture of Sound Recording in America* (New Brunswick, N.J.: Rutgers University Press, 1999), 63; Robert R. Phillips, "First-Hand: Bing Crosby and the Recording Revolution," Engineering and Technology History Wiki, accessed April 2015, http://ethw.org/First-Hand:Bing_Crosby_and_the_Recording_Revolution.

25. Kittler, "Rock Musik—ein Missbrauch von Heeresgerät," in *Medien und Maschinen: Literatur im technischen Zeitalter*, ed. Theo Elm and Hans H. Hiebel (Freiburg: Rombach Druck- und Verlagshaus, 1991), 245–57; Kittler, "Rock Music: A Misuse of Military Equipment," in *The Truth of the Technological World: Essays on the Genealogy of Presence*, trans. Erik Butler (Stanford, Calif.: Stanford University Press, 2014), 152–64.

26. For an insightful critique of academic musicology's neglect of acoustical embodiment, see Nicholas Cook, "Seeing Sounds, Hearing Images: Listening Outside the Modernist Box," in *Musical Listening in the Age of Technological Reproducibility*, ed. Gianmario Borio (Farnham, UK: Ashgate, 2015), 185–202.

27. See Simon Reynolds, *Rip It Up and Start Again: Postpunk 1978–1984* (London: Penguin Books, 2006), 124–38; Simon Ford, *The Wreckers of Civilization: The Story of COUM Transmissions and Throbbing Gristle* (London: Black Dog, 2001).

28. See William S. Burroughs and Daniel Odier, *The Job: Interviews with William S. Burroughs* (London: Penguin Books, 1989), 62–65.

29. See Volcler, *Extremely Loud*, 53–57.

30. See Cheng, *Just Vibrations*, 93–103.

31. See Elise Labott, Patrick Oppmann, and Laura Koran, "US Embassy Employees in Cuba Possibly Subject to 'Acoustic Attack,'" *CNN*, August 10, 2017, http://www.cnn.com/2017/08/09/politics/us-cuba-acoustic-attack-embassy/index.html.

32. See Friedrich A. Kittler, "God of the Ears," in *The Truth of the Technological World*, 45–56.

33. For a recording of the Südwestfunk production, see Ernst Jandl and Frederike Mayröcker, *Fünf Mann Menschen*, vinyl 7", included with the book *Neues Hörspiel: Texte Partituren*, ed. Klaus Schöning (Frankfurt am Main: Suhrkamp, 1969). See also Monika Pauler, *Bewusstseinsstimmen: Friederike Mayröckers auditive Texte: Hörspiele, Radioadaptionen und "Prosa-Libretti" 1967–2005* (Muenster: LIT Verlag, 2010); Axel Dunker, "'und brüllzten wesentlich': Laut und Geräusch bei Dada und in der Neo-Avantgarde Ernst Jandls," in *Phono-Graphien: Akustische Wahrnehmung in der detuschsprachigen Literatur von 1800 bis zur Gegenwart*, ed. Marcel Krings (Würzburg: Königshausen & Neumann, 2011), 209–18.

34. Amiri Baraka, *It's Nation Time*, vinyl LP (Detroit: Black Forum/Motown, 1972). See also Jessica E. Teague's excellent reading of the recording and its use of stereophonics as a means of conjuring up an imagined Pan-African space in her "Black Sonic Space and the Stereophonic Poetics of Amiri Baraka's *It's Nation Time*," *Sound Studies* 1, no. 1 (2015): 22–39.

35. See Kahn, *Noise, Water, Meat*, 158–99; Richard Kostelanetz, *Conversing with Cage* (New York: Routledge, 2003); Liz Kotz, *Words to Be Looked At: Language in 1960s Art* (Cambridge, Mass.: MIT Press, 2007).

Notes to Page 147

36. Here I am indebted to Ritwik Banerji's 2016 talk, "*Magenmusik*: Listening to Silence as Disciplinary Practice in Berlin's *Echtzeitmusik* Scene" (presentation at the German Studies Association 40th Annual Conference, San Diego, Calif., September 29–October 2, 2016).

37. Uzair Paracha, a Pakistani-American convicted of aiding members of al-Qaeda, describes the "deafening silence of complete isolation." Paracha, "Innocent in the Eyes of the Law," in *Hell Is a Very Small Place: Voices from Solitary Confinement*, ed. Jean Casella, James Ridgeway, and Sarah Shourd (New York: New Press, 2016), 51. See also Atul Gawande, "Hellhole," *New Yorker,* March 30, 2009, https://www.newyorker.com/magazine/2009/03/30/hellhole; Tom Rice, "Sounds Inside: Prison, Prisoners and Acoustical Agency," *Sound Studies* 2, no. 1 (2016): 6–20.

WORKS CITED

Abels, Ludwig. "Das neue Wien." *Die Zeit*, June 24, 1899, 204–6.

Adorno, Theodor W. "Physiologische Romantik." 1932. In *Noten zur Literatur*, edited by Rolf Tiedemann, 634–36. Frankfurt am Main: Surhkamp, 1974.

Albers, Irene. *Sehen und Wissen: Das Photographische im Romanwerk Émile Zolas*. Munich: Fink, 2002.

Allais, Kai. " 'Geräusche'—Textlichkeit und Serialität. Musils Novelle 'Die Versuchung der stillen Veronika.' " In *Robert Musils 'Kakanien—Subjekt und Geschichte. Festschrift für Karl Dinklage zum 80. Geburtstag*: Musil-Studien 15, edited by Josef von Strutz, 292–307. Munich: Wilhelm Fink, 1987.

Altenberg, Peter. Contribution to *Detlev von Liliencron im Urteil zeitgenössischer Dichter: Dem Dichter der 'Adjutantenritte' und des 'Poggfred' überreicht*, edited by Fritz Böckel. Berlin: Schuster & Loeffler, 1904.

———. "Der Nebenmensch." *Das Recht auf Stille* 2, no. 2 (February 1910): 10.

———. "Sanatorien für Nervenkranke." In *Bilderbogen des kleinen Lebens*. Berlin-Westend: Erich Reiss Verlag, 1909.

———. "Der Nebenmensch." 1911. In *Neues Altes*. Berlin: S. Fischer, 1919.

———. "Der Schreibunterricht." In *Bilderbogen des kleinen Lebens*. Berlin-Westend: Erich Reiss Verlag, 1909.

———. *Fechsung*. Berlin: S. Fischer, 1915.

———. *Märchen des Lebens*. Berlin: S. Fischer, 1908.

———. *Nachfechsung*. 1916. Berlin: S. Fischer, 1919.

———. *Prodromos*. Berlin: S. Fischer, 1906.

———. "Sanatorien für Nervenkranke." *Das Recht auf Stille* 1, no. 11 (October 1909): 213.

———. *Vita Ipsa*. Berlin: S. Fischer, 1918.

———. *Was der Tag mir zuträgt: Fünfundfünfzig neue Studien*. Berlin: S. Fischer, 1901.

———. *Wie ich es sehe: In der Fassung des Erstdrucks*. Berlin: Fischer Taschenbuch Verlag, 2009.

———. *Wie ich es sehe*. Zürich: Manesse Verlag, 2007.

Ames, Eric. "The Sound of Evolution." *Modernism/Modernity* 10, no. 2 (April 2003): 297–325.

Anderson, Ross. *The Forgotten Front: The East African Campaign, 1914–1918*. Stroud, Gloucestershire: History Press, 2014.

Antheil, George. "The Negro on the Spiral, or A Method of Negro Music." In *Negro Anthology, 1931–1933*, edited by Nancy Cunard, 346–51. London: Nancy Cunard at Wishart & Co., 1934.

"Antilärm-Enquete." *Das Recht auf Stille* 1, no. 3 (January 1909): 34–38.

"Antilärmiten." *Das Recht auf Stille* 1, no. 4 (February 1909): 53–57.

"Antilärm-Umfrage." *Das Recht auf Stille* 1, no. 6 (April 1909): 105–8.

Ardenne, Manfred von. "Plastisches Hören von Rundfunkdarbietungen." *Funk*, no. 23 (1925): 281.

———. "Raumgetreues oder Räumliches Hören?" *Die Sendung*, March 26, 1926, 4.

Asumfix, Ella. "Auf dem Stadtperron." *Das Recht auf Stille* 1, no. 9 (July 1909): 167–68.

Attali, Jacques. *Noise: The Political Economy of Music.* 1977. Translated by Brian Massumi. Minneapolis: University of Minnesota Press, 2009.

Auerbach, Siegmund. "Sechs Forderungen an Kurhotels." *Das Recht auf Stille* 1, no. 9 (July 1909): 158–59.

Baginsky, B. "Die Unfallbegutachtung in der Ohrenheilkunde." *Berliner Klinische Wochenschrift*, September 11, 1905, 1169–73.

Bahr, Hermann. "Die Überwindung des Naturalismus." 1891. In *Kritische Schriften II*, edited by Claus Pias, 128–33. Weimar: VDG, 2004.

Balázs, Béla. *Der sichtbare Mensch oder die Kultur des Films.* 1924. Frankfurt am Main: Suhrkamp, 2001.

Ball, Hugo. *Die Flucht aus der Zeit.* Munich: Duncker & Humblot, 1927.

Bancel, Nicolas, Pascal Blanchard, Giles Boëtsch, Eric Deroo, Sandrine Lemaire, and Charles Forsdick, eds. *Human Zoos: From the Hottentot Venus to Reality Shows.* Liverpool: Liverpool University Press, 2008.

Banerji, Ritwik. "*Magenmusik*: Listening to Silence as Disciplinary Practice in Berlin's *Echtzeitmusik* Scene." Presentation at the German Studies Association 40th Annual Conference, San Diego, Calif., September 29–October 2, 2016.

Baraka, Amiri. *It's Nation Time.* Detroit: Black Forum/Motown, 1972, vinyl LP.

Barker, Andrew. *Telegrams from the Soul: Peter Altenberg and the Culture of Fin-de-siècle Vienna.* Columbia, SC: Camden House, 1996.

Bassett, Caroline. "Twittering Machines: Antinoise and Other Tricks of the Ear." *differences: A Journal of Feminist Cultural Studies* 22, nos. 2/3 (2011): 276–99.

Bathrick, David, and Andreas Huyssen, eds. *Modernity and the Text: Revisions of German Modernism.* New York: Columbia University Press, 1989.

Bauer, Max. *Der grosse Krieg im Feld und Heimat: Erinnerungen und Betrachtungen.* Tübingen: Osiander'sche Buchhandlung, 1921.

Becker, Frank. "Augen-Blicke der Größe: Das Panorama als nationaler Erlebnisraum nach dem Krieg von 1870/71." In *Das 19. Jahrhundert als Mediengesellschaft*, edited by Jörg Requate, 178–91. Munich: Oldenbourg, 2009.

———. *Bilder von Krieg und Nation: Die Einigungskriege in der bürgerlichen Öffentlichkeit Deutschlands 1864–1913.* Munich: Oldenbourg Wissenschaftsverlag, 2001.

Bell, Alexander Graham. "Experiments Relating to Binaural Audition." *American Journal of Otology* 2, no. 3 (1880): 169–79.

Beller, Steven. *Vienna and the Jews, 1867–1938: A Cultural History.* Cambridge: Cambridge University Press, 1989.

Benjamin, Walter. "Das Kunstwerk im Zeitalter seiner technischen Reproduzierbarkeit: Erste Fassung." In *Gesammelte Schriften*, edited by Rolf Tiedermann and Hermann Schweppenhäuser, 431–69. Frankfurt am Main: Suhrkamp, 1974.

Works Cited

———. "Paris, die Hauptstadt des XIX. Jahrhunderts." 1935. In *Gesammelte Schriften 5*, book 1, *Das Passagen-Werk*, ed. Rolf Tiedermann, 45–59. Frankfurt am Main: Suhrkamp, 1991.

———. "Paris, the Capital of the Nineteenth Century." In *The Work of Art in the Age of Its Technological Reproducibility, and Other Writings on Media*, ed. Michael W. Jennings, Brigid Doherty, and Thomas Y. Levin, 96–115. Cambridge, Mass.: Harvard University Press, 2008.

———. "The Work of Art in the Age of Technological Reproducibility [First Version]." Translated by Michael W. Jennings. *Grey Room* 39 (Spring 2010): 11–37.

Bierbaum, Otto Julius. "Ein lyrischer Hauptmann." In *Liliencron*, edited by Otto Julius Bierbaum, 3–15. Munich: G. Müller, 1910.

Bierwirth, Maik. "Detlev von Liliencron und das Verlags- und Urheberrecht von 1901." In *Turns and Trends der Literaturwissenschaft: Literatur, Kultur und Wissenschaft zwischen Nachmärz und Jahrhundertwende im Blickfeld aktueller Theoriebildung*, edited by Christian Meierhofer and Eric Scheufler, 129–46. Zurich: Germanistik.ch, 2011.

Birdsall, Carolyn. *Nazi Soundscapes: Sound, Technology and Urban Space in Germany, 1933–1945*. Amsterdam: Amsterdam University Press, 2012.

Biro, Matthew. *The Dada Cyborg: Visions of the New Human in Weimar Berlin*. Minneapolis: University of Minnesota Press, 2009.

Bijsterveld, Karin. *Mechanical Sound: Technology, Culture, and Public Problems of Noise in the Twentieth Century*. Cambridge, Mass.: MIT Press, 2008.

Blackshaw, Gemma. "Peter Altenberg: Authoring Madness in Vienna circa 1900." In *Journeys into Madness: Mapping Mental Illness in the Austro-Hungarian Empire*, edited by Gemma Blackshaw and Sabine Wieber, 109–29. New York: Berghahn Books, 2012.

Blake, Clarence. "Über die Verwertung der Membrana tympani als Phonautograph und Logograph." *Archiv für Augen- und Ohrenheilkunde* 5 (1876): 434–39.

Bleibtreu, Karl. *Revolution der Lyrik*. Leipzig: W. Friedrich, 1886.

Blumenthal, Oskar. "Das Konzert der Strasse." *Neue Freie Presse*, February 7, 1907, 2.

Bochow, Martin. *Schallmesstrupp 51: Vom Krieg der Stoppuhren gegen Mörser und Haubitzen*. 2nd ed. Stuttgart: Union Deutsche Verlagsgesellschaft, 1933.

Bock, Thilo. "'Negermusik und koptische Heilige': Die Unmöglichkeit des Lachens bei Hugo Balls Dadaismus." In *Avantgarde und Komik*, edited by Ludger Scherer and Rolf Lohse, 97–115. Amsterdam: Rodopi, 2004.

Bohrer, Karl Heinz. *Die Ästhetik des Schreckens: Die pessemistische Romantik und Ernst Jüngers Frühwerk*. Munich: Hanser, 1978.

Bök, Christian. "When Cyborgs Versify." In *The Sound of Poetry / The Poetry of Sound*, edited by Marjorie Perloff and Craig Dworkin, 129–41. Chicago: University of Chicago Press, 2009.

Bosmajian, Haig A. *The Language of Oppression*. Washington, D.C.: Public Affairs Press, 1974.

Bourgoing, Jean de, ed. *Briefe Kaiser Franz Josephs an Frau Katharina Schratt*. Vienna: Ullstein, 1949.

Boutin, Aimée. *City of Noise: Sound and Nineteenth-Century Paris*. Urbana: University of Illinois Press, 2015.

Boyer, John W. *Culture and Political Crisis in Vienna: Christian Socialism in Power, 1897–1918*. Chicago: University of Chicago Press, 1995.

———. *Political Radicalism in Late Imperial Vienna: Origins of the Christian Social Movement, 1848–1897*. Chicago: University of Chicago Press, 1981.

Brain, Robert. *The Pulse of Modernism: Physiological Aesthetics in Fin-de-siècle Europe*. Seattle: University of Washington Press, 2015.

Brod, Max. *Streitbares Leben*. Munich: Kindler, 1960.

Brokoph-Mauch, Gudrun. *Robert Musils "Nachlass zu Lebzeiten."* New York: Peter Lang, 1985.

Brosthaus, Heribert. "Struktur und Entwicklung des 'anderen Zustands.'" *Deutsche Vierteljahrsschrift für Literaturwissenschaft und Geistesgeschichte* 39 (1965): 338–440.

Brown, Barclay. "The Noise Instruments of Luigi Russolo." *Perspectives of New Music* 20, nos. 1/2 (Autumn 1981–Summer 1982): 31–48.

Brunner, Gustav. "Zur Lehre von den subjectiven Ohrgeräuschen." *Zeitschrift für Ohrenheilkunde* 8 (1879): 185–207.

Buklijas, Tatjana. "Cultures of Death and Politics of Corpse Supply: Anatomy in Vienna, 1848–1914." *Bulletin of the History of Medicine* 82, no. 3 (Fall 2008): 570–607.

Bülow, Frieda von. *Tropenkoller: Episode aus dem deutschen Kolonialleben*. Berlin: F. Fontane, 1905.

Bunzel, Wolfgang. *Das deutschsprachige Prosagedicht: Theorie und Geschichte einer literarischen Gattung der Moderne*. Tübingen: Niemayer, 2005.

Bürger, Peter. *The Decline of Modernism*. Translated by Nicholas Walker. University Park: Penn State University Press, 1992.

Burke, Edmund. *A Philosophical Enquiry into the Origin of our Ideas of the Sublime and Beautiful*. 1757. Edited by Adam Phillips. Oxford: Oxford University Press, 1998.

Burke, Susan. *Becoming Modern: The Life of Mina Loy*. New York: Farrar, Straus and Giroux, 1996.

Burliuk, D., Alexander Kruchenykh, V. Mayakovsky, and Victor Khlebnikov. "Slap in the Face of Public Taste." 1912. In *Russian Futurism through Its Manifestoes, 1912–1928*, edited by Anna Lawton, 51–52. Ithaca, N.Y.: Cornell University Press, 1988.

Burmeister, Ralf, Michael Oberhofer, and Esther Tisa Francini, eds. *dada Africa: Dialogue with the Other*. Zurich: Scheidegger and Spiess, 2016.

Burns, Barbara, "The Influence of Ivan Turgenev's *Sportsman's Sketches* on the Stories of Detlev von Liliencron." *Orbis Litterarum* 56 (2001): 106–20.

Burroughs, William S., and Daniel Odier. *The Job: Interviews with William S. Burroughs*. London: Penguin Books, 1989.

Butler, Shane. *The Ancient Phonograph*. New York: Zone Books, 2005.

Campe, Rüdiger. "The 'Rauschen' of the Waves: On the Margins of Literature." *SubStance* 19, no. 1 (1990): 21–38.

Carl, Florian. *Was bedeutet uns Afrika? Zur Darstellung afrikanischer Musik im deutschsprachigen Diskurs des 19. und frühen 20. Jahrhunderts*. Muenster: LIT, 2004.

Cheng, William. *Just Vibrations: The Purpose of Sounding Good*. Ann Arbor: University of Michigan Press, 2016.

Chladni, Ernst Florens Friedrich. *Die Akustik*. Leipzig: Breitkopf und Härtel, 1802.

Chop, Max. "Feldgottesdienst nach der Schlacht vor Maubeuge." Recorded 1914. Archivnummer 2590065, X130, DRA Frankfurt am Main, mp3 audio.

Chop, Max. "Im Lager vor Paris." Recorded 1914. Archivnummer 2590065, X130, DRA Frankfurt am Main, mp3 audio.

Clarke, Joseph L., ed. "Acoustic Modernity." Special issue, *Grey Room* 60 (Summer 2015).

Cloonan, Martin, and Bruce Johnson. *Dark Side of the Tune: Popular Music and Violence*. Burlington, VT: Ashgate, 2008.

Cloonan, Martin, and Bruce Johnson. "Killing Me Softly with His Song: An Initial Investigation into the Use of Popular Music as a Tool of Oppression." *Popular Music* 21, no. 1 (January 2002): 27–39.

Coetzee, J. M. "Time, Tense and Aspect in Kafka's 'The Burrow.'" *MLN* 96, no. 3 (April 1981): 556–79.

Conrad, Sebastian. *German Colonialism: A Short History*. Cambridge: Cambridge University Press, 2012.

Cook, Nicholas. "Seeing Sounds, Hearing Images: Listening Outside the Modernist Box." In *Musical Listening in the Age of Technological Reproducibility*, edited by Gianmario Borio, 185–202. Farnham, UK: Ashgate, 2015.

Corino, Karl. *Robert Musil: Eine Biographie*. Reinbek bei Hamburg: Rowohlt, 2003.

Corrales, C. Eduardo, and Albert Mudry. "History of the Endolymphatic Sac: From Anatomy to Surgery." *Otology & Neurotology* 38, no. 1 (January 2017): 152–56.

Corngold, Stanley. *Franz Kafka: The Necessity of Form*. Ithaca, N.Y.: Cornell University Press, 1988.

Cotugno. *De aquaeductibus auris humanae internae*. Neapoli: Simoniana, 1761.

Cowan, Michael. "Imagining Modernity through the Ear: Rilke's *Aufzeichnungen des Malte Laurids Brigge* and the Noise of Modern Life." *Arcadia* 41, no. 1 (2006): 124–46.

Crary, Jonathan. "Dr. Mabuse and Mr. Edison." In *Art and Film since 1945: Hall of Mirrors*, edited by Russell Ferguson (New York: Monacelli Press, 1996), 262–79.

———. *Techniques of the Observer: On Vision and Modernity in the Nineteenth Century*. Cambridge, Mass.: MIT Press, 1990.

Crook, Tim. "Vocalizing the Angels of Mons: Audio Dramas as Propaganda in the Great War of 1914 to 1918." *Societies* 4 (2014): 180–221.

Curtin, Adrian. "Vibration, Percussion and Primitivism in Avant-Garde Performance." In *Vibratory Modernism*, edited by Anthony Enns and Shelley Trower, 227–47. Basingstoke: Palgrave Macmillan, 2013.

"Der Phonograph bei Feldmarschall Moltke." *Schlesische Zeitung*, October 22, 1889, 2.

Derrida, Jacques. *Paper Machine*. Translated by Rachel Bowlby. Stanford, Calif.: Stanford University Press, 2005.

———. *Speech and Phenomena and Other Essays on Husserl's Theory of Signs*. Translated by David B. Allison. Evanston, Ill.: Northwestern University Press, 1973.

———. "Tympan." In *Margins of Philosophy*, translated by Alan Bass, ix–xxix. Chicago: University of Chicago Press, 1982.

Detlev von Liliencron (1844–1909): Facetten eines bewegten Dichterlebens: Ausstellung 21. Juni—28. August 2009. Kiel: Schleswig-Holsteinische Landes-bibliothek, 2009.

Dickerman, Leah. "Dada Gambits." *October* 105 (Summer 2003): 3–12.

"Die Beschießung von Paris (Dezember 1870)." Recorded 1890. Archivnummer 2612004, X130, DRA Frankfurt am Main, mp3 audio.

"Die Erstürmung einer russischen Stellung." Recorded 1915. Archivnummer 2832507, X130, DRA Frankfurt am Main, mp3 audio.

"Die Erstürmung von Lüttich (August 7, 1914)." Recorded ca. 1917. Archivnummer 2570043, X130, DRA Frankfurt am Main, mp3 audio.

"Die Mobilmachung am 1. August 1914." Recorded ca. 1915. Archivnummer 2570043, X130, DRA Frankfurt am Main, mp3 audio.

"Die Schlacht bei Sedan." Recorded 1905. Archivnummer 2763459, X130, DRA Frankfurt am Main, mp3 audio.

Diller, Ansgar. "Die Weihnachtsringsendung 1942: Der Produktionsfahrplan der RRG." *Rundfunk und Geschichte* 29, nos. 1/2 (2003): 47–51.

Dolar, Mladen. "The Burrow of Sound." *differences: A Journal of Feminist Cultural Studies* 22, nos. 2/3 (2011): 112–39.

Dolmetsch, Carl. *Our Famous Guest: Mark Twain in Vienna.* Athens: University of Georgia Press, 1992.

Du Moncel, Comte Th. *The Telephone, the Microphone, and the Phonograph.* London: C. Kegan Paul, 1879.

Dunker, Axel. "'und brüllzten wesentlich': Laut und Geräusch bei Dada und in der Neo- Avantgarde Ernst Jandls." In *Phono-Graphien: Akustische Wahrnehmung in der detuschsprachigen Literatur von 1800 bis zur Gegenwart*, edited by Marcel Krings, 209–18. Würzburg: Königshausen & Neumann, 2011.

Eckert-Möbius, A. "Mikroskopische Untersuchungstechnik und Histologie des Gehörorgans." In *Handbuch der Hals- Nasen- Ohrenheilkunde*, vol. 6, edited by A. Denker and O. Kahler, 211–359. Berlin: Julius Springer, 1926.

Edschmid, Kasimir, ed. *Briefe der Expressionisten.* Frankfurt am Main: Ullstein, 1964.

Edwards, Paul N. *The Closed World: Computers and the Politics of Discourse in Cold War America.* Cambridge, Mass.: MIT Press, 1996.

"Eine Szene aus der Schlacht bei Sedan am 1. September 1870." Recorded in 1890. Archivnummer 2612004, X130, DRA Frankfurt am Main, mp3 audio.

Encke, Julia. *Augenblicke der Gefahr: Der Krieg und die Sinne (1914–1934).* Munich: Fink, 2006.

Engel, Manfred. "Wildes Zürich: Dadaistischer Primitivismus und Richard Huelsenbecks Gedicht *Ebene*." In *Poetik des Wilden*, edited by Jörg Robert and Friederike Felicitas Günther, 393–419. Würzburg: Königshausen and Neumann, 2012.

Enns, Anthony. "The Human Telephone: Physiology, Neurology, and Sound Technologies." In *Sounds of Modern History: Auditory Cultures in 19th- and 20th-Century Europe*, edited by Daniel Morat, 46–68. Oxford: Berghahn, 2014.

Works Cited

Epping-Jäger, Cornelia. "Stimmgewalt: Die NSDAP als Rednerpartei." In *Stimme: Annäherung an ein Phänomen*, edited by Doris von Kolesch and Sybille Krämer, 147–71. Frankfurt am Main: Suhrkamp, 2006.

Erlmann, Veit. *Reason and Resonance: A History of Modern Aurality*. New York: Zone Books, 2010.

Eshun, Kodawo. *More Brilliant Than the Sun*. London: Quartet, 1998.

Ewald, J. Rich. "Zur Physiologie des Labyrinths." *Archiv für die Gesamte Physiologie* 76 (1899): 147–88.

Eybl, Martin, ed. *Die Befreiung des Augenblicks: Schönbergs Skandalkonzerte 1907 und 1908: Eine Dokumentation*. Vienna: Böhlau, 2004.

Fendrich, Anton. "Die Schlacht in der Champagne." In *Der Krieg: Illustrierte Chronik des Krieges 1914/15*, vol. 3, 538–44. Stuttgart: Frankh'sche Verlagshandlung, 1915.

Ferenczi, Sandor. *Hysterie und Pathoneurosen*. Leipzig: Internationaler Psychoanalytischer Verlag, 1919.

Fetz, Bernhard. "'ihre stimme klingt manchmal als wären es sie'—Zur Vielstimmigkeit der Wiener Gruppe." In *verschiedene sätze treten auf: Die Wiener Gruppe in Aktion*, edited by Thomas Eder and Juliane Vogel, 119–32. Vienna: Paul Zsolnay Verlag, 2008.

Frevert, Ute. *Die kasernierte Nation: Militärdienst und Zivilgesellschaft in Deutschland*. Munich: Beck, 2001.

Frevert, Ute, ed. *Militär und Gesellschaft im 19. und 20. Jahrhundert*. Stuttgart: Klett-Cotta, 1997.

Föcking, Marc. "Drei Verbindungen: Lyrik, Telefon, Telegrafie 1900–1913 (Liliencron, Altenberg, Apollinaire)." In *Die schönen und die nützlichen Künste*, edited by Knut Hickethier, 167–80. Munich: Fink, 2007.

Ford, Simon. *The Wreckers of Civilization: The Story of Coum Transmissions and Throbbing Gristle*. London: Black Dog, 2001.

Fore, Devin. *Realism after Modernism: The Rehumanization of Art and Literature*. Cambridge, Mass.: MIT Press, 2015.

Forrer, Thomas. "Phonograph, Symbolic: Acoustic Evidence in Arno Holz' *Phantasus*." *Journal of Sonic Studies* 13 (December 2016), https://www.researchcatalogue.net/view/322719/322720/0/0.

Fosbery, G. V. "The Phonograph and Its Application to Military Purposes." *Journal of the Royal United Services Institution* 37, no. 187 (1893): 989–99.

Friedell, Egon. *Ecce Poeta*. Berlin: S. Fischer, 1912.

Fuchs, Eduard. *Illustrierte Sittengeschichte vom Mittelalter bis zur Gegenwart*. Vol. 2. Munich: Albert Langen, 1910.

Fuld, Werner. "Die Quellen zur Konzeption des 'anderen Zustands.'" *Deutsche Vierteljahrsschrift* 50 (1976): 664–82.

Füllner, Karin. *Dada Berlin in Zeitungen: Gedächtnisfeiern und Skandale*. Siegen: Forschungsschwerpunkt Massenmedien und Kommunikation an der Universität-Gesamthochschule-Siegen, 1986.

———. "Richard Huelsenbeck: 'Bang! Bang! Bangbangbang,' the Dada Drummer in Zurich." Translated by Barbara Allen. In *Dada Zurich: A Clown's Game from Nothing*, edited by Brigitte Pichon and Karl Riha, 89–103. New York: G. K. Hall, 1996.

Galili, Doron. "Postmediales Wissen um 1900: Zur Medienarchäologie des Fernsehens." *Montage A/V* 25, no. 2 (2016): 181–200.

Gammel, Irene, and Suzanne Zelazo. "'Harpsichords Metallic Howl—': The Baroness Elsa von Freytag-Loringhoven's Sound Poetry." *Modernism/Modernity* 18, no. 2 (April 2011): 255–71.

Gawande, Atul. "Hellhole." *New Yorker,* March 30, 2009, https://www.newyorker.com/magazine/2009/03/30/hellhole.

Gehrke, Martha Maria. "Das Ende der privaten Sphäre." In *Radio-Kultur in der Weimarer Republik*, edited by Irmela Schneider, 136–38. Tübingen: Gunter Narr, 1984.

Gerber, Dr. "Lärm in Kurorten." *Das Recht auf Stille* 1, no. 10 (September 1909): 1771–80.

Gess, Nicola, Florian Schreiner, and Manuela K. Schulz, eds. *Hörstürze: Akustik und Gewalt im 20. Jahrhundert*. Würzburg: Königshausen and Neumann, 2015.

Gitelman, Lisa. *Scripts, Grooves, and Writing Machines: Representing Technology in the Edison Era*. Stanford, Calif.: Stanford University Press, 1999.

Goebbels, Joseph. *Adolf Hitler: Bilder aus dem Leben des Führers*. Hamburg: Cigaretten/Bilderdienst Hamburg/Bahrenfeld, 1936.

———. *Signale der neuen Zeit: 25 ausgewählte Reden*. 1934. Munich: Zentralverlag der NSDAP, Franz Eher Nachfolger, 1940.

Goodman, Steve. *Sonic Warfare: Sound, Affect, and the Ecology of Fear*. Cambridge, Mass.: MIT Press, 2010.

Goodyear, John. "Escaping the Urban Din: A Comparative Study of Theodor Lessing's *Antilärmverein* (1908) and Maximilian Negwer's *Ohropax* (1908)." In *Germany in the Loud Twentieth Century: An Introduction*, edited by Florence Feiereisen and Alexandra Merley Hill, 19–35. Oxford: Oxford University Press, 2012.

Göttsche, Dirk. "'Geschichte, die kleine sind': Minimalisierung und Funktionalisierung des Erzählens in der Kleinen Prosa um 1900." In *Kafka und die kleine Prosa der Moderne*, edited by Manfred Engel and Ritchie Robertson, 17–33. Würzburg: Königshausen & Neumann, 2010.

Greinz, Hugo. *Detlev von Liliencron: Eine literaturhistorische Würdigung*. Berlin: Schuster & Loeffler, 1896.

Grey, Thomas S. "*Eine Kapitulation*: Aristophanic Operetta as Cultural Warfare in 1870." In *Richard Wagner and His World*, ed. Thomas S. Grey, 87–122. Princeton, N.J.: Princeton University Press, 2009.

Griese, Volker. *Detlev von Liliencron: Chronik eines Dichterlebens*. Muenster: Monsenstein und Vannerdat, 2009.

Griffin, Donald R. *Listening in the Dark: The Acoustic Orientation of Bats and Men*. New Haven, Conn.: Yale University Press, 1958.

Gumbrecht, Hans Ulrich. "A Farewell to Interpretation." In *Materialities of Communication*, edited by Hans Ulrich Gumbrecht and K. Ludwig Pfeiffer, translated by William Whobrey, 389–402. Stanford, Calif.: Stanford University Press, 1994.

———. "Modern—Modernität—Moderne: Ein irritierender Begriff." In *Geschichtliche Grundbegriffe*, edited by Otto Brunner, 93–131. Stuttgart: Klett Cotta, 1978.

Works Cited

Hadamovsky, Eugen. *Propaganda und nationale Macht*. Oldenburg: Gerhard Stalling, 1933.

Hamilton, John T. *Music, Madness, and the Undoing of Language*. New York: Columbia University Press, 2008.

Hanstein, Adalbert von. *Das jüngste Deutschland: Zwei Jahrzehnte miterlebter Literaturgeschichte*. Leipzig: R. Voigtländer, 1900.

Häntzschel, Günter. "Geschlechterdifferenz und Dichtung: Lyrikvermittlung im ausgehenden 19. Jahrhundert." In *Hansers Sozialgeschichte der deutschen Literatur vom 16. Jahrhundert bis zur Gegenwart. Band 7. Naturalismus, Fin de siècle, Expressionismus 1890–1918*, edited by York-Gothart Mix, 53–63. Munich: Carl Hanser, 2000.

Hanusch, Ferdinand. *Aus meinen Wanderjahren: Erinnerungen eines Walzbruders*. Reichenberg: Selbstverlage des 'Textilarbeiter,' 1904.

Hart, Heinrich. "Wir Westfalen." In *Gesammelte Werke* 3, edited by Julius Hart and Wilhelm Bölsche, 11–96. Berlin: E. Fleischel, 1907.

Hartewig, Karin. "Klack, klack, klack: Der erotische Klang der Stöckelschuhe." In *Sound der Zeit: Geräusche, Töne, Stimmen, 1889 bis heute*, edited by Gerhard Paul and Ralph Schock, 405–9. Göttingen: Wallstein, 2014.

Haupt, Albrecht. "Schloss Wiligrad in Mecklenburg." *Zeitschrift für Architektur und Ingenieurwesen* 49, no. 1 (1903): 1–12.

Hauser, Susanne. *Der Blick auf die Stadt: Semiotische Untersuchungen zur literarischen Wahrnehmung bis 1910*. Berlin: Reimer, 1990.

Hayles, N. Katherine. *How We Became Posthuman: Virtual Bodies in Cybernetics, Literature, and Informatics*. Chicago: University of Chicago Press, 1999.

———. *Writing Machines*. Cambridge, Mass.: MIT Press, 2002.

Heller, Reinhold. "Blaue Reiter." In *Encyclopedia of German Literature*, vol. 1, edited by Matthias Konzett, 118–20. Chicago: Fitzroy Dearborn, 2000.

Henderson, Linda Dalrymple. "Vibratory Modernism: Boccioni, Kupka, and the Ether of Space." In *From Energy to Information: Representation in Science and Technology, Art, and Literature*, edited by Bruce Clarke and Linda Dalrymple Henderson, 126–49. Stanford, Calif.: Stanford University Press, 2002.

Herder, Johann Gottfried. *Abhandlung über den Ursprung der Sprache*. 1772. Edited by Dr. Theodor Matthias. Leipzig: Brandstetter, 1901.

———. "Viertes Wäldchen." In *Sämmtliche Werke* 4, edited by Bernhard Suphan, 3–198. Berlin: Weidmannsche Buchhandlung, 1878.

Hiebler, Heinz. "Weltbild 'Hörbild': Zur Formengeschichte des phonographischen Gedächtnisses zwischen 1877 and 1929." In *Die Medien und ihre Technik: Theorien—Modelle—Geschichte*, edited by Harro Segeberg, 166–82. Marburg: Schüren, 2004.

Hitler, Adolf. "Vor dem Volksgericht, Vierundzwanzigster Verhandlungstag." In *Sämtliche Aufzeichnungen, 1905–1924*, edited by Eberhard Jäckel and Axel Kuhn, 1197–215. Stuttgart: Veröffentlichungen des Instituts für Zeitgeschichte, 1980.

Hoffmann, Christoph. *"Der Dichter am Apparat": Medientechnik, Experimentalpsychologie und Texte Robert Musils 1899–1942*. Munich: Fink, 1997.

———. "Wissenschaft und Militär: Das Berliner Psychologische Institut und der I. Weltkrieg." *Psychologie und Geschichte* 5, nos. 3/4 (April 1994): 261–85.

Höfler, Günther A. "Das neue Paradigma des Krieges und seine literarischen Repräsentationen. Dargestellt an Detlev v. Liliencron, Ernst Jünger und Thor Goote." In *Intimate Enemies: English and German Literary Reactions to the Great War 1914–1918*, edited by Franz Karl Stanzel and Martin Löschnigg, 277–91. Heidelberg: Universitätsverlag C. Winter, 1993.

Holz, Arno. *Das Buch der Zeit*. In *Werke 5*, edited by Wilhelm Emrich and Anita Holz. Neuwied am Rhein: Luchterhand, 1961–64.

———. "Selbstanzeigen: Phantasus." *Die Zukunft* 23 (1898): 217.

Hordzewitz, Else. *Liliencrons ungedruckte Kriegstagebücher und ihre Bedeutung für seine Kriegsdichtung*. Würzburg: Konrad Triltsch, 1938.

Hornbostel, Erich Moritz von. "African Negro Music." *Africa: Journal of the International African Institute* 1, no. 1 (January 1928): 30–62.

———. "Beobachtungen über ein- und zweiohriges Hören." *Psychologische Forschung* 4 (1923): 64–114.

———. "Das räumliche Hören." In *Handbuch der normalen und pathologischen Physiologie*, edited by G. v. Bergmann, A. Bethe, G. Embden, A. Ellinger, 602–18. Berlin: Springer, 1926.

———. "Physiologische Akustik." *Berichte über die gesamte Physiologie und experimentelle Pharmakologie* 3, no. 1 (1922): 372–96.

Hornbostel, Erich Moritz von, and Max Wertheimer. "Über die Wahrnehmung der Schallrichtung." In *Sitzungsberichte der Preussischen Akademie der Wissenschafte*, 388–96. N.p.: Preussische Akademie der Wissenschaften, 1920.

Horowitz, Seth S. *The Universal Sense: How Hearing Shapes the Mind*. New York: Bloomsbury, 2012.

Horst, Max. "Abschied von Regiment." Recorded in Berlin, ca. 1910. Archivnummer 4607987, A0163 Edison, DRA Frankfurt am Main, mp3 audio.

Huelsenbeck, Richard. *Afrika in Sicht: Ein Reisebericht über fremde Länder und abenteuerliche Menschen*. Dresden: W. Jess, 1928.

———. "Dada als Literatur" (1958). In *Dada-Logik, 1913–1972*, edited by Herbert Kapfer, 371–73. Munich: Belleville, 2012.

———. *Dada siegt: Eine Bilanz des Dadaismus*. Berlin: Malik Verlag, 1920.

———. *Deutschland muss untergehen! Erinnerungen eines alten dadaistischen Revolutionärs*. Berlin: Malik, 1920.

———. "Ein Besuch im Cabaret Dada." *Der Dada* 3 (April 1920): 6–8.

———. *En avant Dada: Eine Geschichte des Dadaismus*. Leipzig: Paul Steegemann Verlag Hannover, 1920.

———. "Erklärung." In *Dada-Almanach: Vom Aberwitz ästhetischer Contradiction— Textbilder, Lautgedichte, Manifeste*, edited by Andreas Trojan and H. M. Compagnon, 127. Zurich: Manesse, 2016.

———. "Erste Dadarede in Deutschland." 1918. In *Dada Almanach*, edited by Richard Huelsenbeck, 104–8. Paris: Éditions Champ Libre, 1980.

———. "Letzte Nächte." *Die Aktion* (September 1915): 494–95

———. *Phantastische Gebete*. Berlin: Der Malik-Verlag, 1920.

———. *Verwandlungen*. Munich: Roland-Verlag Dr. Albert Mundt, 1918.

Huelsenbeck, Richard, Marcel Janko, and Tristan Tzara. "L'amiral cherche une maison a louer." 1916. In *Manifesto: A Century of Isms*, edited by Mary Ann Caws, 294–95. Lincoln: University of Nebraska Press, 2001.

Hull, Isabel V. *Absolute Destruction: Military Culture and Practices of War in Imperial Germany*. Ithaca, N.Y.: Cornell University Press, 2013.

Hüppauf, Bernd-Rüdiger. *Von sozialer Utopie zur Mystik: Zu Robert Musils Der Mann ohne Eigenschaften*. Munich: Wilhelm Fink, 1971.

Huysmans, J. K. *À rebours*. Translated by John Howard. Hales Corners, Wis.: Voasha Publishing, 2008.

Huyssen, Andreas. "Fortifying the Heart Totally: Ernst Jünger's Armored Texts." *New German Critique* 59 (Spring/Summer 1993): 3–23.

———. *Miniature Metropolis: Literature in an Age of Photography and Film*. Cambridge, Mass.: Harvard University Press, 2015.

"Im Lazarett." Recorded 1914. Archivnummer 2842528, X130, DRA Frankfurt am Main, mp3 audio.

Innerhofer, Roland. "Stimm-Bruch: Akustische Inszenierungen der Wiener Gruppe." In *verschiedene sätze treten auf: Die Wiener Gruppe in Aktion*, edited by Thomas Eder and Juliane Vogel, 99–118. Vienna: Paul Zsolnay Verlag, 2008.

Jandl, Ernst, and Friederike Mayröcker. *Fünf Mann Menschen: Hörspiel*. Recorded in 1968, directed by Peter Michel Ladiges. In *Neues Hörspiel: Texte Partituren*, edited by Klaus Schöning. Frankfurt am Main: Suhrkamp, 1969, vinyl 7".

"Janitscharen-Musik." In *Musikalisches Conversations-Lexikon: Eine Encyklopädie der gesammten musikalischen Wissenschaften* 5, edited by Hermann Mendel, 361–63. Berlin: Robert Oppenheim, 1875.

Janouch, Gustav. *Conversations with Kafka*. Translated by Goronwy Rees. New York: New Directions, 2012.

Jelavich, Peter. *Berlin Cabaret*. Cambridge, Mass.: Harvard University Press, 1993.

Johnson, Edward H.. "A Wonderful Invention—Speech Capable of Indefinite Repetition from Automatic Records." *Scientific American*, November 17, 1877, 304.

Jonsson, Stefan. *Subject without Nation: Robert Musil and the History of Modern Identity*. Durham: Duke University Press, 2000.

Joppig, Gunther. "*Alla Turca*: Orientalismen in der europäischen Kunstmusik vom 17. bis zum 19. Jahrhundert." In *Europe und der Orient 800–1900*, edited by Gereon Sievernich and Hendrik Budde, 295–304. Gütersloh: Bertelsmann Lexikon Verlag, 1989.

Jünger, Ernst. *Das Abenteuerliche Herz: Erste Fassung: Aufzeichnungen bei Tag und Nacht*. 1929. Stuttgart: Klett-Cotta, 2004.

———. *Der Kampf als inneres Erlebnis*. Berlin: E. S. Mittler & Sohn, 1922.

Kafka, Franz. *Amtliche Schriften*. Edited by Klaus Hermsdorf. Berlin: Akademie-Verlag, 1984.

———. *Briefe, 1902–1924*. Edited by Max Brod. New York: Schocken Books, 1958.

———. *Briefe an Felice und andere Korrespondenz aus der Verlobungszeit*. Edited by Erich Heller and Jürgen Born. Frankfurt am Main: Fischer Taschenbuch Verlag, 2003.

———. *Briefe an Milena*. Edited by Jürgen Born and Michael Müller. Frankfurt am Main: Fischer, 2006.

———. *Der Proceß*. Frankfurt am Main: S. Fischer, 2007.

———. *Die Erzählungen und andere ausgewählte Prosa*. Edited by Roger Hermes. Frankfurt am Main: Fischer, 2006.

———. "Grosser Lärm." In *Herder-Blätter: Faksimile-Ausgabe zum 70. Geburtstag von Willy Haas*, edited by Rolf Italiaander, 42. Hamburg: Freie Akademie der Künste, 1962.

———. *Tagebücher, 1909–1912*. Edited by Hans-Gerd Koch. Frankfurt am Main: Fischer Taschenbuch Verlag, 2008.

———. *Tagebücher 1912–1914*. Edited by Hans-Gerd Koch. Frankfurt am Main: Fischer Taschenbuch Verlag, 2008.

———. *Tagebücher, 1914–1923*. Edited by Hans-Gerd Koch. Frankfurt am Main: Fischer Taschenbuch Verlag, 1990.

Kahn, Douglas. *Noise, Water, Meat: A History of Sound in the Arts*. Cambridge, Mass.: MIT Press, 2001.

Kandinsky, Wassily. *Klänge*. Munich: R. Piper, 1913.

———. "Über Bühnenkomposition." 1912. In *Der Blaue Reiter*, edited by Wassily Kandinsky and Franz Marc, 103–13. Munich: R. Piper, 1914.

Kane, Brian. "Sound Studies without Auditory Culture: A Critique of the Ontological Turn." *Sound Studies* 1, no. 1 (2015): 2–21.

———. *Sound Unseen: Acousmatic Sound in Theory and Practice*. Oxford: Oxford University Press, 2014.

Kapeller, Ludwig. "Der stereophonische Rundfunk." *Funk*, no. 27 (1925): 317–19.

Kaufmann, Christian. "Dada Reads Ethnological Sources: From Knowledge of Foreign Art Worlds to Poetic Understanding." In *dada Africa: Dialogue with the Other*, edited by Ralf Burmeister, Michael Oberhofer, and Esther Tisa Francini, 96–103. Zurich: Scheidegger & Spiess, 2016.

Kaufmann, David. "Der Phonograph und die Blinden." *Neue Freie Presse*, December 27, 1889, 4.

Kelly, Alan. *His Master's Voice: The German Catalogue: A Complete Numerical Catalogue of German Gramophone Recordings Made from 1898 to 1929 in Germany, Austria, and Elsewhere by the Gramophone Company Ltd*. Westport, Conn.: Greenwood Press, 1994.

Kelly, Alfred. "War and Unification in Germany History Schoolbooks." In *1870/71–1989/90: German Unifications and the Change of Literary Discourse*, edited by Walter Pape, 37–60. New York: Walter de Gruyter, 1993.

Kennaway, James. *Bad Vibrations: The History of the Idea of Music as a Cause of Disease*. New York: Routledge, 2012.

Kerr, Alfred. "Fluch der bösen Tat." (1901). In *Gesammelte Schriften* 4, 336–38. Berlin: S. Fischer, 1917.

Kimmich, Dorothee, and Tobias Wilke. *Einführung in die Literatur der Jahrhundertwende*. Darmstadt: WBG Wissenschaftliche Buchgesellschaft, 2006.

Kirschenbaum, Matthew. *Track Changes: A Literary History of Word Processing*. Cambridge, Mass.: Harvard University Press, 2016.

Kittler, Friedrich A. *Discourse Networks,1800–1900*. 1985. Translated by Michael Metteer and Chris Cullens. Stanford, Calif.: Stanford University Press, 1989.

———. *Gramophone, Film, Typewriter*. 1986. Translated by Geoffrey Winthrop-Young and Michael Wutz. Stanford, Calif.: Stanford University Press, 1999.

Works Cited

———. "Im Telegrammstil." In *Stil: Geschichten und Funktionen eines kulturwissenschaftlichen Diskurselements*, edited by Hans Ulrich Gumbrecht und K. Ludwig Pfeiffer, 358–70. Frankfurt am Main: Suhrkamp, 1986.

———. "Literatur und Literaturwissenschaft als Word Processing." In *Germanistik Forschungsstand und Perspektiven*, edited by Georg Stötzel, 410–19. Berlin: Walter de Gruyter, 1985.

———. "Rock Musik—ein Missbrauch von Heeresgerät." In *Medien und Maschinen: Literatur im technischen Zeitalter*, edited by Theo Elm and Hans H. Hiebel, 245–57. Freiburg: Rombach Druck- und Verlagshaus, 1991.

———. "Signal-Rausch-Abstand." In *Materialität der Kommunikation*, edited by Ulrich Gumbrecht and K. Ludwig Pfeiffer, 342–59. Frankfurt am Main: Suhrkamp, 1988.

———. *The Truth of the Technological World: Essays on the Genealogy of Presence*. Translated by Erik Butler. Stanford, Calif.: Stanford University Press, 2014.

———. "Unpublished Preface to *Discourse Networks*." 1983/87. Translated by Geoffrey Winthrop-Young. *Grey Room* 63 (Spring 2016): 91–107.

Kittler, Friedrich, and Thomas Macho, eds. *Zwischen Rauschen und Offenbarung: Zur Kultur- und Mediengeschichte der Stimme*. Berlin: Akademie Verlag, 2002.

Kittler, Wolf. "Grabenkrieg—Nervenkrieg—Medienkrieg: Franz Kafka und der 1. Weltkrieg." In *Armaturen der Sinne: Literarische und technische Medien 1870 bis 1920*, edited by Jochen Hörisch and Michael Wetzel, 289–309. Munich: Fink, 1990.

Klee, E. "Das jüngste Wunder der Neuzeit." *Wissenschaftliche Beilage der Leipziger Zeitung*, no. 32 (April 21, 1878): 189–90.

Kleinschmidt, Hans J. "The New Man—Armed with the Weapons of Doubt and Defiance: Introduction." In Huelsenbeck, *Memoirs of a Dada Drummer*, edited by Hans J. Kleinschmidt, translated by Joachim Neugroschel, xiii–1. New York: Viking Press, 1969.

Klotz, Sebastian, ed. *"Vom tönenden Wirbel menschlichen Tuns": Erich M. von Hornbostel als Gestaltpsychologe, Archivar und Musikwissenschaftler: Studien und Dokumente*. Berlin: Schibri-Verlag, 1998.

Klötzel, C. Z. "Radio." *Prager Tagblatt*, February 7, 1924, 4.

Koch, Gertrud. "Bela Balazs: The Physiognomy of Things." Translated by Miriam Hansen. *New German Critique* 40 (Winter 1987): 167–77.

Koch, Hans-Gerd, and Klaus Wagenbach, eds. *Kafkas Fabriken*. Marbach am Neckar: Deutsche Schillergesellschaft, 2002.

Köhn, Eckhardt. *Strassenrausch: Flanerie und kleine Form: Versuch zur Literaturgeschichte des Flaneurs bis 1933*. Berlin: Das Arsenal, 1989.

Kostelanetz, Richard. *Conversing with Cage*. New York: Routledge, 2003.

Kotter, Simon. *Die k. (u.) k. Militärmusik: Bindeglied zwischen Armee und Gesllschaft?* Augsburg: Universitätsbibliothek, 2015.

Kotz, Liz. *Words to Be Looked At: Language in 1960s Art*. Cambridge, Mass.: MIT Press, 2007.

Kracauer, Siegfried. *Strassen in Berlin und anderswo*. Berlin: Das Arsenal, 1987.

Krämer, Sybille. "Die 'Rehabilitierung der Stimme': Über die Oralität hinaus." In *Stimme: Annäherung an ein Phänomen*, edited by Doris Kolesch and Sybille Krämer, 269–95. Frankfurt am Main: Suhrkamp, 2006.

Kudszus, W. G. "Translating Transition: Dada, Fort/Da, Grimm's Da." *Interdisciplinary Journal for Germanic Linguistics and Semiotic Analysis* 12, no. 1 (Spring 2007): 59–67.

Kuenzli, Rudolf E. "The Semiotics of Dada Poetry." In *Dada Spectrum: The Dialectics of Revolt*, edited by Stephen C. Foster and Rudolf E. Kuenzli, 51–70. Madison: Coda Press, 1979.

Kurz, Gerhard. "Das Rauschen der Stille: Annäherungen an Kafkas 'Der Bau.' " In *Zur Ethischen und ästhetischen Rechtfertigung*, edited by Beatrice Sandberg and Jakob Lothe, 152–74. Freiburg: Rombach, 2002.

Labott, Elise, Patrick Oppmann, and Laura Koran. "US Embassy Employees in Cuba Possibly Subject to 'Acoustic Attack.' " *CNN*, August 10, 2017, http://www.cnn.com/2017/08/09/politics/us-cuba-acoustic-attack-embassy/index.html.

Lafferty, William Charles, Jr. "The Early Development of Magnetic Sound Recording in Broadcasting and Motion Pictures, 1928–1950." PhD diss., Northwestern University, 1981.

Lamprecht, Karl. *Zur jüngsten deutschen Vergangenheit, 1. Band, Deutsche Geschichte, Erster Ergänzungsband*. Berlin: R. Gaertners Verlagsbuchhandlung, 1902.

Lasky, Marvin. "Review of Undersea Acoustics to 1950." *Journal of the Acoustical Society of America* 61, no. 2 (February 1, 1977): 283–97.

Latham, Clara. "Listening to the Talking Cure: *Sprechstimme*, Hypnosis, and the Sonic Organization of Affect." In *Sound, Music, Affect: Theorizing Sonic Experience*, edited by Maria Thompson and Ian Biddle, 101–16. London: Bloomsbury, 2013.

Latham, Sean, and Gayle Rogers. *Modernism: Evolution of an Idea*. New York: Bloomsbury, 2015.

Lauter Ruhe: 100 Jahre Ohropax: 100 Jahre Luxus für die Ohren. Wehrheim: Ohropax GmbH, 2007.

Lemmermann, Heinz. *Kriegserziehung im Kaiserreich*. Lilienthal: Eres, 1984.

Leonhard, Rudolf. "Die Situation des Hörspiels." 1928. In *Radio-Kultur in der Weimarer Republik*, edited by Irmela Schneider. Tübingen: Gunter Narr Verlag, 1984.

Lessing, Theodor. *Der Lärm: Eine Kampschrift gegen die Geräusche unseres Lebens. Grenzfragen des Nerven- und Seelenlebens* 54. Wiesbaden: Verlag von J. F. Bergmann, 1908.

———. "Der Verein gegen Lärm." *Die Zukunft* 51 (September 1908): 427–42.

———. "Die Lärmschutzbewegung." *Dokumente des Fortschritts* 1 (1908): 954–61.

———. "Ruhe-Hotels: Ein neuer Vorstoß des Antilärmvereins." *Das Recht auf Stille* 1, no. 9 (July 1909): 157–58.

———. "Über den Lärm." *Nord und Süd* 97 (1901): 71–84.

Lessing, Theodor, ed. *Der Lärmschutz* 6, no. 53 (February 1914).

Liliencron, Detlev von. *Adjutantenritte und andere Gedichte*. Leipzig: Wilhelm Friedrich, 1883.

———. "An Hugo Wolf." Recorded in 1906, vocalist Marcel Salzer. Archivnummer 2874478, X130, DRA Frankfurt am Main, mp3 audio.

———. *Ausgewählte Briefe*, vol. 2. Berlin: Schuster & Loeffler, 1910.

Works Cited

———. *Ausgewählte Gedichte.* 9th ed. Berlin: Schuster & Loeffler, 1905.

———. *Briefe in neuer Auswahl,* edited by Heinrich Spiero. Stuttgart: Deutsche Verlags- Anstalt, 1927.

———. Review of *Das Buch der Zeit* by Arno Holz. *Das Magazin für die Literatur des In- und Auslandes: Organ des Allgemeinen Deutschen Schriftsteller-Verbandes* 54, no. 31 (August 1, 1885): 483–84.

———. *Detlev von Liliencrons Briefe an Hermann Friedrichs aus den Jahren 1885–1889.* Berlin: Corcordia Verlags-Anstalt, 1910.

———. "Die Macht der Musik." *Nord und Süd* 127, no. 379 (October 1908): 479.

———. "Der Richtungspunkt." In *Krieg und Frieden: Novellen.* Leipzig: W. Friedrich, 1891.

———. *Gute Nacht: Hinterlassene Gedichte.* Berlin: Schuster & Loeffler, 1909.

———. *Kriegsnovellen.* Berlin: Schuster & Loeffler, 1896.

———. *Liliencrons Gedichte: Auswahl für die Jugend: Zusammengestellt von der Lehrervereinigung zur Pflege der künstlerischen Bildung in Hamburg.* Berlin: Schuster & Loeffler, 1901.

———. "Portepeefähnrich Schadius." In *Unter flatternden Fahnen: Militärische und andere Erzählungen.* Leipzig: W. Friedrich, 1888.

Lucae, August. *Zur Entstehung und Behandlung der subjectiven Gehörsempfindungen.* Berlin: Otto Enslin, 1884.

Lunn, Eugene. *Marxism and Modernism: An Historical Study of Lukács, Brecht, Benjamin and Adorno.* Berkeley: University of California Press, 1982.

Lydenberg, Robin. "Sound Identity Fading Out: William Burroughs' Tape Experiments." In *Wireless Imagination,* edited by Douglas Kahn and Gregory Whitehead, 409–37. Cambridge, Mass.: MIT Press, 1992.

Mach, Ernst. "Bermerkungen über den Raumsinn des Ohres." *Annalen der Physik* (1865): 331–33.

Maché, Britta. "The Noise in the Burrow: Kafka's Final Dilemma." *German Quarterly* 55, no. 4 (November 1982): 526–40.

Maeterlinck, Maurice. *The Treasure of the Humble.* 1896. Translated by Alfred Sutro. New York: Dodd, Mead, 1899.

Mansell, James G. *The Age of Noise in Britain: Hearing Modernity.* Champaign: University of Illinois Press, 2017.

Mao, Douglas, and Rebecca L. Walkowitz. "The New Modernist Studies." *PMLA* 123, no. 3 (2008): 737–48.

Marinetti, F. T. *Critical Writings.* Edited by Günter Berghaus, translated by Doug Thompson. New York: Farrar, Straus and Giroux, 2006.

Marinetti, F. T., Luigi Russolo, and Francesco Balilla Pratella. *Musica Futurista: The Art of Noises: Music & Words from the Italian Futurist Movement 1909–1935.* Salon Recordings. Salon LTMCD 2401, 2004, compact disc.

Martini, Fritz. "Nachwort." Afterword to *Papa Hamlet und Ein Tod,* by Arno Holz and Johannes Schlaf, 103–17. Stuttgart: Reclam, 1972.

Matsumoto, Matataro. "Researches on Acoustic Space." *Studies from the Yale Psychological Laboratory* 5 (1897): 1–75.

McBride, Patrizia. *The Void of Ethics: Robert Musil and the Experience of Modernity.* Evanston, Ill.: Northwestern University Press, 2006.

McLuhan, Marshall. *The Literary Criticism of Marshall McLuhan, 1943–1962.* Edited by Eugene McNamara. New York: McGraw-Hill, 1969.

McNeill, William H. *Keeping Together in Time: Dance and Drill in Human History*. Cambridge, Mass.: Harvard University Press, 1995.

Medieus. "Schlafsanatorien—Traum oder Wirklichkeit?" *Das Recht auf Stille* 2, no. 4 (April 1910): 23.

Menke, Bettine. *Prosopopoiia: Stimme und Text bei Brentano, Hoffmann, Kleist und Kafka*. Munich: Fink, 2000.

Menke, Richard. *Telegraphic Realism: Victorian Fiction and Other Information Systems*. Stanford, Calif.: Stanford University Press, 2008.

Meyer, Erwin. "Über das stereoakustische Hören." *Elektrotechnische Zeitschrift*, May 28, 1925, 805–7.

Meyer, J., ed. *Meyers Konversations-Lexicon*, vol. 1 (A–Alexandreum). Hildburghausen: Verlag des Bibliographischen Instituts, 1840.

———. *Meyers Konversations-Lexikon*, vol. 1 (A–Atlantiden). Leipzig: Verlag des Bibliographischen Instituts, 1890.

Meyer, Lothar. "Die Blaue Liste." *Das Recht auf Stille* 1, no. 9 (July 1909): 160.

Meyer-Kalkus, Reinhart. *Stimme und Sprechkünste im 20. Jahrhundert*. Berlin: Akademie-Verlag, 2001.

"Militärmusik." *Das Recht auf Stille* 2, no. 5 (May 1910): 28.

Milner, Greg. *Perfecting Sound Forever: An Aural History of Recorded Music*. New York: Farrar, Straus and Giroux, 2009.

Möbius, Hanno. *Der Positivismus in der Literatur des Naturalismus: Wissenschaft, Kunst und soziale Frage bei Arno Holz*. Munich: Fink, 1980.

Morat, Daniel. "Cheers, Songs, and Marching Sounds: Acoustic Mobilization and Collective Affects at the Beginning of World War I." In *Sounds of Modern History: Auditory Cultures in 19th- and 20th-Century Europe*, edited by Daniel Morat, 177–200. Oxford: Berghahn, 2014.

Morat, Daniel, ed. *Sounds of Modern History: Auditory Cultures in 19th- and 20th-Century Europe*. Oxford: Berghahn, 2014.

Morgan, Robert P. "'A New Musical Reality': Futurism, Modernism, and 'The Art of Noises.'" *Modernism/Modernity* 1, no. 3 (September 1994): 129–51.

Morton, David. *Off the Record: The Technology and Culture of Sound Recording in America*. New Brunswick, N.J.: Rutgers University Press, 1999.

Moyd, Michelle R. *Violent Intermediaries: African Soldiers, Conquest, and Everyday Colonialism in German East Africa*. Athens: Ohio University Press, 2014.

Müller, Lothar. *Die Zweite Stimme: Vortragskunst von Goethe bis Kafka*. Berlin: Klaus Wagenbach, 2007.

Münsterberg, Hugo. "Raumsinn des Ohres." *Beiträge zur Experimentellen Psychologie*, no. 2 (1889): 182–234.

Musil, Robert. *Briefe: 1901–1942*. Edited by Adolf Frisé. Reinbek bei Hamburg: Rowohlt, 1981.

———. *Der Mann ohne Eigenschaften*. 1930. Hamburg: Rowohlt, 1952.

———. *Gesammelte Werke*, vols. 1 and 2. Edited by Adolf Frisé. Reinbek bei Hamburg: Rowohlt, 1978.

———. *Posthumous Papers of a Living Author*. Translated by Peter Wortsman. New York: Archipelago Books, 2006.

———. *Tagebücher*. Edited by Adolf Frisé. Reinbek bei Hamburg: Rowohlt, 1976.

Nenzel, Reinhard. *Kleinkarierte Avantgarde: Zur Neubewertung des deutschen Dadaismus: Der frühe Richard Huelsenbeck: Sein Leben und sein Werk bis 1916 in Darstellung und Interpretation.* Bonn: Reinhard Nenzel Verlag, 1994.

Niebisch, Arndt. *Media Parasites in the Early Avant-Garde: On the Abuse of Technology and Communication.* New York: Palgrave, 2012.

Oertel, Bruno. "Die Schädigungen des Gehörorgans durch Explosions- und Schalleinflüsse." In *Handbuch der ärztlichen Erfahrungen im Weltkriege 6: Gehörorgan, obere Luft- und Speisewege,* edited by Otto Voss, 75–91. Leipzig: Johann Ambrosius Barth, 1921.

Ohler, Norman. *Blitzed: Drugs in Nazi Germany.* Translated by Shaun Whiteside. Boston: Houghton Mifflin Harcourt, 2017.

Otis, Laura. *Networking: Communicating with Bodies and Machines in the Nineteenth Century.* Ann Arbor: University of Michigan Press, 2001.

Pador, Heinrich. "Die Phonographie im Dienste der Dichtkunst und Rhetorik." *Phonographische Zeitschrift,* November 28, 1900, 59.

———. "Die Phonographie im Dienste der Dichtkunst und Rhetorik (Schluss)." *Phonographische Zeitschrift,* December 12, 1900, 67–68.

———. "Schrift-Poesie." *Neue Litterarische Blätter* 3, no. 10 (July 1, 1895): 255–57.

Passow, Adolf. *Die Ohrenheilkunde der Gegenwart und ihre Grenzgebiete 5: Die Verletzungen des Gehörorganes.* Wiesbaden: Bergmann, 1905.

Paracha, Uzair. "Innocent in the Eyes of the Law." *Hell Is a Very Small Place: Voices from Solitary Confinement,* edited by Jean Casella, James Ridgeway, and Sarah Shourd, 43–54. New York: New Press, 2016.

Pauler, Monika. *Bewusstseinsstimmen: Friederike Mayröckers auditive Texte: Hörspiele, Radioadaptionen und "Prosa-Libretti" 1967–2005.* Muenster: LIT Verlag, 2010.

Payer, Peter. "The Age of Noise: Early Reactions in Vienna, 1870–1914." *Journal of Urban History* 33, no. 5 (July 2007): 773–93.

———. "Der Klang von Wien: Zur akustischen Neuordnung des öffentlichen Raumes." *Österreichische Zeitschrift für Geschichtswissenschaften,* no. 4 (2004): 105–31.

———. "Vom Geräusch zum Lärm: Zur Geschichte des Hörens im 19. und frühen 20 Jahrhundert." In *Der Aufstand des Ohrs: Die neue Lust am Hören,* edited by Volker Bernius, 106–19. Göttingen, Vandenhoeck & Ruprecht, 2006.

Payton, Rodney J. "The Music of Futurism: Concerts and Polemics." *Musical Quarterly* 62, no. 1 (January 1976): 25–45.

Phillips, Robert R. "First-Hand: Bing Crosby and the Recording." Accessed April 2015. https://ethw.org/First-Hand:Bing_Crosby_and_the_Recording_Revolution.

"Phonographen-Automaten." *Phonographische Zeitschrift* 3, no. 9 (1902): 105.

Picker, John M. *Victorian Soundscapes.* Oxford: Oxford University Press, 2003.

Pierce, Arthur Henry. *Studies in Auditory and Visual Space Perception.* New York: Longmans, Green, 1901.

Pierce, George Washington. *The Songs of Insects: With Related Material on the Production, Propagation, Detection, and Measurement of Sonic and Supersonic Vibrations.* Cambridge, Mass.: Harvard University Press, 1948.

Plessner, Maximilian. *Die neueste Erfindung: Das Antiphon; Ein Apparat zum Unhörbarmachen von Tönen und Geräuschen.* Rathenow: Schulze und Bartels, 1885.

———. *Zukunft des elektrischen Fernsehens.* Berlin: Dümmler, 1892.

Plumpe, Gerhard. *Epochen moderner Literatur: Ein systemtheoretischer Entwurf.* Wiesbaden: Springer Fachmedien, 1995.

Politzer, Adam. *Atlas der Beleuchtungsbilder des Trommelfells im gesunden und kranken Zustande: Für praktische Ärzte und Studirende.* Vienna: Wilhelm Bräumüller, 1896.

Pötzl, Eduard. "Die Antiphonerln." In *Wien, Bd. 1: Skizzen.* Leipzig: Philipp Reclam, 1885.

Powley, Harrison. "Janissary Music (Turkish Music)." In *Encyclopedia of Percussion,* edited by John H. Beck, 224–29. New York: Routledge, 2007.

Pratella, F. B. *Autobiografia.* Milan: Pan, 1971.

Prochnik, George. "The Orchestra." *Cabinet* 41 (Spring 2011), http://www.cabinetmagazine.org/issues/41/prochnik.php.

Pudor, Dr. "Die unterirdische Verkehrsstrasse." *Das Recht auf Stille* 2, no. 1 (January 1910): 2–3.

Raab, R. "Das Grammophon, eine neue Schallwiederholungsmaschine." *Ueber Land und Meer* 63 (1890): 395–96.

Radkau, Joachim. "Die wilhelminische Ära als nervöses Zeitalter, oder: Die Nerven als Netz zwischen Tempo- und Körpergeschichte." *Geschichte und Gesellschaft* 20, no. 2 (April–June 1994): 211–41.

Rasula, Jed. *Destruction Was My Beatrice: Dada and the Unmaking of the Twentieth Century.* New York: Basic Books, 2015.

Rehding, Alexander. "Of Sirens Old and New." In *The Oxford Handbook of Mobile Music Studies,* vol. 2, edited by Sumanth Gopinath and Jason Stanyek, 77–108. Oxford: Oxford University Press, 2014.

Révész, Géza. "Gibt es einen Hörraum? Theoretisches und Experimentelles zur Frage eines autochthonen Schallraumes nebst einer Theorie der Lokalisation." *Acta Psychologica* 3 (1937): 137–92.

Reynolds, Simon. *Rip It Up and Start Again: Postpunk 1978–1984.* London: Penguin Books, 2006.

———. "Wargasm: Militaristic Imagery in Popular Culture." *Frieze* (September 1995), https://frieze.com/article/wargasm/.

Rhine, Marjorie E. "Manufacturing Discontent: Mapping Traces of Industrial Space in Kafka's Haptic Narrative Landscapes." *Journal of the Kafka Society of America* (June/December 2005): 65–70.

Rice, Tom. "Sounds Inside: Prison, Prisoners and Acoustical Agency." *Sound Studies* 2, no. 1 (2016): 6–20.

Rilke, Rainer Maria. *Die Aufzeichnungen des Malte Laurids Brigge.* Edited by Manfred Engel. Stuttgart: Reclam, 1997.

———. *The Notebooks of Malte Laurids Brigge.* Translated by Burton Pike. Champaign: Dalkey Archive Press, 2008.

Rippey, Theodore F. "Kracauer and Sound: Reading with an Anxious Ear." In *Culture in the Anteroom: The Legacies of Siegfried Kracauer,* edited by Johannes von Moltke and Gerd Gemünden, 183–98. Ann Arbor: University of Michigan Press, 2012.

van der Rohe, Mies. *Mies van der Rohe: Das kunstlose Wort; Gedanken zu Baukunst*. Edited by Fritz Neumeyer. Berlin: Siedler, 1986.

Rogowski, Christian. "'Ein anderes Verhalten zur Welt': Robert Musil und der Film." *Sprachkunst* 23 (1992): 105–18.

Rohlfs, Gerhard. *Quer durch Afrika: Reise vom Mittelmeer nach dem Tschad-See und zum Golf von Guinea*, vol. 2. Leipzig: F. A. Brockhaus, 1875.

Röpke, Friedrich. *Die Berufskrankheiten des Ohres und der oberen Luftwege*. Wiesbaden: Bergmann, 1902.

Rubey, Norbert, and Peter Schoenwald. *Venedig in Wien: Theater- und Vergnügungsstadt der Jahrhundertwende*. Vienna: Ueberreuter, 1996.

Russolo, Luigi. *The Art of Noises*. 1916. Translated by Barclay Brown. New York: Pendragon Press, 1986.

Salten, Felix. *Das Österreichische Anlitz: Essays*. Berlin: S. Fischer, 1910.

Scarpa. *Anatomicae disquisitions de auditu et olfactu*. Ticini: Petri Galeatii, 1789.

Schaffner, Jakob. *Die goldene Fratze: Novellen*. Berlin: S. Fischer Verlag, 1912.

Schanze, Helmut. "Der Experimentalroman des deutschen Naturalismus: Zur Theorie der Prosa um 1890." In *Handbuch des deutschen Romans*, edited by Helmut Koopmann, 460–67. Düsseldorf: Bagel, 1983.

Schellack, Fritz. "Sedan- und Kaisergeburtstagsfeste." In *Öffentliche Festkultur: Politische Feste in Deutschland von der Aufklärung bis zum ersten Weltkrieg*, edited by Dieter Düding, Peter Friedemann, and Paul Münch, 278–97. Reinbek bei Hamburg: Rowohlt, 1988.

"Schlacht in den Karpaten." Recorded 1915. Archivnummer 2832507, X130. DRA Frankfurt am Main, mp3 audio.

Schmedes, Ernst. "Die Taktik der Preussen beim Ausbruche des Feldzuges 1870 und ihre Änderung im Laufe desselben." *Österreichische militärische Zeitschrift* 12 (1871): 183–96.

Schmidbauer, O. "Das Magnetofon und seine physikalischen Grundlagen (Schluß)." *Funkschau*, no. 5 (1949): 90.

Schmidt, Michael J. "Visual Music: Jazz, Synaesthesia and the History of the Senses in the Weimar Republic." *German History* 32, no. 2 (2014): 201–33.

Schnitzler, Arthur. *Jugend in Wien*. Vienna: Fritz Molden, 1968.

Schnapp, Jeffrey T. "Propeller Talk." *Modernism/Modernity* 1, no. 3 (September 1994): 153–78.

Schölzel, Hagen. *Guerillakommunikation: Genealogie einer politischen Konfliktform*. Bielefeld: transcript, 2013.

Schrage, Dominik. "'Singt alle mit uns gemeinsam in dieser Minute': Sound als Politik in der Weihnachtsringsendung 1942." In *Politiken der Medien*, edited by Daniel Gethmann and Markus Stauff, 267–85. Zürich: Diaphanes, 2005.

Schütze, Hermann. "Raumhören (Stereoakustik)." *Kosmos: Gesellschaft der Naturfreunde*, no. 5 (1926): 155–57.

Schweiger, Werner J. "Das Skandalkonzert im Wiener Musikverein." In *Peter Altenberg- Almanach: Lese-Heft des Löcker Verlags*. Vienna: Löcker, 1987.

Schwandt, Erich. "Fortschritte in Schallaufzeichnung und raumgetreuer Rundfunkwiedergabe." *Funkschau*, nos. 10/12 (1943): 91.

Schwartz, Hillel. "Inner and Outer Sancta: Ear Plugs and Hospitals." In *The Oxford Handbook of Sound Studies*, edited by Trevor Pinch and Karin Bijsterveld, 273–97. Oxford: Oxford University Press, 2011.

Scott de Martinville, Édouard-Léon. *The Phonautographic Manuscripts of Édouard-Léon Scott de Martinville*. Edited by Patrick Feaster. N.p.: FirstSounds, 2009.

Seelig, Lutz Eberhardt. *Ronacher: Die Geschichte eines Hauses*. Vienna: Hermann Böhlaus, 1986.

Serres, Michel. *The Five Senses: A Philosophy of Mingled Bodies (I)*. Translated by Margaret Sankey and Peter Cowley. London: Continuum, 2008.

Siegel, E. M. "Das Sprechen des kulturellen Archivs: Sieben Thesen zur phonographischen Schreibweise des Naturalismus." In *Phono-Graphien: Akustische Wahrnehmung in der deutschsprachigen Literatur von 1800 bis zur Gegenwart*, edited by Marcel Krings, 179–88. Würzburg: Königshausen & Neumann, 2011.

Siegel, Harold B. *Turn-of-the-century Cabaret: Paris, Barcelona, Berlin, Munich, Vienna, Cracow, Moscow, St. Petersburg, Zurich*. New York: Columbia University Press, 1987.

Siegert, Bernhard. *Cultural Techniques: Grids, Filters, Doors, and Other Articulations of the Real*. Translated by Geoffrey Winthrop-Young. New York: Fordham University Press, 2014.

———. "Das Amt des Gehorchens: Hysterie der Telephonistinnen oder Wiederkehr des Ohres 1874–1913." In *Armaturen der Sinne: Literarische und technische Medien 1870 bis 1920,* edited by Jochen Hörisch and Michael Wetzel, 83–106. Munich: Fink, 1990.

———. "Rauschfilterung als Hörspiel." In *Robert Musil—Dichter, Essayist, Wissenschaftler*, edited by Hans-Georg Pott, 193–207. Munich: Fink, 1993.

———. *Relays: Literature as an Epoch of the Postal System*. Translated by Kevin Repp. Stanford, Calif.: Stanford University Press, 1999.

Silber, Erwin. "Ein Brief." *Das Recht auf Stille* 1, no. 5 (March 1909): 82–83.

Silberstein, August. *Die Kaiserstadt am Donaustrand: Wien und Wiener in Tag- und Nachtsbilder*. Vienna: Moritz Perles, 1873.

Simfors, Per. *Extrakte des Schweigens: Zu Sprache und Stil bei Peter Altenberg*. Tübingen: Stauffenburg Verlag, 2009.

Simmel, Georg. *Soziologie: Untersuchungen über die Formen der Vergesellschaftung Soziologie*. Leipzig: Duncker & Humblot, 1908.

Simon, Leslie E. *German Research in World War II: An Analysis of the Conduct of Research*. New York: J. Wiley & Sons, 1947.

Simons, Oliver. "Botschaft oder Störung? Eine Diskursgeschichte des 'Rauschens' in der Literatur um 1800." *Monatshefte* 100, no. 1 (2008): 33–47.

———. *Raumgeschichten: Topographien der Moderne in Philosophie, Wissenschaft und Literatur*. Munich: Fink, 2007.

Spackman, Barbara. "Mafarka and Son: Marinetti's Homophobic Economics." *Modernism/Modernity* 1, no. 3 (September 1994): 89–107.

Spector, Scott. *Violent Sensations: Sex, Crime, and Utopia in Vienna and Berlin, 1860–1914*. Chicago: University of Chicago Press, 2016.

Spiero, Heinrich. *Detlev von Liliencron*. Berlin: Schuster & Loeffler, 1913.

Spiero, Heinrich, ed. *Neue Kunde von Liliencron: Des Dichters Briefe an seinen ersten Verleger*. Leipzig: Xenien-Verlag, 1911.

Sprengel, Peter. "Fantasies of the Origin and Dreams of Breeding: Darwinism in German and Austrian Literature around 1900." *Monatshefte* 102, no. 4 (Winter 2010): 458–78.

Works Cited

Staar, Gerhard. "Plastisches Hören mit Doppelempfänger." *Funk*, no. 28 (1925): 340.

Stahl, Fritz. "Expressionisten-Abend." *Beilage zur Vossischen Zeitung*, May 14, 1915.

Stargardt, Nicholas. *The German Idea of Militarism*. Cambridge: Cambridge University Press, 1994.

Steege, Benjamin. *Helmholtz and the Modern Listener*. Cambridge: Cambridge University Press, 2012.

Stern, Fritz. *Kulturpessimismus als politische Gefahr: Eine Analyse nationaler Ideologie in Deutschland*. Bern: Scherz, 1963.

Sterne, Jonathan. *The Audible Past: Cultural Origins of Sound Reproduction*. Durham: Duke University Press, 2003.

Sterne, Jonathan, and Tara Rodgers, "The Poetics of Signal Processing." *differences: A Journal of Feminist Cultural Studies* 22, nos. 2/3 (2011): 31–53.

Stöckmann, Ingo. *Der Wille zum Willen: Der Naturalismus und die Gründung der literarischen Moderne, 1880–1900*. New York: De Gruyter, 2009.

Stool, Sylvan E., Marlyn J. Kemper, and Bennett Kemper. "Adam Politzer, Otology and the Centennial Exhibition of 1876." *Laryngoscope* 85, no. 11 (1975): 1898–904.

Stopka, Katja. *Semantik des Rauschens: Über ein akustisches Phänomen in der deutschsprachigen Literatur*. Munich: M Press, 2005.

Strowick, Elisabeth. "Epistemologie des Verdachts. Zu Kafkas 'Bau.'" In *The Parallax View: Zur Mediologie der Verschwörung*, edited by Marcus Krause, Arno Meteling, and Marcus Stauff, 123–35. Munich: Fink, 2011.

Strother, Z. S. "Looking for Africa in Carl Einstein's *Negerplastik*." *African Arts* 46, no. 4 (Winter 2013): 8–21.

Stumpf, Carl. *Tonpsychologie*. Vol. 1. Leipzig: S. Hirzel, 1883.

Sulzer, Johann Georg. *Allgemeine Theorie der Schönen Kunste in einzeln, nach alphabetischer Ordnung der Kunstwörter auf einander folgenden, Artikeln abgehandelt 3. Theil*. Leipzig: Weidmannschen Buchhandlung, 1793.

Sussman, Henry. "The All-Embracing Metaphor: Reflections on 'The Burrow.'" In *Critical Essays on Franz Kafka*, edited by Ruth V. Gross, 130–52. Boston: G. K. Hall, 1990.

Szendy, Peter. *All Ears: The Aesthetics of Espionage*. Translated by Roland Végsö. New York: Fordham University Press, 2017.

"Szene aus dem Kampf mit den Hereros." Recorded ca. 1904/1905. Archivnummer 2822470, X130, DRA Frankfurt am Main, mp3 audio.

Tatar, Maria. *Lustmord: Sexual Murder in Weimar Germany*. Princeton, N.J.: Princeton University Press, 1995.

Teague, Jessica E. "Black Sonic Space and the Stereophonic Poetics of Amiri Baraka's *It's Nation Time*." *Sound Studies* 1, no. 1 (2015): 22–39.

Teuber, Oscar. *Die österreichische Armee von 1700 bis 1867*. Vienna: Emil Berté & C. and S. Czeiger, 1895.

Tgahrt, Richard, ed. *Dichter Lesen. Von Gellert bis Liliencron*. Vol. 1. Marbach am Neckar: Deutsche Schillergesellschaft, 1984.

Theweleit, Klaus. *Male Fantasies*. Vols. 1 and 2. 1977/78. Translated by Stephen Conway, Erica Carter, and Chris Turner. Minneapolis: University of Minnesota Press, 1987/89.

212 Works Cited

Thiérard, Hélène. "Negro poem, sound poem? Everyone his own Other." In *dada Africa: Dialogue with the Other*, edited by Ralf Burmeister, Michael Oberhofer, and Esther Tisa Francini, 22–28. Zurich: Scheidegger & Spiess, 2016.

Thomas, Christian Erik. "'Ich werde ganz einfach telegraphieren'—Subjekte, Telegraphie, Autonomie und Fortschritt in Theodor Fontanes Gesellschaftsromanen." PhD diss., University of British Columbia, 2002.

Thompson, Emily. *The Soundscape of Modernity: Architectural Acoustics and the Culture of Listening in America, 1900–1933*. Cambridge, Mass.: MIT Press, 2002.

Thompson, Silvanus. "On the Function of the Two Ears in the Perception of Space." *London, Edinburgh, and Dublin Philosophical Magazine and Journal of Science* 8 (January–June 1882): 406–16.

Trabant, Jürgen. "Herder's Discovery of the Ear." In *Herder Today: Contributions from the International Herder Conference*, edited by Kurt Mueller-Vollmer, 345–66. New York: de Gruyter, 1990.

Traumatische, idiopathische und nach Infektionskrankheiten beobachtete Erkrankungen des Nervensystems bei den deutschen Heeren im Kriege gegen Frankreich 1870/71. Berlin: Ernst Siegfried Mittler und Sohn, 1886.

Tucholsky, Kurt. *Gesamtausgabe Texte und Briefe 6: Texte 1923–1924*. Edited by Stephanie Burrows and Gisela Enzmann-Kraiker. Reinbek bei Hamburg: Rowohlt, 2000.

———. *Gesamtausgabe Texte und Briefe 10: Texte 1928*. Edited by Ute Maack. Reinbek bei Hamburg: Rowohlt, 2001.

Türk, Johannes. "Rituals of Dying, Burrows of Anxiety in Freud, Proust, and Kafka: Prolegomena to a Critical Immunology." *Germanic Review* 82, no. 2 (2007): 141–56.

Twain, Mark. *In Defense of Harriet Shelley, and Other Essays*. New York: Harper & Brothers, 1918.

———. "Knipst, Brüder, knipst." *Das Recht auf Stille* 2, no. 7 (July 1910): 37–38.

Utz, Peter. *Das Auge und das Ohr im Text: Literarische Sinneswahrnehmung in der Goethezeit*. Munich: Wilhelm Fink, 1990.

Van De Water, T. R. "Historical Aspects of Inner Ear Anatomy and Biology that Underlie the Design of Hearing and Balance Prosthetic Devices." *Anatomical Record* 295, no. 11 (2012): 1741–59.

Virilio, Paul. *War and Cinema: The Logistics of Perception*. 1984. Translated by Patrick Camiller. London: Verso, 1989.

Vogel, Jakob. *Nationen im Gleichschritt: Der Kult der 'Nation in Waffen' in Deutschland und Frankreich, 1871–1914*. Göttingen: Vandenhoeck & Ruprecht, 1997.

Volcler, Juliette. *Extremely Loud: Sound as a Weapon*. Translated by Carol Volk. New York: New Press, 2013.

Wade, Nicholas J., and D. Deutsch. "Binaural Hearing before and after the Stethophone." *Acoustics Today* 4, no. 3 (2008): 16–27.

Wade, Nicholas J., and Hiroshi Ono. "From Dichoptic to Dichotic: Historical Contrasts between Binocular Vision and Binaural Hearing." *Perception* 34 (2005): 645–68.

Works Cited

Wallaschek, Richard. *Primitive Music: An Inquiry into the Origin and Development of Music, Songs, Instruments, Dances, and Pantomimes of Savage Races.* London: Longmans, Green, 1893.

Wawro, Geoffrey. *The Franco-Prussian War: The German Conquest of France in 1870–1871.* Cambridge: Cambridge University Press, 2003.

Weiber, Peter, ed. *Die Wiener Gruppe: Ein Moment der Moderne 1954–1960.* Berlin: Springer, 1998.

Weigand, Hermann J. "Franz Kafka's 'The Burrow' ('Der Bau'): An Analytical Essay." *PMLA* 87 (1972): 152–66.

Weigel, Sigrid. "Die Stimme als Medium des Nachlebens: Pathosformel, Nachhall, Phantom: Kulturwissenschaftliche Perspektiven." In *Stimme: Annäherung an ein Phänomen*, edited by Doris Kolesch and Sybille Krämer, 16–39. Frankfurt am Main: Suhrkamp, 2006.

Wenzel, Silke. "Das musikalische Befehlssystem von Pfeife und Trommel in der Frühen Neuzeit." In *Paradestück Militärmusik: Beiträge zum Wandel staatlicher Repräsentation durch Musik*, edited by Peter Moormann, Albrecht Riethmüller, and Rebecca Wolf, 277–98. Bielefeld: transcript, 2012.

Werbeck, Kai-Uwe. "Walking the Corridors of Mass Media: Rolf Dieter Brinkmann's 1973–1974 Cologne Tape Recordings and the Poetics of Disruption." *Seminar* 50, no. 2 (May 2014): 216–30.

Werner, Heinrich. "Rückkehr in die Stadt." *Neues Wiener Tagblatt*, October 2, 1911, 1–2.

White, Michael. "Umba! Umba! Sounding the Other, Sounding the Same." In *dada Africa: Dialogue with the Other*, edited by Ralf Burmeister, Michael Oberhofer, and Esther Tisa Francini, 165–71. Zurich: Scheidegger & Spiess, 2016.

Wielen, Paul von. "Plaudereien am Kamin." *Ueber Land und Meer* 40 (20), no. 47 (October 1877/78): 978–80.

Wiener, Oskar. *Mit Detlev von Liliencron durch Prag.* Frankfurt am Main: H. Lüstenöder, 1918.

Wildenthal, Lora. *German Women for Empire, 1884–1945.* Durham: Duke University Press, 2001.

Wilke, Tobias. "Da-da: 'Articulatory Gestures' and the Emergence of Sound Poetry." *MLN* 128, no. 3 (April 2013): 639–68.

———. "Tacti(ca)lity Reclaimed: Benjamin's Medium, the Avant-Garde, and the Politics of the Senses." *Grey Room* 39 (Spring 2010): 39–51.

Winter, Max. "Wiener Lärm." *Arbeiter-Zeitung*, May 20, 1908, 1–3.

Winthrop-Young, Geoffrey. "De Bellis Germanicis: Kittler, the Third Reich, and the German Wars." Special Section on Friedrich Kittler and War, *Cultural Politics* 11, no. 3 (November 2015): 361–75.

———. "Drill and Distraction in the Yellow Submarine: On the Dominance of War in Friedrich Kittler's Media Theory." *Critical Inquiry* 28, no. 4 (2002): 825–54.

Wipplinger, Jonathan O. *The Jazz Republic: Music, Race, and American Culture in Weimar Germany.* Ann Arbor: University of Michigan Press, 2017.

Wolff, Larry. *Child Abuse in Freud's Vienna: Postcards from the End of the World.* New York: New York University Press, 1988.

Zmegac, Viktor. "Die Geburt der Gesundheit aus dem Geist der Dekadenz: Somatische Utopien bei Peter Altenberg." In *Ideologie und Utopie in der deutschen Literatur der Neuzeit*, edited by Bernhard Spies, 88–99. Würzburg: Königshausen & Neumann, 1995.

Zweig, Stefan. *Die Welt von Gestern: Erinnerungen eines Europäers*. Frankfurt am Main: S. Fischer, 1952.

INDEX

Adorno, Theodor, 50
affect, 11–13, 16, 43–44, 50, 55–61, 69, 80–81, 96, 104–5, 119, 139–40, 142. *See also* vibrational force
Altenberg, Peter, 18, 80, 117, 123, 137–39, 143, 146; and antinoise movement, 66–67, 70; and antiphone, 66–68, 70; *As I See It*, 57, 63–64; and Dada, 77; "The Drummer Belín," 17, 47–57, 59, 62, 64, 71, 77, 91, 97, 104, 162n7; and onomatopoeia, 17, 48, 54–55; and percussion, 47–50, 52–57, 68; and performance, 47–49, 51–57, 59; and prose poem, 64, 67; and silence, 62–65; and tympanic regime, 52–55, 68–70, 91, 97–98, 104; and World War I, 68–69
American Civil War, 10–11
antinoise movement: Germany, 39, 61, 65, 67, 70; views on aesthetics, 66
anti-Semitism, 62
Aristotle, 9

Bahr, Hermann: 49
Balázs, Béla, 116
Ball, Hugo, 74–76, 93
Barker, Andrew, 166n56
Barthes, Roland, 16
Bausenwein, Victor, 44
Beethoven, Ludwig van, 37
Bell, Alexander Graham, 9, 101–2, 162n7
Benjamin, Walter, 26, 74, 88
Berg, Alban, 50
Berlin, 11, 58, 74, 99, 102, 104, 114, 147
Bierbaum, Otto Julius, 26, 156n12
binocular vision, 110–11
Birdsall, Carolyn, 85, 139
Biro, Matthew, 87
Blake, Clarence, 9, 162n7

Blei, Franz, 61
Blue Rider group, 76
Bosmajian, Haig A., 140
Brain, Robert, 15
Braun, Lily, 61
Brinkmann, Rolf Dieter, 145
Bruck, Arthur Moeller van den, 140
Brunner, Gustav, 185n48
Bülow, Frieda von, 80, 81
Burke, Edmund, 8
Burroughs, William S., 145–46

cabaret, 13, 16, 44
Cage, John, 145, 147
Carl, Florian, 81
Chladni, Ernst Florens Friedrich, 183n33
Chopin, Henri, 145
Cloonan, Martin, 12
cochlea, 8–9, 55
Coetzee, J. M., 133
colonialism, 71, 77–86, 173n51
Conrad, Sebastian, 80
contagion, 25, 39–40, 147, 167n69
Cotugno, Domenico, 8
Cowan, Michael, 164n17
Crary, Jonathan, 177n12
cubism, 78

Dada, 17, 50, 70–73, 137; and multilingualism, 92–93; and onomatopoeia, 74, 77, 82, 84, 90–94, 96; and percussion, 74, 76, 78, 85, 87–88, 90–98; and performance, 76–77, 86–87, 90–93, 96; and sonic warfare, 85; and voice, 75
decadence, literary, 166n58
Derrida, Jacques, 14, 44, 133, 164n23
Devrient, Max, 20
Döblin, Alfred, 14
Dolar, Mladen, 134

215

216 Index

Dostoevsky, Fyodor, 22
drums. *See* percussion

ear, anatomy and physiology of, 126,
 128–29, 138, 162n7
eardrum, 11, 15, 62, 131; in Dada,
 86–88, 96, 98; in Franco-Prussian
 War, 34; literary figures of, 16, 18,
 49, 55, 68, 70, 91, 106; medical
 studies of, 34, 52, 104; in modernism,
 16; and National Socialism, 141; in
 naturalism, 24; in romanticism, 7–9;
 and sound reproduction, 9, 101–2,
 137, 163n14; and urban noise, 5–7,
 10, 13, 51, 65; in World War I, 104;
earplugs, 3–7, 10, 66–68, 119, 122, 132,
 172n46
Ebbing-Jäger, Cornelia, 141
Edison, Thomas, 10–11, 24
Einstein, Carl, 78
Encke, Julia, 152n32, 180n61
Ephraim, Jan, 78
Eshun, Kodwo, 149n4
ethnomusicology, 81–82
expressionism, 50, 76, 78; and noise, 77

film, 74–75, 115–18
Fore, Devin, 15
Franco-Prussian War, 12, 34–35, 53–54,
 137. *See also* Liliencron, Detlev von
Frenssen, Gustav, 80
Freud, Sigmund, 162n7
Friedell, Egon, 50, 54, 63
Friedrich, Wilhelm, 156n12
Fuchs, Eduard, 113
Fučík, Julius, 68
futurism, 17, 76, 91, 93; musical
 aesthetics of, 71–73; and
 onomatopoeia, 71; and performance,
 71, 73; Russian, 77; and tympanic
 regime, 73, 75

Galen, 9
Ganne, Louis, 68
Gitelman, Lisa, 14
Goebbels, Joseph, 32, 140–42
Goodman, Steve, 3, 11–13, 58
gramophone, 9, 61, 63, 171n18. *See also*
 phonograph
Grass, Günther, 18, 140

Grosz, George, 79, 88
Gumbrecht, Hans Ulrich, 133

Habermas, Jürgen, 86
Hadamovsky, Eugen, 140
Hamburg, 19
Hanstein, Adalbert von, 139n40
Hart, Heinrich, 22
Hausmann, Raoul, 171n18
Hayles, N. Katherine, 14
hearing loss, 122, 143, 149n3
Heartfield, John, 87
Helmholtz, Hermann von, 99
Herder, Johann Gottfried, 7–9, 56
Hitler, Adolf, 18, 143; and voice, 140–42
Höch, Hannah, 87
Hoffmann, E.T.A., 7
Hofmannsthal, Hugo von, 14, 61, 66;
 "Chandos Letter," 64
Holz, Arno, 20, 155n12, 156n15,
 157n20, 159n40
Hornbostel, Erich Moritz von, 82,
 99–100, 102–3, 106, 108, 110–12,
 115–16
Huelsenbeck, Richard, 17, 105, 123,
 138, 146; *Africa in Sight*, 79; early
 poetry, 77; *Fantastic Prayers*, 77–78,
 82–85, 88–96, 98, 117; *Germany
 Must Perish*, 85; negro songs, 77–78,
 83; "A Visit to the Cabaret Dada,"
 87–88
Husserl, Edmund, 133
Huysman, J. K., 166n58

Ibsen, Henrik, 22
imperception, 18, 122, 124–25, 127,
 137
impressionism, literary, 16–17, 49, 81,
 137–38. *See also* Altenberg, Peter
indexicality. *See* onomatopoeia
industrialization, 10, 14, 63, 67, 73, 147

Janco, Marcel, 79
Jandl, Ernst, 145, 147
Janouch, Gustav, 125
jazz, 79, 173n47
Johnson, Bruce, 12
Joseph, Emperor Franz, 59
Jünger, Ernst, 27, 137–38, 146; *The
 Adventurous Heart*, 104–5

Index

Kafka, Franz, 14–16, 61, 96–98, 116, 118, 137–39, 147; *America*, 120; "The Burrow," 18, 118, 120, 123–35, 138, 146; *The Castle*, 120; and domestic noise, 119–21; "Great Noise," 119; and industrial noise, 120–22; "Investigations of a Dog," 120, 122; "Josephine, the Singer or the Mouse Folk," 120, 122; and narrative time, 132–33; *Office Writings*, 120; and self-observation, 127–28, 130, 133–35; "Silence of the Sirens," 120, 122; *The Trial*, 120–22
Kahn, Douglas, 6, 13
Kandinsky, Wassily, 76–77
Kane, Brian, 123
Kempelen, Wolfgang Ritter von, 9
Kerr, Alfred, 44, 61
Kirschenbaum, Matthew, 14
Kittler, Friedrich, 10–11, 14, 22, 146, 151n31
Kittler, Wolf, 125
Klages, Ludwig, 115
Klee, Paul, 78
Klötzel, C. Z., 124
Köhler, Wolfgang, 99
Kracauer, Siegfried, 139–40

Lamprecht, Karl, 32
language: crisis of, 66. *See also* silence, cult of
Lessing, Theodor, 61, 65–67, 70
Liliencron, Detlev von, 16–17, 47–48, 50, 53, 69–70, 98, 105, 138; and literary form, 23–26; and literary naturalism, 20–22, 155n12; and masculinity, 24, 32; "The Music Is Coming," 19–21, 25, 34–42, 44–45, 162n7; and noise, 26–31; and onomatopoeia, 23–24, 27, 29–34, 39, 40–42, 44; and percussion, 31–34, 37, 40–42; and performance, 20, 25, 34, 42–45; and phonograph, 19–20; and poetics of signal processing, 24–31, 49; *Rides of the Adjutant and Other Poems*, 28–31, 156n12; and soundscape of war, 26–31; "A Summer Battle," 30, 32; and tympanic regime, 24, 69–70; war diaries, 26–27
Loos, Adolf, 162n7

loudspeaker, 10, 141
Lucier, Alvin, 145
Lueger, Karl, 62

Mach, Ernst, 176n4
machine gun, 31, 47, 54, 60, 72, 96
Maeterlinck, Maurice, 64
Mann, Franziska, 61
Mann, Thomas, 14
Marinetti, F. T., 71, 73; *Mafarka the Futurist*, 78; "Zang tumb tumb," 72
Marriot, Emil, 61
Martinville, Édouard-Léon Scott de, 9
Mayröcker, Friederike, 145, 147
McBride, Patrizia, 179n45
McLuhan, Marshall, 14
McNeil, William, 13
media theory, 13–14, 101, 137
Meisel-Heß, Grete, 61
microphone, 6, 10, 100, 141; ultrasonic, 124–25
militarism, militarization, 12, 25–26, 34, 37, 59–62, 67, 104–5, 137–39, 141
mimesis, 40–42, 90, 98, 106
modernism, literary, 13–16, 75, 96, 114, 137, 146–47; ear of, 17–18, 97, 102, 138; and sonic warfare, 103, 123–24, 127, 132, 135; and tympanic regime, 17–18, 97–98, 100–101, 103, 117–18, 123–25, 138
Moltke, Helmuth von, 32
Morat, Daniel, 85
Mozart, Wolfgang Amadeus, 37
Munich, 20, 76
music: African, 80–82, 173n47; European classical, 37, 146–47; military, 11, 25, 32, 34–40, 51, 59, 68–69, 85; Turkish, 37–40, 74
Musil, Robert, 14–17, 27, 96–97, 137; "The Believer," 98, 102–4, 108–18, 138; "The Blackbird," 103, 108; *The Confusions of Young Törleß*, 115; *The Man Without Qualities*, 113; on narrative, 113; and onomatopoeia, 105; and the Other Condition, 103, 115–18; poetics of acoustic space, 102–18, 124, 138, 146; "Toward a New Aesthetic," 115; "Unions," 102; war notebooks, 98, 102, 105–9, 115–16, 118

musique concrète, 112, 145

Napoleon III, 53
Napoleonic Wars, 164n17
National Socialism, 18, 139, 143, 145–46; and tympanic regime, 140–42
naturalism, 17, 49, 137; and form, 20–23, 30–31, 44–45, 139n40; and onomatopoeia, 20
nervousness, 49–50, 66–67, 81, 96, 120, 138
New Modernist Studies, 15
Niebisch, Arndt, 76, 171n18
Nietzsche, Friedrich, 22, 156n15, 157n18
noise (*Lärm*), 12, 61–62, 72, 74, 82, 86, 98, 131, 133, 146–47; abatement, 3–7, 10, 51, 61, 66–68, 119, 122, 132, 172n46; and aesthetics, 65, 104–5; and class, 6, 10, 57, 65, 67, 69; and gender, 56, 61; industrial, 120–21; and negative affect, 55–61, 69, 80–81, 96, 104–5, 119, 139–40, 142; and political power, 60–62; and print media, 65, 68–70; and race, 38, 61, 74, 77, 80–84; ; of the voice, 43–45; urban, 11, 16–17, 50–51, 57–62, 69–70, 74, 81, 110, 138; virtualization of (*see also* imperception)

onomatopoeia, 137–38, 168n69; and Altenberg, 17, 48, 54–55; and Dada, 74, 77, 82, 84, 90–94, 96; and futurism, 71; and Liliencron, 23–24, 27, 29–34, 39, 40–42, 44; and Musil, 105; and naturalism, 20
orientalism, 37
Otis, Laura, 14
otology, 6, 51–52, 162n7

Payer, Peter, 12, 57
percussion: African, 80–82, 84; and Altenberg, 47–50, 52–57, 68; in the city, 60; and Dada, 74, 76, 78, 85, 87–88, 90–98; and Jünger, 104–5; and Liliencron, 32–34, 37, 40–42; and National Socialism, 140–41; in politics, 62; in popular music, 68, 173n47

performance, 13, 16; and Altenberg, 47–49, 51–57, 59; and Dada, 76–77, 86–87, 90–93, 96; and futurism, 71, 73; and Liliencron, 34, 42–45; and National Socialism, 141; and sonic warfare, 17, 96, 104, 146; and war commemoration, 60–61
phonautograph, 9, 162n7
phonograph, 9–10, 16, 24, 75, 85, 137, 139, 174n57, 176n10; and commodification of sound, 19; and Liliencron, 19–20; and World War I, 85, 139; and writing, 19–26, 70, 157n20. *See also* gramophone
photomontage, 87
Picasso, Pablo, 78
Pierce, Arthur Henry, 114
Plessner, Maximilian, 3–7, 10, 67–68, 143
Politzer, Adam, 52
Prague, 25, 44, 124
Pratella, Francesco Balilla, 73
presence, 44, 115, 133, 139, 141
propaganda, 69, 139, 141, 143, 145
psychoanalysis, 11, 152n32
psychophysics, 11

radio, 99, 118, 124, 140–41, 147, 183n26
rationalization, 114–16, 118, 122
Rilke, Rainer Maria, 168n78
Rodgers, Tara, 24
romanticism, 7–10, 13, 34, 56–57
Rühm, Gerhard, 145
Russolo, Luigi, 17, 72–73, 75

Salten, Felix, 60–61, 143
Salzer, Marcell, 20
Scarpa, Antonio, 8
Scheerbart, Paul, 77
Schiller, Friedrich, 7
Schlaf, Johannes, 139n40
Schnitzler, Arthur, 14
Schönberg, Arnold, 61, 162n7
Schönerer, Georg Ritter von, 62
Serner, Walter, 77
shock, 7, 64, 84, 90–93, 107
Siegert, Bernhard, 14, 30, 86
silence, cult of, 62–67, 167n62
Simmel, Georg, 19

Index

siren, mechanical, 121–22
social Darwinism, 20
sonic warfare, 95, 146; and colonialism, 81; and Dada, 85; Goodman's conception of, 11–13; and literature, 15–16, 138–39; and modernism, 103, 123–24, 127, 132, 135; and National Socialism, 140–43; and performance, 17; and urban noise, 3–7
sound: acousmatic, 112; and eroticism, 98, 108, 111–17, 138; and space, 97–98, 110, 138; and the sublime, 8; and temporality, 113, 124, 132, 133
sound poetry, 77, 90, 93; Russian, 76. See also *Dada*
Sousa, John Philip, 68
space, auditory, 97–98, 104–5, 109–10, 113, 124, 138, 146; in experimental psychology, 99–103, 106–8, 111–12, 114–18
Spartacus Uprising, 96
stereophonics, 99–100, 102, 107, 146
Sterne, Jonathan, 9, 13, 15, 24
Straus, Oscar, 20, 162n7
Strauss, Johann, 37
Stumpf, Carl, 110, 175n4
subjective noises, 6–7, 16, 18, 26, 31, 116, 121–24, 127–30
Sulzer, Johann Georg, 7
surveillance, 16, 127–30, 147
Szendy, Peter, 16

tactility, 34, 74, 82, 87–88, 91, 97, 107. *See also* vibrational force.
tape, magnetic, 143–45
Telegrammstil, 20, 27, 30, 64, 159n40
telegraph, 10–11, 24, 26, 30–31, 54, 139n40
telephone, 9–10, 61, 85, 100–2, 107
television, 149n2
Thomas, Phillips, 124–25
Thompson, Emily, 10
transduction: and eardrum, 9; literary, 15, 24, 31, 55–56, 75, 86, 92–93, 96–97, 133, 137–38; and telephone, 101–2
trauma, 108, 120, 137
Tucholsky, Kurt, 61
tympanic regime, 9–10, 13–16, 56–57, 71, 95–96, 102, 137, 146–47; and

Altenberg, 52–55, 68–70, 91, 97–98, 104; and Dada, 74–96, 98; and futurism, 73, 75; and Jünger, 104–5; and Liliencron, 24, 69–70; and modernism, 17–18, 97–98, 100–101, 103, 117–18, 123–25, 138; and National Socialism, 140–42
tympanum. *See* eardrum
Tzara, Tristan, 78

ultrasound. *See* imperception

vertigo, 121–22
vibrational force, 55, 58, 61, 87–88, 91, 94–96, 104, 131, 137, 142, 147
Vienna, 11, 42, 47, 49, 143, 162n7; and noise, 50–51, 57–62, 69–70, 74, 81; and urbanization, 57–59
Virilio, Paul, 177n19
voice, 43–45, 75–76, 140–42

Wallaschek, Richard, 173n47
war: commemorations of, 34–35, 59–60; and literary aesthetics, 28–29, 31–34, 37–38, 53–57; and technology, 10–11, 30, 146
Wars of German Unification, 16, 23, 26, 34, 47; see also *Detlev von Liliencron*
Wawro, Geoffrey, 32
weaponization, of sound, 142–46
Wenzel, Silke, 12
Wertheimer, Max, 99–100, 102–3, 115
Wheatstone, Charles, 9
Wilke, Tobias, 74–75
Wittgenstein, Ludwig, 64
World War I, 12, 35, 61, 75, 94, 99, 120, 125, 137, 139, 173n51, 177n19; and auditory space,100–107; and phonograph, 85–86, 139; propaganda, 68–71, 85–86; soundscape of, 85, 96, 103–4, 117
Wossidlo, Paul, 126
Wüllner, Ludwig, 20

Zeska, Carl von, 20
Zola, Émile, 22
Zurich, 17, 74, 77, 85
Zweig, Stefan, 59